Reader's Digest
COMPLETE
PORTRAIT
COURSE

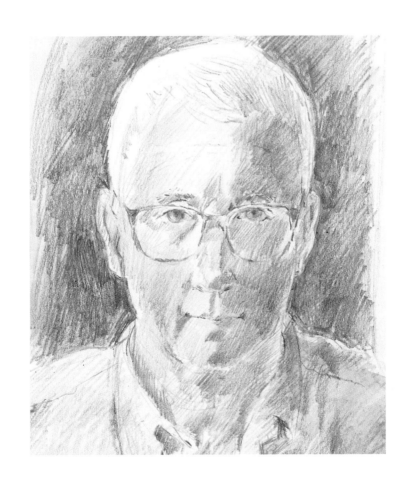

A READER'S DIGEST BOOK

Published by The Reader's Digest Association Limited
11 Westferry Circus
Canary Wharf
London
E14 4HE

www.readersdigest.co.uk

We are committed to both the quality of our products and the services we provide to our customers. We value your comments, so please feel free to contact us on 08705 113366, or via our website at www.readersdigest.co.uk
If you have any comments about the content of our books, you can contact us at gbeditorial@readersdigest.co.uk

ISBN 0 276 42829 3

A CIP data record for this book is available from the British Library

This book was designed and edited by De Agostini UK Ltd based on the partwork *Step-by-*

Produced by Amber Books Ltd
Bradley's Close
74–77 White Lion Street
London N1 9PF
www.amberbooks.co.uk

Printed in Singapore

Contributing Artists:
Alistair Adams: 50, 51, 71-73, 94-98, 99(b), 100, 101, 132-135, 136 (bl,br), 137-139, 228, 229, 230(t), 231-233; Kath Dalmen: 214-216; Abigail Edgar: 108-110; Sharon Finmark: 43-45, 46(tl,tr), 47, 48, 52-54, 55(tl,bl), 56, 57, 102-104, 105(tl,tr), 106, 107, 190-193, 194(tl,tr), 195; Heidi Harrington: 80-82, 83(tl,tr), 84-86; Xiaopeng Huang: 174-177, 178(t), 179-181; Craig Longmuir: 206-208, 209(tl,tr), 210-213; Ian McCaughrean: 24-26, 27(tl,tr,cr,br), 28, 29; Melvyn Petterson: 244-247, 248(tl,tr), 249, 250; Jody Raynes: 182-186, 187(tl,tr), 188, 189; John Raynes: 168-170, 171(tl,bl), 172, 173, 196-199, 200(tl,tr), 201; Tom Robb: 162-165, 166(t), 167; Matthew Schreiber: 126-129, 130(tl,bl,br), 131; Ian Sidaway: 38-40, 41(c,b), 42, 222-224, 225(tl,bl), 226, 227, 238, 239, 240(tl,tr,bl), 241-243; Tig Sutton: 16-20, 21(t), 22, 23, 74-77, 78(bl,br), 79, 140-142, 143(tl,tr,br), 144-147, 148(tl,tr), 149-151; Jane Telford: 251-253, 254(tl,tr), 255, 256; Valerie Wiffen: 111-113, 114(tl,tr), 115, 116; Tracy Wills: 30-34; Albany Wiseman: 6-15, 61, 62(tl,tr,br), 63-70, 87-90, 152-159, 160(tl,bl,br), 161, 202-205, 217(r), 218, 219(tl,cr,bl,br), 220, 221, 234-237.

Picture Credits:
Bridgeman Art Library: Alte Pinakothek, Munich, Germany/Giraudon 119; Ashmolean Museum, Oxford, UK 83(b); Burlington Paintings, London, UK 248(b); Ca' Rezzonico, Museo del Settecento, Venice 125; Christie's Images, London, UK © Estate of Walter R. Sickert 2004. All Rights Reserved, DACS 200(b); Fitzwilliam Museum, University of Cambridge, UK 114(b), © Courtesy of the Artist 160(tr); Galleria degli Uffizi, Florence 35; Gemaldegalerie, Dresden, Germany/Giraudon 123; Graphische Sammlung Albertina, Vienna, Austria 78(t); Hermitage, St. Petersburg, Russia © ADAGP, Paris and DACS, London 2004 121; Isabella Stewart Gardner Museum, Boston, Massachusetts, USA 46(b); Kunsthistorisches Museum, Vienna 21(b), 58; Louvre, Paris, France/Giraudon 124; Mallett Gallery, London, UK 254(b); Musee National d'Art Moderne, Centre Pompidou, Paris, France/Peter Willi © by Dr. Wolfgang & Ingeborg Henze-Ketterer, Wichtrach/Bern 55(br); Musee d'Orsay, Paris, France 49, 99(t); Museo de Santa Cruz, Toledo, Spain 36; Noortman, Maastricht, Netherlands 136(t), 194(b); Palazzo Pitti, Florence, Italy 230(b); Partridge Fine Arts, London, UK 59; Phillips, The International Fine Art Auctioneers, UK 187(b); Prada, Madrid, Spain/ Peter Willi 117; Prada, Madrid, Spain 171(r); Private Collection 130(cr), 148(b); Private Collection/Christie's Images © ADAGP, Paris and DACS, London 2004 37; Private Collection/Courtesy Fischbach Gallery, New York 41(t); © Private Collection/Courtesy of Simon Gillespie Studio, London © Frank Auerbach 209(b); Private Collection/Peter Willi 27(bl); Rafael Valls Gallery, London, UK 143(bl); Rijksmuseum Kroller-Muller, Otterlo, Netherlands 105(b); Scottish National Portrait Gallery, Edinburgh, Scotland 240(br); The Fine Art Society, London, UK 62(bl); © Thyssen-Bornemisza Collection, Madrid, Spain © by Dr. Wolfgang & Ingeborg Henze-Ketterer, Wichtrach/Bern 122; Tretyakov Gallery, Moscow, Russia 166(b); Vatican Museums and Galleries, Vatican City, Italy 60; Victoria & Albert Museum, London, UK 178(b); Corbis: Burstein Collection 225(br); Philadelphia Museum of Art 120; De Agostini: Matthew Rake: 217(cl), 219(tr); Adrian Taylor: 50, 51, 214-216; George Taylor: 6-20, 21(tr), 22-26, 27(tl,tr,cr,br), 28-34, 52-54, 55(tl,bl), 56, 57, 61, 62(tl,tr,br), 63-77, 78(bl,br), 79-82, 83(tl,tr), 84-98, 99(b), 100-104, 105(tl,tr), 106-113, 114(tl,tr), 115, 116, 126-129, 130(tl,bl,br), 131-135, 136(bl,br), 137-142, 143(tl,tr,br), 144-147, 148(tl,tr), 149-159, 160(tl,bl,br), 161-165, 166(t), 167-170, 171(tl,bl), 172-177, 178(t), 179-186, 187(tl,tr), 188-193, 194(tl,tr), 195-199, 200(tl,tr), 201-208, 209(tl,tr), 210-213, 217(r), 218, 219(tl,cr,bl,br), 220-224, 225(tl,bl), 226-229, 230(t), 231-239, 240(tl,tr,bl), 241-247, 248(tl,tr), 249-253, 254(tl,tr), 255, 256.

Reader's Digest
COMPLETE
PORTRAIT
COURSE

42 projects, practical lessons, expert hints and tips

Published by the Reader's Digest Association Limited
London New York Sydney Montreal

CONTENTS

Introducing figure drawing

With these few simple rules as a guide, you'll find that drawing the human figure is much more approachable than you might have thought – it's all a matter of keeping things in proportion.

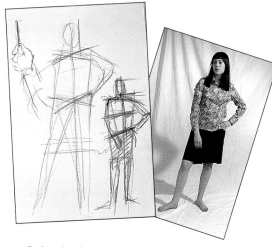

▲ Before beginning your drawing, make plenty of thumbnail sketches from the figure – these will help you to get the feel of the project.

First of all, try to forget that you are drawing a human being. If you look at the figure as you would examine a still-life group, you will find that it seems easier straight away. Forget about producing an accurate likeness, and concentrate instead on understanding and drawing exactly what you see.

Simplify the form

You will find it easier to see objectively if you try to visualise your subject as a series of abstract shapes – spheres and ovals for the head, for example, cylinders for the limbs, and softened cubes for the torso and pelvis. One of the wonderful things about the human body is its flexibility, so notice the way that one part moves against another. If you can't work out how the body is held in a particular pose you can check it by adopting the pose yourself – this is a marvellous way of really getting a 'feel' for what is going on under the surface.

The proportions of the figure

In a standing figure, the height of the head fits into the rest of the body approximately seven times. The legs are about the same length as the head and trunk together, and the navel is placed about three heads down. With the arms by the side, the hands reach halfway down the thighs. These proportions provide a useful starting point, but you will find that individual sitters are often different from this average.

The head fits into a seated body approximately four times. This rule of thumb is useful if you are drawing a seated figure for the first time.

CHECK ANGLES AND PROPORTIONS

To produce a convincing figure drawing, it is important to render key angles and proportions as accurately as possible. You can measure and plan both of these very easily by using a pencil or pastel and your thumb as a measuring tool.

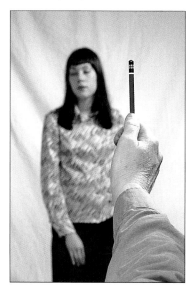

Measuring proportions
Hold your pencil vertically with the sharpened end down. Extend your arm fully, close one eye and look at the model. Align the top of the pencil with a key point – say the top of the model's head – and slide your thumb down until it aligns with another important point, such as the base of her neck. Keeping your arm fully extended, move the pencil to the measurement you want to check.

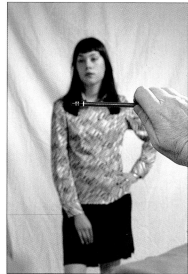

Checking angles
The slope of the shoulders or pelvis is often the key to a pose, but can be difficult to judge by eye. Use a pencil to check these important angles. Extend your arm and align the pencil with the line of the shoulders, for example. Maintaining that angle, transfer the pencil to your drawing and mark the angle on the support – this will give you the correct slope of the shoulders.

PROJECT 1

A STANDING POSE

Ask the model to stand with her hand on her hip and her weight on one leg – this will automatically cause one hip to swing out and the shoulder to dip to counterbalance that swing. Try the pose yourself to get the feel of it.

YOU WILL NEED

Piece of buff-coloured Ingres paper

Conté crayon (studio stick) in sanguine

Soft (4B or 6B) graphite pencil or Staedtler Mars Lumograph EB pencil

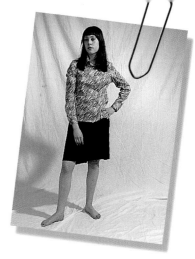

FIRST STEPS

1 ▶ Determine the key verticals and angles
With the help of a sanguine Conté crayon, check the key lines and angles: the centre of the face and torso, and the slopes of the shoulders and pelvis. Note, too, the centre of gravity running down into the weight-bearing left leg. Draw in these key lines with the Conté crayon. Once these are right, the pose will look balanced and convincing.

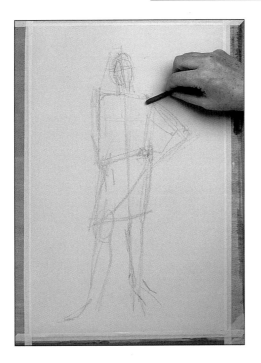

2 ▲ Check the proportions Use the Conté crayon to check the proportions of the figure, using the rule of thumb method. Bear in mind that your model might be slightly different. Check your drawing by making light marks to align with the top of the head and the chin, then use your pencil to transfer this dimension to the paper seven times to locate the feet.

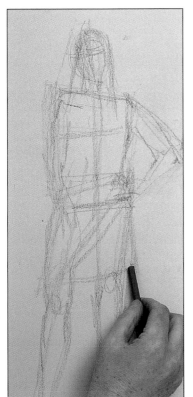

3 ◀ Continue sketching the figure
Using the same sanguine Conté crayon, continue refining the broad outlines of the drawing. Apply the chalk very lightly, measuring, drawing and redrawing until you are satisfied that the stance and proportions are correct. Don't worry about building up lots of lines – these will all be absorbed into the final drawing.

DEVELOPING THE DRAWING

Once you have established the broad shapes and proportions, start to develop the figure in pencil. The Conté sketch provides a useful underpinning for the subsequent drawing.

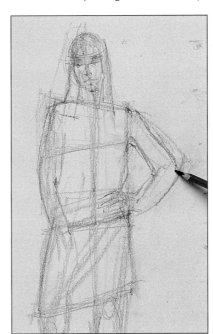

4 ◀ Start to refine the drawing Change to a 4B or 6B graphite pencil, or a Mars Lumograph EB, which is blacker and waxier. Indicate the hairline and the facial details. Because the head is tilted, the lines of the eyes and lips slope slightly. Use the pencil to measure the angles of the left forearm and upper arm. Draw the arm, then compare the negative space between the arm and torso on your drawing to that of the model.

5 ▶ **Simplify shapes**
Continue refining the drawing, studying the model carefully. Places where the body bends, such as the waist, shoulders, elbows and knees, are important. The knee can be rendered as a simple oval.

THE FINISHED PICTURE

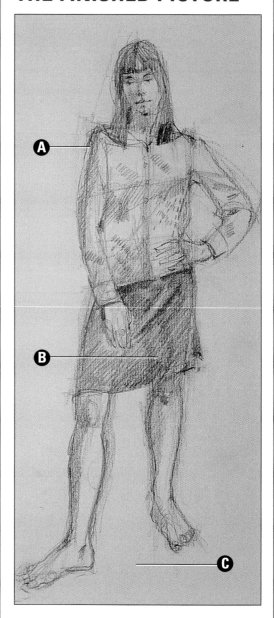

A ———

B ———

——— **C**

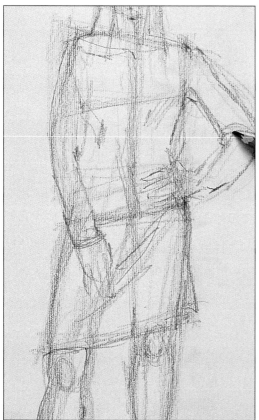

6 ◀ **Add surface detail** When you are happy that the underlying figure is accurate, start to add surface details, such as the folds and creases in the fabric. Use rough, rapid hatching to show how the fabric of the model's blouse falls under her breast, and strengthen the fold where her skirt is pulled across her thighs. The curve at the wrist and the crease at the elbow describe her garment, and at the same time emphasise her rounded arm.

7 ▶ **Add tone** Half-close your eyes so that you can see the areas of darkest tone as well as the highlights. Apply loose hatching to the darkest areas – on the skirt and on the shaded areas on the legs, for example. These touches of dark tone will make the figure appear more solid and three-dimensional.

A Crayon underdrawing
Using a coloured crayon for an underdrawing helped to establish the figure and provided a useful guide for the more detailed pencil drawing. The combination of black and sanguine is visually pleasing.

B Loose hatching
Loosely hatched pencil marks were used to describe the dark skirt and the shading on the figure.

C Tinted paper
The buff colour of the paper was chosen by the artist because of its close similarity to a natural skin tone. This is why certain areas of the paper could be left unworked as highlights.

PROJECT 2

AN ALTERNATIVE POSE

Studying a wide variety of poses is vitally important in figure drawing to get a feel for the proportions and movement of the body. Working with a seated figure gives you the opportunity to examine a whole different set of angles and proportions.

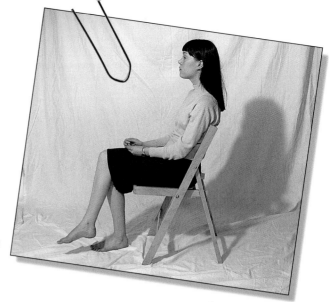

FIRST STEPS

1 ▼ **Establish the main outlines** With a sanguine Conté crayon, lightly lay in the main outlines of the figure. As you work, use a pencil to check the slope of the body, the head, the legs and the chair. Note that, during a long pose, it is inevitable that the model will shift slightly. In the early stages, you can modify your drawing accordingly, but as the drawing progresses, it is best to ask the model to hold one particular position as much as possible – you can discuss what she finds most comfortable.

DEVELOPING THE DRAWING

Now that the outlines of the seated figure have been broadly established, you can start to add detail in pencil. As in the previous study, the Conté sketch provides a useful basis for the subsequent drawing.

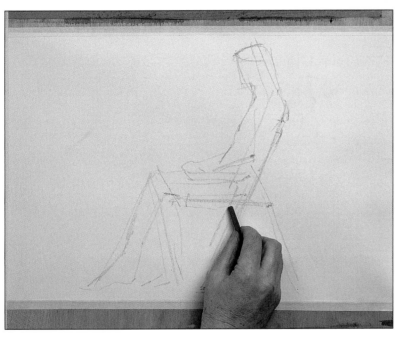

2 ▶ **Refine the drawing** Once you have checked the accuracy of the drawing, you can start to emphasise the important lines. Vary their weight, using heavier, darker lines where there is shadow: on the back of the model's calf and where her back rests against the back of the chair, for example.

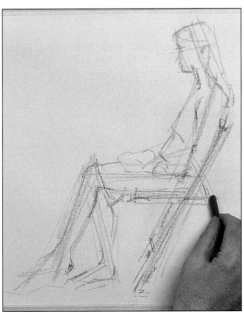

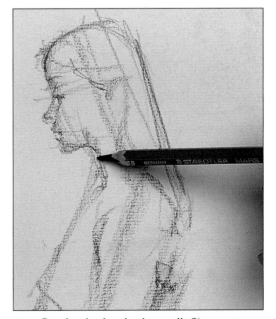

3 ▲ **Develop the drawing in pencil** Change to the EB pencil. Refine the face, adding the details with a few deft touches. Don't overwork the drawing; you will find that the black pencil lines applied over the sanguine Conté crayon begin to show up very quickly.

4 ▼ Draw the hands Study the folded hands carefully, then draw them quickly and economically with a light, energetic line. Draw the outline of the model's jumper and skirt, adding the folds at her elbow, on her back and under her breast. Add touches of dark tone under her skirt and in the angle of the chair.

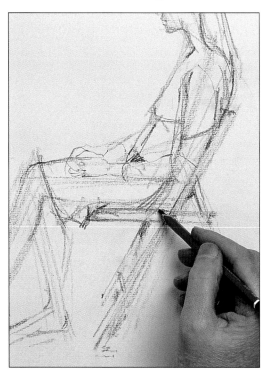

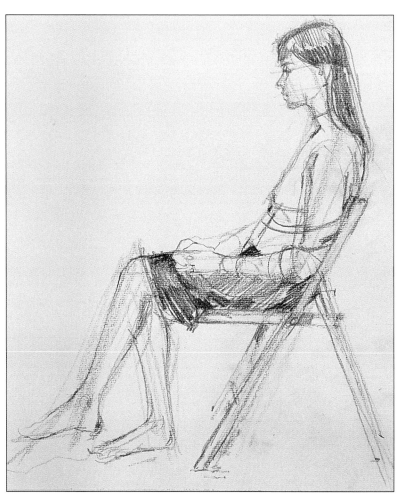

6 ▲ Darken the hair and folds Add dark tones to the hair with hatched lines. Use long, flowing strokes of the pencil to give emphasis and texture to the strands of hair falling on to the model's shoulders. Study the figure carefully and add more folds to the jumper.

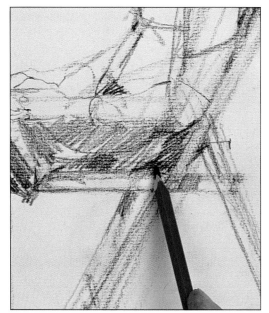

5 ▲ Add tone and detail to the skirt Continue working across the entire drawing, outlining the legs and adding dark tone to the hair and the skirt. Notice the way the hatching follows the folds on the skirt. It is important to include the chair as it explains the model's pose, so draw its legs and add the shadow cast by the upright on the seat.

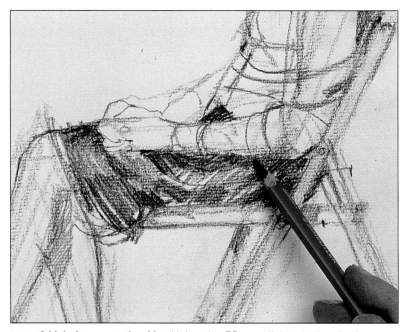

7 ▲ Add dark tones to the skirt Using the EB pencil, hatch the shadow cast by the model's arm on to her skirt. The contrasts of tone on this part of the skirt help to model the roundness of the thigh.

8 ▶ Hatch the cast shadow Holding the EB pencil loosely, start to hatch the shadow cast by the model and the chair. Use light marks that follow the way the shadow falls across the floor and then sweeps up the draped sheet behind. Cast shadows anchor the figure firmly to the horizontal surface and also add an interesting shape to the study.

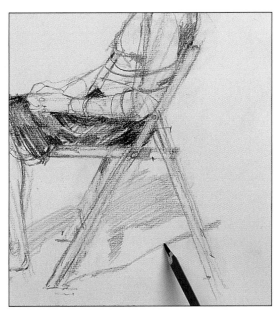

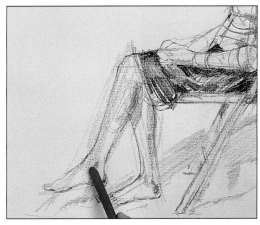

9 ▲ Add warm tone to the legs and hands Use the sanguine Conté crayon to add warm shadows on the ankles and down the back of the calf. Add another touch of tone on the underside of the folded hand.

THE FINISHED PICTURE

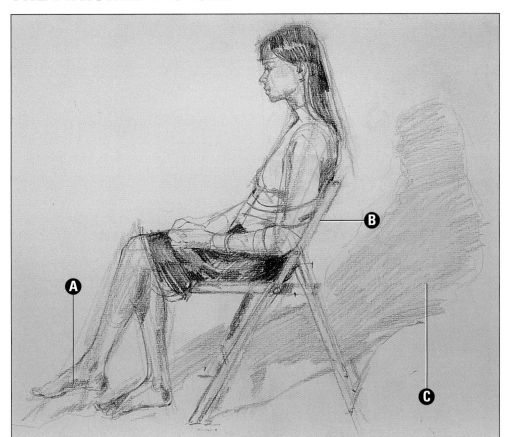

A Sanguine underdrawing
The warm tones of sanguine Conté crayon are ideal for any figure study, especially when combined with a warm, buff-coloured support as here.

B Explain the pose
In a figure drawing, it is important that the viewer can understand the pose. The chair was drawn in some detail to make it clear that the model was supported not only by the seat but by the back.

C Cast shadows
The cast shadows were drawn to set the figure in space and anchor it firmly to the ground. They also improved the composition by providing an interesting shape to balance the main figure.

Looking at anatomy

Combine your talent for art with a little knowledge of science and you'll find that your figure-drawing skills will improve immensely.

▼ The muscles on the plaster cast are well defined and produce a drawing which shows clearly how they are grouped together. The most important muscles for the artist are indicated on the cast.

To draw the figure convincingly, it really pays to have some knowledge of anatomy. After all, if you are familiar with the body's internal structure, you are much more likely to get its external form right. Of course, you don't have to visit mortuaries and operating theatres, as the likes of Leonardo da Vinci and Rembrandt did. Instead, simply practise drawing this anatomical plaster cast.

For the beginner, this type of cast is ideal. First and foremost, unlike a real person, it stays still. Furthermore, it can be a bit intimidating to ask someone to sit nude until you are confident about your figure-drawing skills. (If you're thinking of buying one of these casts, take note: they are costly and only available at specialist art shops.)

Visible form

The basis of anatomy is that, while the skeleton provides the basic framework of the body and determines its proportions, the muscles, which overlay the bones, create the visible form of the figure. The skeleton and muscles work together to produce the vast variety of movements that humans are able to make.

When you move on to a life model, the muscles are unlikely to be quite as pronounced as this cast. However, in most slim, strong models, the muscles will create discernible forms. And with practice, you will soon be able to see exactly how the muscles change in form as the body moves. This, in turn, will help you analyse and capture the overall pose of your model.

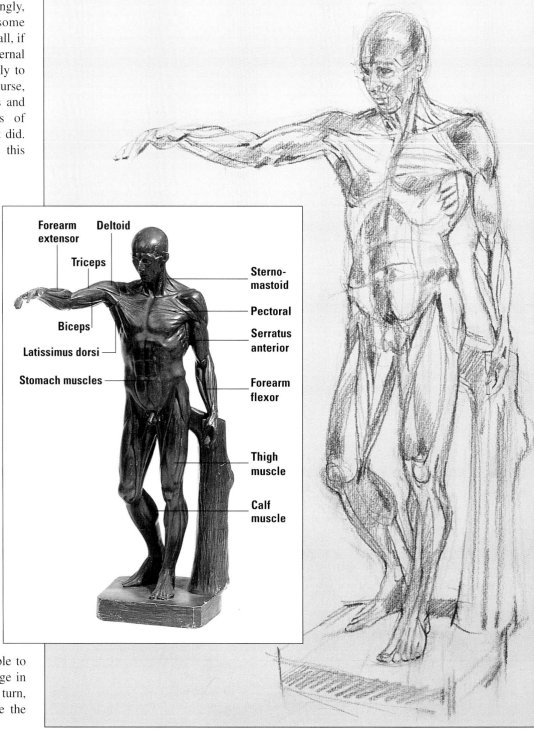

Forearm extensor
Deltoid
Triceps
Biceps
Latissimus dorsi
Stomach muscles
Sterno-mastoid
Pectoral
Serratus anterior
Forearm flexor
Thigh muscle
Calf muscle

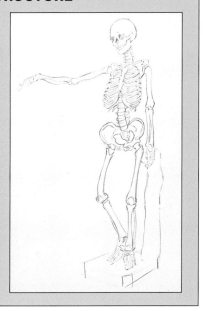
YOU WILL
NEED

Piece of cream pastel paper

Sepia Conté pencil

Craft knife and glasspaper
(for sharpening pencil)

LOOKING AT BONE STRUCTURE

It is important to bear in mind the structure of the skeleton when you work on a figure drawing. The pose of a figure depends on the position of the head, spine, shoulders, pelvis and limbs in relation to each other, and this is easier to ascertain if you can visualise the skeleton beneath the flesh.

As you work through the steps in this project, refer to the skeleton shown here and try to relate the muscles on the anatomical model to the bones they cover. And note that some bones, such as the kneecap, will be visible through the skin.

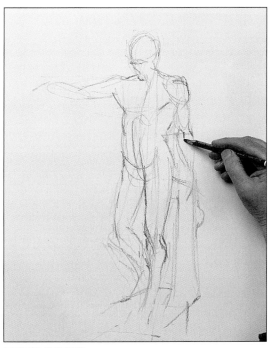

FIRST STEPS

1 ▲ Sketch the figure Using a sepia Conté pencil, sketch the main lines of the figure. As you work, check the proportions of the figure and the angles of the head, torso and limbs. A few guidelines – across the chest and running down the length of the torso and legs – will help you get the stance correct. Indicate the tree stump and stand.

2 ▶ Work on the head Indicate the facial features, the jaw-line and the indented line above the brow. Emphasise the prominent muscle – known as the sterno-mastoid – that runs down the side of the neck, from the base of the skull behind the ear to the inner end of each collarbone.

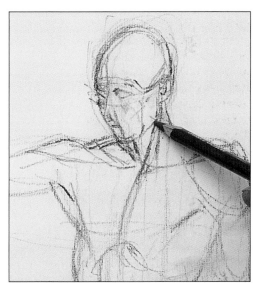

EXPERT ADVICE
Checking the pose

Before beginning your anatomical drawing, make sure you get the stance of the figure right by making a quick sketch of the main lines of the body. Here, the weight is taken by the left leg and the pelvis is tilted at an angle towards the bent right leg.

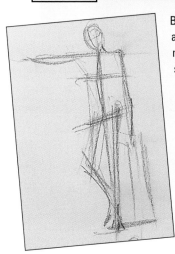

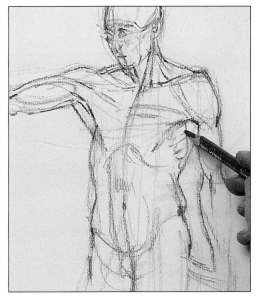

3 ◀ Develop the upper body Just below the armpits, show the ends of the latissimus dorsi muscles, extending around the back from the spine. On each arm, draw the oval biceps, the triceps behind them and the triangular deltoid above. Mark the pectoral muscles on the chest and, below them and to the side, the strap-like serratus anterior muscles.

4 ▶ Describe the limb muscles On the hanging forearm, draw the muscles running from the elbow to the wrist. These comprise the flexor on the inside, which bends the arm, and the extensor on the outside, which straightens it. Define the powerful muscles at the front of the thighs – these connect the pelvis to the shinbone. Indicate the position of the kneecaps with tentative circles. Then draw the calf muscles – note how one calf muscle is seen side-on and one protrudes from behind the shin.

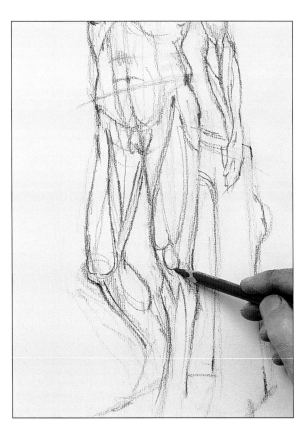

5 ▼ Draw the feet Indicate the bony structure of the feet with lines radiating out from ankle to toes. Bring the tree stump into focus by firming up its outline.

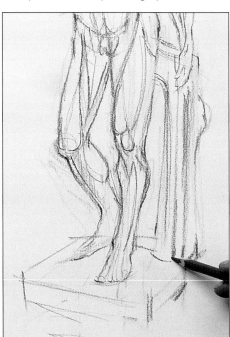

ADDING TONE TO THE BODY

The main muscles on the body are now clearly visible in outline. To help show the contours of the muscle groups, add tone to your drawing by shading with the Conté pencil.

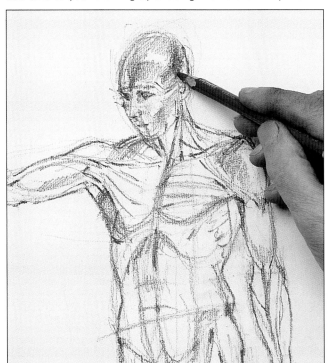

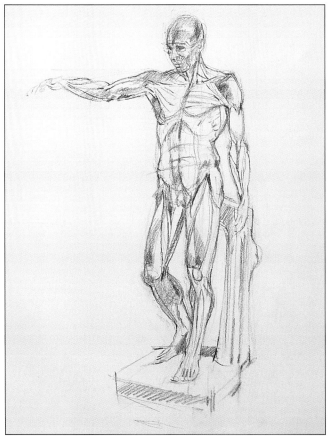

6 ▲ Shade the upper body On the figure's right side, render the dark tones under the biceps and in the armpit. Shade the front of the left shoulder. Darken the shadows under the pectoral muscles and below the rib cage. Then shade mid and dark tones over the face and cranium.

7 ▲ Shade the lower body Complete the flexor and extensor muscles on the right arm. Add definition to the stomach muscles and darken the shadow at the groin. Render a mid tone under the outstretched arm and on the leg muscles. Hatch in some shading on the stand and tree stump.

A FEW STEPS FURTHER

If you want to use your drawing as a reference for future figure studies, define the muscles a little more strongly in places, so that each muscle group will show up clearly.

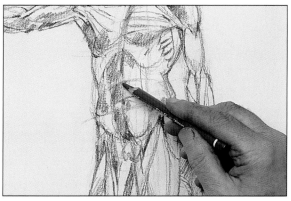

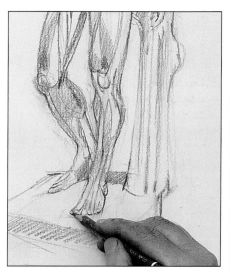

8 ▲ Add tone to the stomach Work over the serratus anterior muscles to emphasise the serrated effect at their edges. Shade more tone on to the regular blocks of muscles down one side of the stomach.

9 ▲ Define the feet Give the structure of the feet a little more detail, defining the toe nails, the heels and the ankle bones. Shade the shin of the left leg.

THE FINISHED STUDY

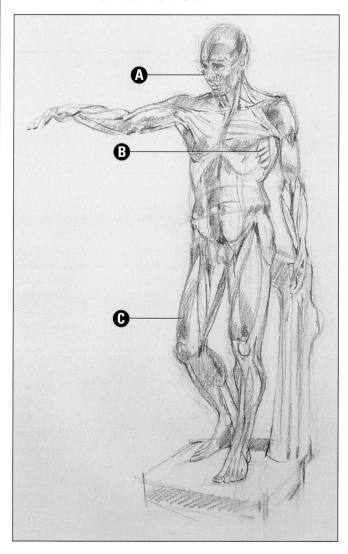

A Head proportions
As the cast has no hair, you can clearly see that facial features occupy only a small area in the bottom half of the skull.

B Muscle shapes
The outlines of the muscles have been clearly defined, so that it is easy to see how they overlap to build up the structure of the body.

C Body contours
Through subtle shading, the muscles take on a three-dimensional appearance, which helps to suggest the rippling contours of the body.

Drawing portraits

If you have ever wanted to record the likenesses of the people around you, but have felt uncertain about how to tackle the subject, now is your chance to try a simple, effective approach.

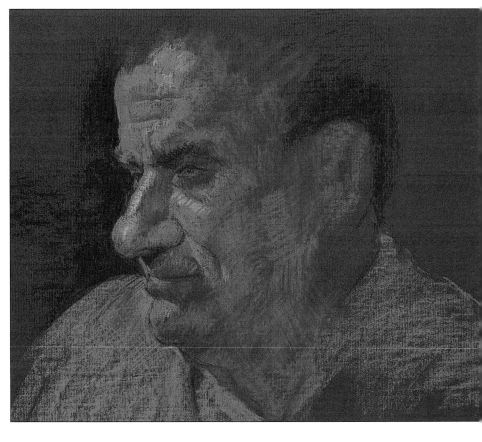

Help is at hand for all those who would love to draw their friends and family but find the prospect rather challenging. This subject can be simplified to make portraiture just as accessible as other genres.

The aim of this project is to enable you to portray the head from three different viewpoints. You will need some coloured papers, a handful of soft pastels and a willing sitter. The first portrait starts off as an egg, and nothing could be much simpler than that!

Visualising facial structure

A face is composed of small surface areas or 'planes'. The planes facing the light are pale, whereas those facing away from the light are darker. If you find this difficult to visualise, try to imagine what your subject would look like if he or she were made of folded paper, rather like an origami model. Instead of rounded cheeks and other features, the face would be composed of angled planes.

Bearing this in mind, you can begin a portrait by establishing the subject in bold planes of light and dark, without worrying too much at this stage about whether the picture looks realistic.

Skin colour

Skin consists of both warm and cool colours. Light areas are generally warm, containing oranges, pinks and yellows; shadows are darker, often containing cooler browns, violets, blues and greens. You can apply this general rule

▲ **With an understanding of the basic structure of the face, you can achieve a realistic and characterful portrait.**

to all portraits, making adjustments to the colour proportions to accommodate particular skin types and racial differences if necessary.

Human skin is made up of several translucent layers that change appearance according to the light. As no single opaque colour will capture this quality effectively, you will need to overlay two or more colours to get a realistic effect. Soft pastels are excellent in this respect, because they can be overlaid easily so that the undercolours show through the pastel strokes.

PROPORTIONS OF THE HUMAN FACE

When working on the initial stages of a portrait, it is useful to remember that the human face is basically shaped like an egg. If you divide the egg into two approximate halves, the eyes fall more or less on the dividing line. If you then draw another line dividing the lower half in two, you will find the position of the bottom of the nose.

Divide the lower section into two halves again and the dividing line determines the approximate position of the mouth.

Obviously, every face is different, and you may have to adjust these proportions to suit your particular subject. However, as a general rule, an egg divided into equal sections provides a useful starting point.

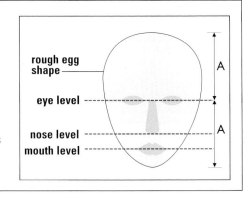

rough egg shape — eye level ---- nose level ---- mouth level ---- A — A

PROJECT 1

FULL-FRONTAL FACE

For this front-view portrait, restrict yourself to just two colours. This will allow you to concentrate on the main features and on the broad areas of light and shade on the face.

As you can see from the portrait, the features are clearly visible because the subject is lit from one side with the other half of the face being thrown into shade. Front lighting on a full face tends to make the features appear flatter than they really are, and is therefore avoided by many portrait artists.

1 ▶ **Start with an egg shape** Using charcoal or a dark grey pastel, lightly sketch a basic egg shape – obviously, your subject's own head will be different, but the egg provides a useful starting point. Using the diagram on the previous page as a guide, sketch in a few horizontal lines to help you position the main features.

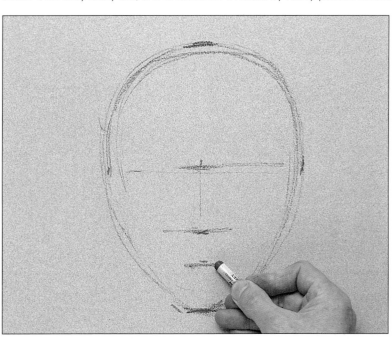

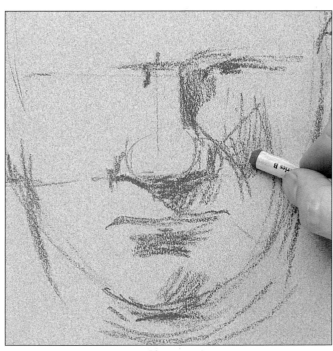

2 ▲ **Draw the facial features** Adapt and define the features, adjusting the drawing so that it begins to ressemble your sitter. For example, here the nose is broadened to suit that of the subject. Pick out the main shadows on the face and block these in using hatched lines.

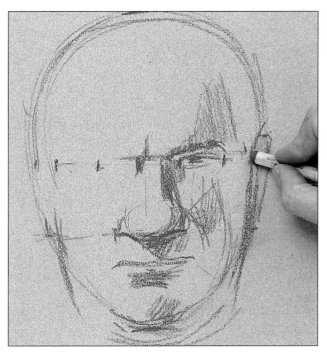

3 ▲ **Adapt the shape of the head** As you progress, keep checking the proportions of the subject, paying as much attention to the spaces between the features as to the features themselves. Adjust the shape of the basic oval to match the outline of the face you are drawing.

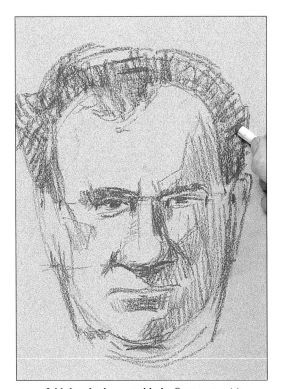

4 ▲ **Add the shadows and hair** Carry on with the dark tone, picking out the rest of the shadows on the face. Don't forget the shadows under the eyebrows. These are important because they set the eyes in the face, avoiding a staring look. Sketch in the hair, treating this as a solid area of tone.

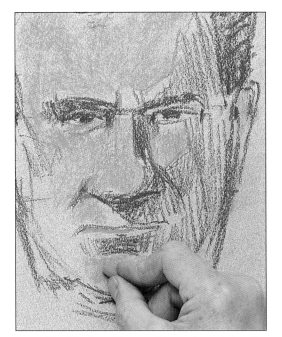

5 ▲ **Block in the mid-tones** Use a dark pink soft pastel to block in the rest of the face, this time picking out the warm medium tones which cover most of the illuminated side of the head. Again, simplify the planes into large, chunky shapes on the forehead, cheeks and chin, and on the front and side of the nose.

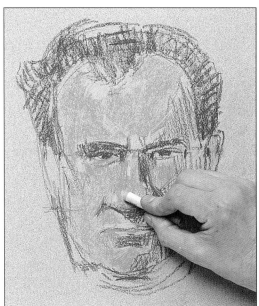

6 ◄ **Add the highlights** Finally, choose a pale orange pastel for the highlights on the face. Look carefully at the subject to see where tiny patches of light are reflected on the prominent areas – forehead, nose, cheeks and upper lip and draw these in fine, cross-hatched lines.

THE FINISHED SKETCH

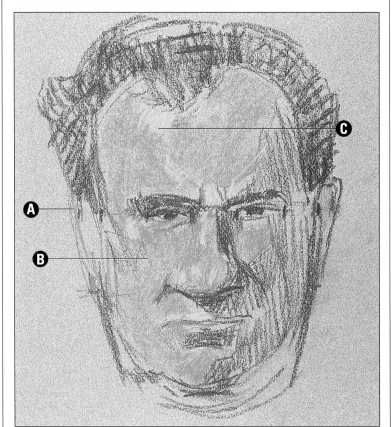

A The basic shape
The egg shape showing the position of the features was developed to form the outline of the face. The same dark tone was used to indicate the shaded side of the face.

B The mid-tone
A warm, dark pink pastel was used for the middle tones. Applied as blocks of colour, it shapes those areas of the face which are not in shadow.

C Pale highlights
Prominent areas of the face catching direct light are picked out and cross-hatched in very pale orange pastel.

CREATING REALISTIC SKIN TONES

Skin colours can be mixed by building up layers of soft pastels. A predominantly warm mixture might contain small amounts of a cooler colour; a cool tone might contain some warm colour. The colours here are just a few of the warm and cool pastels which can be built up to create realistic skin colours. Experiment with these and other shades to develop your own portrait palette.

Cool colours

From left to right: Indigo; Violet; Hooker's green; Grey; Ultramarine; Cobalt

Warm colours

From left to right: Indian red; Pale orange; Burnt sienna; Raw sienna; Pink; Yellow ochre

Sheet of grey-green pastel paper

Charcoal or dark grey soft pastel

3 soft pastels: Dark pink; Mid brown; Pale pink

1 ▶ Draw some guide lines As with the full frontal view, it is best to start with a few light guide lines. Use charcoal or a dark grey soft pastel to sketch the cranium and to position the facial features.

PROJECT 2

PORTRAIT IN PROFILE

Unlike a full-face portrait, a profile – or side view – of the face often benefits from being lit from the front. In this way, the features and expression of the subject are sharply defined, particularly when seen against a plain background as in this pastel study.

The following very general guidelines will prove useful when making the initial drawing. Start by sketching in the back of the head as an arc and the face as a straight, vertical line. As a rule of thumb, the distance from the face line to the back of the head is approximately the same as the distance from the mouth to the top of the head. Also, the jaw line usually falls about halfway between the line of the face and the back of the head. The ear is positioned just behind the jaw line.

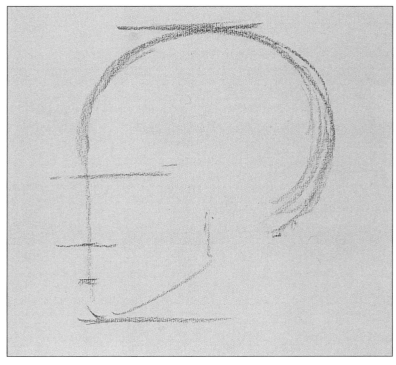

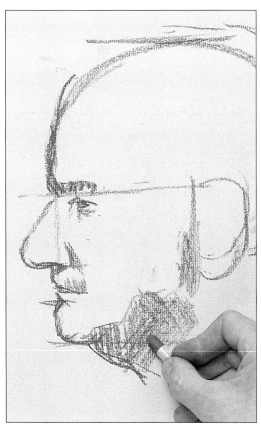

2 ▲ **Establish the broad shadows** Position the ear, then develop the drawing, making sure that the features are all correct in relation to each other. Start to block in the main shadow areas, using parallel cross-hatched strokes.

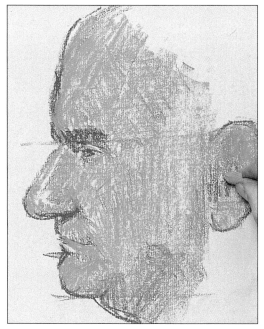

3 ▲ **Block in the warm skin tones** Use a dark pink soft pastel to block in the warm tones on the jaw, forehead, cheekbones and nose. Work a little mid brown soft pastel into the dark shadow areas.

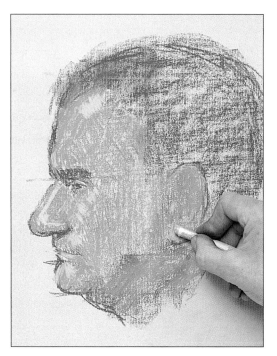

4 ◄ **Add the hair and highlights** Using the charcoal or dark grey soft pastel, block in the hair as a lightly rendered area of flat colour. Finally, use a pale pink pastel to pick out the highlights on the raised areas of the face – the nose, ear, forehead and cheekbone as well as around the mouth and chin.

THE FINISHED PROFILE SKETCH

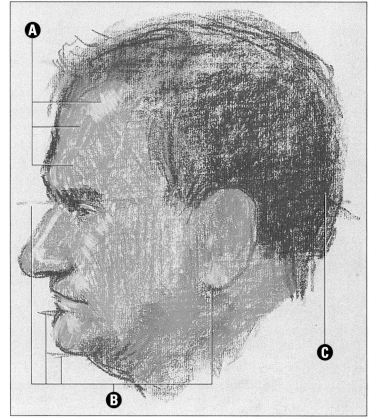

A Overlaid colours
The skin was applied as overlaid cross-hatched planes, using three basic colours – pale pink, dark pink and brown.

B Facial features
The nose, mouth, eye, jaw line and ear were positioned once the overall shape of the head was established.

C Blocked-in hair
The hair was blocked in over the basic structure of the back of the head as a flat shape of overall dark tone.

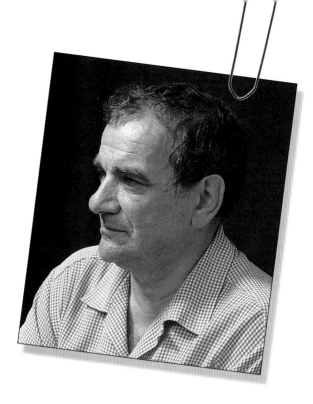

PROJECT 3

THREE-QUARTER VIEW

The final portrait depicts a three-quarter view of the head – the position between a full face and a profile. This view presents the subject informally and naturally, and is extremely popular with portrait artists for that reason.

Brilliant red paper paves the way for a sizzling colour scheme. Although much of the paper is eventually covered by layers of pastel, flecks of red show through the strokes to brighten and warm the skin tones of the finished picture.

Because colour plays such a dominant role in this picture, the initial approach differs slightly from the first two studies. Here, the flesh colours of the face are established before the outline is drawn. However, you should not find this way of working difficult, as the principles are exactly the same: careful construction and simplified planes of light and shade.

Master Strokes

Jean Fouquet (c.1425-80)
Gonella, the Ferrara Court Jester

A celebrated painter in fifteenth-century France, **Jean Fouquet** produced this characterful portrait of a court jester in 1445, while he was travelling in Italy. He has portrayed the jester's wrinkled, expressive face and aging features honestly, yet sympathetically. The artist has also perfectly captured the jester's subtly humourous expression with a slight smile playing about his lips. Fouquet's work has an almost sculptural sense of form and he has modelled the face with translucent flesh tones and sensitive line work.

One skin tone blends imperceptibly into another to create the curves and furrows on the old man's face and the shaded areas around his eyes and mouth.

Features such as the jester's hair and beard are painted in impeccable detail and help to bring him to life as a personality.

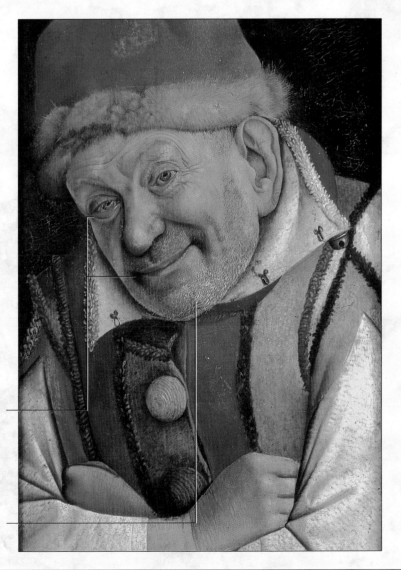

1 ▲ **Start mapping out the face** Keeping your strokes light and loose, start by drawing the palest areas of the face with an orange pastel. Use a medium grey pastel to suggest the eyes and the deeper shadows.

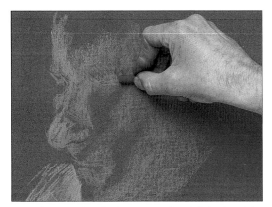

2 ▲ **Suggest the shadow areas** Establish the shirt and outline of the chin in pale grey. Using the side of the medium grey pastel, lightly block in the main shadows, allowing the red paper to show through. Hatch the shadows on the shirt and under the eyebrows in dark grey.

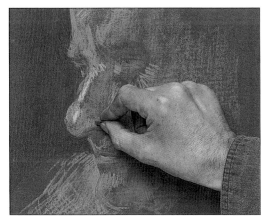

3 ▲ **Establish the background** Block in the background with the side of the dark grey pastel, redefining the outline of the face. Use brown to emphasise some of the shadows and creases. Overlay hatched strokes of pale yellow, orange and pale grey for the light flesh tones.

4 ▶ **Extend the background shadow** Strengthen the deep background tone with the side of the dark grey pastel, taking the heavy shading out towards the edge of the picture.

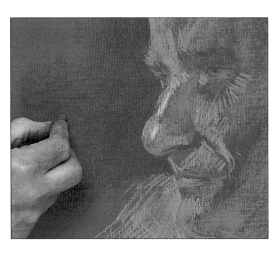

5 ◀ **Develop the light and dark areas** Block in the pale patches on the side of the face and on the throat with the orange pastel. Strengthen and define the broad facial shadow, using the medium grey pastel. Extend the shading towards the back of the face and into the neck.

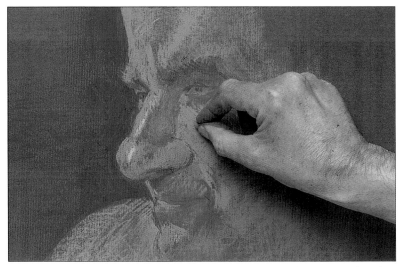

6 ▲ **Strengthen the skin colours** Working with small hatched lines, develop the face by strengthening and building up the planes of colour and overlaid pastel strokes. Introduce some areas of brown to add more warmth to the existing grey shadows.

7 ▼ **Add the hair** The hair is treated as a single dark mass with patches of denser tone in the shadow areas. Here, the deep shade around and behind the ear is emphasised in dark grey, using heavy opaque strokes.

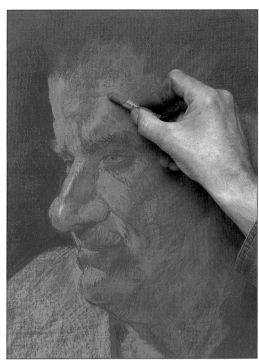

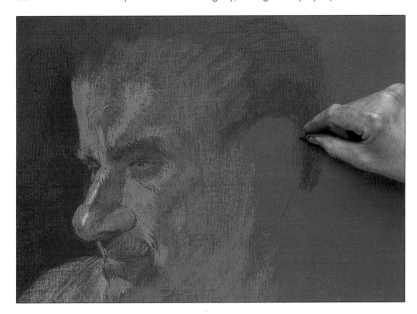

8 ▲ **Draw the wrinkles** Finally, lightly sketch in the position of the forehead creases and the lines around the mouth, using the brown pastel. These marks should not be too pronounced, so try to keep the strokes light and feathery.

THE FINISHED SKETCH

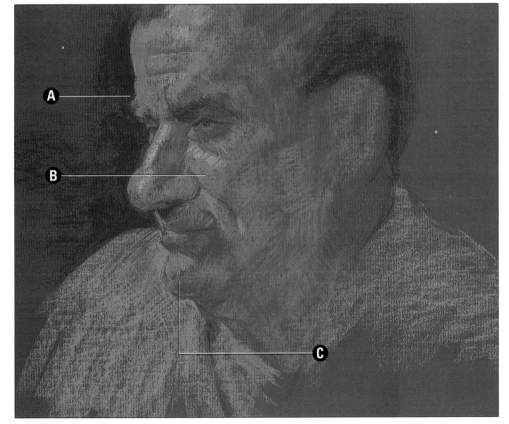

A The background
The dark background emphasises the pale highlights on the skin and gives a crisp, well-defined edge to the face.

B Hatched skin colours
Layers of pastel colours were built up to create a variety of subtle skin tones from cool, greyish shadows to pale orange highlights.

C Red undercolour
The red paper shows through the pastel strokes, providing a warm, unifying undercolour to the other colours in the portrait.

Period pose

This study of a girl painted in oils on cardboard was set up to echo the work of the great French artist Henri de Toulouse-Lautrec.

Toulouse-Lautrec (1864-1901) often chose scantily clad music-hall dancers or ladies of the night as his subjects and painted them in natural poses in intimate settings. This model in period costume is reminiscent of these figure studies.

One of his favourite techniques was working in oils directly on to cardboard without any preliminary drawing. Why did he choose cardboard as a support? Because it was cheap and readily available and allowed him to work with a quick, free technique, using the colour of the board as the background to his paintings. Pierre Bonnard (1867-1947) and Edouard Vuillard (1868-1940) also painted on cardboard, although it is undoubtedly Toulouse-Lautrec who is most often associated with the medium.

While his paintings were executed on an ordinary, throwaway material, there was nothing dismissive or mundane in his treatment of his subject matter. Unlike the majority of French society, Lautrec viewed his dance-hall ladies with great tenderness and intimacy.

Working on cardboard

Although cardboard is seen as a cheap material, it is as durable and permanent a support as fine-quality paper. You can buy 100 per cent rag cardboard from art supply shops. It comes in white and off-white in two-ply and four-ply thicknesses. However, any acid-free cardboard would be suitable.

Being fairly absorbent, cardboard is similar to unprimed canvas to paint on and is particularly useful for anyone who wants a good, inexpensive material to practise on. Its great advantage is its availability, plus the fact that its colour works as a mid tone, unifying all the other colours.

▶ **The colour of the cardboard support left showing around the figure is an integral part of this study in oils.**

YOU WILL NEED

Piece of buff coloured cardboard 60 x 45cm (23½ x 18in)

13 oil paints: Cadmium red; Cerulean blue; Titanium white; Burnt sienna; Rose madder; Sap green; Phthalo blue; Lamp black; Permanent mauve; Vermilion hue; Lemon yellow; Naples yellow; Alizarin crimson

Brushes: No.5 round; No.4 flat

Turpentine; Linseed oil

Oil painting palette

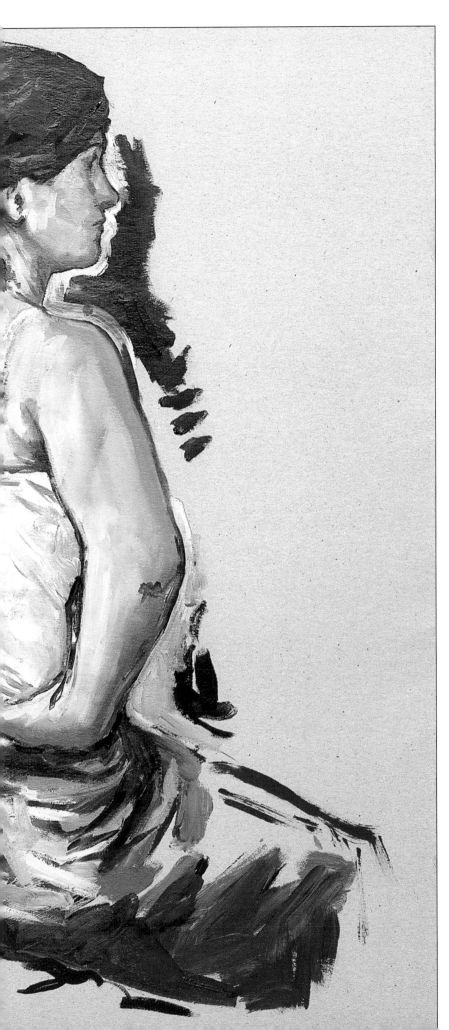

1 ▼ Sketch the figure in paint Dilute cadmium red with equal amounts of turpentine and linseed oil. Using a No.5 round brush, outline the figure, starting with the head. Don't worry about getting everything perfect at this stage.

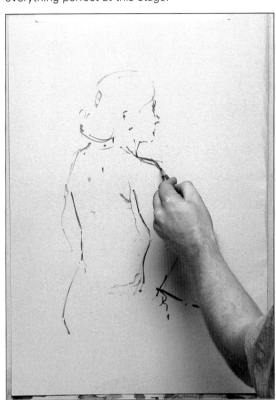

2 ▼ Define the hair Use cerulean blue to define the curves of the model's hair and left shoulder. Add a squiggle or two of blue to suggest stray strands of hair escaping from the loose bun.

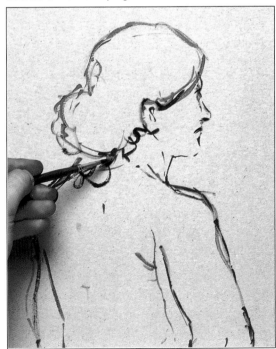

DEVELOPING THE PICTURE

Now that the outlines of the figure are established, begin to block in the clothing and the flesh tones. As you work, make minor adjustments to the pose if necessary by overpainting your initial lines.

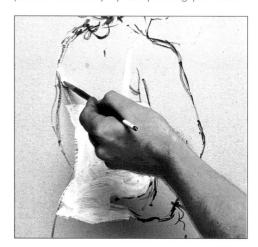

3 ◄ Fill in the camisole With a No.4 flat brush and titanium white, paint the girl's camisole top. Cover the area loosely, using a fairly dry brush so that some of the background shows through. Form the two straps with single, downward brush strokes.

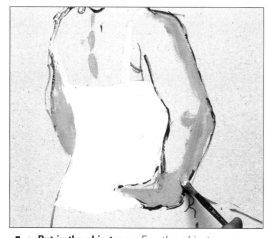

4 ▲ Put in the skin tones For the skin tones, mix burnt sienna, rose madder and white. Apply it with the flat brush, covering the parts of the body that are in shadow – the left arm, the outer edge of the right arm and the spine.

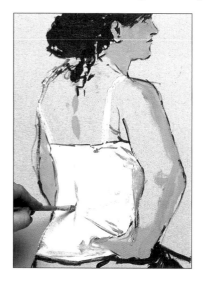

5 ◄ Work shadows on the camisole Paint the model's face in the same mix of pink. Then dilute sap green with a little turpentine and linseed oil and draw a thin line along the top of the camisole and down the left side. Use a mix of phthalo blue and white with a touch of lamp black to suggest shadows on the camisole.

Express yourself

Study in sepia

This tonal version of the portrait is worked in sepia watercolour, mixed with black for the darker shadows. The model's profile is thrown into relief by the heavy black background, which is broken only by the flash of plain white paper on the right.

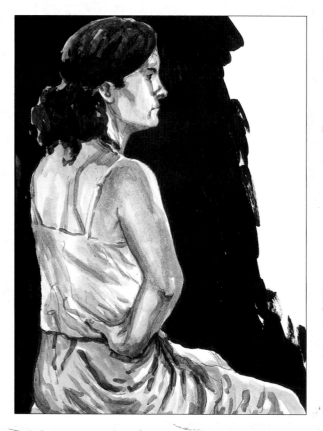

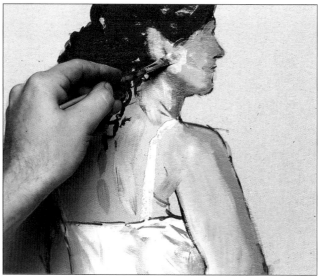

6 ▲ Modulate the flesh tones Adjust the flesh tones to reflect lights and darks. Use rose madder plus white for the highlights and mix in a touch of permanent mauve and vermilion hue for areas of shadow.

7 ▼ Build up the hair Put in lighter tones on the back and arm with mixes of rose madder, lemon yellow and white. With the No.5 round, edge the straps with a mix of phthalo blue, black and white. Use a phthalo blue/mauve mix to suggest shadows in the hair. Add highlights with mixes of Naples yellow and burnt sienna; put in reds with alizarin crimson and white.

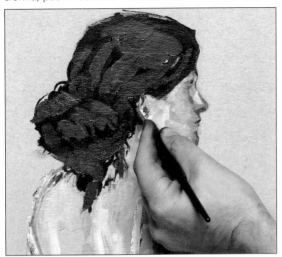

8 ▶ Throw the figure into relief Use sap green to strengthen the outline of the right arm against the whiteness of the camisole. Change to the No.4 brush and paint pure lamp black around the left side of the girl's body to locate her within a three-dimensional space.

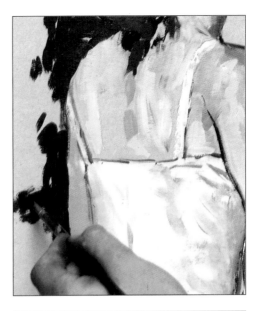

Master Strokes
~⊷~

Henri de Toulouse-Lautrec (1864-1901)
Two Friends

This painting is typical of the intimate way in which Toulouse-Lautrec portrayed women. The eye follows the contours of the relaxed figures, from the bent elbow on the left to the curve of the hip on the right. These rounded forms are echoed by the plump shapes of the sumptuous bedding. Mixed-media techniques using pastel and oils brilliantly describe textures as various as skin, hair and flimsy fabric.

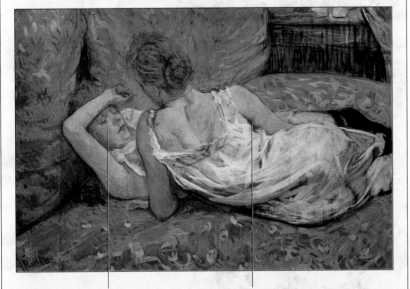

Layers of blended pastel give the skin a rosy bloom, while hatched lines form the contours of the face.

The limbs are outlined in brown to sharpen their shape and separate them from the background.

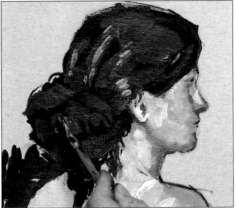

9 ▲ Lighten the hair Put highlights on the hair with pale mixes of white, Naples yellow and rose madder. Follow the curves with your brush strokes.

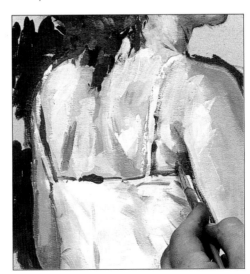

10 ▲ Contrast lights and darks Put in white highlights on the girl's back and right arm. Mix grey-blue from phthalo blue, white and black for the shadow areas. Use alizarin with a touch of phthalo blue under her arm.

EXPERT ADVICE
Blending the colours

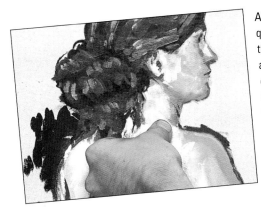

Although the oil paint dries quickly on the cardboard, there is still time to adjust and manipulate the colours. Use your thumb to blend tones together where you want more subtle gradations of colour, for example in the lovely soft skin tones on the neck.

11 ▶ **Paint the skirt** Mix a range of pinks and oranges from cadmium red, burnt sienna, lemon yellow, white and rose madder. Apply to the skirt with broad strokes of the No.4 flat brush. Use black and the No.5 round to outline the skirt and suggest the stool.

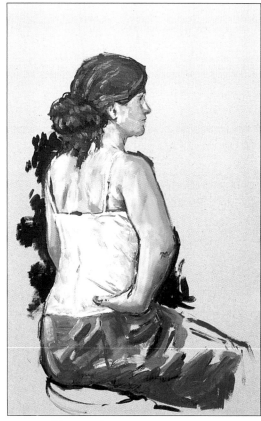

12 ▲ **Blend the flesh tones** Add more white highlights on the right arm and neck and blend them together. Mix alizarin crimson with a touch of black; add detail to the elbow and thumb and patch in the background on the right.

A FEW STEPS FURTHER

As this study is intended to have a sketch-like appearance, the elements of the picture can be left in a semi-finished state. Nevertheless, the pose feels a little too incomplete, as though the girl is floating within the space.

13 ▶ **Extend the dark backdrop** Mix phthalo blue with black and a touch of white. Using the No.5 round brush, paint around the girl's face to bring her head into relief as you did for her body (see step 8).

14 ▲ **Modify the nose** The dark backdrop to the face appears too dominant. Rectify this by painting over it with white. At the same time, use the white to modify the shape of the girl's nose, making it slightly more delicate.

15 ▼ **Paint over the brown** Squiggle some sap green on the girl's bent elbow to create a stronger shadow. The brownish area to the right of her forearm now seems too dark. Use white with a touch of phthalo blue to overpaint it. Slim down the arm with a fine outline of sap green.

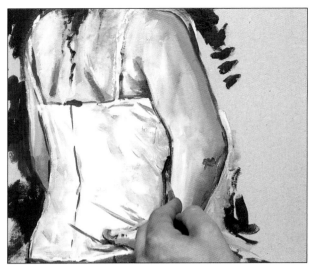

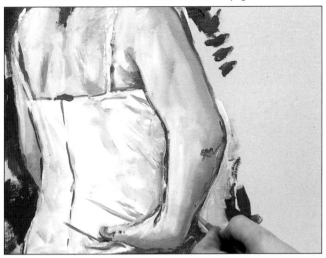

16 ▲ **Make a final adjustment** With the light tones on the right of the girl echoing the colour of her camisole, there is a tendency for the eye to read the colours as one. Define the edge of the camisole more clearly by outlining the girl's stomach in phthalo blue.

THE FINISHED PICTURE

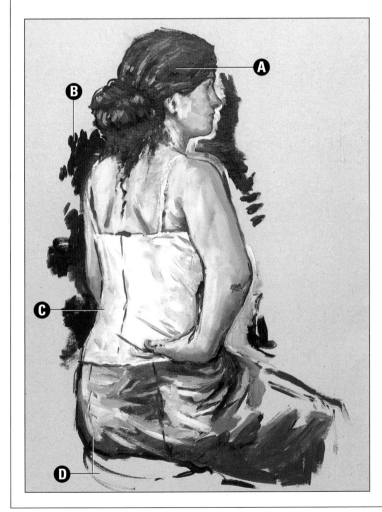

A Hair tints
The hair is a rich mix of reddish browns. Dark blue shadows and pinky yellow highlights follow the curves of the drawn-back style.

B Black backdrop
The flashes of dark tones around the model serve to throw the pose into relief.

C Shadows on white
Blue-greys have been used for the shadows in the crisp, white fabric of the camisole.

D Sketchy appearance
The skirt and wooden stool have been intentionally left unfinished to give a sketchy feel to the work.

Foreshortened figure

Take a new angle on figure drawing with this charcoal study of a young man observed from a low viewpoint.

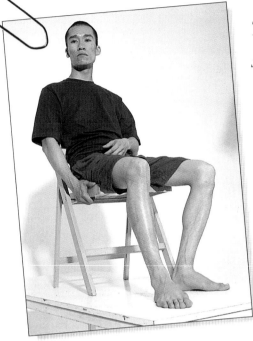

Figure studies tend to be drawn from a conventional viewpoint with the artist working on the same level as the model. However, you can create unexpected results by positioning yourself above or below your model so that the figure is foreshortened. Seen in this way, a figure appears to take on quite different proportions. You can even exaggerate the foreshortening effect to increase the drama of the picture.

A loose style

This drawing was worked in charcoal, which encourages a free, bold approach. Make the initial drawing quickly, putting down the pose as you see it rather than giving it the proportions you might expect. Then work over your first marks, firming them up as necessary.

Don't worry about making mistakes. With charcoal, you can change your lines easily by erasing them with a putty rubber or just your finger. It doesn't matter how often you do this – the faint marks that remain add a dynamic feeling to the drawing.

▶ **Working on a piece of paper almost a metre high encouraged the artist to use the charcoal in a bold, gestural way.**

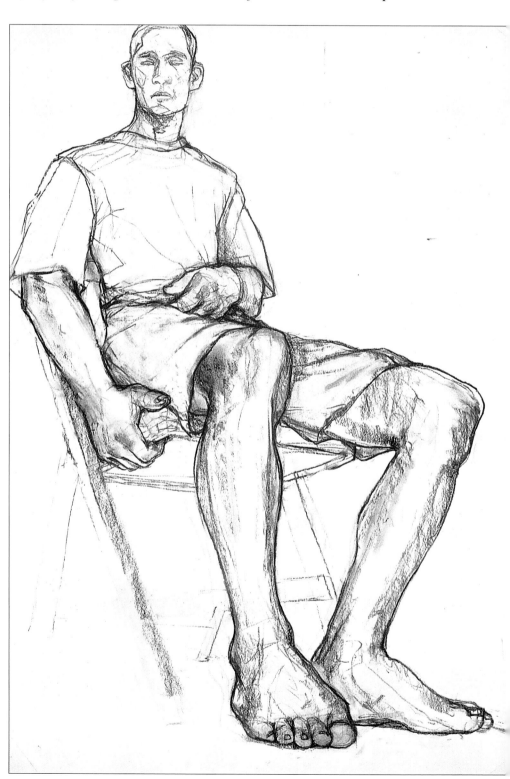

SETTING UP A FORESHORTENED POSE

For this study, the artist set up the model on a chair placed on a table while she drew from a kneeling position in front of him. This created a foreshortened effect with the feet and legs seeming very large in comparison to the upper body. Ask a friend to sit for you and adopt similar poses. View your model from different sides and use sketches and photos to help you decide on a composition for the final drawing. (A Polaroid or digital camera is handy for instant results.) Look out for any unsightly or off-putting negative shapes created by the limbs of the figure or, indeed, the limbs of the chair. Also make sure your model can hold the pose comfortably.

YOU WILL NEED	
Piece of cartridge paper 84 x 60cm (33 x 23½in)	Charcoal pencil
	Stick of compressed charcoal
Willow charcoal	Craft knife (to sharpen pencil)
Putty rubber	Spray fixative

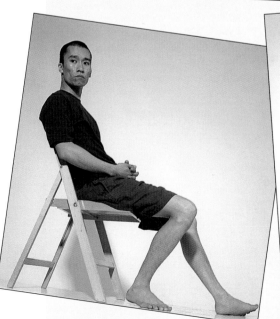

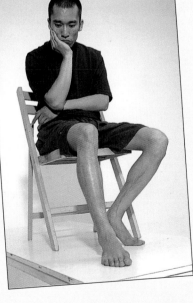

FIRST STEPS

1 ▼ Sketch the body Outline the body, using a stick of willow charcoal. See how the feet look larger than life, while the left forearm appears compressed.

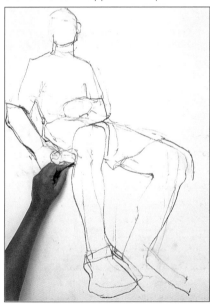

2 ▼ Redefine the hands Check the proportions of the hands by measuring with a pencil or by using linking lines (see Trouble Shooter, over the page). Make changes as necessary. Here, the artist redefined the sitter's left arm and hand.

3 ▶ Draw features

Keep checking the accuracy of your initial drawing as you move from one area to another. Here, the head and shoulders have been moved up to reflect the correct position. Change to a charcoal pencil to draw the facial features. Mark in the hairline and draw the ears. Outline the triangle of shadow under the chin.

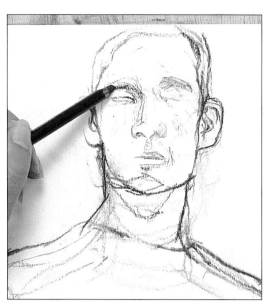

TROUBLE SHOOTER

CHECKING THE POSE

As you draw, constantly assess the relative positions of the limbs. Link one area to another with a lightly drawn charcoal line – here the artist draws a vertical from the end of the top hand to check its alignment with the bottom hand. If the angle of the line is wrong, correct the drawing as necessary.

4 ◀ Rework the legs

Pick up the willow charcoal again and work over the original drawn lines of the shorts and legs – reposition them if necessary. Define the contours of the calf muscles and ankles. Begin work on the toes of the right foot. Using a short length of charcoal on its side, apply a little tone to show shadow around the kneecap.

5 ▼ Develop the toes

Darken the shadows between the toes on the right foot. Draw the nails and joints and mark in the tendons. Add tone on the ankle bone and up the leg.

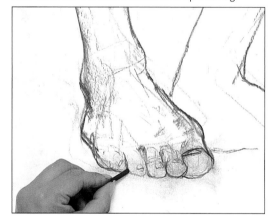

DEVELOPING THE FOREGROUND

To convey a sense of scale in the composition, begin to work into the lower part of the body in more detail, so that the eye is attracted here initially before moving up towards the head.

6 ▶ Work up the right hand

Rough in the chair to anchor the figure in space. Firm up the outline of the right arm, then draw veins on the back of the hand and show the curled fingers. Using the short stick of charcoal, shade along the edges of the arm, across the hand and on the inner edge of the right leg. Add a dark smudge of charcoal in the crook of the right knee.

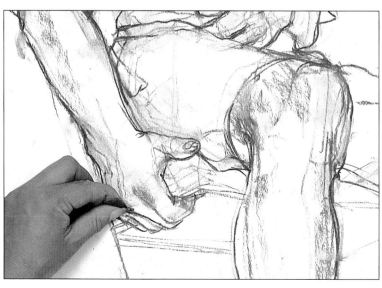

7 ▶ Add more detail to the feet Shade the edges of the left leg and foot to build up their three-dimensional form. Finish drawing the left foot, showing the curve of the arch and the shadow under it. Define the toes and nails and the line of the ankle bone.

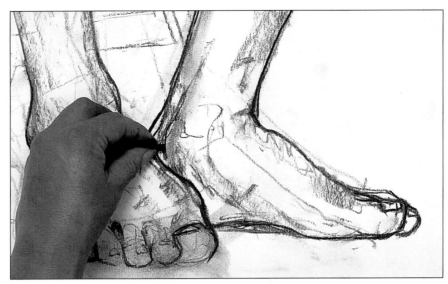

8 ▼ Block in the shorts Tidy up the outlines of the legs and the shadows on them. Block in the shorts with the side of the short stick of charcoal, marking fabric creases. Smooth the texture with your fingers, then lighten the tone by using a putty rubber to erase pigment around the creases.

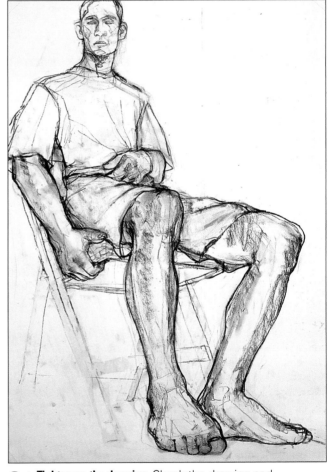

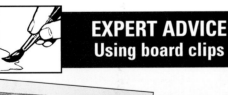

EXPERT ADVICE
Using board clips

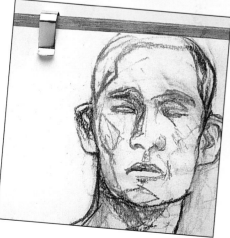

The strong metal clips given away with this issue are a quick and easy alternative to masking tape for securing large pieces of paper to your drawing board.

9 ▲ Tighten up the drawing Check the drawing and rework outlines if they have been rubbed away as you worked. Mark in more folds in the T-shirt and darken the shadows on the left hand. Using the charcoal pencil, add definition to the features, blocking in the shadow under the chin and emphasising the shape of the cheekbones.

Now it only remains to deepen the tone in some areas and to put in a few emphatic final details. Create some highlights by erasing pigment with the putty rubber.

10 ▼ **Darken the toes** Using a compressed charcoal stick, work a darker tone over the toes and smudge with your finger. Add dark shadows under the toes, then go over the outlines of the toes and nails.

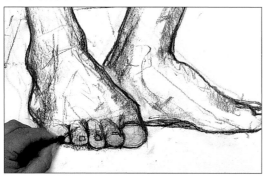

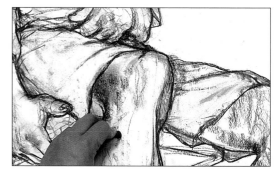

11 ▲ **Build up contrast on the legs** Add dark tone with compressed charcoal to the left hand and arm. Extend more dark tone across the legs, smudging in places with your finger. Lift out a highlight down the right shin with the putty rubber. Fix the drawing with spray fixative.

THE FINISHED PICTURE

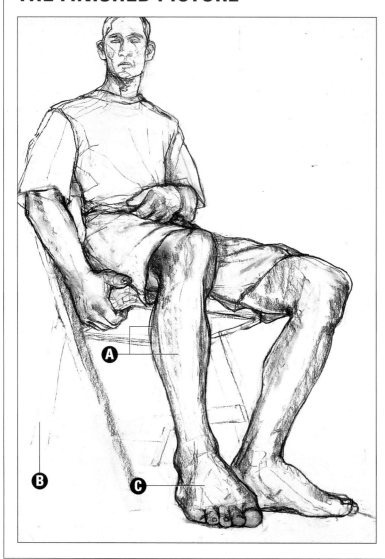

A Rich blacks and soft greys
The full potential of charcoal was exploited in this drawing. The outlines are strong and dark, but where the pigment was rubbed, it has become paler and softer, ideal for subtle tonal work.

B Lightly drawn chair
The chair was drawn very simply and lightly to make sense of the model's pose without distracting from the main focus of the composition.

C Big feet
As well as being large in comparison to the head and chest, the feet were worked more emphatically. This helps to increase the impression of recession.

Elongating the figure

For many cultures in history, a full figure has been the epitome of beauty. In the West, however, artists have been drawn to a slimmer, streamlined shape.

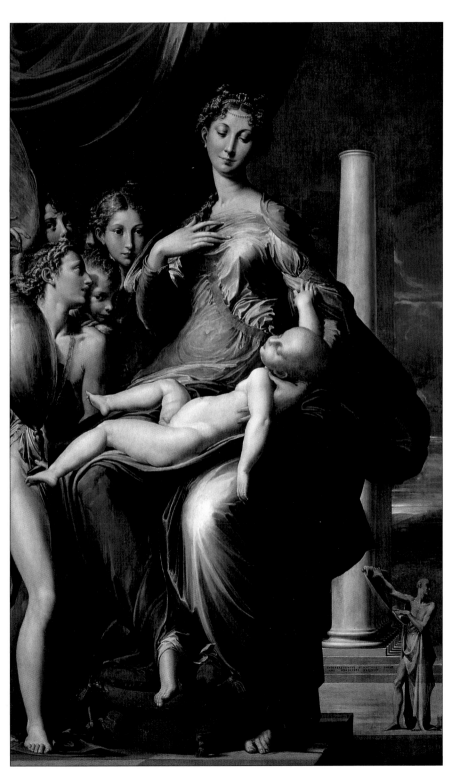

◄ To idealise Mary and Jesus in *Madonna with the Long Neck*, Parmigianino deliberately stretched both their figures.

Artists through the centuries have stretched human anatomy to suit their purposes. Like a tall, slender supermodel, an elongated figure often looks supremely elegant, even when lengthened to impossible proportions.

The famous painting by Parmigianino (1503-40) – *Madonna with the Long Neck* (unfinished at his death) – is an early case in point (see left). Born in Parma in northern Italy, Parmigianino lived in the shadow of the giants of the High Renaissance, Leonardo da Vinci, Raphael and Michelangelo, who had perfected realistic figure depiction.

Deliberate distortion

Parmigianino took the beauty of their Madonnas a stage further by introducing deliberate distortion. His Madonna has the graceful neck of a swan, with elegantly tapering fingers. Christ lying in her lap has the head of a baby on the body of a three-year-old.

Even the angel at the extreme left has a long leg jutting into the picture space, balanced by the strange column in the right background. Its equally odd proportions, coupled with the tiny figure in the bottom right-hand corner, show that Parmigianino's quirky style was deliberate, in composition as well as in figure distortion. This self-conscious approach, playing with the principles of proportions and perspective established during the Renaissance, became known as Mannerism. It is not to everyone's taste – then as now.

While Parmigianino was working in Italy, the ideas of the Italian Renaissance had not yet crossed the Alps to northern Europe. In the early sixteenth century, artists were still

working in the Gothic tradition – a movement largely associated with architecture but also applied to painting.

Gothic paintings are often characterised by elegant, swaying figures, and the German Albrecht Altdorfer (c.1480-1538) was a leading artist in this tradition. His *Christ Taking Leave of His Mother* (c.1520) has a much more conventional composition than Parmigianino's painting. Christ is central, flanked by two disciples on the right and female onlookers on the left, all begging him not to go to Jerusalem to his death.

Religious stature

However, Altdorfer's figures are equally elongated, accentuated by the stiff folds of their garments sweeping from shoulder to ankle. Even the fir trees are extraordinarily tall. As in a Gothic cathedral, with its turrets and spires reaching to Heaven, Altdorfer wanted to give his religious figures stature, to have them stretching towards the divine. By contrast, the earthly family who commissioned the work appear tiny and unimportant in the front right-hand corner.

Nearly one hundred years later, the paintings of El Greco (1541-1614) bear a marked similarity to Gothic and, particularly, Mannerist art. As his name suggests, El Greco was born in Greece where he trained as a painter of icons – stiff, solemn and deliberately unnaturalistic. When travelling in Italy, he saw the work of Parmigianino, among others.

He finally settled in Toledo in Spain where his powerful style of elongated figures, contorted with emotion, found favour in the religious atmosphere there. Their long, crisply draped robes, defined by angular, chalky highlights, add to the upward flicker of his figures. For El Greco, religious belief literally heightened the key players in his paintings.

Glamour portraits

Religious fervour was only one reason for elongating the figure. Canny portraitists of the late nineteenth century, competing with photographers, realised (not for the first time in the story of art) that a painting can make the sitter look much better than in real life, while still giving a convincing likeness.

James Tissot (1836-1902) was a French painter of elegant Parisian society,

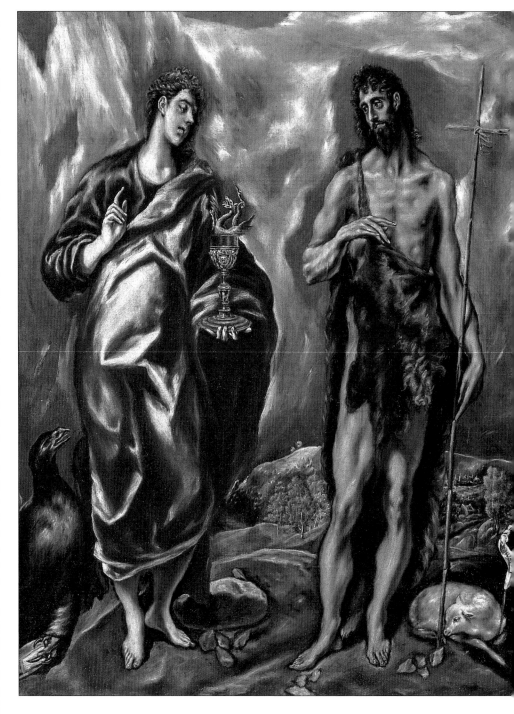

▲ *St John the Evangelist and St John the Baptist* (1605-10) demonstrates El Greco's technique of extending figures into almost flame-like forms.

who later moved to London where he found equal success. In his 1870 painting of cavalry officer and explorer Frederick Gustavus Burnaby, Tissot accentuates the charisma of this Victorian hero. Over 1.92m (6ft 4in) tall and reputedly the strongest man in the British army, Tissot presents him at ease, with perfectly twirled

moustache, the seemingly endless length of his leg accentuated by the vertical red stripe of his uniform. His long arm is held languidly, a cigarette in his hand. The artist shows Burnaby making it all look simple, the epitome of British understatement. His confident bearing and powerful physique confirm stories of his bravery and exploits – as do the armour and a map showing far-flung regions in the background.

The American John Singer Sargent (1856-1925) also eventually settled in London. Born in Boston, he, like Tissot,

spent time in Paris painting society portraits. His painting *Dr Pozzi at Home* (1884) has a slightly sinister glamour, especially in the light of the doctor's dubious reputation. His gynaecological operations were watched by the fashionable and he was known as a great sensualist, which Sargent subtly conveys by portraying him in a long, deep red dressing gown, his tapering fingers and hands extending from the cuffs.

Eventually shot by a mistress's jealous husband, Dr Pozzi was at the time the lover of Mme Gautreau, whom Sargent painted in the same year. Sargent exaggerates the artificiality of her hennaed hair, powdered skin, cinched-in waist and superb figure, almost to the point of caricature. In the ensuing furore caused by the lovers and these portraits, Sargent fled to London. He eventually became super-rich from his tall and thin portraits, such as that of Graham Robertson.

Smouldering beauty

Giovanni Boldini (1845-1931), a contemporary of Sargent, also specialised in painting the smouldering beauty of the rich and famous. He disregards the rules of anatomy to splendidly glamorous effect in his painting *Gertrude Elizabeth, Lady Colin Campbell* (*c*.1897). She leans seductively against the curved arm of a chaise-longue, half-smiling, in a black ball gown that sets

▶ Alberto Giacometti elongated the figure to extreme and rather unsettling proportions in sculptures such as *Standing Woman* (1958) (right). The Swiss-born sculptor perfected his style in 1947, after the full horrors of Nazi death camps were revealed to the world.

off her dark hair and eyes, and sweeps to the floor. From the top of her head to the tip of her shiny, black high-heeled shoes, she exudes desirability and knowing self-assurance.

The twentieth century

With the rise of modern art, the realism that had dominated painting from the Renaissance onwards became less important. Artists looked with new interest at the paintings of the Mannerists and El Greco. Painter and sculptor Alberto Giacometti (1901-66) was an artist with as individual a view as El Greco. He elongated his figures to skeletal, emaciated proportions, paring them down to their essence and emphasising their isolation. Especially in the aftermath of the Second World War, he used his solitary, attenuated figures to question any meaning in life.

Elongating can shift the perception of figures to heighten religious zeal, to glamorise a portrait or to make it stand out from its surroundings. It will be interesting to see what the twenty-first century brings to this kind of distortion.

Lengthening the look

Parmigianino made many drawings from which we can trace the increasing elongation and contortion of his figures. Try doing the same, either with an existing full-length portrait you have made or from a live sitter. Stretch the anatomy by degrees and see the effect – how far you can take it before the image looks like a caricature.

If you have someone to sit for you, ask them to put on different outfits. Notice how a long shift, in the Gothic manner, makes someone look much taller than a separate top and bottom, which bisect the figure at the waist. A single colour is most lengthening. For a female sitter, put her in a glamorous long dress or ball-gown if you have one, and try doing a Sargent-style portrait.

A concave mirror elongates its reflection. If you have one or can improvise one, do a self-portrait from it. Next time you are trying on clothes, have a good look at the mirror and yourself in it – shops often use slightly concave mirrors for flattering effect.

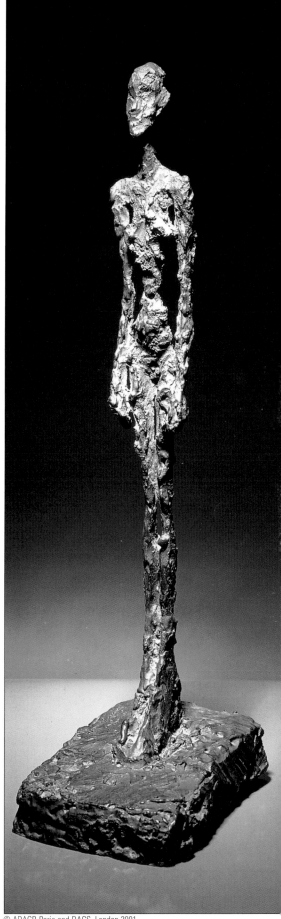

Underwater swimmer

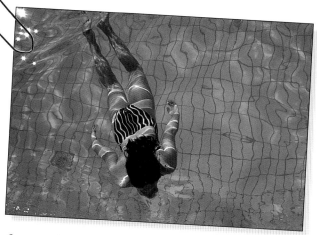

*Full of life and movement, this unusual picture of a swimmer
gliding through the water is a combination of watercolour and collage.*

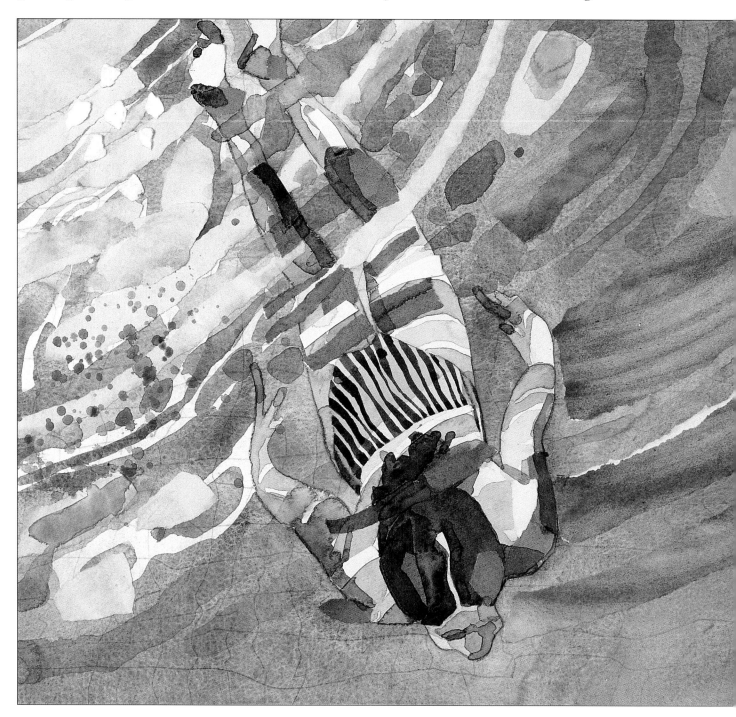

Swimming pools are full of colour and pattern. Ripples play across the water and light catches the splashes, producing a sparkling effect. This makes for an interesting painting subject.

This composition focuses on a single swimmer gliding just below the surface of the water. The movement of the water distorts the appearance of the tiled pool floor and the swimmer's body, giving rise to unexpected, fluid shapes. The light hitting and reflecting off both the water and the figure creates a distinctive patterned effect that lends itself to being reproduced in blocks of colour.

▼ **Paint and torn paper complement each other in this graphic representation of a streamlined figure in the water.**

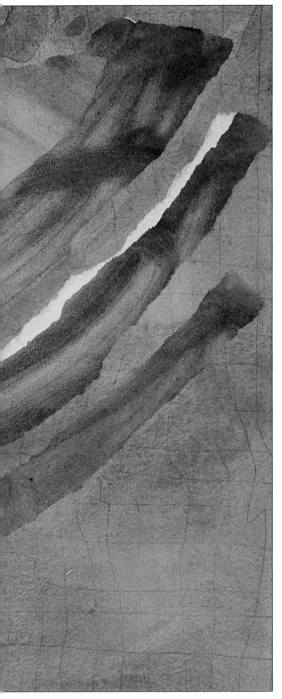

Paint and paper

Watercolour and collage have been combined in this step-by-step to create an interesting textured painting. The paint is applied in stages wet-on-dry, each layer building up the strength of colour. Once you've mixed a wash, add a little more of one or other of the colours as you paint to avoid a uniform look. You could also add a little gum arabic to the mixes to intensify the colour, but this is up to you.

Apply the collage once the painting is complete, using painted watercolour papers. When tearing shapes, try to capture the general movement of the water and the patterns on the swimmer. Due to the weave of the paper, tearing in one direction will produce a white edge, whereas if you tear the other way you'll get a coloured edge. Use this to your advantage by letting the white edges represent ripples catching the light.

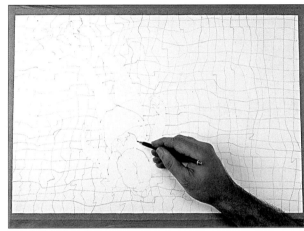

FIRST STEPS

1 ▲ **Draw the main elements** Using a 2B pencil, outline the figure of the swimmer and draw the tiles on the base of the swimming pool. Notice how the rippling water distorts the tiles into a pattern of undulating lines.

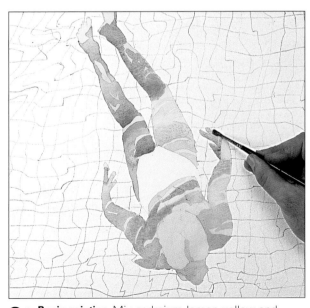

2 ▲ **Begin painting** Mix cadmium lemon yellow and brown madder watercolour. Using a No.7 round brush, wash this over the figure. Darken the mix with brown madder and permanent mauve and paint mid tones on the body, leaving bands of pale tone showing through.

3 ▶ Add dark tones
Add ultramarine
to the brown mix to
make a purplish-brown
for the hair; dilute for
the pattern of dark
tones on the figure.
Extend the fingers to
give an impression of
movement. Block
in the swimsuit with
the cadmium lemon;
add brown madder
for the shadow. Mix
Payne's grey and
burnt umber to make
a dark tone for the
hair and the right eye.

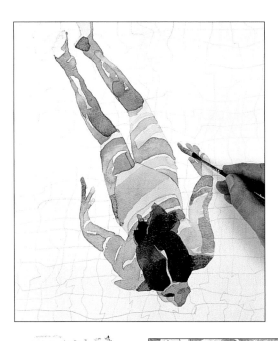

4 ▼ Block in the water Mix Payne's grey and
ivory black. Changing to a 6mm (¼in) flat
brush, paint stripes on the swimsuit. Make a
dilute wash of cobalt turquoise and cerulean
blue. Wash over the pool with a No.12 round.

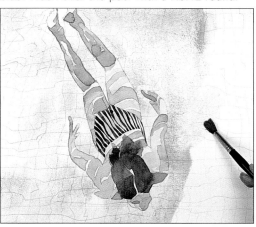

Express yourself

A change of format

Combining paint with collage is fun, so why not
try another composition in the same vein? Here,
the swimmer glides down the paper, creating
a vertical line that leads to a circle of ripples. Her
shadow on the tiles is a distorted version of her
body shape and gives depth to the water. Texture
is built up with collage shapes, as in the step-by-
step, but the watercolour is more subdued.

**5 ◀ Paint the water
pattern** Make a
stronger mix of the
two blues and paint
the pattern made by
the moving water on
the left, leaving some
of the undercolour
showing. On the
right, completely
cover the undercolour.

DEVELOPING THE PICTURE

You have now laid the foundation for the collage. Before you begin, paint
papers with colours that correspond to those of the swimmer and water:
a dark and a pale blue, a dark and a pale flesh tone, and a dark hair colour.

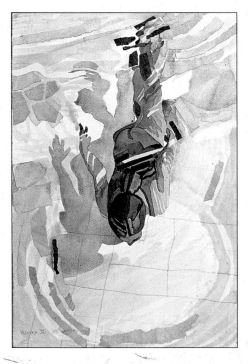

**6 ▶ Arrange pale blue
shapes** Tear a piece
of pale blue painted
paper (see Expert
Advice, opposite)
into a variety of strips
and patches that
correspond with the
pattern of light and
ripples on the water.
Arrange the torn
paper shapes on
the painting – some
pieces can overlap
the swimmer's body.

Master Strokes

Alice Dalton Brown (b. 1939)
Pool, Tropical Reflection

Dalton Brown has used oils to produce a wonderfully detailed rendition of a swimming pool – quite a contrast to the more abstract shapes of the step-by-step project. The artist has divided the canvas broadly into two halves – the green of the foliage against the blue of the water. Look closely at the green foliage and you begin to see other beautiful colours – yellows for the sunlit leaves, browns for the branches and even the odd shade of purple.

The wall helps guide the eye around the picture – from the red flowered plant in the corner to the trunk of the palm tree on the right.

The swimming pool holds a wonderful array of reflections, from the spiky palm leaves to the bold linear shape of the trunk.

7 ▶ Glue the ripples
Spray adhesive on to the back of the pale blue shapes and stick them in position. You can butt shapes up to the body by cutting long strips with a scalpel. Either cut them directly on the paper, or if you prefer, mark a line with the pencil and then use the scalpel on a cutting mat.

EXPERT ADVICE
Prepare collage papers

Choose a variety of papers for the collage – firm, slightly textured ones are best. Using a No.12 round brush, paint the papers loosely, working in all directions and allowing the brush marks to show so that you create an interesting surface (as shown right).

8 ▼ Add to the collage Tear some dark blue paper into curved bands and glue them on the right. Now tear small patches and strips of paper in dark flesh and hair shades; place them on the legs, shoulders and hair. Make some fit the body contours, but extend others to suggest the distorting effect of the water.

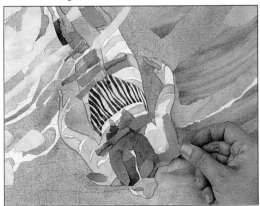

9 ▼ Stick on pale colours Stick small strips of pale, flesh-coloured paper on the legs, feet, shoulders and back to add highlights. Finally, glue tiny scraps of white paper in the top left of the picture to represent dappled light.

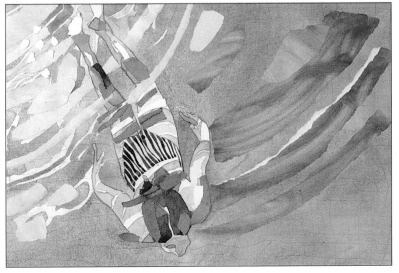

The collage is now complete and cleverly plays up the textural and patterned elements in the picture. To blend the collage into the painting a little, add some more touches of watercolour here and there.

10 ▶ **Work on the water** Using the stronger blue wash from step 5, paint some ripples in the water, taking the brush marks right across the arms and legs. Splatter drops of dark blue to the left of the swimmer.

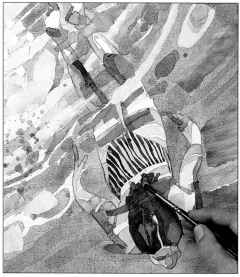

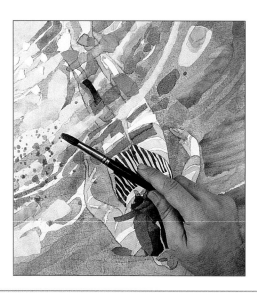

11 ▲ **Add definition** With stronger mixes of the hair and flesh colours from the palette, paint shadows on the hair and limbs. Define the right eye, and the fingers, heels and toes.

THE FINISHED PICTURE

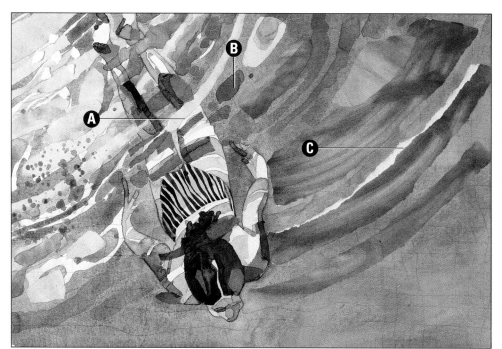

A Raised texture
Torn from a range of medium-weight watercolour papers, the stuck-down shapes add texture to the smooth, flat surface of the underpainting.

B Wet-on-dry
Each layer of paint was left to dry before the next was applied, so the blocks of colours have well-defined edges that complement the patterns made by the collage.

C Torn edge
The uneven white edge of one of the torn pieces of collage paper is left unpainted to suggest a ripple catching the light in the swimming pool.

Tango dancers

Watercolour is a lively medium that is well suited to an animated subject, such as this study of couples dancing the tango in a park.

When it comes to capturing quick movements, photographs really come into their own. As they freeze the motion, you have the chance to analyse what's happening and the freedom to paint at leisure what you have seen. In this painting, two shots of couples dancing the tango have been used together to make an interesting composition. The artist chose this particular dance for its precise sequence of repeated steps, which are easy to photograph.

Simplified subject

In order to focus on the movement within a scene, it is best to simplify the background. In this picture the artist has eliminated the onlookers so that all the attention is on the dancers. The figures are kept quite simple, apart from the detail in the creases of the clothes, which reflect the movement of the bodies underneath them.

Watercolour gives swift, fluid results and can be used in a loose, sketchy way. It is a spontaneous medium and, as such, is a good choice for conveying the liveliness of moving objects. In the main, it has been used here wet on dry, with some blurred edges to enhance the sense of movement.

Purple madder and Antwerp blue are used throughout the painting, but particularly for the two central figures. The purple madder, a strong colour, helps to bring the main dancer to the front of the picture, while the blue provides a cool contrast.

▶ **Use a light, lively touch to capture the stylised steps and body stances of these tango dancers.**

YOU WILL NEED

Piece of 300 gsm (140lb) Not watercolour paper 38 x 30cm (15 x 12in)

0.5 propelling pencil

Brushes: Nos.6, 4, 3 and 10 rounds

13 watercolours: Purple madder; Cadmium orange; Burnt sienna; Yellow ochre; Sepia;

Antwerp blue; Payne's grey; Alizarin crimson; Ultramarine; Vandyke brown; Naples yellow; Dark emerald; Viridian

Mixing palette or dish

Jar of water

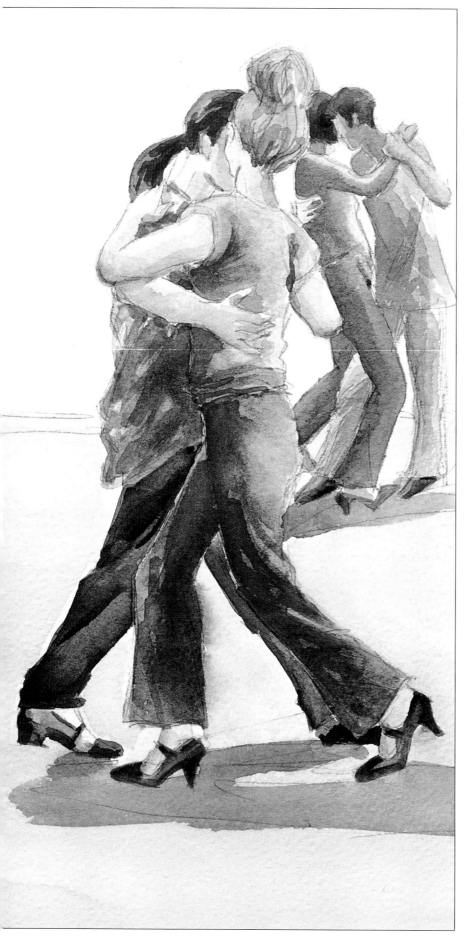

SKETCHING FROM LIFE

Although working from photographs is useful, the best way to learn about the moving figure is to make a series of sketches from life. Work quickly, trying to capture the essence of the action in a series of quick sketches using a chunky medium such as charcoal or pastel.

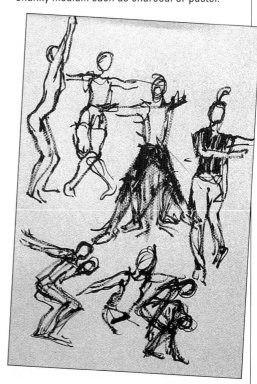

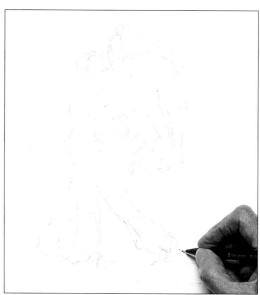

FIRST STEPS

1 ▲ Establish the drawing Quickly and lightly sketch in the figures, using a 0.5 propelling pencil. Keep detail to a minimum, but mark in the folds of the clothes and lightly define the areas of shadow under the dancers' feet.

2 ▶ Paint in the main figure With a No.6 round brush and purple madder watercolour, lightly block in the woman's trousers. Change to cadmium orange and paint in her T-shirt.

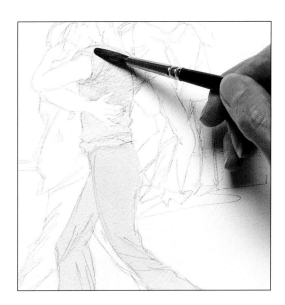

DEVELOPING THE PICTURE

The main figure in your composition has now been blocked in. The light, warm tones of her clothes bring her to the front of the picture. Continue by working the other figures in relation to her.

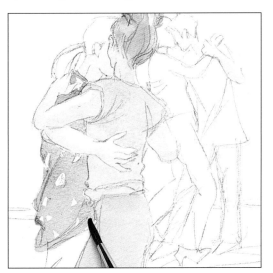

4 ◀ Add flesh tones Use a light wash of burnt sienna to paint the woman's skin. Again, create some highlights by leaving white paper showing. Fill in the flesh tones of her partner and add shading to both with a stronger wash. Paint in the skin tones of the couple in the background. Change to Antwerp blue and paint the man's shirt.

3 ▲ Add her hair Now use a No.4 round brush to mix burnt sienna and yellow ochre. Paint the woman's hair, but leave some white paper for highlights. Add sepia to the mix for shading.

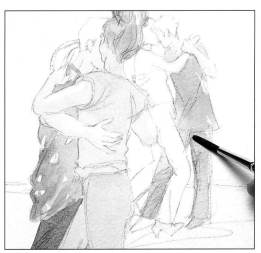

5 ▲ Create recession With a mix of Antwerp blue and Payne's grey, paint the trousers of the dancing partner. Now use just Payne's grey to block in the man in the background. Keep your brush strokes soft and blurred, so that the figure seems to recede in the picture plane.

6 ▶ Develop the background figures Use a mix of alizarin crimson and a little ultramarine to block in the female figure's trousers, then add a little sepia to the Antwerp blue and Payne's grey mix from step 5 and paint her jumper. Using a clean brush, remove some of the colour to create highlights. Change to a No.3 round and use sepia to paint the dark hair of three dancers.

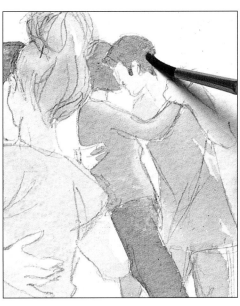

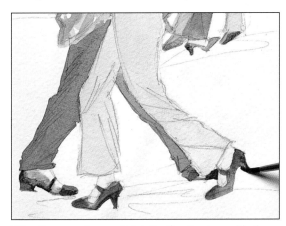

7 ▲ Focus on the small details Continuing with the careful work, use the same brush and Payne's grey to paint in the shoes of all the figures. Vary the depth of colour with stronger and weaker mixes to create highlights and shadows.

8 ► Work wet-on-wet
Still using the No.3 round brush, add shading to the dark hair with Vandyke brown. Return to the No.6 round brush and use clear water to dampen the painted area of the blonde woman's trousers. Flood in some purple madder to deepen the tone. Now mix in a little Payne's grey to darken the purple and describe the folds of the trousers. Soften the edges of the folds with a clean brush.

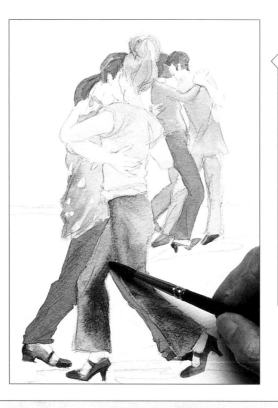

TROUBLE SHOOTER

TAKING BACK PAINT

If you have put on too much colour, it's simple to remedy. Take off paint with a clean brush and clean water, blot the area with kitchen paper and leave it to dry. To complete the change, rework the details in the relevant colour.

Master Strokes
John Singer Sargent (1856-1925)
El Jaleo

The impression of movement is brilliantly captured in this oil painting of a Spanish dancer and accompanying musicians. From the dexterous fingers of the guitarists to the dramatic poses of the women in their fine costumes, every part of the picture conveys lively action. Strong shadows cast on the wall echo the shapes of the heads and arms, increasing the animated effect. Although the palette is mainly black, white and buff, it is enlivened by vivid splashes of scarlet, crimson and orange.

The arcing line of the shadow on the wall behind the dancer extends the backward slant of her body.

Feathery brush strokes around the dancer's shawl convey the movement of the swirling, fringed fabric.

The orange on the chair provides a point of bright interest in an area of light neutral colours.

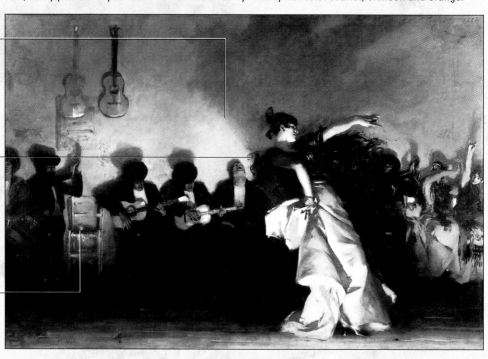

9 ◄ **Work up shadows**
Using the No.4 round and a mix of cadmium orange and purple madder, deepen the flesh tones of the foreground couple, then paint shadows on the woman's T-shirt. Change to the No.3 round and define the fabric folds with a mix of cadmium orange and Vandyke brown. Paint shadows in her hair with burnt sienna.

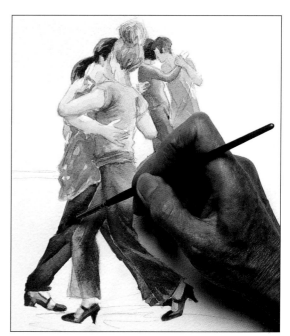

10 ▲ **Add shadow** Add more shadows to the flesh tones with mixes of purple madder and burnt sienna, and burnt sienna and sepia; highlight with Naples yellow. Changing to the No.6 round, define the background couple with stronger mixes of the colours used for their clothes in steps 5 and 6. Now darken the purple trousers with purple madder, the blue shirt with Antwerp blue and a dark emerald/viridian mix, and the blue trousers with a Payne's grey/Antwerp blue mix.

Express yourself

Watch your step

This version of the dancers was worked in acrylics on canvas. The artist has altered the composition significantly, working in a landscape format and adding another dynamic element – an extra dancing pair. As in the main project, the background is eliminated – but here the horizon line, too, has been removed, allowing the lively visible brush strokes to fill the canvas, further enhancing the sense of movement.

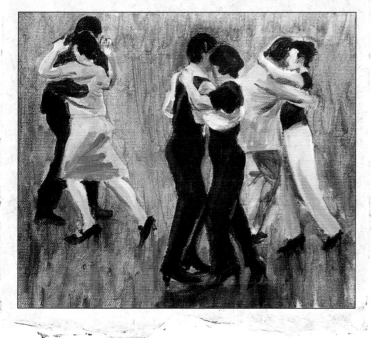

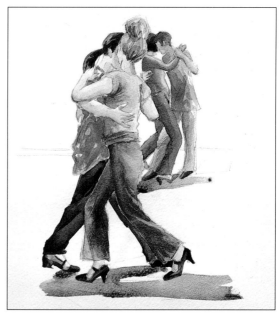

11 ▲ **Lift the details** Use the No.3 round and burnt sienna to vary the flesh tones of the male background figure. Now change to Payne's grey and work up the shadows all over the picture – on the figures, hair and shoes. Add sepia to the grey and, diluting the paint well and keeping the tone light, use the No.6 round to paint the shadows cast on the ground by the couples. Leave to dry.

Now that you have successfully painted in the figures, it's time to add the extra details that will tie the composition together and emphasise the picture's sense of movement.

12 ▶ **Add a wash in the foreground**
Using a No.10 round brush and a wash of Naples yellow, apply colour right across the foreground. Work freely, painting over the shadows cast by the figures.

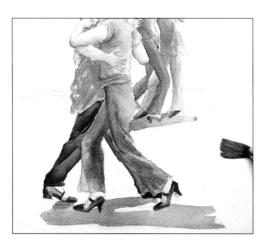

13 ▲ **Add refinements** Use the No.3 round brush and sepia to darken shadows on the foreground woman's T-shirt, then work over her legs with alizarin crimson and sepia. Change to a No.10 round to wash cadmium orange over the foreground. Work up the shadows on the blue shirt with Payne's grey.

THE FINISHED PICTURE

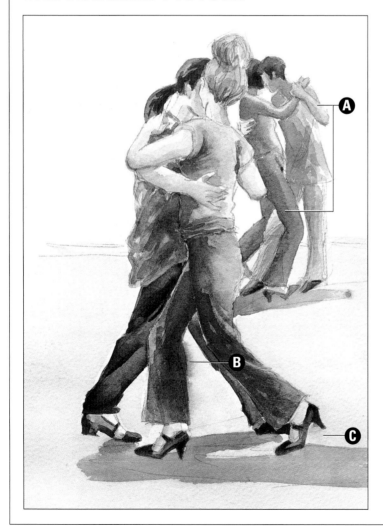

A Conveying movement
The legs and arms of the dancers create a variety of diagonals, giving them a real sense of movement.

B Softened edges
Where shadows are added to the clothing, particularly on the trousers, the edges are blurred and softened. Hard lines would give a static effect.

C Taking steps
The artist left a space between the heel of the shoe and the shadow on the ground to indicate that the foot and leg are raised in movement.

Composing the sitter

To attain a good figure study or portrait, choosing the best pose for your model should be taken as seriously as applying the paints.

When composing a sitter it's vital to consider not only the pose of your model – but also how that pose relates to the format of your support, the background, lighting and your viewpoint.

You might want to create a particular mood, or recreate a classical composition, or perhaps you want something quite informal, such as the black-and-white pictures in this article. First, think about how the figure relates to the shape of your support. If the figure is small in relation to the size of the canvas, the subject will seem remote and inaccessible. The distance between the artist and the subject creates a similarly distant relationship between viewer and subject. Conversely, if the figure is closely cropped within the picture area, the person appears accessible – almost within physical reach of the viewer.

Another device for creating a sense of familiarity is to ensure that the viewer's attention is held within the composition. The directions of the arms, hands and head can be arranged to form a circular or enclosed shape that retains the eye within the painting. Poses where the face looks out towards the frame of

AN INFORMAL AIR

In his 1882 painting of Charlotte Dubourg, Henri Jean Fantin-Latour has taken care to chose a pose and composition that counteract the otherwise formal nature of this commissioned portrait.

A EYE POSITION
Instead of looking directly out from the canvas, the subject averts her gaze to create a less formal mood. The angle of the head to the right balances the angle of the legs to the left.

B ENCLOSED COMPOSITION
The arms help create a loose circular shape at the centre of the picture (even though the hands do not quite meet). This creates an enclosed composition that holds the eye of the viewer within the picture area.

C ASYMMETRICAL POSE
The arms and legs are directed at an angle to offset the upright, centrally placed face and torso.

the picture work against a sense of intimacy, as do poses in which arms and hands point outwards.

Eye contact

One simple way to create a formal figure or portrait painting is to have the sitter looking straight at you. This creates direct eye contact and establishes a relationship between viewer and subject in the finished painting.

For a more informal painting, make sure the sitter's attention is focused elsewhere. In these sketches, the sitter either looks downwards or slightly to one side. The result is natural and spontaneous – more like a candid photograph than a deliberately posed model.

A comfortable pose

It is as important for the sitter to be at ease with the pose as it is for the artist to like what they see. An awkward position will almost certainly look unnatural in the painting. So make sure the chair is comfortable and has enough cushions.

A pose inevitably changes as the sitter relaxes. The sitter will be unaware of this gradual slump, so wait a few minutes before starting, to allow the model to settle into position. Also consider how easy the facial expression is to hold.

Frequent breaks are essential. In life classes, the model usually takes a 15-minute break after 45 minutes, but an inexperienced model may need more. Don't get so involved in your painting that you forget the needs of the sitter!

FULL LENGTH

Here, the pale shapes of the face and limbs form a pleasing oval that helps lead the eye around the picture. Note also how the figure provides a strong diagonal, with the pale tone of the face at top right balanced by the foot at bottom left.

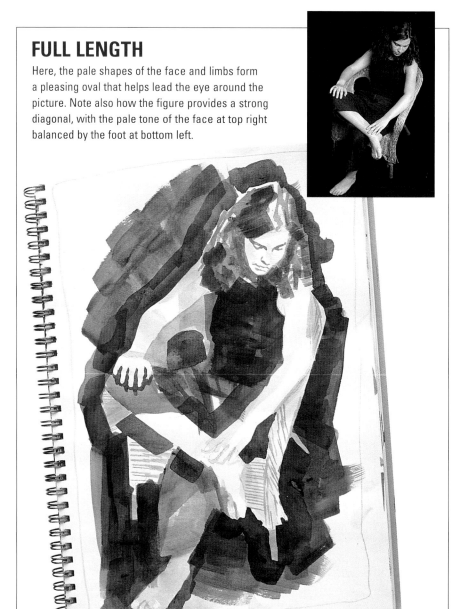

THREE-QUARTER LENGTH

Accentuated by the arms of the chair, this pose forms an even stronger diagonal than the picture above. The artist has emphasised this diagonal by taking the study across a double page. And the model's gaze – down and to the left – encourages us to wander along the length of the diagonal.

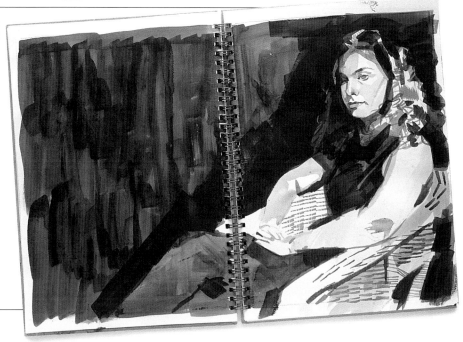

Ask your subject to tell you when it is time for a rest. Apart from the discomfort, sitting for a portrait can be boring. Playing music is a good idea provided it does not affect your concentration.

Resuming the pose

Finding exactly the same pose after a break is impossible because the folds and creases of clothing can never be coaxed back into the same place. Accept this and try to get the model into as similar a position as possible.

Many artists like to keep the painting 'on the move', particularly in the early stages. For these painters, the constant redrawing necessary to accommodate small changes in the clothing helps to keep the image alive and spontaneous.

Alternatively, if you want a still subject, try using a digital or Polaroid camera to capture the pose before the first break. This way, you can continue working on the clothing as it was at the start. And before a break, use masking tape or chalk to mark the position of feet, hands and elbows on the floor and chair.

If you're doing a proper portrait rather than a loose figure study, pay attention to the background. You may

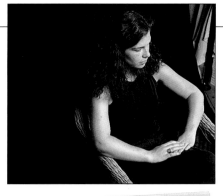

HALF LENGTH

Sometimes it pays to break the rules. Here the model is looking out of the composition rather than into the other page. The result is unusual yet dynamic – and it creates a sense of solitude. (Compare this to the more conventional, 'looking in' composition in the three-quarter length box.)

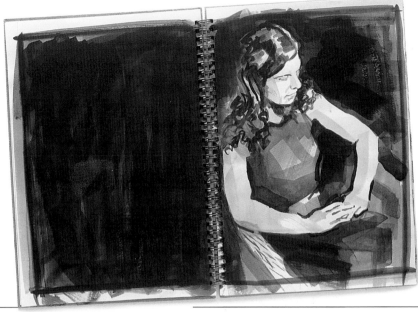

need to introduce a special backdrop or perhaps move the sitter around. Models often have their own preferences, wanting to be portrayed in personal settings, perhaps in a particular room or against a favourite colour.

The background

A busy or patterned background inevitably detracts from the sitter. This is not necessarily a bad thing, but it does need careful planning, such as choosing colours and lighting that prevent the figure from becoming entirely dominated.

In these sketches, the artist was interested in showing the importance of shape and rhythm in the composition. The fair-skinned model was asked to wear a sleeveless black top and the artist chose a plain black background to create maximum contrast. Reversing the tones – placing a dark-skinned model against a light background would create a similarly dramatic effect.

Finally, don't overlook the lighting, which always plays a crucial part in the composition of portraits.

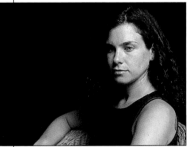

HEAD AND SHOULDERS

The model's pose here is very similar to the three-quarter length one but close cropping throws the focus on to the face. Unusually for a portrait, the artist has used landscape format. This creates a large black area on the left to balance the pale tones of the face and arms on the right. In between is a strong diagonal formed by the edge of the model's hair and arm.

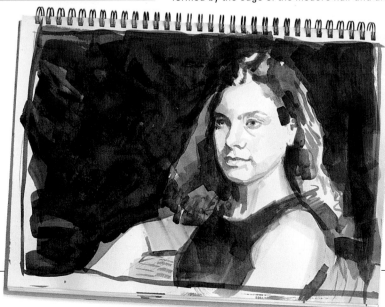

Interior with a mirror

Reflections in a mirror add an extra dimension to a composition, not only repeating images but also revealing features not visible in the 'real' interior.

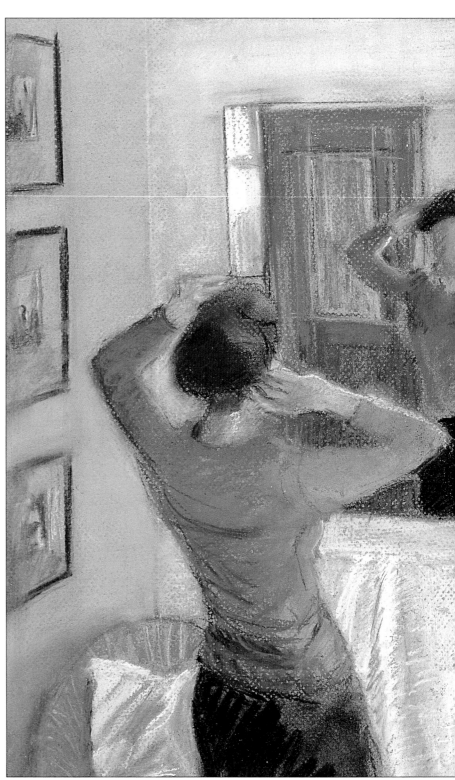

H ave you noticed that some pastel works are referred to as drawings and others as paintings? As pastels are so versatile and can be used in different ways, both terms are accurate. You can treat pastel sticks like pencils and work in line alone. Or you can use the soft, crumbling pigment to create areas of dense colour similar to that achieved in oils or acrylics.

For this interior the artist took advantage of both these qualities and used a combination of line and colour to build up an intricate composition of shapes, shadows and reflected light.

Mirrors and other reflective surfaces produce repeated shapes and angles that can be used to advantage when planning a picture. Central to this pastel interior are the woman's raised arms, which are reflected in the mirror and create diagonal rhythms at the centre of the composition.

Line drawing

To help you complete this painting, use the two pastels given away free with this issue. Start work by making a simple line drawing in black. These lines can be reinforced as work progresses to define selected shapes. For example, the frames of the pictures and the mirror are strengthened with ruled lines to emphasise their geometric shapes. In addition, the folds of the woman's sweater are overdrawn in black in order to describe the form of the underlying torso.

▶ **Blended and rubbed pastels create a velvety surface when thickly applied. The texture of the pastel paper shows through thinner layers of colour.**

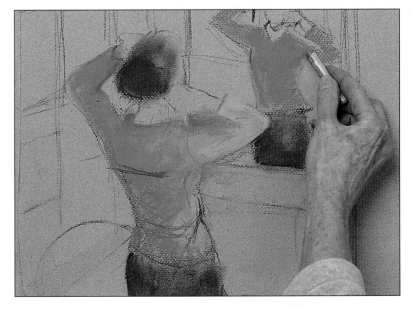

YOU WILL NEED

Piece of grey pastel paper
55 x 43cm (21½ x 17in)

16 soft pastels: Black; Indigo;
Mid grey; Pale grey; Pale yellow
ochre; Burnt umber; Burnt
sienna; Yellow ochre; Pale yellow;

Orange; White; Pale turquoise;
Venetian red; Raw umber; Pale
green; Emerald green

Ruler

Fixative

FIRST STEPS

1 ▶ Make an outline drawing Start by making
a line drawing of the subject in black pastel.
Leave plenty of space around the drawing so
that you can extend the composition if you
wish. When you are happy with the drawing,
start to establish the main tonal contrasts.
Subsequent colours can then be related to
these existing lights and darks. Block in the
beret, first with black, then indigo.

**2 ◀ Establish lights
and darks** Before
adding more colour,
create the light and
dark tones on the
figure. Starting with
the sweater, use mid
grey for the shaded
side and pale grey for
the side on which the
light falls. Blend the
two tones together by
rubbing gently with
your finger.

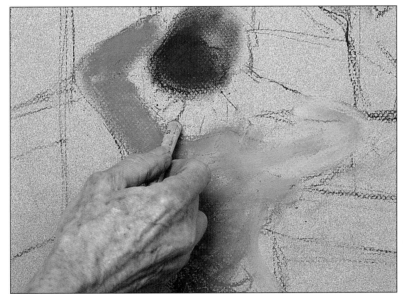

3 ▶ Develop the figure
Use black pastel to
block in the woman's
skirt and its reflection,
adding a touch of pale
yellow ochre to show
reflected light. Shade
the sweater on the
reflected figure with
mid grey and add a
touch of burnt umber
to the background to
establish a warm tone.

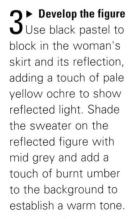

4 ▼ **Introduce colour** Block in the reflected door in burnt sienna and add highlights of yellow ochre. Moving back to the figures, establish the face and hands using pale yellow ochre, pale yellow and yellow ochre for the light areas and orange for the shadows. Blend the flesh tones a little to get a smooth effect.

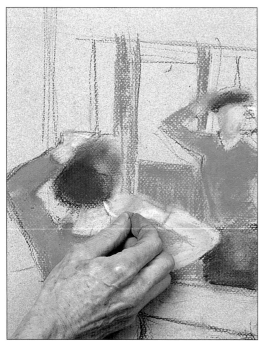

5 ▼ **Establish the walls** Use pure white pastel to depict the reflected sunlight in the mirror. With the side of the pastel, loosely block in the walls in pale yellow ochre. Smudge the pastel strokes together to achieve a solid colour.

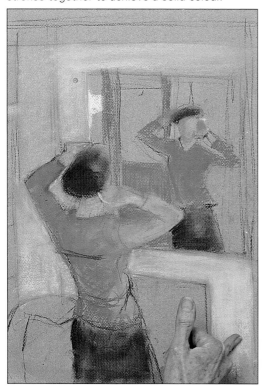

EXPERT ADVICE
Trying out colours

The colour of the paper affects the colour of the pastel marks, so it is a good idea to try out each pastel on the paper you are using before committing it to the picture. Denser colours and tones can then be built up by applying two or more layers of pastel and blending with your finger between each layer.

6 ▶ **Develop shadows and highlights**
Indicate the shadow on the left wall with a layer of pale grey. Draw highlights on the sweater in pale turquoise, following the folds. Work pale grey and white on the towel and add a white highlight to the towel rail. Block in the reflected wall in the mirror in pale grey. Establish the foreground cushion in pale grey with blended shadows of Venetian red.

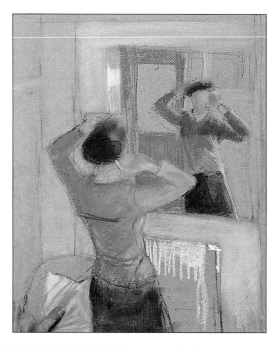

7 ◀ **Define the door and mirror** Outline the reflected door in raw umber and block in the dark glass in mid grey. Define the edge of the mirror in black, using a ruler to achieve a straight, narrow line.

8 ▲ **Add detail to the chair** Block in the wicker chair, working in stripes of pale turquoise, orange and pale green. Follow the weave of the wickerwork to describe the curved form of the chair back. Define the top edge of the cushion with a strong white highlight.

DEVELOP THE PICTURE

Most of the main areas of the picture are now established. Complete the blocking in, then stand back to reconsider the composition. At this stage, the right side of the picture looks rather cramped. You have left plenty of empty space around the picture area, so there is still time to extend the composition.

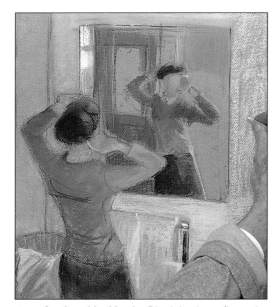

9 ▲ **Continue blocking in** Block in the reflected wallpaper in emerald green overlaid with orange. Add linear definition to the woman's beret in black with a highlight of pale yellow ochre. Add more pale grey shadows to the towel and define the rail in black. Working with the side of the pastel stick, extend the wall to the right of the picture area in pale yellow ochre.

Master Strokes

Ernst Ludwig Kirchner (1880-1938)
Woman Before the Mirror

This painting by German Expressionist artist Kirchner is characterised by simplified forms and strongly contrasting, intense hues applied as areas of flat oil colour. The composition is particularly interesting because of the unexpected angle of the mirror, which adds a jarring note to the top of the picture. The dressing table, too, slants steeply away from the viewer before curving round towards the sensuous figure of the woman.

An intriguing feature of the picture is the reflection – notice how it doesn't actually echo the woman's pose but appears to be another 'self' gazing out of the mirror. The facial features are described with a few bold brush strokes that nevertheless give character to the face.

The white corset among all the mid and dark tones in the picture immediately focuses the eye on the figure of the woman.

The only area of pattern in the painting is provided by the floral carpet which also introduces extra colours into the composition.

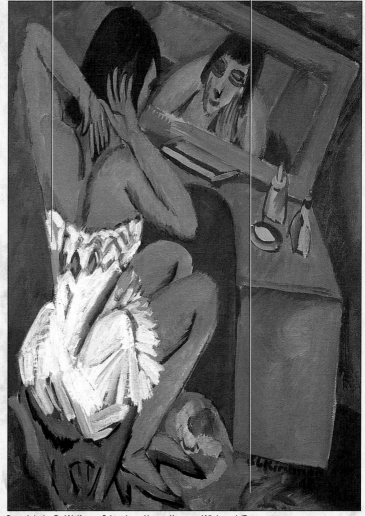

10 ▼ **Develop the composition** Tone down the reflected door by darkening the glass panel with mid grey. Overlay this with streaks of pale turquoise to create an impression of frosted glass. Block in the shadow behind the chair in mid grey, blending this to soften the shape. Start to sketch in the position of the three framed photographs on the left-hand side of the picture.

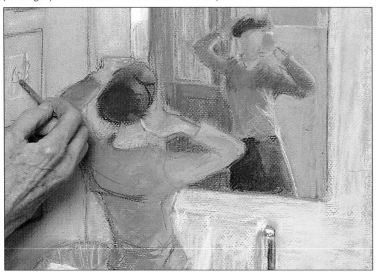

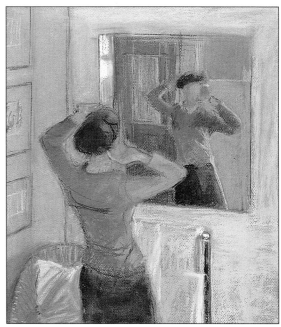

11 ▲ **Establish the frames** Change to the black pastel to complete the photograph frames. If necessary, use a ruler to ensure crisp, straight lines.

Express yourself
Focus on tones

Try a tonal version of the same subject. This chalk-and-charcoal drawing on grey paper gave the artist the opportunity to concentrate on the lights and darks without worrying about local colour.

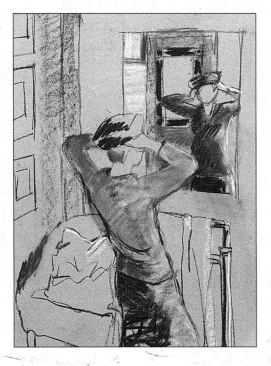

A FEW STEPS FURTHER

The picture now works well as an arrangement of shapes and colours. However, a few details and finishing touches will add to the atmosphere and make the interior more interesting.

12 ▲ **Work on the foreground** Strengthen the wall with dense strokes of pale yellow ochre. Further develop the photograph frames in black. Then indicate the photos themselves in white as well as black, blending the pastel strokes to create an impression rather than a detailed rendering.

13 ▼ **Intensify the tones** Using firm strokes with the black pastel, redefine the dark tone of the skirt and its reflected image.

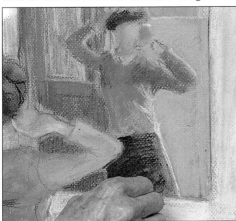

14 ▲ **Define details** Use raw umber to outline the fingers on the woman's hand and to shade the hair. Strengthen the shadows on the neck with a little black and on the beret with indigo. Spray the picture with fixative to prevent smudging.

THE FINISHED PICTURE

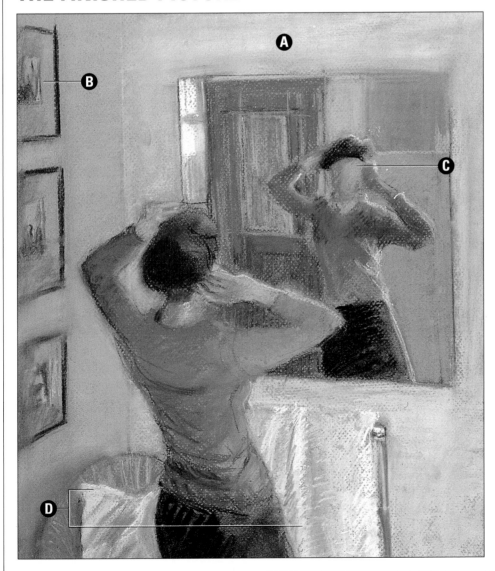

A Framed reflections
The wall around the mirror, deliberately portrayed as a flat, pale shape, frames the reflections within the mirror.

B Angular shapes
The three rectangular frames on the left echo other geometric shapes in the composition, including the mirror, panelled door and towel rail.

C Featureless face
The woman's face was left without defined features to avoid distracting the viewer from the main impact of the painting – the repetition of shapes and angles in the reflection. The featureless face also adds a little mystery to the painting.

D Bright highlights
Densely hatched strokes of pure white are used for the sharp highlights on the cushion and towel.

Group composition

Groups of figures present particular compositional challenges. It is interesting to look at how artists past and present have handled this subject, and how they have resolved the difficulties of positioning figures in a group convincingly.

▲ *Peasant Wedding* (1568) by Pieter Bruegel the Elder (*c.* 1525-69) has been composed so that the seated group of people forms a strong diagonal shape across the canvas.

The human figure is uniquely expressive, with gestures that can be 'read' by others. A hunched figure might express despondency, while a seated figure with head in hands could suggest contemplation or resignation.

In group compositions, figure painters can make use of gestures to suggest a narrative. For example, pointing hands can draw attention to a significant person or event, or indicate that something important is occurring 'off-stage'. The gaze is another important aspect of the figure within a painting. In a group study, the direction of the gaze of individuals can create a network of linkages, uniting some people into clusters and setting others apart.

Multiple portraits

The group portrait has long been an important subject for artists. Such paintings were also a useful source of income, as artists were often specially commissioned to capture a group scene.

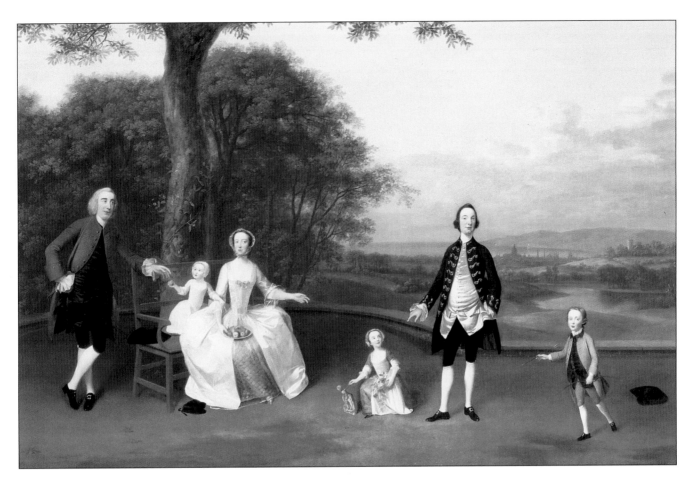

Like today's wedding and school photographs, these portraits provide a valuable record of a particular group at a specific time or on a significant occasion. Individuals are clearly identifiable and are shown looking their best.

The Dutch artist Rembrandt van Rijn (1606-69) painted one of the best-known examples of this genre, commonly referred to as *The Night Watch* (1642). The title of the picture is actually *The Militia Company of Captain Frans Banning Cocq and Lieutenant Willem van Ruytenburch*. Rembrandt was very original in his treatment of this group subject, showing the guardsmen informally, preparing to 'fall in' rather than rigidly lined up and 'on parade'. Most group portraits of this time were static and obviously posed, whereas Rembrandt managed to give his study a more spontaneous feel.

A type of portrait known as a 'conversation piece' became popular in the eighteenth century. The sitters were painted conversing in an apparently informal setting such as a domestic interior or a landscape. Conversation pieces were painted by the fashionable artists of the time, such as Johann Zoffany (1734-1810) and William Hogarth (1697-1764), but they were also the stock-in-trade of jobbing painters who toured the country offering their services to the gentry and minor aristocracy.

Grand subjects

Some of the most ambitious group studies deal with themes from religion, mythology and history. The biggest and most spectacular are the wall paintings surviving in Italy from the fourteenth to sixteenth centuries – the Renaissance period. These murals fulfilled many purposes. They were an attractive way of decorating walls, and, because they were costly, they advertised the wealth of the client. They were also a visual way of telling an important story at a time when many people were illiterate.

Probably the best-known mural is the cycle painted by Michelangelo (1475-1564) on the ceiling and end walls of the Sistine Chapel in the Vatican, Rome. This stupendous work was carried out in two stages. The ceiling fresco took four years to complete, from 1508 to 1512,

▲ In this eighteenth-century conversation piece, *The Till Family* (*c*. 1750-51), by Arthur Devis (1711-87), the family members pose informally in a landscape setting.

'Borrowing' a composition

You can often find a solution to a compositional problem by studying the work of other artists, either in galleries or in reproductions. Make thumbnail sketches of compositions which strike you as particularly effective. And don't feel bad about 'stealing' a composition from another artist – just make sure your thefts are from the best. The history of art is littered with examples of artists taking ideas from other artists and making them their own. The more you look and sketch, the more clearly you will understand the thought processes that give rise to good composition.

with the artist working into wet plaster, section by section. *The Last Judgement*, on the end wall, was started more than 20 years later, in 1535, and unveiled on All Hallows' Eve (Halloween) in 1541 when Michelangelo was 66 years old.

The ceiling describes nine biblical scenes and 300 figures. *The Last Judgement* caused controversy because the nude figures of the risen dead were considered indecent. On an order from Pope Paul IV, Daniele de Volterra (1509-66) was charged with the task of discreetly clothing them, and became known as 'breeches-maker' for his pains. Fortunately, Michelangelo didn't live to see these 'improvements'.

During this century, a few artists have tackled grand figurative subjects. Stanley Spencer (1891-1959) made several studies of events in the life of Christ, such as the Last Judgement and the Resurrection, interpreting them in a modern idiom. His *Port Glasgow Resurrection Series* (1945-50) was intended to be a huge, single canvas 15m (50ft) wide, but the project was too ambitious and he had to split the composition into a number of independent canvases.

During World War Two, Spencer was employed as an official war artist and was commissioned to paint a series of five paintings which recorded the work of the shipbuilders in the Lithgow shipyards in Port Glasgow. Some of the *Shipbuilding on the Clyde* canvases were very long. *The Template*, for example, measured 51 x 579cm (20 x 228in). They were complicated compositions, showing large numbers of men at work.

Genre subjects

Scenes from daily life are often described as 'genre' paintings. Typical subjects include peasants at work, celebrations, tavern scenes, dancing, ice-skating and children at play. The Flemish school painter Pieter Bruegel the Elder (*c.* 1525-69) was a master of this type of art. In *Peasant Wedding* (1568), revellers crowd round a long table which the painter views from a diagonal position. The scene looks as though it has been captured spontaneously but, on closer inspection, the firm compositional structure can be seen. The revellers' heads are positioned at a point about one-third of the way down the picture plane, and several strong diagonals lead the eye into the depth of the picture space. By contrast, standing figures and timber uprights provide a repeated vertical emphasis which rhythmically breaks the diagonal and horizontal stresses. Touches of scarlet clothing dotted around cause the eye to dance over the picture surface, a clever device which encourages you to explore the painting. But when you first view the painting, you are unaware of this artifice – the rigorous structure functions at an unconscious level.

▶ **This part of Michelangelo's (1475-1564) ceiling fresco in the Sistine Chapel shows (bottom to top) the Creation, Eve being made from Adam's rib, and the Temptation in the Garden of Eden. The painter's mastery of complex groups is evident.**

Sketching a group of people

If you carry a sketchbook around with you, you can make rapid drawings wherever you are and capture the many ways people move and interact when in a group.

Getting models and friends to pose for you is a marvellous way to learn about drawing the human figure, but the most interesting sketches are often those made from everyday life. These spontaneous sketches are full of movement and atmosphere, interesting poses and expressive gestures.

Sketching in public

Find a quiet corner where you won't be jostled. Equip yourself with a newspaper, a cup of coffee or a glass of beer so that you blend into the background – your subjects probably won't notice what you are doing. Keep your materials simple – a small sketch book, a pencil or pen, a pencil sharpener and an eraser are all you need. Study the scene carefully and then start to draw, looking for the telling details – a profile, a gesture, a fold of fabric. Work quickly and don't worry about the accuracy of your lines. The pages of your sketchbook are the best place to experiment and find out what you can do.

Part of the skill of successful sketching is training your visual memory. You cannot be sure that your subjects will hold a pose for more than a few seconds, so you will have to rely on your memory to complete a sketch. If you practise regularly, you will soon discover that this becomes easier.

You may find, too, that even when people are moving about a great deal, they often return to the same pose, so you can sometimes go back and refine your drawing. It is especially useful to bear this in mind when drawing people at sports matches – both players and spectators.

SKETCHING IN A CAFÉ

The size of sketch book you use will depend on the circumstances. If you are in a crowded environment, it makes sense to work in a small sketch book, but in a quiet corner of a café, like the one in this exercise, a large sketch book is practical. A large page also allows you to make several small studies of individual figures and to include plenty of detail if you wish.

1 ▶ Start the sketch Using a black, waxy EB pencil, or another drawing medium that you feel comfortable with, begin sketching the first figure. Work freely and loosely, looking for details, such as the angle of the head or a hand clasping a glass.

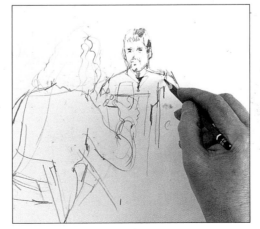

2 ◀ Add the second figure Draw the figure of the man, noticing in particular the distance between him and the first figure you sketched. The EB pencil gives a great variety of tones from velvety black to grey. Make a mental note of the glasses and other items on the table – these details may be useful at a later date.

3 ▼ **Draw the third figure** Draw the girl seen in profile on the left of the group. With practice, you will be able to establish a figure with just a few lines. Don't worry about the composition – simply record what you see.

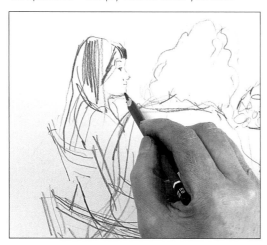

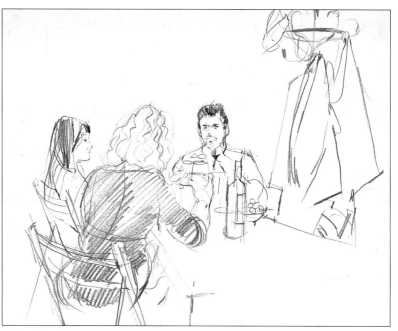

4 ▲ **Sketch the background** It is worth adding details from the background, if you have time. The coat stand adds an important vertical element and the curling hooks at the top have a decorative quality. Complete the sketch by adding hatched tone on the back of the figure in the foreground.

CREATING A PICTURE FROM SKETCHES AND PHOTOGRAPHS

Even the most basic sketch can conjure up a particular moment, a gesture, a look. Wherever possible, make sketches of individuals and details from the background, too. This will supplement your other material and help you to commit the scene to memory. The more reference material you have, the better.

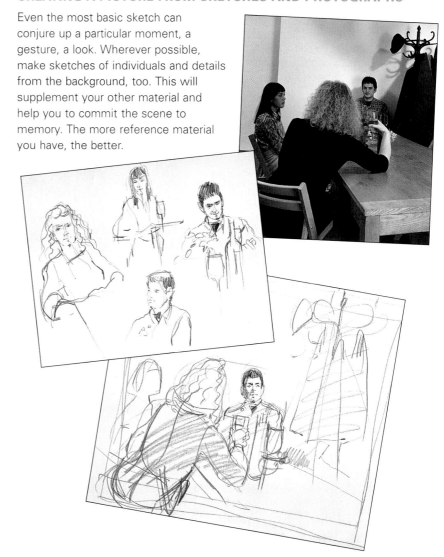

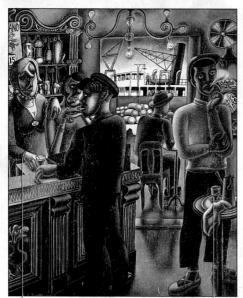

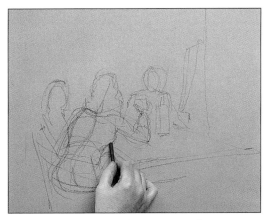

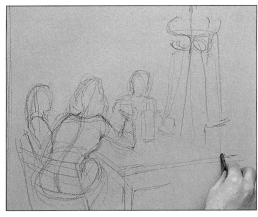

1 ▲ Start the drawing Study your reference material and decide what format suits the composition best. Working lightly with a black pastel stick, position the three main figures. Look for their centres of gravity and the rhythms of their poses. Indicate the location of the spine on the foreground figure.

2 ▲ Add the coat rack Still using the black pastel, sketch the coat rack – an important vertical element that marks the right-hand edge of the picture. Working with fluid gestures, develop the figures, thinking about the forms of the bodies underneath so that you can effectively suggest their solidity.

▼ **YOU WILL NEED**

Large piece of mid-grey pastel paper

11 pastel sticks:
Black; White;
Naples yellow;
Venetian red; Raw
umber; Magenta;
Olive green; Oxide
of chromium;
Ultramarine; Pink;
Flesh tint

5 pastel pencils:
Black; White;
Naples yellow;
Venetian red;
Cadmium yellow

3 ▼ Add some tone and detail Change to the black pastel pencil. With loosely hatched marks, suggest the dark tone on the back and arm of the foreground figure. This dark area is an important element of the composition. Add touches of detail to the man's face.

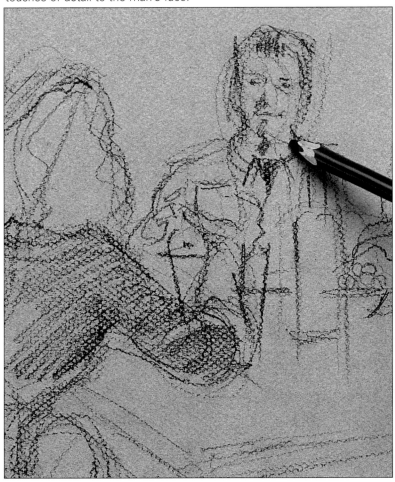

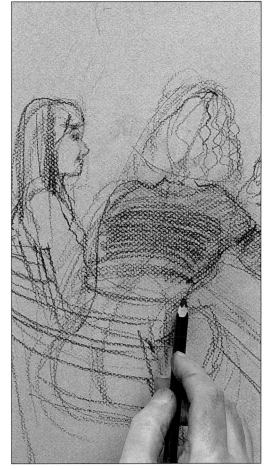

4 ▲ Develop the other figures Still using the black pastel pencil, develop the head of the girl in profile. Draw the sweeping lines of the chair-back and use hatched lines that loop across the back of the foreground figure to suggest the bulk and weight of the torso.

5 ▼ Add white pastel to the wall Break a small segment off a white pastel stick and use this piece on its side to work colour over the background. The grey paper showing through the white pastel will give this area a vibrant and luminous quality which would be absent in an area of solid white. Take the white around the head in profile, using it to 'cut back' into and refine the silhouette.

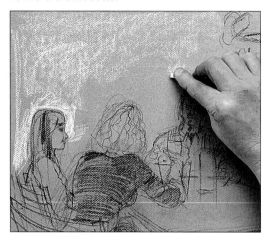

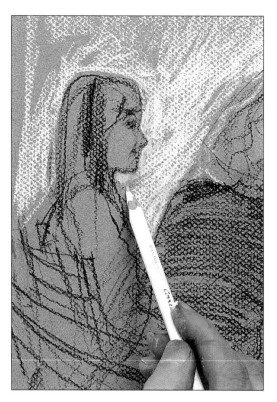

6 ◄ Finish the wall Use a white pastel pencil to take the white of the wall around the heads and shoulders of the seated group. The contrast between the figures and the bright background is an important aspect of the composition, and the 'negative space' of the white wall will be a key element of the finished picture.

DEVELOPING THE PICTURE

The composition is now broadly established. Stand back and review your progress so far. Check the drawing in a mirror – because the reversed image is unfamiliar, it is easier to spot inaccuracies. Make any necessary adjustments and then start to add colour.

7 ► Add colour to the hair Using white and Naples yellow pastel pencils, start to indicate the wavy texture of the foreground figure's hair. A few rapidly drawn lines are an excellent shorthand to depict this area.

8 ► Develop the flesh tones Add some touches of Venetian red and cadmium yellow pastel pencil to give variety to the curly hair. Use a Naples yellow pastel stick for the flesh tones on the illuminated side of the man's face and Venetian red for the warm tones on the shaded side. Apply the same colours to the arm in the foreground. Don't press too hard – the lightly worked colour breaks over the textured paper, giving the image a pleasingly luminous quality.

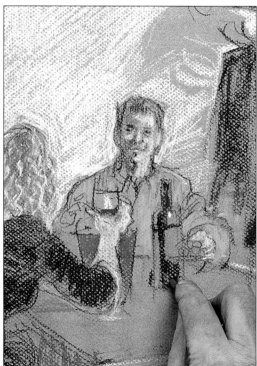

9 ▲ Add more local colour Using pastel sticks, work over the entire image. Apply light strokes of raw umber for the table and the blouse of the left-hand figure; Venetian red for the terracotta plant pot; magenta for the wine bottle and the coat on the stand; olive green for the man's shirt; oxide of chromium for the plant; and ultramarine for the other coat on the stand. Use a black pastel stick to add some detail to the wine bottle.

10 ▼ **Fill in the top surface of the table** Use the Naples yellow pastel stick to block in the light tone of the table-top. Apply the colour lightly.

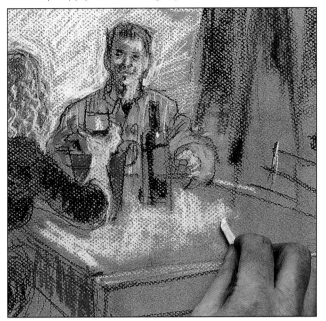

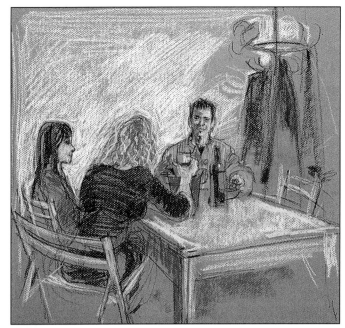

11 ▲ **Finish the table** Use the same Naples yellow pastel stick to complete the legs of the table, as well as the backs and seats of the chairs.

A FEW STEPS FURTHER

All the main elements of the picture are now in place and the colours have been broadly established. Although the picture was composed later from sketches and photographs made on location, the image retains the energy of a sketch made on the spot. You could take this painting much further, but it would lose some of its immediacy – pastel is easily overworked. However, a few more details will add impact.

12 ▶ **Add colour to the red coat** When working with pastel, it is difficult to blend colours. If you want to create a range of tones, you need to use pastels in various tints and shades of each colour. Therefore, add more magenta to the coat on the stand, and use a touch of pink for the highlights.

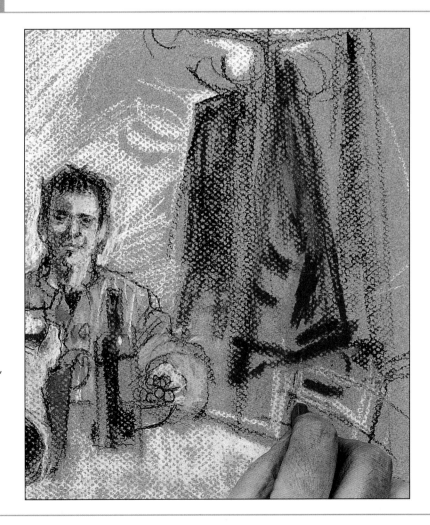

13 ▶ **Develop the light and shade**
Add strokes of flesh tint where the shoulders of the figure on the left catch the light. Use a sepia pastel to add a warm but dark tone to the side of the table – this increases the sense of depth in this area of the picture.

14 ▲ **Add final details** Use a black pastel pencil to add touches of detail that strengthen the drawing of the profile of the girl on the left. Avoid the temptation to overwork the drawing.

THE FINISHED PICTURE

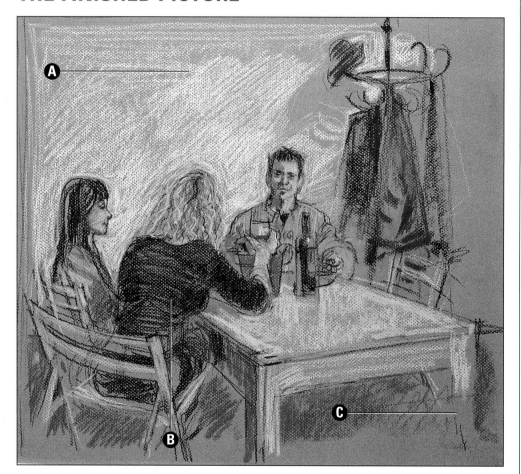

A Negative space
Don't be frightened of large 'empty' areas. Here, the large area of white wall became an important shape within the finished painting.

B Paper texture
The regular texture of the paper gave it tooth so that it held the pastel. It also broke up areas of pastel, creating passages of luminous broken colour.

C Tinted paper
The artist used a mid-grey paper to provide a useful base tone to underlie the entire painting and hold it together.

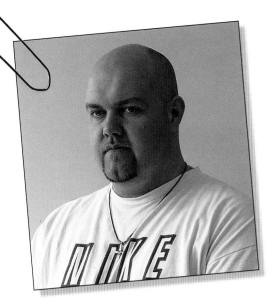

Drawing the head

Although each person's head is unique, there are certain fundamental principles of figure drawing that can help you improve your portrait skills.

There are many aspects to consider when you are drawing a portrait – how to establish the shape of the head, how to convey an individual's facial features and how to build up a sense of form through shading. If you master these concepts, you will find it easier to create a good likeness.

Skull structure

A knowledge of how the underlying bone structure of the skull determines the shape of the head and facial features is extremely helpful when you are drawing from life and trying to analyse your model's main characteristics. The form of the skull is initially evident on the surface of the face in the appearance of the cheekbones, the jaw and chin, the ridge of the nose and the dome of the cranium. The skull's structure also determines the relative positions of the facial features.

Certain proportions tend to be similar in most people. For example, the distance from the top of the head to the eyes is roughly equal to the distance from the eyes to the chin. The distance from the eyebrows to the bottom of the nose is more or less the same as from the bottom of the nose to the chin. The gap between the eyes is approximately the width of an eye. However, you should always check an individual's proportions by measuring with your pencil.

▶ **Where the form of the head can be seen clearly, as on this model with a shaven head, it is easier to relate the visible features to the underlying structure of the skull.**

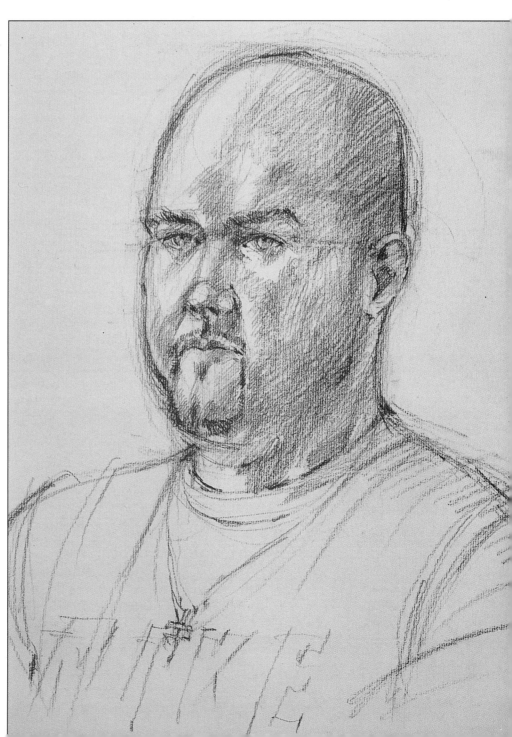

DRAWING FACIAL FEATURES

Although everybody's features are unique, there are common characteristics to look out for when you are drawing them. The classical features represented in these plaster models are based on the sculpture *David* by Michelangelo (1475-1564). The models are available from the British Museum in London.

EYE
The eye is simply a ball set inside a bony socket in the skull. Shading above the eye suggests the protruding brow bone. Lids are shown by pairs of curved lines around the iris.

NOSE
A simple but helpful way of visualising the nose is as a cylinder emerging from a sphere with a quarter sphere on each side for the nostrils. Shade around the nose and inside the nostrils to define them.

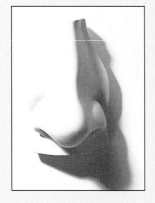 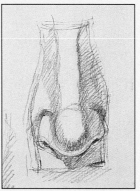

MOUTH
The mouth is made up of lobes: three on the upper lip (a circular central area and a lobe on either side), and two on the lower lip. The chin forms a circular form below it. Emphasise the line where the lips close together.

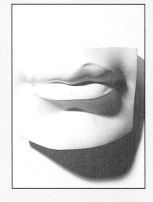

EAR
The ear can be broken down into an outer rim of cartilage ending in the large lobe and, inside this, a protruding semi-circular piece of cartilage. Add shadows in and around the ear to define these features.

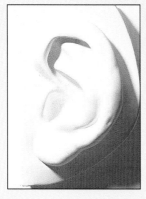 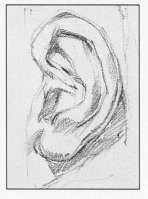

YOU WILL NEED

Piece of cream pastel paper	(for erasing mistakes)
Sanguine Conté pencil	Scalpel or craft knife (for sharpening Conté pencil)
Putty rubber	

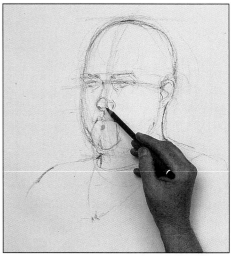

FIRST STEPS

1 ▲ Establish the proportions Using a sanguine Conté pencil, draw the outline of the head and shoulders. Measure proportions with your pencil and lightly mark in a curved line at the level of the eyes and another down the centre of the face to help place the nose. Sketch in the features and begin to develop them (see left).

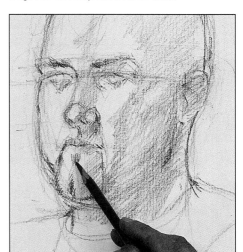

2 ▲ Work up some details Begin modelling the head with long, light hatching lines on the right of the head, neck and jaw. Lightly shade in the lips, marking a heavier line where they meet. Darken the beard and eyebrows, and the shadows under the nose.

MODELLING THE HEAD

Give the head a more solid feel by adding and refining areas of tone. Remember the head is lit from the left, so most of the shading will be on the right-hand side.

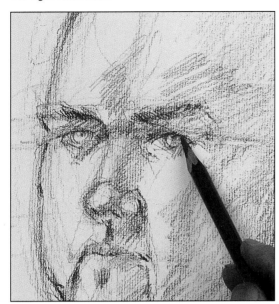

3 ▲ **Work on the eyes** As you develop the eyes, check that they still sit well on the curved guideline you drew in step 1. Emphasise the upper lids and hatch a little shading above them to indicate the shadow under the jutting brow-bone. Draw the irises and put in the pupils.

TROUBLE SHOOTER

SENSITIVE LIPS

Avoid the temptation to draw lips with strong outlines and then shade them in afterwards. They will look more sensitively drawn if you use shading alone to define them. The top lip is shaded more heavily than the upturned lower lip, which catches the light.

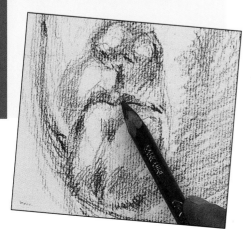

The underlying structure

Underpinning the soft flesh of the face is the bony structure of the skull. Keep the shape of the skull in mind when you are drawing a portrait, as it helps you make sense of the features of the head. In both the three-quarter view and the side view shown here, you can see how the skull is based on a sphere and an egg-shaped oval. The facial area is quite small compared to the whole skull.

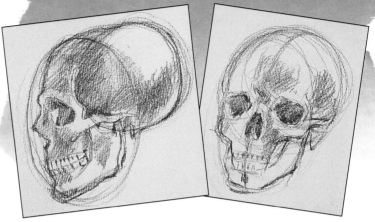

4 ▶ **Develop the mouth and ear** Work up some dark tone on the far right of the head, which is in the deepest shadow. Define the lips more clearly, but don't give them heavy outlines (see Trouble Shooter). Using a combination of shading and line work, define the outer areas and recesses of the ear.

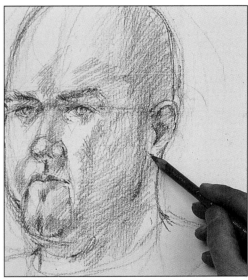

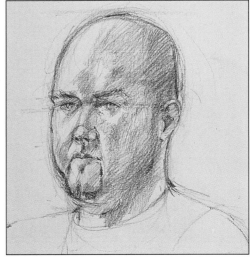

5 ◀ **Work on final details** Go over the outline of the head once more to firm up the shape. Make two emphatic marks for the nostrils and darken the beard. Lightly extend the shading on the right of the head and face, covering the whole cheek area except for a highlight under the eye.

Now that the head is worked in a lot of detail, a little more definition on the upper body will give a better balance to the portrait. Don't overdo it, though – the main point of interest is the head.

6 ▶ Sketch the T-shirt Lightly suggest the logo on the T-shirt and draw the silver chain and cross. Add light tone to the shoulder on the right with some well-spaced hatching lines.

7 ▲ Put in the last facial details Sharpen the Conté pencil well and work over all the features, putting in details that you might have missed, such as the dots at the inner corners of the eyes. Complete the moustache and beard with short hatched lines.

THE FINISHED PICTURE

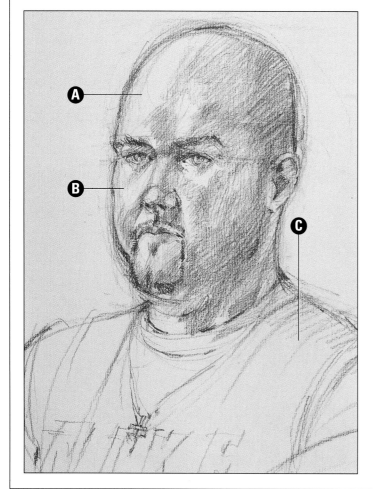

A Egghead
The distinctive egg-shaped form of the head can be seen quite clearly in this portrait, reflecting the underlying structure of the skull.

B Informative pose
The three-quarter view of the head, with strong lighting from the left, gives good contrasts of tone and shows the shapes of the features distinctly.

C Head and shoulders
The upper body, though only sketchily drawn, is necessary to anchor the head and put it in context, adding to the character of the portrait.

An eye for detail

There's more to depicting eyes than accuracy – you should also try to invest them with a sense of life that says something about the sitter's character.

When we look at a person we usually notice their eyes first, and the old saying that the eyes are 'the windows of the soul' does have some truth. Perhaps more than any other facial feature, the eyes convey a person's character and emotions, and they are a vital element in any portrait.

Eye anatomy

Although eyes vary in shape, size and colour from one person to another, the underlying anatomical structure is the same. The eyeball is basically spherical and the visible portion of its surface is small in relation to the area that is hidden behind the eyelids.

When drawing or painting eyes, beginners often make the mistake of leaving white showing all around the iris, giving the sitter a rather manic stare! In fact, the upper lid covers a small portion of the iris (the coloured area) and so, for most of the time, does the lower lid, except when the eyes are looking up.

Always draw both eyes in tandem – don't finish one and then start on the other. The eyes work as a pair, so draw them as a pair.

Start by sketching

As with all the facial features, it is best to begin drawing the eyes by sketching the overall shape with very light, tentative strokes; hard, dark outlines tend to make the eyes appear 'pasted on'. Start by indicating the spherical shapes of the eyeballs, then sketch in the lids that

ANATOMY OF THE EYE

The eyes are spheres that 'sit' inside the circular cups of the eye sockets; use your fingertip gently to feel the roundness of your eyeballs through your upper eyelids. Note how the covering eyelids follow this form. The distance between the eyes varies between individuals, but as a general rule the distance between the two inner eye corners is about one-eye's width.

The upper lid folds over the lower one at the outer corner.

The upper eyelid obscures the top curve of the iris.

The upper lid has a more pronounced curve than the lower one.

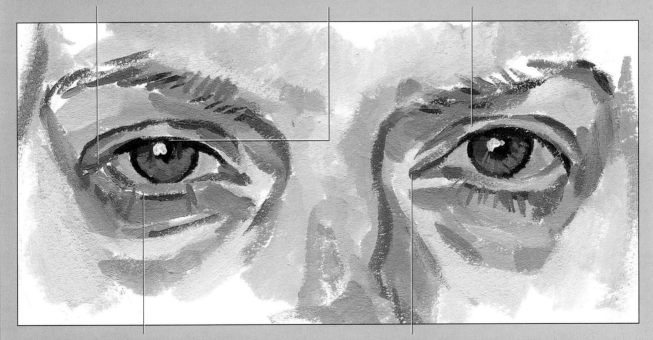

The bottom lid has a discernible top and bottom edge – however, it is not as thick as the top lid.

The tear duct is a defined shape in the inner corner of the eye. It often points down slightly.

wrap around them. Indicate the rims of the eyelids, and then place the pupils and the irises.

Light and shade

Once you are happy with the basic construction, you can start to refine the contours and develop the tones, keeping in mind the structure beneath. Observe how the lights and shadows – on the lids, the white of the eye and on the surrounding skin – help define the spherical shape of the eye. Often the eyelids cast a shadow on the surface of the eye, while a shadow cast by the brow bone accentuates the depth of the eye socket.

The sparkle that gives life to the eyes comes from the moisture on the surface catching and reflecting light. The iris is also illuminated from within as some of the light that passes through the pupil bounces back. To capture the sparkle of the eyes you must observe carefully the subtle modulations of tones and highlights. For example, the brightest highlight on the eye will sparkle more if the whites of the eyes are toned down slightly (see right).

Eyelashes

Build up the form of the eye and the area surrounding it at the same time, so that the eye becomes an integral part of the face and does not appear 'stuck on'. Avoid overstating the eyelashes. Even though you know that they consist of many fine hairs, don't try to paint every single lash – unless you are working on a large scale or in close up (as on the right). Usually it is best to use just a few curving irregular lines with dry brush strokes.

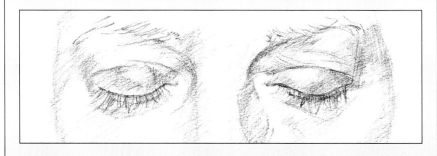

CLOSED EYES

You can create a very restful portrait by depicting your sitter with the eyes closed. This emphasises the spherical form of the eyes so make sure you capture this with close observation of the tonal variations. Also note how in this front-on view of the closed eyes, the eyelashes become much more prominent.

Most importantly, remember that you are not simply drawing a pair of eyes – you are drawing a pair of eyes that is unique to one individual, and accuracy is vital if you are to achieve a convincing likeness. Observe the eyes of your sitter closely: are the eyelids narrow or hooded? What about the shape and thickness of the eyebrows and their distance from the eyes? How does the arch of the upper lid differ from the curve of the lower one? Don't forget to look at the eyes in the context of the whole face, constantly measuring and comparing the sizes and positions of the eyes in relation to the other features.

Also note that the eyes of Oriental people are different. They have an extra layer of fat attached to the eyelid muscle, flattening the surface from the eyebrow to the eye socket. Their tear ducts point down almost vertically and they don't have an upper eyelid crease.

▼ **The surface of the eyeball is highly reflective; as light falls on it, a highlight appears on the iris, giving the eyes their lively quality. Notice here how the whites of the eyes have been toned down to a bluish-grey, against which the bright highlights really sparkle.**

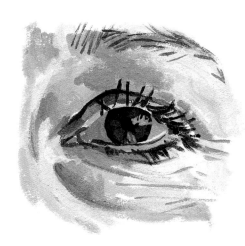

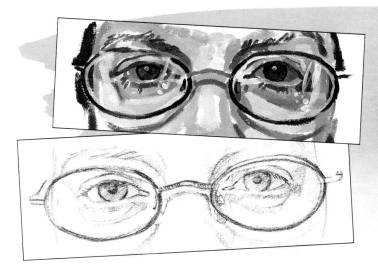

Tackling spectacles

Depicting spectacles requires a sureness of touch. The trick is to suggest their presence rather than reproduce them in precise detail. Select only the important lines, tones and reflections that shape and define the spectacles – put them in with a minimum of detail so that they don't detract attention from the sitter's face. In the painting (top), a few small strokes of off-white suggest reflections from the glass of the lenses. In the drawing, the reflections have not been put in, but the viewer still 'reads' glass. If the spectacles cast shadows on to the face (as they do in both pictures here), put them in but again underplay them.

YOUNG AND OLD, SMILING AND FROWNING

When drawing eyes, watch out for the differences between the eyes of children and older people. In children, the eye sockets are more open and the flesh is tight, so the eyes are less likely to be in deep shadow. The opposite applies in older people. Also pay attention to how the eyes change when the facial expresssion changes.

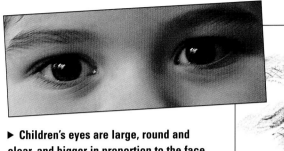

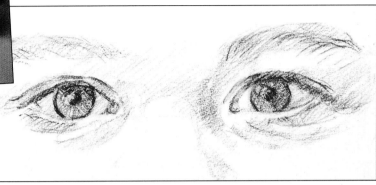

▶ Children's eyes are large, round and clear, and bigger in proportion to the face than adults' eyes. Because the skin and muscles are firm, there is very little shadow around the eyes.

◀ As we age, the skin around the eyes begins to sag and wrinkle and the eyelids droop. With advanced age, the eyes appear to sink deeper into the sockets.

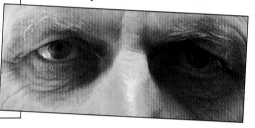

▶ In a smiling face, the eyes often appear larger and more rounded. The space between the eye and the eyebrow is greater, the upper eyelids are well defined and the eyebrows are more arched.

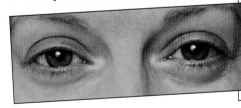

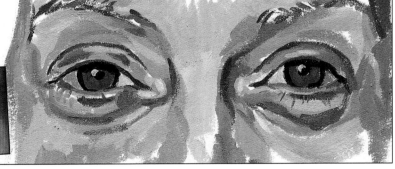

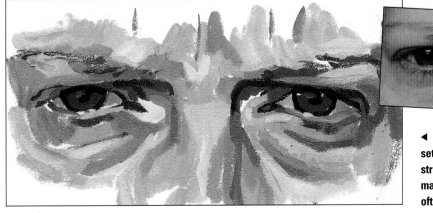

◀ When frowning, the eyes appear deeply set. The eyelids are narrower, the eyebrows straighter and the skin beneath the browline may overhang the lids. These effects are often exaggerated in men's eyes.

Drawing hands

Drawing hands is a useful skill, as convincing hands make all the difference to portraits and to figure-drawing in general. The best way to begin is to try some studies, such as the ones shown here, so that you can observe hands closely.

Hands play a vital role in figure studies. Not only can they convey movement or gesture, but they can also reflect the age, gender, lifestyle and personality of the subject. This is why a portrait that includes the hands is usually more interesting and compelling than one that does not.

Sadly, the hands are often overlooked, neglected or, like the feet, drawn too small in relation to the rest of the body. The aim of this project is to help you appreciate the importance of the hands, and it encourages you to find simple ways of capturing their apparent complexity. Don't worry if you have no model because, even when drawing, you have a hand to spare which can either be observed directly or reflected in a mirror.

Tones and colours

Keep the colours simple. No more than three or four pastel colours are used in each of these studies – just enough to indicate the lights, darks, warms and cools in broad terms. Also, choose a tinted paper, as this gives you an extra colour and also provides a medium tone against which both dark and light pastel tones will show up clearly.

The studies

Each of the four studies here looks at a different aspect of drawing hands, starting with a charcoal sketch showing the basic outline and proportions of the back of an outstretched hand. The other three are colour studies in soft pastel showing a pair of hands, the palm of the hand, and a closed fist.

▲ **Hands are so flexible that you will find endless poses for them. Here, four different views show hands from various angles.**

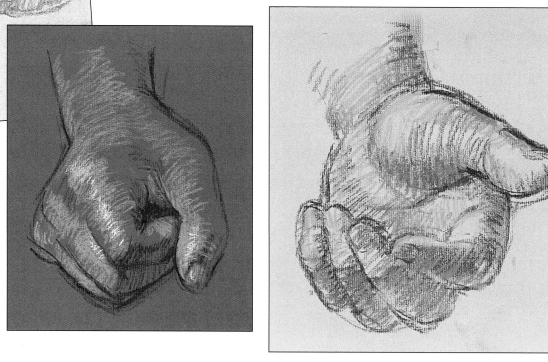

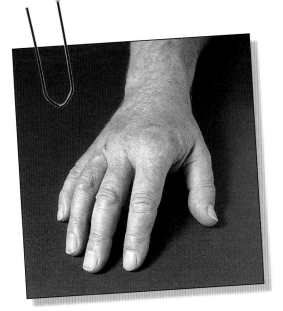

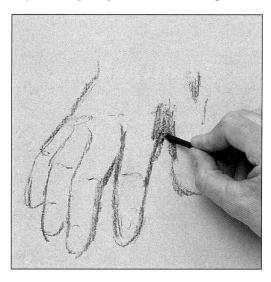

PROJECT 1

THE BACK OF THE HAND

Lay your hand, palm downwards, on a flat surface (it will be easier to see and draw if you use a mirror). Look carefully at your fingers. These taper at the tips, but will probably be surprisingly even in width. Note that each finger has three joints, including the knuckle. If you join each set of joints to form a curved line, you will end up with three arcs running almost parallel to each other. These provide a good general construction guide.

1 ▶ Sketch the outline Use charcoal to plot out the shape of the hand lightly. Pay particular attention to the width of each finger – you will find this easier to gauge if you also concentrate on accurately drawing any spaces between the fingers.

▲ **This basic position is a good starting point for your first hand-drawing, enabling you to observe the shape and length of the fingers.**

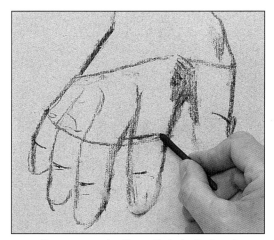

2 ▲ Use construction lines To help find and check the correct position of each finger joint, draw arcs to connect each row of joints.

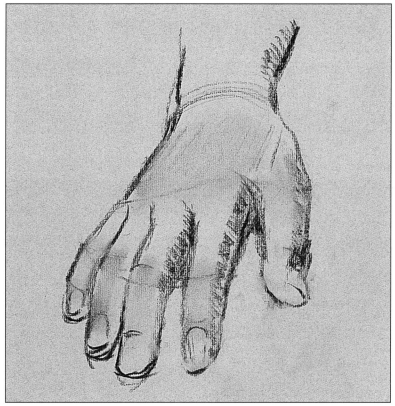

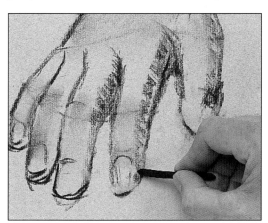

3 ▲ Hatch the shadows Indicate the shaded sides of the fingers with neat parallel strokes, following the curved forms.

4 ▲ The finished study The completed hand is well proportioned and has a convincing shape. Notice how the fingers are basically narrow cylinders and how the lines of dark hatched tone indicate the roundness of the forms. The middle finger is the longest and straightest, with the other fingers bending slightly towards it.

PROJECT 2

A PAIR OF HANDS

For this pose, you will need to borrow a willing pair of hands. If this is not possible, use the reflection of your own hands in a mirror. Take a good look, then work from memory. From time to time, stop drawing to reposition your hands and check your work.

When you are drawing two hands, they must look the same size. Ensure this by first drawing the outlines as two mitten-like shapes. If the mittens look roughly the same size, then go ahead and construct the fingers and the rest of the hands within these outlines. Just two pastel colours, a mid blue and a mid brown, are used here in order to establish the relationship between the warm and cool flesh tones.

YOU WILL NEED

Sheet of grey-blue paper

2 soft pastels: Cobalt blue; Medium brown

1 ▶ Start with cool outlines
Using a cobalt blue pastel, draw the hands in outline. Use light cross-hatching strokes to suggest the broad shadow planes across the knuckles and the backs of the hands.

▲ If possible, find a willing sitter to pose for this hand study. You can then concentrate on making the hands equal in size and proportion without having to keep moving one of your own hands.

2 ▲ Introduce the warm tones Change to a medium brown pastel for the warmer tones in the hands. Introduce the brown into the shadowed areas, working over the initial blue pastel hatching.

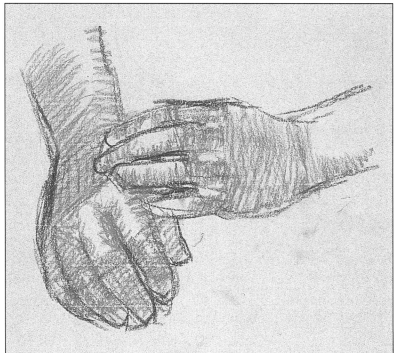

3 ▲ The finished study Continue to work with parallel hatched and cross-hatched marks, using the direction of the strokes to describe the planes and curves on the backs of the hands, wrists and fingers. The brown and blue pastels, as well as the grey-blue paper, indicate the warm and cool tones of the skin.

◀ When the hand is at rest, the fingers tend to curl up, forming a rounded shape. This viewpoint shows a foreshortened thumb.

▼ YOU WILL NEED

Sheet of pale orange paper

Charcoal

3 pastel colours: Red-brown; Dull pink; Crimson

PROJECT 3

OPEN HAND

In this relaxed position, the fingers of the hand are curled up and only partially visible. We are looking slightly down the thumb rather than seeing its full length. This viewpoint makes the fingers and thumb appear shorter than they actually are – a phenomenon known as 'foreshortening'. This does not present a problem provided you draw what you see rather than what you know to be there.

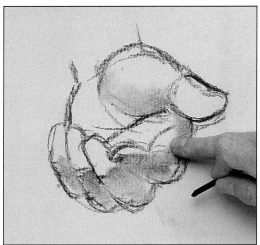

1 ▲ **Make an outline sketch** Use charcoal for the initial outline sketch, making sure the shapes and proportions of the fingers and thumb are correct in relation to each other. Lightly mark in the shadows on the underside of the fingers and rub these back slightly with your finger.

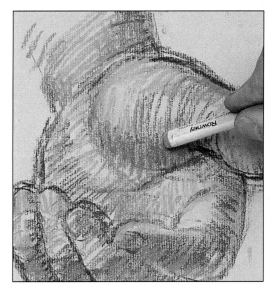

3 ◀ **Add the paler areas** Change to a cool, dull pink for the lighter areas. Again, work in directional strokes that follow the forms to indicate the curves of the hand. Add a touch of crimson to show the creases in the palm of the hand.

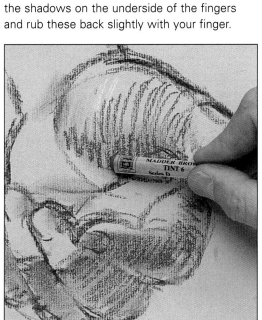

2 ▲ **Indicate the shaded areas** Develop the shadows with a red-brown pastel, using the charcoal underdrawing as a guide. Make crisp, hatched lines that follow the curved forms of the thumb and fingers.

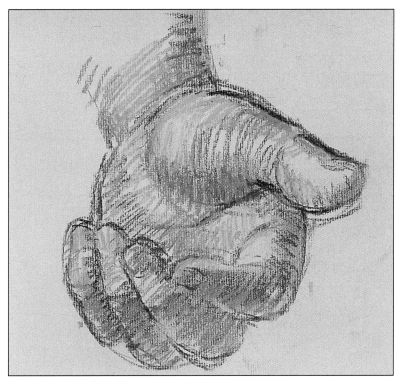

4 ▲ **The finished study** The foreshortened effect in this drawing is clearly evident. The outlined shape of the open hand is compact and round, rather than long and narrow as we know a hand to be, and as it would appear if it were viewed from above.

Master Strokes

Albrecht Dürer (1471-1528)
Hands of an Apostle

Dürer was primarily known for his woodcuts and engravings, and was a brilliant draughtsman. He paid meticulous attention to detail, a quality very evident in this sensitive portrayal of hands held up in prayer. This realistic brush drawing is worked on a slate blue background, the paper forming a mid tone between the black and white. The contours have been described with small hatched and cross-hatched marks, leaving the blue paper to show features such as the veins and the folds of skin around the knuckles. Bright highlights on the front edges of the hands imply strong illumination from the left of the picture.

Tiny hatched lines are worked around the contours of the fingers, palms and backs of the hands to build up their curved forms. The lines are white in the light and black in the shadows.

A little dilute black paint suggests the shadow of the turned-back cuffs and part of the sleeves. There is no more detail beyond the cuffs, so the viewer's attention is fully on the hands.

▲ This hand study is drawn in a different way from the others. The form is created by building up colour, tone and contours before drawing the actual outline.

1 ▶ Start with the skin colour Use a light brown pastel for the flesh colour of the hand. Work loosely and thinly, allowing the strokes to follow the curves of the fingers.

PROJECT 4

CLOSED FIST

Try making a pastel study of your closed fist, this time starting without the usual preliminary outline drawing. It is not as difficult as it sounds. Simply begin by establishing the skin colours and the internal contours, then gradually work outwards towards the outline.

YOU WILL NEED

Sheet of blue paper

4 pastel colours:
Light brown; Dark brown; Orange-pink; Very pale orange

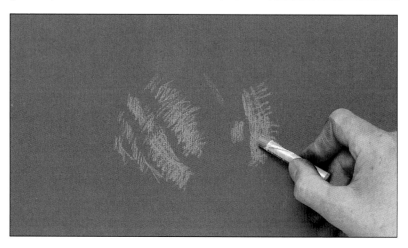

EXPERT ADVICE
Trying out the colours

Before you begin your drawing of hands, first try out your chosen pastel colours on the tinted paper to make sure they contrast sufficiently. The paper and pastels should provide a good range of flesh tones and colour temperatures.

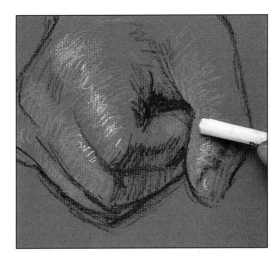

4 ◄ Add the highlights Finally, add the highlights along the tops of the fingers and the thumb. This is done in a shade of very pale orange – an almost white tint.

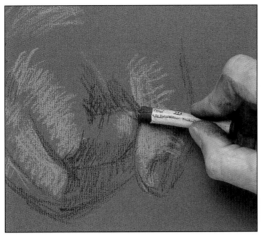

2 ▲ Add the shadows and outline Use thin hatched strokes of dark brown to render the shadows. With the same colour, draw the outline of the closed fist and fingers.

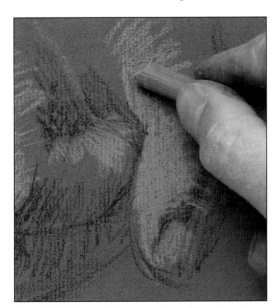

3 ▲ Work in a medium warm tone Changing to an orange-pink pastel, work into the fist, using this warm, rosy tone to link the existing dark and light areas. Do this by overlapping the existing colours with the new colour.

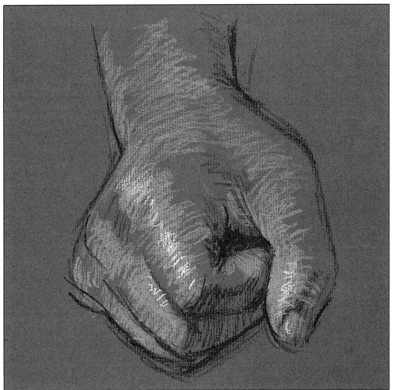

5 ▲ The finished study The flesh tones of warm pink, orange and brown contrast with the cool tone of the blue paper, which shows through the skin colours to represent the shadows. The dark brown outline, added during the later stages of the drawing, defines and contains the internal colours and the contours of the fist.

Capturing a likeness

Practise your portraiture skills with this oil painting of a young man. With accurate drawing and subtle colour handling, you'll get an excellent likeness.

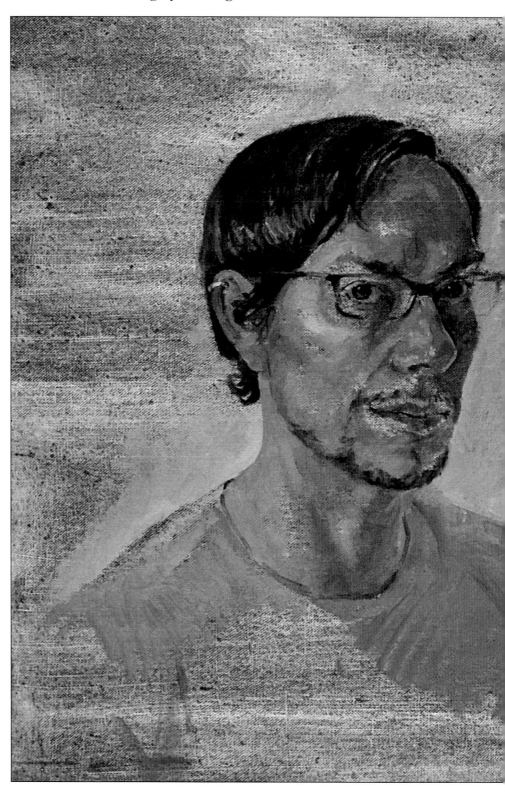

Many artists can come up with perfectly acceptable head-and-shoulders studies. But how many can really record what is unique about the person they are painting?

Being able to capture a likeness is not easy. You have to be prepared to take time really looking at your subject in depth and, of course, to practise converting your observations into an accurate painting.

The making of this oil painting reveals many secrets behind conveying the essence of a person. But remember, there is no better practice than painting from life – so when you feel confident enough, ask a friend to sit for you.

Preparing the canvas

A fine linen canvas was used for the support in this study. If preparing your own canvas you will need to do so several weeks before you want to begin work on the painting. First, the canvas must be stretched over wooden stretchers, then sized with either rabbit-skin glue or PVA and left to dry overnight. Next, a lead-white oil primer should be applied, and this can take about three weeks to dry.

Finally, knock back the stark whiteness of the ground with a thin, turpsy mixture of Payne's grey and yellow ochre oil paint applied with a No.20 filbert brush, then leave for a day or two to dry. The resulting mid tone cancels the glare of the white primer and allows you to see the effects of the lights and darks immediately. It also serves to unify the painting.

Plan the composition

Before you begin your initial drawing, study your sitter closely and adjust the pose and lighting until you are satisfied with the result. View your subject through half-closed eyes, which allows you to see the general distribution of light and dark areas. These are just as important in a portrait as in any other subject, but are often neglected.

The three-quarter view used for the step-by-step focuses on the head and shoulders. This angle provides scope for an interesting composition and avoids symmetry. Using charcoal, which is easy to correct, start by establishing the line of the nose, noting where it passes between the eyes. This acts as a centre point for the drawing, from which you can assess the distance to the eyes. Once you get the eye-nose relationship correct, work outwards to the rest of the head.

Rendering the eyes

Getting the eyes right is one of the keys to capturing a good likeness of your subject. However, eyes are often over-worked and drawn out of proportion to the rest of the head – the eyes are generally smaller than we assume them to be.

Make the eyes of a piece with the rest of the study. Don't paint individual lashes, as this makes the eyes look over-defined. A dark line along the upper eye is usually sufficient, with perhaps a couple of lashes picked out.

Dabs of paint

Don't be tempted to paint the iris with one blob of colour – instead, work it up gradually with dabs of paint. Start with a neutral grey, then add just a bit of colour to about one quarter of the eye – this will have the desired effect. The whites, too, look far from uniform. Remember that the eye is a sphere, so the whites appear to vary in tone as the eye curves.

▼ **A subtle range of coloured neutrals set against a toned ground is used to capture the flesh tones of the sitter.**

FIRST STEPS

1 ▼ **Make a sketch** Sketch the head using a thin stick of charcoal. Start by locating the nose, then position the eyes. These are the key relationships around which the rest of the drawing will be constructed. Knock back the charcoal lines with a rag to avoid contaminating the paint.

◄ **Tone down the brightness of the white-primed canvas with a thin mix of yellow ochre and Payne's grey oils.**

81

2 ▶ Begin painting
Using a No.4 filbert, paint the eyebrows with a mix of Payne's grey and flake white. Mix a basic flesh tint from white, lemon yellow, cobalt blue and alizarin crimson for the side of the nose. Pick out highlights on the side and tip by increasing the white in your flesh mix. For the top of the nose, make a pinkish mix of cobalt blue, yellow ochre, alizarin and white. Add viridian to this mix for the nostrils and lips.

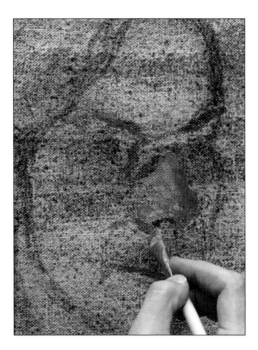

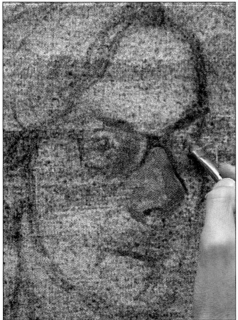

3 ◀ Start on the eyes
Work back into the painting with charcoal, defining the nose and spectacles. With the No.4 filbert and a mix of cobalt blue and transparent red oxide, indicate the eyes and the shadows around them. Add more of the pinkish mix from step 2 to the nose – notice how flecks of unmixed yellow ochre enliven the paint surface on the bridge of the nose.

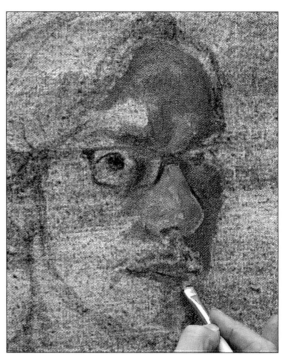

4 ▲ Paint the face Mix cobalt blue, lemon yellow, spectrum violet and white to create browns for the forehead. Dab on the pinkish mix, too. Add viridian to the forehead mix and darken eyes and spectacles. Mix varying proportions of spectrum violet, lemon yellow and white to paint the shaded side of the face. Paint the lips using the same rich browns – the lower lip is lighter in tone.

EXPERT ADVICE
Pot luck

Use a washer/dipper tray to help you complete this oil painting. The large compartment can be used for the turpentine and the small one for the linseed oil.

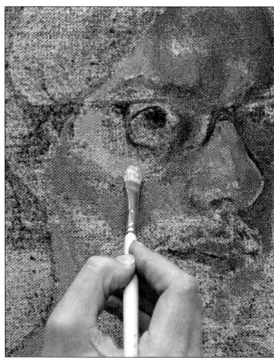

5 ▲ Add light tones Block in the shadow under the near cheekbone with the brownish mix from step 4. Make a pale mix of cobalt blue, alizarin crimson, lemon yellow and flake white for the light area where the top of the cheekbone catches the light.

DEVELOPING THE PICTURE

At this point, use a painting knife to scrape the colour from your palette to provide a clean working surface for new mixes. Begin to put the head into context by working on the clothing and background.

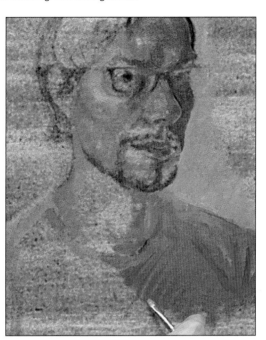

6 ▲ Add cool tones Take some of the basic flesh tint down into the neck. Mix flake white, raw umber, lemon yellow and cobalt blue and use this for the cool tones on the lit side of the face. Mix a dark tone from Payne's grey, ultramarine, transparent red oxide, burnt umber, viridian and white. Paint the moustache and beard, the line between the lips, and the shadows under the lips and nose.

7 ▶ Start on the T-shirt Paint a light flesh tint on the near eyelid. Describe the whites of the eyes, using white with viridian and white with lemon yellow and spectrum violet. Block in the background with a mix of white, cobalt blue and cadmium orange. For the neck, mix flesh tones from spectrum violet, lemon yellow and white. Block in the T-shirt with cobalt blue/ yellow ochre/ white and cobalt blue/white.

Master Strokes

Sir Anthony van Dyck (1599-1641)
Study of a Man Wearing a Falling Collar

One of the greatest Flemish painters of the seventeenth century, van Dyck had a refined style that is evident in this study for a portrait. The sitter's florid complexion, especially strong across the nose and cheeks, is brilliantly conveyed with rosy tones. Darker tones under the chin suggest plump folds of flesh. The head is viewed slightly from below, which tends to exaggerate the man's supercilious expression.

Touches of warm red lightly scumbled over the cool, dark-toned background echo the highly coloured flesh tones of the face.

Very loosely defined with simple brush strokes, the white lace collar is included as much to anchor the head in space as to be an informative part of the portrait.

8 ► Work on hair and eyes Mix a brown from transparent red oxide, ultramarine and flake white and use this to paint the hair. Paint shadows under the eyelids and in the eye socket, using alizarin crimson, lemon yellow and spectrum violet. A dot of red in the corner of the eye gives it a lively appearance. Use transparent red oxide mixed with a touch of cobalt blue and flake white to edge the eye.

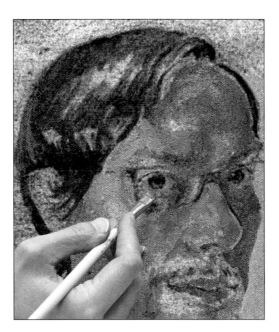

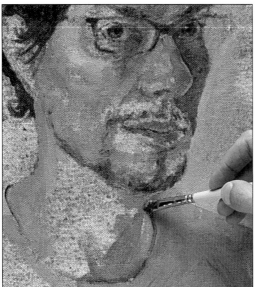

9 ◄ Complete the eyes Develop the tones around the eyes, making very fine adjustments without overworking this area. Use the brown from step 8 to suggest upper and lower lashes – don't draw a continuous line around the eyes, as this will make the sitter look startled. Darken flesh tones on the neck and indicate the shadow around the T-shirt neckline.

10 ► Paint the ear Check the size and location of the ear by measuring and finding alignments with your brush. The ear has a rich blood supply, so use warm flesh tones mixed from cobalt blue, alizarin crimson, lemon yellow and flake white to paint it.

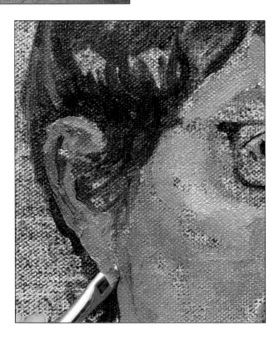

Express yourself
Charcoal study

Before starting with oils, it pays to do a drawing to familiarise yourself with your sitter. This can be a quick sketch or, as here, a more considered work. In this charcoal study, linear marks define the features and blended areas build up the form.

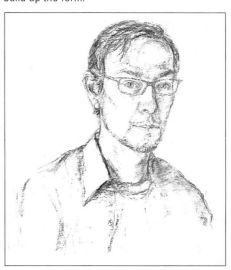

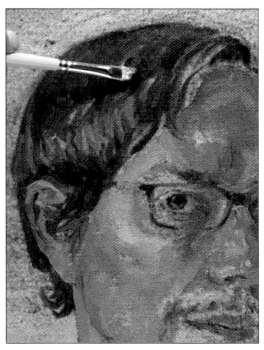

11 ▲ Add texture to the hair Work into the hair with various mixes of alizarin crimson, viridian and white to vary the tones, and to suggest its sheen and the way it reflects light. Allow your brush to follow the way the hair lies.

12 ▼ **Add more colour to the neck** Work into the neck with mixes of lemon yellow/cobalt blue/alizarin crimson and spectrum violet/lemon yellow/white, cleaning your brush on a tissue or rag between mixes. Arrange light and dark areas, and warm and cool ones, so that you build up a three-dimensional impression of the neck. If an area looks flat when it should be rounded, adjust the tones very slightly.

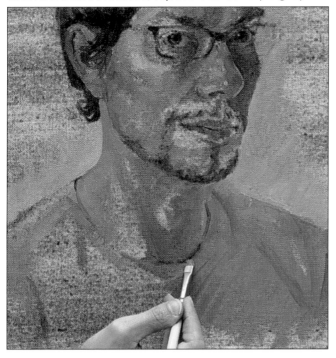

13 ▼ **Soften the hair** At this stage, the junction between the hair on the right of the head and the background is too harsh – use a rag to soften it.

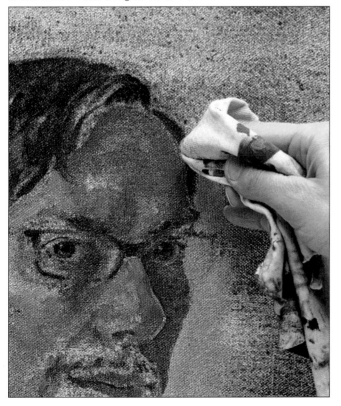

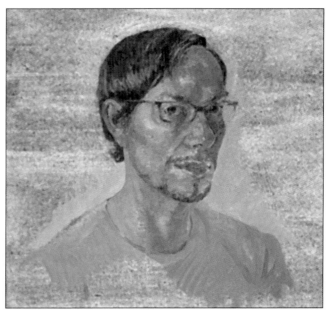

14 ▲ **Pull tones together** Study the subject and the image carefully and then work across the painting, adding touches of light and dark tone to knit the various passages together and make them read as a whole. It is not necessary to cover up the ground completely – by showing through subsequent patches of paint it creates a unifying effect.

A FEW STEPS FURTHER

The portrait has now come together – probably more quickly than you expected due to the unifying tones already provided by the ground. Just a few characterful details need to be added. A little more background colour will suggest the solidity of the figure and the space behind it.

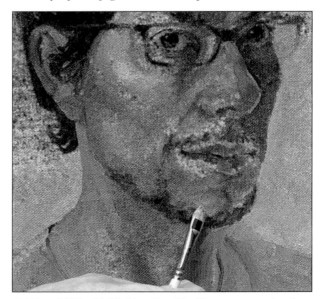

15 ▲ **Add the highlight on the chin** Use a warm mix of cobalt blue, alizarin crimson, lemon yellow and white for the highlight on the chin.

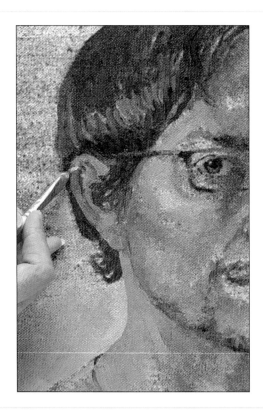

16 ◄ **Put in the silver earring** Indicate the distinctive earring with a buttery mix of white and lemon yellow, adding just a touch of spectrum violet to knock it back. Don't be tempted to overwork this detail.

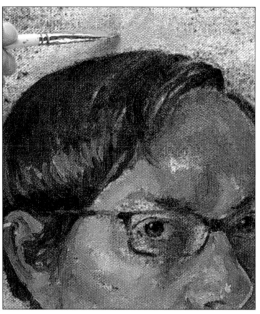

17 ▲ **Suggest the background** Scumble in an indication of the light background with a mixture of white and cobalt blue knocked back with cadmium orange and yellow ochre.

THE FINISHED PICTURE

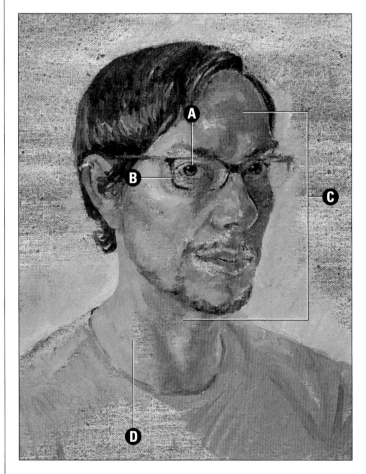

A Dabs of colour
The eyes were built up from subtly graduated dabs, not just one blob of colour.

B Subtle spectacles
The spectacles were just suggested with touches of colour rather than painted with a harsh drawn line – this prevents them from becoming too dominant.

C Warm versus cool
Warm tones on prominent features, such as the nose, forehead and ears bring these areas forward, while cool shadows under the chin and cheekbones sit back in space.

D A toned ground
A thin wash of warm undercolour shows between the patches of paint and knits the image together.

Capturing personality

As well as aiming for a good likeness, a portrait should hint at the sitter's character.

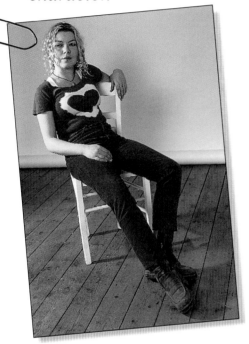

An important aspect of figure drawing is capturing the personality of your sitter. Personality is a more elusive quality to convey than the sitter's physical characteristics, but you can incorporate clues into your drawing that will help to build up a rounded view of the individual.

Natural pose

For example, you can suggest your model's character by his or her pose, facial expression and clothing. In addition, you can put your model in familiar surroundings or show them with a favourite possession. A person's general attitude can also be very telling. Look at whether they usually stand confidently or slouch, whether they gaze out boldly or keep their eyes downcast, whether they smile or remain passive.

If you are using a model or a friend to sit for you, ask them to wear clothes that

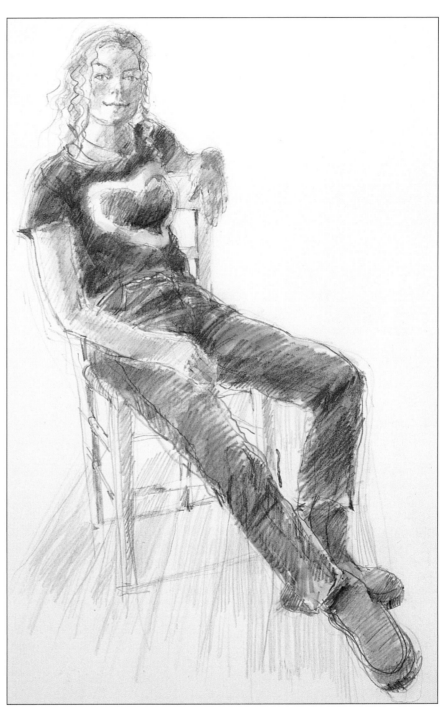

they feel comfortable in and let them adopt a pose that feels natural. In the drawing here, the young woman favours casual jeans and a T-shirt and is leaning back in her chair in a relaxed fashion.

Colour is another means by which you can convey personality, so the drawing was worked in water-soluble

▲ The casual pose of the model reflects her youth and relaxed personality.

coloured pencils. The bold red of this sitter's clothes suggests that she has a confident and outgoing nature. The dynamic diagonal created by the out-stretched pose has a similar effect.

FIRST STEPS

1 ▼ **Make a sketch** Using a medium black water-soluble coloured pencil, sketch the figure. Establish the slight tilt of the head and the position of the eyes with crossing guidelines. Use another guideline down the front of the torso to show the angle of the upper body leaning back against the chair. Indicate the fabric creases on the trousers. To show how the body is supported, put in the chair legs and back.

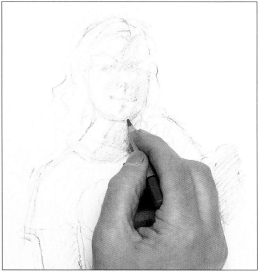

2 ▲ **Introduce a flesh tone** With a burnt ochre coloured pencil, shade the left side of the model's face and neck, adding a little extra shading on the right cheek and eye socket. More loosely, shade the burnt ochre on the model's left hand and the top of her right arm. Sharpen the pencil to define the facial features.

3 ◀ **Colour the red clothes** Change to a pale geranium lake pencil to shade in the bright red T-shirt; make bold, textural marks, pressing quite hard. Fill in the heart motif with medium black. Continue the red colour on to the jeans, using looser hatching lines here. Let your marks follow the stretch of the fabric as it creases across the model's stomach and folds around her legs.

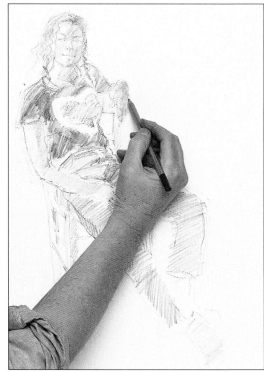

4 ▲ **Develop the picture overall** Use yellow ochre as a base colour for the hair, suggesting the wavy strands with raw umber (see Expert Advice opposite). Mark in the darker hair at the front with medium black. Develop the shadow on the flesh tones of the face and arms with a Pompeian red pencil, blending it over the burnt ochre. Using medium black, hatch in some tone on the legs and back of the chair. Shade the right boot with a little burnt ochre.

ADDING WATER

The advantage of using water-soluble pencils is that you can smooth out the colour with a little water on a soft brush to give a painterly look to your drawing. Extra shading and details can be added over the colour washes with dry pencil marks.

5 ▶ Add water to the clothes Dip a No.10 soft round brush into clean water. Brush it over the pale geranium lake of the T-shirt and jeans to blend the previous shading into a soft wash. Rinse the brush before blending the black shading on the T-shirt heart.

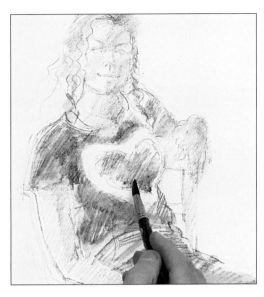

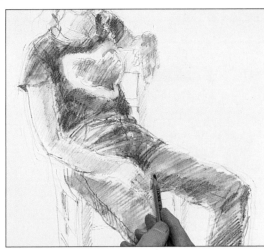

6 ▲ Build up shadows To suggest how the light falls across the clothing, work up some darker tone on top of the washed-over pale geranium lake. Use an Indian red coloured pencil for this, rendering the shadows on the T-shirt, the lower part of the legs and the inside of the left thigh. Use bold linear marks to represent the pull of the fabric folds across the stomach.

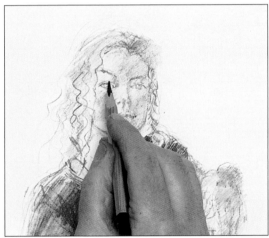

7 ◀ Develop the face Brush a little water over the flesh tones on the face and neck to smooth out the skin colour. When this has dried, warm up the cheeks and lips with dark carmine. Sharpen a Vandyke brown pencil and define the eyebrows, eyes and jawline.

EXPERT ADVICE
Making waves

To suggest the waves in the model's hair, hold the coloured pencil lightly about halfway down its length and make loose zigzag lines. By working in this way, you will avoid drawing too tightly and spoiling the effect of the casual hair style.

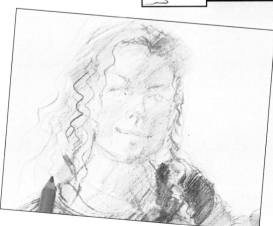

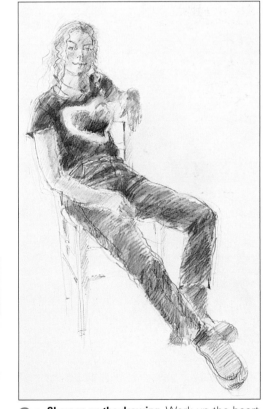

8 ▲ Sharpen up the drawing Work up the heart on the T-shirt with medium black. Still using black, outline the fingers, draw the necklace and add dark shadow to the chair back. Strengthen the pale geranium lake shading on the jeans. With loose lines, hatch brown ochre, then Vandyke brown and a little Indian red over the boots. Strengthen their outlines with sketchy lines in these colours.

The drawing of the model is now complete, but it is worth paying some attention to the floor to give the composition a firm base.

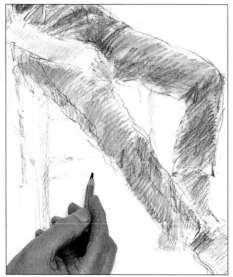

9 ▲ **Put in cast shadows** To help 'anchor' the chair to the floor, introduce the shadows cast by the chair legs, using medium black. Darken the tone of the chair with more hatching on its legs. Add colour to the woven straw chair seat with a little gold ochre hatching.

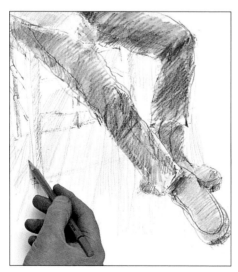

10 ▲ **Draw the floorboards** Wash a little water over the boots to blend the drawn lines together. With the well-sharpened Vandyke brown pencil, emphasise the outlines of the boots and darken their soles. Shade the floorboards with long hatched lines in gold ochre, then edge them with black.

THE FINISHED PICTURE

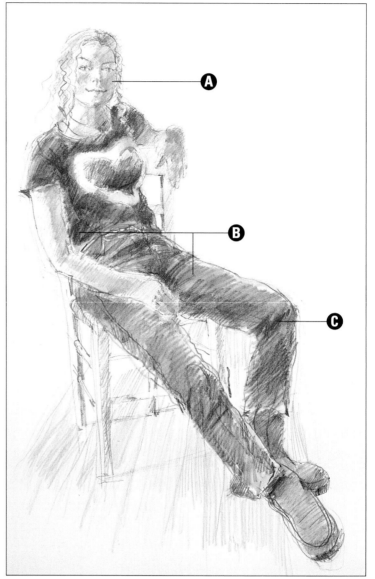

A Character study
The facial features were drawn in enough detail to convey the youth and relaxed expression of the model.

B Light to dark
On the jeans and T-shirt, the lighter red was shaded in first, then the darker red was hatched in over the top.

C Colour blending
Washing over hatched lines made with water-soluble coloured pencil softens them and blends the colours together.

Lighting a portrait

By changing the lighting when you are planning a portrait, many different aspects of the sitter's face can be revealed.

When Leonardo da Vinci (1452-1519) painted a portrait, he preferred to light his subject from above. This created a similar effect to daylight and showed his sitter in the most natural way, so that he could capture a good likeness.

Like Leonardo, many contemporary portrait painters prefer to paint their subject in a natural-looking light. However, unlike artists of the past, we are not restricted to daylight or the limited glow of oil lamps. With the advantages of modern lighting, we are able to simulate daylight with controllable artificial lighting, and easily supplement it to create a more flattering effect, if necessary. We can move or change the light

▶ **Two lights – a general overhead light and a light placed to one side of the sitter – are used with a reflector board to create a flattering effect with soft shadows and muted highlights.**

SOFT, DIFFUSED LIGHTING

If you want a natural look for your model, there are various ways of setting up the lighting so that it flatters the face while retaining a good likeness. You can combine natural and artificial light sources or make use of reflected light.

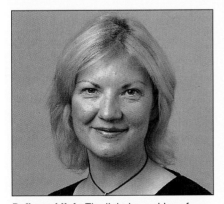

Reflected light The light here shines from the left of the sitter. A white board placed on the right of the woman reflects some light on to the shaded side of the face to create a soft, even illumination.

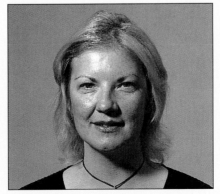

Soft shadows This face is lit from two sources – front and above left. This creates a greater tonal range – note the contrast between the highlight on her forehead and the shadow on the right cheek.

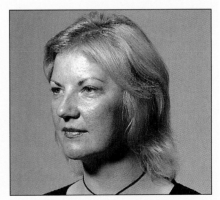

General lighting The set-up here combines natural and artificial light. Daylight from a window to the left of the sitter is enhanced by a light overhead and a reflector board to the right.

STRONG, DIRECTIONAL LIGHTING

You can produce dramatic and sometimes startling effects by positioning a single light above, below or to one side of your sitter's face. With directional lighting, some areas of the face will be brightly lit, while others will be in deep shadow, creating strong contrasts. You can change your model's appearance radically in this way.

Directional overhead lighting A single directional light above the sitter catches on the upward-facing planes and casts dramatic shadows downwards – especially under the nose and chin.

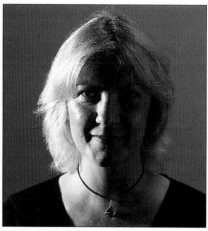

Side-lit front view A single light placed to the side of the subject dramatically illuminates one side of the face and hair, throwing the other into darkness. Note how the lit side of the nose really stands out.

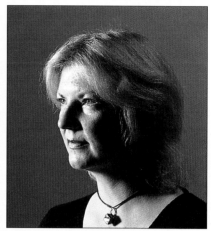

Side-lit three-quarter view When the sitter turns towards a side light, the front of her face is illuminated. The other side of the face is in shadow. Note how much detail there is in the well-lit eye sockets.

Dramatic lighting from below A light held below the chin produces a dramatic, horror-movie effect, throwing the top of the nose, chin, cheeks, brow and hair into shadow.

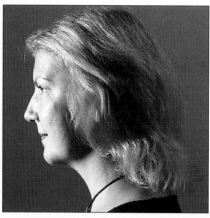

Profile shot In this classical pose, a single light is used to draw attention to the face. Note how the front of the face stands out from both the background and also the darker tones of the back of the head.

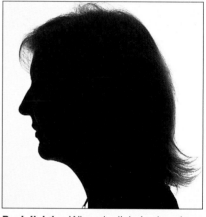

Back lighting When the light is placed behind the sitter, features, form and colour are lost. Instead, the whole head is seen in silhouette and attention is drawn to the sitter's profile.

source to create or diminish background shadow and to alter shadows on the subject's face. We can even evoke a particular atmosphere in a portrait painting by using tinted bulbs, diffused or reflected beams, or directional light.

Lighting the features

The human face is a complex structure, made up of the skull and facial features. These structures of bone and muscle are covered with flesh and skin, which give the face a soft, rounded appearance. Differentiating between the light and shaded areas when painting needs a subtle touch, because the two merge gradually on the rounded surface.

Under a strong directional light, however, the illuminated and shaded areas are clearly visible as planes on the surface of the face. Each plane catches the light in a different way – those turned towards the light are illuminated and appear pale in tone, while those facing away from the light are darker. This effect is illustrated by the two drawings opposite, in which the tones gradually become darker as the facial planes turn away from the light.

Dramatic lighting

Depending on the type and position of the light source, different sets of planes will be picked out and illuminated. You will find that by changing the lighting, you can make a huge difference to the

appearance of the sitter's face. An overhead light, for example, will pick out and illuminate the planes on the forehead, top of the nose and upper lip. A light placed below the face, on the other hand, will emphasise the bottom of the chin and the underside of the nose.

The rather dramatic effect that you can create with a single light source can be used to your advantage. For example, if your sitter's facial features are less than prominent, a strong side-light can help to strengthen the forms of the face by defining the planes more clearly.

The natural effect

For a more natural effect, however, you can produce softer results by using more than one light source. Experiment with different effects by combining daylight from a window with an electric lamp, or by using two lamps of different strengths, or with coloured bulbs. If you are lucky enough to have a large, north-facing window, you'll attain some wonderfully soft lighting.

You can also soften the effect of a strong directional light by placing a piece of white card (at least one metre square) on the shaded side of the face. This will throw back some of the light and create a flattering, softer illumination on the shaded side of the face.

Colour and light

Another factor to consider when you are planning how to set up the lighting for a portrait is the colour of the light itself. You will notice, for instance, that flesh colours will change dramatically under different types of light.

If your model is posing out-of-doors or seated by a window, cool daylight can appear white or blue when reflected on skin. On the other hand, electric lighting is often yellow or orange, and this will warm the colour of the subject's face.

Experiment with lighting

As a portrait painting can succeed or fail due to the lighting, it is well worth spending a little time experimenting with it. In this way, you will discover the potential of different types of lighting. Your own face can provide you with a convenient starting point, so why not begin with a self-portrait?

Set up a number of different lights and lighting angles to discover which are the most effective. Consider the possibilities of either daylight or artificial lighting, then try using a combination of both. And consider ways of using lighting to evoke a mood appropriate to your sitter.

Revealing face structure

Directional lighting reveals the structure of the face as a series of planes. By distinguishing between the dark, medium and light tones of these facial planes, you will find it easier to 'sculpt' the face on the paper.

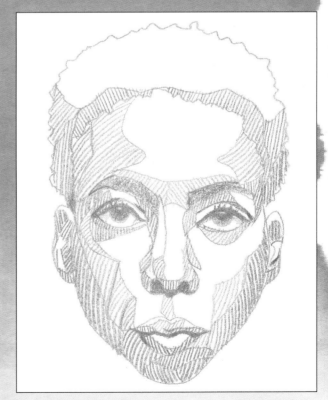

Side lighting Here, side-lighting from the right shows up the illuminated planes down this side of the face, while those on the left, which are turned away from the light, are darker.

Overhead lighting Lit from above, the planes on the top surface of each feature become clearly visible. They are not regular, but correspond in shape to the bones and muscles underneath.

Back-lighting the figure

By painting your model against the light, you can create an unusual and dramatic portrait with strong tonal contrasts and subtle shadows.

This striking portrait demonstrates the dramatic impact that can be achieved by working with back-lighting, or *contre jour*.

With the light behind the subject, you are bound to lose a lot of the detail and three-dimensional form of the face. However, you can make the most of the outline of the head, especially if you show the face fully or partly in profile. If the body of the model is also side-on, you'll get the back-lighting skimming across the clothing, creating dramatic areas of contrast in your painting.

For the most part, however, the figure will be composed of very shadowy tones. At first glance, it may seem that these areas are almost black – but look closely and you'll see a range of distinct tones and muted colours. In this painting, for instance, the shadowed side of the face contains a subtle variation of reds, browns and greens.

To make these colour adjustments easily, make sure you retain a little of all the mixes you make. You might need to use more of a mix for something you missed earlier, or you might want to adapt an existing mix to create another tone in the same colour range. Remember that you can also alter the richness of your colours by varying the direction of your brush strokes – the colours will appear to change depending on how the light falls on the textured surface of the oil paint.

Smooth out the background

While distinct brush strokes help to give the figure solidity, use smoother marks in the background. This will make the figure appear to stand out. To blend the paint, use the fan brush given away with this issue. (Also use the free terre verte oil paint – its cold, greyish-green colour is ideal for your flesh and shirt mixes.)

Before embarking on the oil painting, spend some time finding the best position for your model, and make some rough sketches (see right). When you actually begin, start with a simple line drawing of the body. Re-adjust the lines until you are happy that the proportions and position of all the body parts are correct. Then begin blocking in colour.

The artist who painted this picture chose to paint on medium-density fibre-board (MDF). It provides a smooth surface, a good mid toned ground and is capable of taking a lot of paint without warping. Before you start, you can apply a coat of clear acrylic sealer (or primer) to the MDF to protect the paint against any impurities the board may contain.

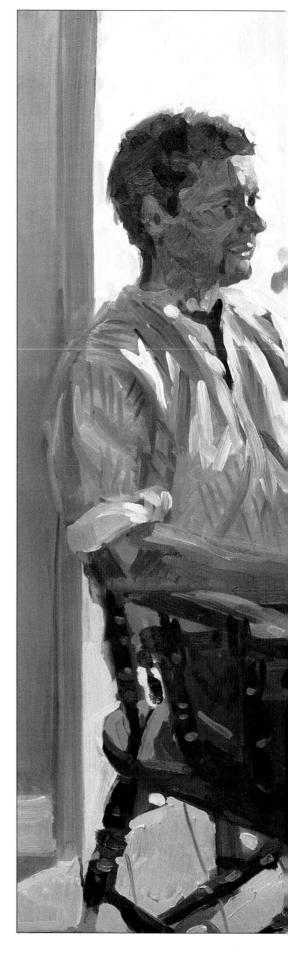

▶ **With a back-lit, or *contre-jour*, figure study, you attain a lot of shadowy tones, giving the subject an air of mystery.**

YOU WILL NEED

Piece of MDF (or a canvas board), 60 x 40cm (24 x 16in)

Mixing palette or dish

Brushes: Nos.1, 8, 10, 3 and 5 flats; No.2 round; No.2 fan

8 oil paints: Phthalo blue (green shade); Titanium

white; Cadmium yellow; Cadmium red; Viridian green; Lemon yellow; Alizarin crimson; Terre verte

Turpentine

Clear acrylic sealer (or primer)

White spirit – to clean brushes

ESTABLISH THE ANGLE OF THE HEAD

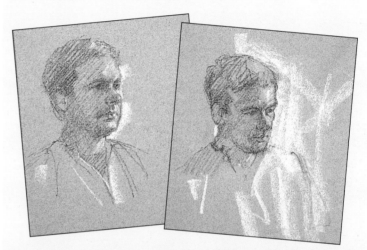

Once your model is seated in front of the light source, spend some time sketching different positions of the head and upper body. Aim to achieve an interesting outline against the pale background. Remember: with *contre-jour* lighting, a full or partial profile view against the light will show the model's facial features more clearly than a front view.

1 ▶ Make an underpainting

Use a weak mix of phthalo blue for the underpainting – you need a dark colour that will be visible while you are working on the rest of the portrait. Using a No.1 flat brush, paint in the basic shape of the figure, chair and the background. This gives you the chance to establish angles and proportions, and to mark in details such as the position of the hairline and the sleeves.

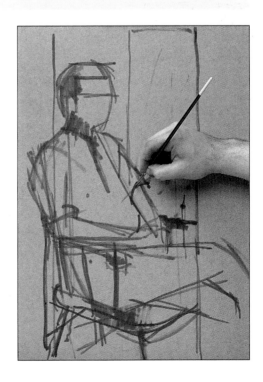

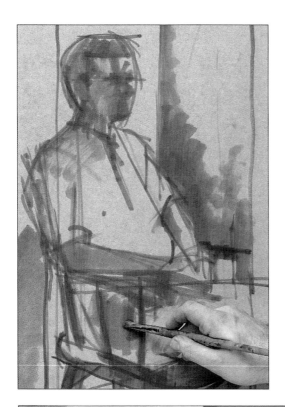

2 ◄ **Begin the tonal work** Using a No.8 flat brush and the same weak mix of phthalo blue, begin to add more tone to the underpainting. Note that the face is almost entirely made up of dark tones, due to the strong shadow which results from the back-lighting. Allow the paint to dry.

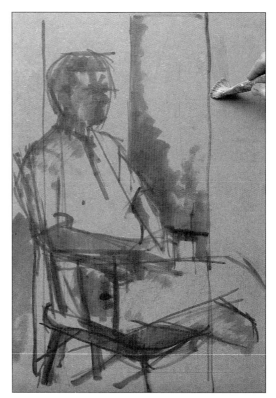

3 ▲ **Seal the underpainting** Apply a clear acrylic sealer over the whole picture with a No.10 flat brush and allow to dry. The sealant fixes the underpainting, so if you need to scrape off any paint at a later stage, you will not remove the underpainting.

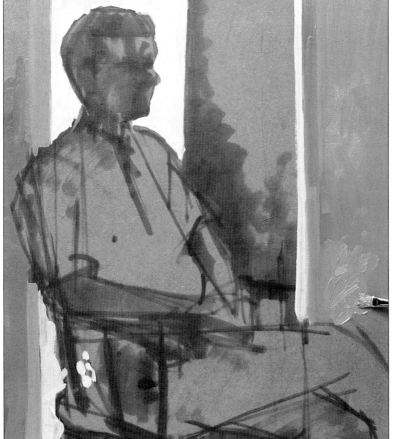

4 ▲ **Start blocking in the background** Mix titanium white with a tiny amount of cadmium yellow and phthalo blue to block in the lightest areas – the bright light on the door and door frame. Add a little cadmium red and viridian green to the white mix and use this neutral colour to block in the vertical strip of the door frame in shadow. Paint the wall with a mix of phthalo blue, lemon yellow, and a little alizarin crimson and terre verte.

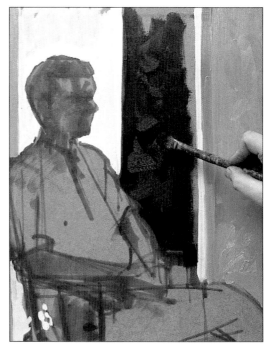

5 ▲ **Fill in the dark areas** Mix cadmium red with phthalo blue and, using the No.8 flat, block in the area of the deep shadow beyond the door. It is important to set up the extremes of light and dark early on, since they form the basis of the composition.

DEVELOPING THE PICTURE

With the outline of the model established and the background lights and darks blocked in, the next stage is to work on the more subtle tones found in the shaded areas of the model's face and clothing. When painting the flesh colours in particular, take care to keep the tones close together.

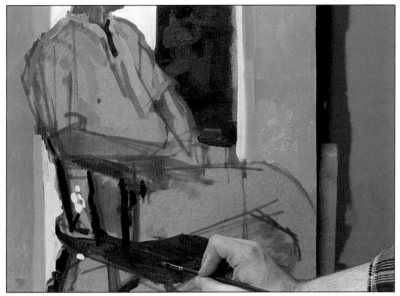

6 ▲ Begin to add shadows Look for the areas of neutral shadow on the shirt front. Using a No.3 flat brush, apply a mix of alizarin crimson, titanium white and terre verte to the shirt to suggest the shadows in the folded fabric. Darken the mix with phthalo blue, cadmium red, viridian green and alizarin crimson to make a very dark tone for the shaded areas of the chair. Add a little cadmium yellow for slightly lighter wood tones.

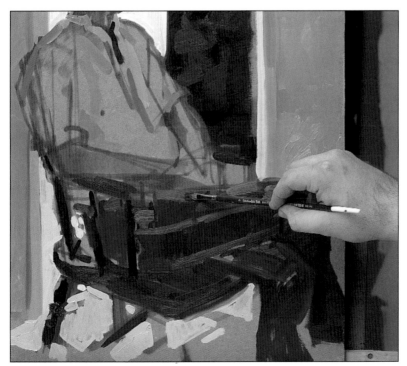

7 ▲ Block in the trousers Mix titanium white and cadmium yellow with a little cadmium red and phthalo blue. Use this mixture to block in the lighter areas of the floor. Then block in the trousers, using a mix of phthalo blue, cadmium red and a little lemon yellow. Lighten the mix with titanium white to add the highlights, seams and creases on the trousers.

Express yourself
A tonal Conté study

This sketch of the model in profile was made with Conté crayons on a textured pastel paper. The sanguine shade of Conté establishes the dark tones on the shaded side of the face, while the white shows the brightly lit background and the highlights on the shirt. The grey-brown colour of the support provides the mid tones.

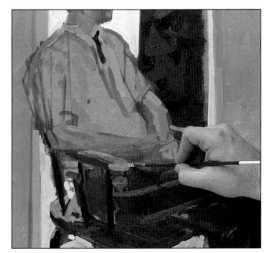

8 ▲ Start applying the skin tones Mix alizarin crimson, lemon yellow and terre verte. Apply this colour to the forearm, then block in the neck. Lighten the mix using a little titanium white and apply to the highlights on the front of the neck, arms and fingers. Add a little viridian green to this mix for the highlights on the wooden chair.

9 ▼ **Work on the shirt** Mix titanium white and a little cadmium yellow to create a warm, but bright, white. Use this to add highlights to the shirt. Darken the warm white with a little terre verte and cadmium red and block in more of the shirt fabric. Now take another look at the shirt. You might see areas of shadow that you missed earlier, in step 6. Use the darker shirt colour you mixed in this step to add more shadows if needed.

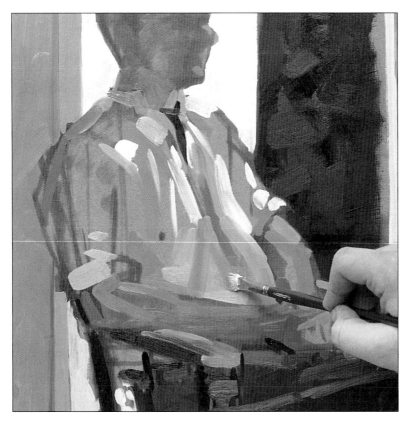

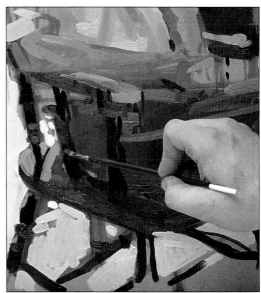

10 ▲ **Darken the chair** Paint the area of dark shadow on the chair seat, mixing lots of phthalo blue with cadmium red to produce a rich, bluish-black colour. Add a little viridian green and paint the shadowy bars of the chair, using the No.1 flat brush.

11 ▶ **Add highlights to the shirt** Mix titanium white with a little viridian green and alizarin crimson and apply to the shirt, using a No.5 flat brush. Pay very close attention to the areas of light and shadow and the creases in the fabric. Redden the mix slightly for the darker areas. Add brighter highlights, using titanium white with a touch of lemon yellow and cadmium red applied with the No.1 flat brush.

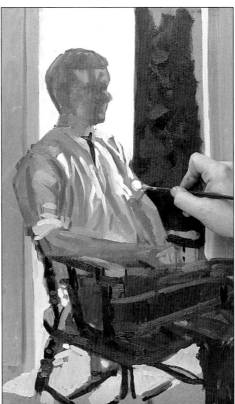

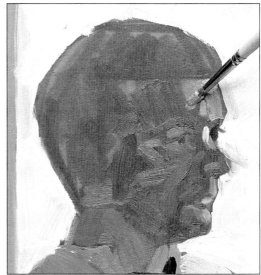

12 ▲ **Begin work on the head** Change to a No.2 round brush. Create a dark, reddish flesh colour using titanium white, cadmium red, alizarin crimson, lemon yellow and terre verte. Apply to the areas of dark shadow on the face and on the underside of the chin. Redden and darken the mix by adding more cadmium red and alizarin crimson. Apply this to the face, varying the direction of your brush strokes to suggest muscle and bone structure. Use the same colour to define the nostril, lips and eyelid. Mix in some titanium white to lighten the original face colour and add the highlights on the forehead and nose.

Master Strokes

Henri de Toulouse-Lautrec (1864-1901)
Paul Leclercq

The figure in this oil painting holds a relaxed pose similar to that of the model in the step-by-step. However, here, the subject is turning his head so that he gazes directly out of the picture.

His slightly quizzical expression seems to invite a response from the viewer. The unusual application of oil paint in sketchy vertical lines gives the impression of a pastel painting.

The pale face of the sitter stands out from a darker backdrop. This is in contrast to the step-by-step where the face provides a dark shape against a light background.

The objects in the background on the left are suggested with a little line work. As a result, they do not detract from the main subject of the composition.

The brown cardboard support shows through the painted marks to form an integral part of the harmonious colour scheme.

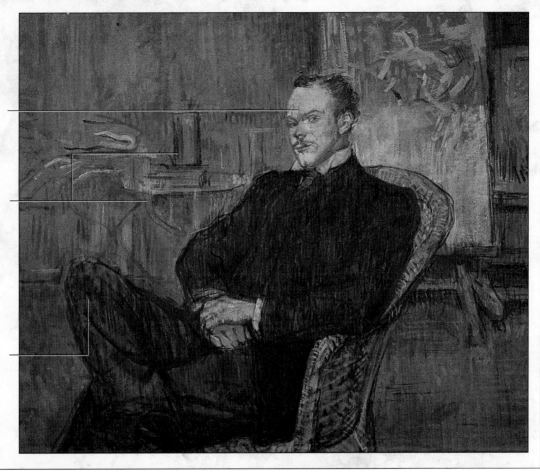

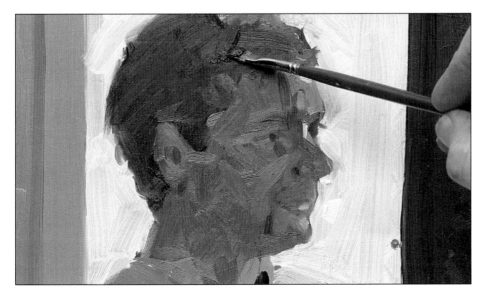

13 ◄ **Block in the hair** For the shadows above the top lip and beneath the eye, mix lots of terre verte into the original flesh colour used in step 12. Changing to the No.1 flat brush, block in the hair and eyebrows, using a mix of cadmium red and phthalo blue. As you work on the hair, look very closely at the outline of the head against the light background and redefine the painting if necessary.

14 ▼ **Blend hard edges** See if there are any hard edges of paint that would benefit from being smoothed out – for example, on the blue wall. Use a No.2 fan brush to blend these edges gently into the surrounding paint.

15 ▼ **Complete the tonal areas on the shirt** Even up some of the patchy areas of light and shade on the sleeve and front of the shirt, using the mixes from step 9. Paint the skirting board, adding lots of titanium white to the blue wall colour from step 4.

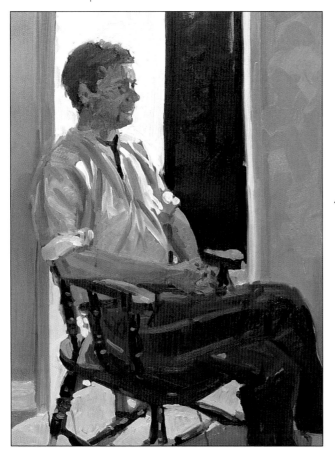

A FEW STEPS FURTHER

The portrait is now a striking rendering of the subject. A few extra touches will intensify the atmosphere and really bring the painting to life.

16 ▲ **Add depth and detail** Add alizarin crimson and viridian green to the dark hair mix used in step 13. Using the No.5 flat brush, apply this around the seat of the chair, beneath the model's legs and around his waist. This 'pinches in' the dark areas, adding depth to the shadows. Then use the same colour to define individual floorboards.

TROUBLE SHOOTER

USING A FAN BRUSH

To smooth out the paint in the background – especially on the walls and on the dark area beyond the door – the artist used a fan brush extensively. The long, splayed-out bristles are ideal for blending paint and rendering flat, featureless areas of the painting.

17 ▸ Put in some finishing touches

Darken the original reddish colour from step 12 with phthalo blue, then paint the door handle with the No.2 round brush. Lighten the mix with white for the shadow of the handle. Use the same colour to suggest the detail of the pattern on the shirt – a few well-observed lines are all that is necessary. Finally, go back to the dark mix to add the pupil of the left eye.

THE FINISHED PICTURE

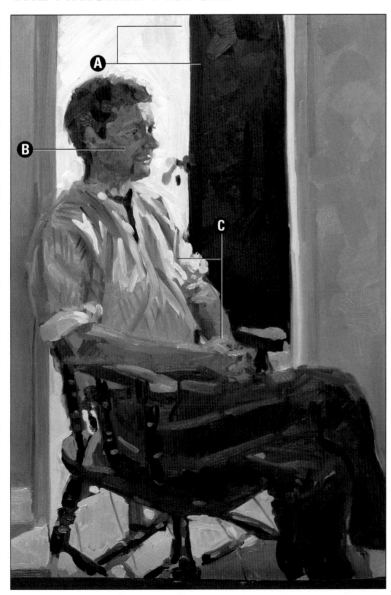

A Bold background

Broad vertical bands of light, medium and dark colours form a simple, striking background to the portrait.

B Facial structure

The structure of the face was built up with layer upon layer of paint. The direction of the brush strokes emphasises the form of the underlying bones and muscles.

C Tonal contrast

Most of the figure is in deep shadow, except for the areas of the face and clothing that catch the back-lighting. This sets up lively tonal contrasts in the portrait.

A dark, moody figure study

A figure in a setting such as a bar can tell a story and suggest a mood, as well as forming a pleasing composition.

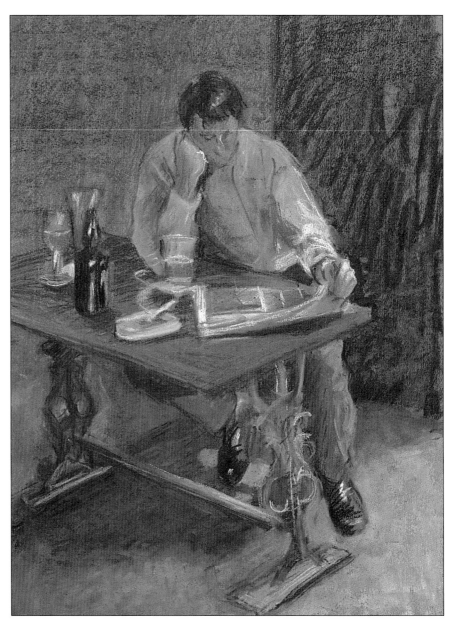

The inclusion of a human figure brings an interior scene to life and engages our interest. Many of the best Impressionist paintings, for example, are scenes of ordinary people doing mundane things: sitting in bars and cafés, or reading by the fire.

Conveying atmosphere

When painting a figure in a setting, remember that you are not aiming to create a portrait of an individual; there is no need to worry about getting an exact likeness. What is important is that your picture tells a story and conveys the mood of the person, arousing a sympathetic response in the viewer.

There is a strong 'slice of life' element in this pastel study of a man in a pub. Everything about it – the figure's pose, the dark tones and colours, the dim lighting – conveys an introspective, perhaps even a melancholy atmosphere.

The man's face is barely suggested, yet we can gauge his mood from the weight of his head resting on his hand. We might imagine that we are seated at the next table, idly curious about the man. Is he deeply absorbed in his newspaper or is he is merely giving it a quick glance? Is there something about his slumped posture that suggests his main aim is to drown his sorrows? We shall never know, but we enjoy the picture because it has an air of mystery.

Tone and colour

Think how you can use the elements of your picture – light, shadow, colour, composition, the pose – to express a particular atmosphere or emotion. Rich, dramatic colours and strong contrasts create tension and passion, while cool, neutral colours and soft contrasts create feelings of calm. Similarly, the tonal values in a painting can be used to underline mood. Lighter tones convey an upbeat mood, while darks and mid-tones express drama or melancholy.

▲ **If handled freely, pastels are the ideal medium for capturing the play of light and the sense of a fleeting moment.**

FIRST STROKES

1 ▶ Start the drawing
Study the figure carefully, assessing the proportions and angles of the head and upper body. Lightly sketch the figure and background with charcoal, dividing the picture area into interesting shapes. Use the side of the charcoal stick to block in the dark area on the right.

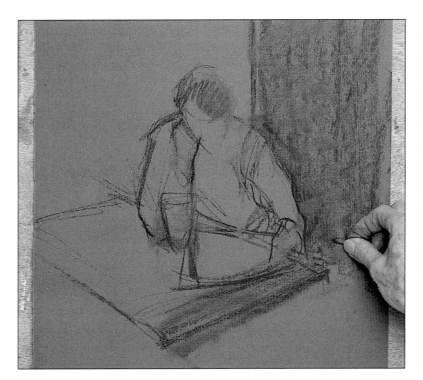

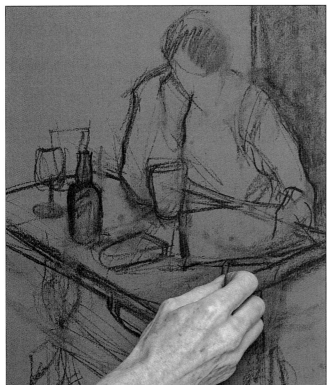

2 ▲ Add some details Sketch in the table legs and the newspaper, glasses and bottle. Avoid making solid, continuous outlines; instead, let the charcoal move lightly over the paper, making adjustments as you go.

3 ▶ Complete the drawing Draw the figure's legs and feet. Take care to get them in proportion with the upper body, and notice how they appear foreshortened because they are bent.

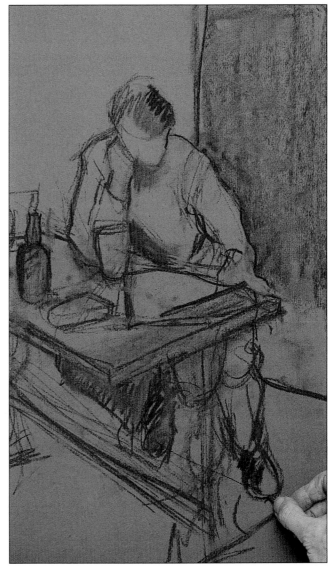

DEVELOPING THE PICTURE

Step back and assess the composition. Have you expressed the weight and balance of the figure? Do the figure, table and background form a unified group? Are the perspective angles correct? Once you are happy with the underdrawing, you can build up the colours with confidence.

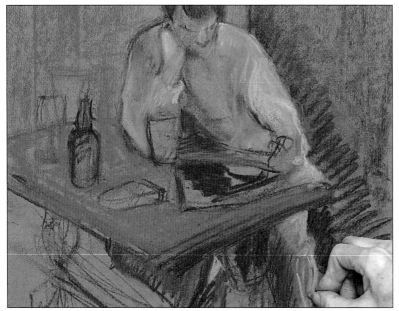

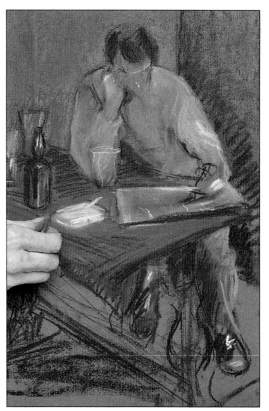

4 ▲ Establish the lights and darks Start to rough in the main areas of light and dark tone; you can then work up or down from these. Apply the colours lightly, using broken pieces of pastel on their sides. Use burnt sienna on the back wall and table top, and add a shadow on the blue wall, overlaying charcoal with a few strokes of purple pastel. Then work on the figure itself, creating the flesh tones with burnt sienna, raw sienna and yellow ochre. Define the shape of the head and hands, and block in the clothing with mid and pale greys.

5 ▲ Add some highlights To establish the direction of the light, put in lighter tones and highlights, using pale grey, cadmium yellow and very pale yellow ochre. Use the same colours to draw the ash-tray. Define the nose with a stroke of cadmium orange. Sweep in strokes of purple, black (charcoal) and mid grey on the table top, and add definition to the bottle and glasses.

6 ▲ Develop the whole picture Build up the flesh tones on the hand with yellow ochre and raw sienna. Don't work on one area for too long, but move around the picture, adding small touches of colour and adjusting the tones in relation to their neighbours. This helps create a lively picture surface.

EXPERT ADVICE
Using a stump

A stump, or torchon, consists of tightly rolled paper in the shape of a thick 'pencil'. It is used for blending and spreading pastel colours on the paper without getting your fingers dirty. The ends taper to a point, so you can also use it to blend small areas of detail.

8 ▼ Strengthen the darks Work over the dark wall on the right with vigorous strokes of charcoal, leaving them unblended. Use your fingers or a stump to blend and spread the strokes of dark colour previously applied to the shadow on the floor.

7 ▲ Work on the lower section Apply burnt sienna to the dark part of the floor and yellow ochre to lightest parts. Add more definition to the shoes and trousers, and suggest the highlights on the wrought iron legs of the table with cadmium orange and yellow ochre. Hatch over the shadow area of the floor with strokes of purple.

Master Strokes

Pierre Auguste Renoir (1841-1919)
At the Café

The French Impressionist Renoir was drawn towards painting figures, particularly pretty women, in lively settings, such as bars or theatres. In this oil painting he has captured a candid moment in a busy café – almost as a modern photographer would. The main characters are interacting with each other – the two women are looking up at the waiter, while the man gazes at the woman in the foreground. As in our step-by-step, the viewer is invited to guess at the story behind the intriguing scenario.

Sketchy dabs and strokes of paint create a hazy background that helps focus attention on the main action of the painting.

A strong diagonal in the composition is created by the slant of the women's bodies. This leads the eye from the bottom left corner to the women's faces and ultimately to the waiter.

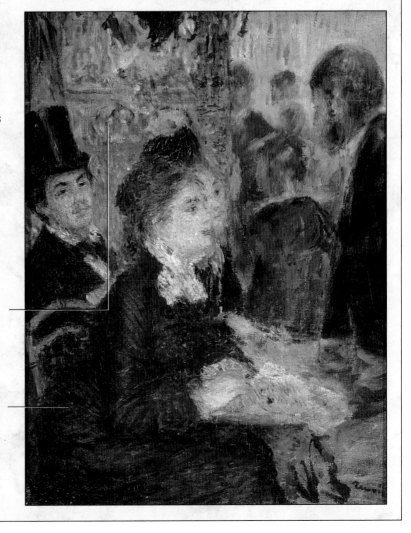

9 ▼ **Scumble over the wall** Break off a small piece of charcoal and, using it on its side, go over the brown wall very lightly with horizontal strokes. This suggests rough plaster or brickwork, adding texture to the wall without making it dominate the focal point of the picture.

10 ▲ **Develop the features** Now that the picture is nearing completion, you can start to work on the finer details. Suggest (but don't overdo) the eyes and nose with charcoal, and define the hair. Then develop the flesh tones on the face and hand with burnt sienna, cadmium orange and purple, adding the highlights last with pale yellow ochre.

Express yourself
Dramatically lit scene

The interplay of light and dark is the main characteristic of this painting of a jazz band by the same artist who painted the step-by-step. To throw the brilliantly lit figures and faces into focus, the background areas behind them are washed with a dark tone. The prevailing colour of the scene is orange, but a touch of its complementary colour, blue, is introduced by the long scarf worn by the trumpeter.

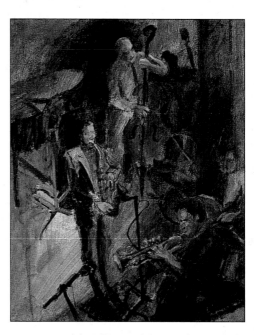

A FEW STEPS FURTHER

You have now established the low-key mood of the subject. All that remains is to enrich the image with a few hints of warm colour to suggest light spilling in from an unseen window and to provide an effective foil for the cool, dark colours of the interior.

11 ▶ **Use broken colour** To give more textural and colour interest to the floor, work over the pool of light with short, broken strokes of purple-grey, burnt sienna and pale yellow ochre (snap off short pieces of pastel and use them on their sides).

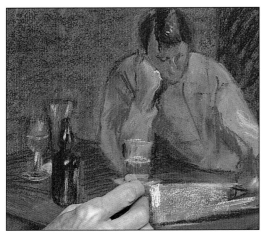

12 ▲ **Introduce warm touches** The drinks in the glasses glow warmly because of the light shining through from behind. Suggest this with touches of cadmium red, burnt sienna and cadmium orange. Add touches of orange to the table leg and to the man's nose and hand.

13 ▼ **Add some final details** Use pale yellow ochre to punch in some final details and highlights on the sleeve and hand. Finally, spray the picture with fixative to prevent the colours smudging.

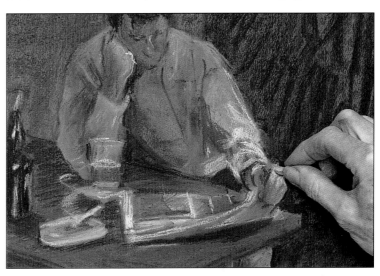

THE FINISHED PICTURE

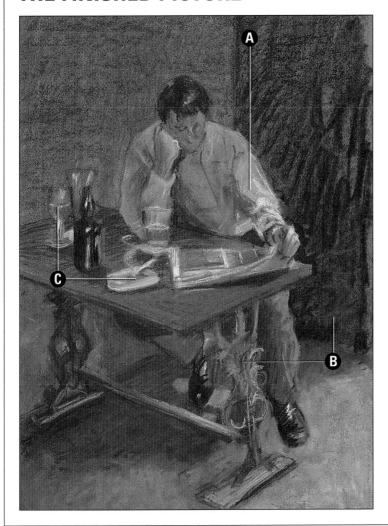

A Body language
With his body leaning towards a newspaper, the sitter assumes a pose that is natural and also forms a satisfying composition.

B Freedom of handling
A varied range of pastel marks has created an active picture surface full of textural interest.

C Bright spots
Touches of bright, warm colour provided by the items on the table and by the highlights on the figure attract the eye and encourage it to move around the composition.

Sketching the figure

Here we look at how to create a sense of movement in your figure drawing – even when the subject is stock-still.

How do artists make their figures come to life? In life drawing, the model is usually standing, lying or sitting. Yet the best figure drawings and paintings have a sense of motion and rhythm, even when the pose is a static one.

Working quickly

There are various ways of achieving this elusive feeling of movement, the most effective of which is quite simply to work quickly. Rapid sketches are invariably more animated than finished drawings and paintings. They are gener-

ally done on the spot, often with lively lines and splashes of colour applied with a quick flick of the wrist and, inevitably, this spontaneous approach creates a sense of life and action.

Line drawings have an inherent sense of movement that tonal or shaded drawings often lack. This is because hatching and other types of shading needed to emphasise the form of the figure often work against a sense of motion and rhythm – they make the drawn figure appear solid and therefore more static.

A sure-fire way of conveying an idea of motion in a drawing is to concentrate

on the outlines and contours of the subject, making the lines as fluid and natural as possible. The pencil drawing of the walking figure below was done quickly and without looking at the paper at all. What's more, the artist barely lifted the pencil off the paper during the process.

Responding to the subject

This is an unusual approach, but it's one that often works because it forces the artist to respond directly to the subject without having to worry about the drawing technique. Such drawings or paintings may not always be

WALKING FIGURE

To achieve a convincing walking motion, the artist looked at the moving model rather than the drawing. She hardly took the pencil off the paper – instead she simply left it trail off in places. This way of working often produces – as here – a drawing of real beauty and sensitivity that an exact image would lose.

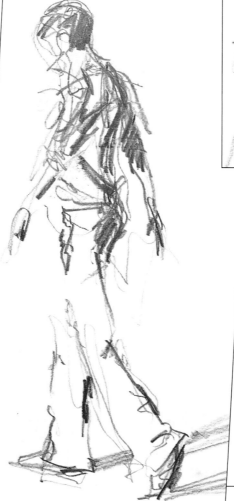

▼ Breaking up the outline of a figure adds to the sense of movement. Here, the back of the left thigh (on the right) is drawn with one line – suggesting the stretching of the hamstring – but the front of the other thigh is 'lost' altogether.

▲ Gestural strokes define the form of the back in a much more expressive way than shading or cross-hatching.

▲ Half finishing the foot suggests a fleeting movement. If it had been fully drawn, the model might have looked as if she were holding a pose rather than walking.

MOVING FIGURES

When drawing the moving figure, try to pick out one instant in the complete action. If necessary, ask your model to repeat the process until you have a clear mental image of it. Alternatively, ask her to hold a pose in the movement for a few seconds.

▲ SUPERIMPOSED MOVEMENT IN SEPIA INK
The model is stopped midway as she stands up from a sitting position. Using a small sable brush, our artist recorded three stages of this action to produce an animated sequence of figure drawings.

◄ SPINNING FIGURE IN CHARCOAL
The subject was moving around continuously as the artist used a few deft lines to capture the model's swinging arms and the swirling motion of her skirt.

anatomically accurate, but they will certainly be lively and interesting.

The figure stretching upwards (see over the next page) was also done without taking the drawing tool – in this case a pastel stick – off the paper. In this image, however, the artist was concerned with accuracy as well as expressing motion and so dragged the pastel slowly across the surface. This continuous, flowing mark echoes the sinuous pose of the model and captures her slow, graceful, stretching movement.

It's quite possible to communicate a sense of rhythm and movement even when working from a figure in a static pose, such as lying down or sitting. You can achieve this simply by drawing or painting in a spontaneous way, using lively marks. However, a figure in action offers even more scope for introducing movement into your work. To get the most natural-looking pose, ask your model to carry out a number of different actions and then to freeze in mid-movement. The resulting poses may be difficult to maintain for more than a moment or two, but this is all you need. In fact, your work will benefit from being done quickly.

Repetitive movement

If, however, the model's mid-movement pose looks stiff and unconvincing, it is also possible to sketch from a moving model. The walking figure opposite was done in this way. It helps if the action is repetitive, as is the case when someone walks. You can then see the part of the pose you want to draw time after time.

STATIC FIGURES

Using a variety of materials, our artist explored some of the different ways in which an impression of motion can be introduced into a still figure. Test some of these ideas for yourself. Work quickly, using just the materials you have to hand. Above all, try to ignore detail. The secret lies in working spontaneously – in responding to the rhythms of the model's pose rather than attempting to produce an accurate representation of the figure.

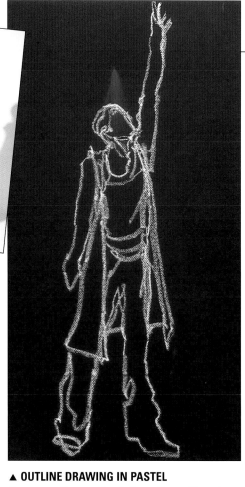

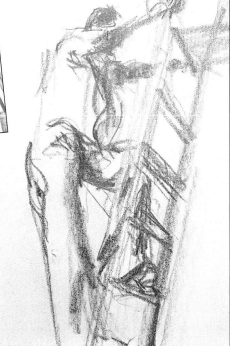

▶ FORESHORTENING IN CHARCOAL
The legs loom forward in this drawing because of the close, low vantage point. The ladder accentuates the foreshortening and the strong upward direction of the drawing.

▲ OUTLINE DRAWING IN PASTEL
Here a continuous line follows the outline of the figure, emphasising the stretching motion of the pose and giving the whole sketch a sense of movement.

▼ TONAL DRAWING IN CHARCOAL
This pose may be static physically, but it is very active visually. The varying angles of the legs and arms lead the eye around the picture and this effect is enhanced by the use of charcoal. The artist used her fingers to create lively, directional smudges, which describe the dark shadows without destroying the rhythm of the pose.

▶ ARBITRARY COLOUR IN PASTEL
Using red for the flesh tones and to outline the trousers is not exactly true to life, but it helps capture the exuberant spirit of the pose. The artist was sitting on the floor and the low viewpoint has helped create an explosive sensation, as if the figure is about to shoot upwards.

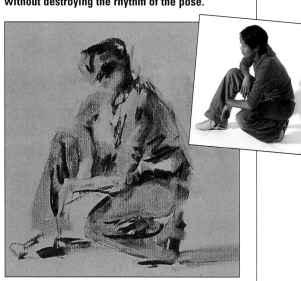

Seated figure in gouache

Soft, harmonious colours and an unusual pose make for an interesting study with the emphasis on modelling forms with light and dark flesh tones.

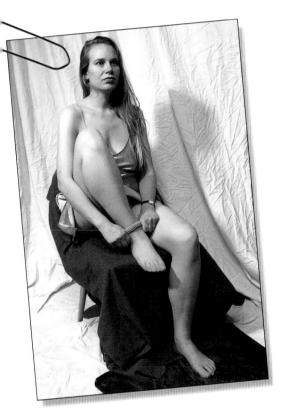

I f a friend has agreed to pose for you, make the most of it – having a model is a great luxury. But at the same time don't abuse his or her generosity. Decide on a pose that is comfortable for them as well as interesting for you.

Bear in mind that your painting could, and probably will, take several hours. Don't expect your model, however flexible and well-intentioned, to hold an uncomfortable pose for too long. Also, whatever pose you establish, give him or her plenty of breaks. If, as in this case, it's a seated position, put a little masking tape on the ground to mark where the model's foot goes. Then she can return to her original position no matter how many coffee breaks she takes.

Paint with large brushes

The loose feel of this figure study is achieved initially by painting the outline with a large brush, rather than drawing it in pencil. Develop the form with flesh tints, again using a large brush. Gouache is opaque, so you can adjust the shapes and proportions as you progress, if necessary. Only change to a small brush for the final details of the facial features.

Stay-wet palette

To prevent your paints from drying out while you work, use a Stay-wet palette, which keeps paint moist for hours. This type of palette is made with quick-drying acrylics in mind, but is also useful for gouache paints if you are working on a project over a long period of time.

You can make your own palette from a polystyrene tray from a supermarket. Cut blotting paper to fit, then cut greaseproof paper to the same size. Place the

blotting paper – the lining of the reservoir – in the tray and add a little water. Now put the greaseproof paper – the membrane – over it to form a surface to hold the paints. As the paints gradually dry out, more water is absorbed from the dampened reservoir paper below to keep them fresh.

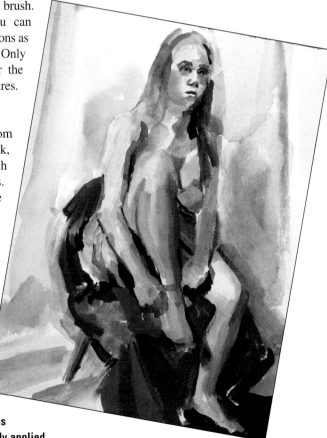

▶ The peachy flesh tones of this model are rendered with loosely applied gouache paint. The russet red cloth and pink slip add to the overall harmony.

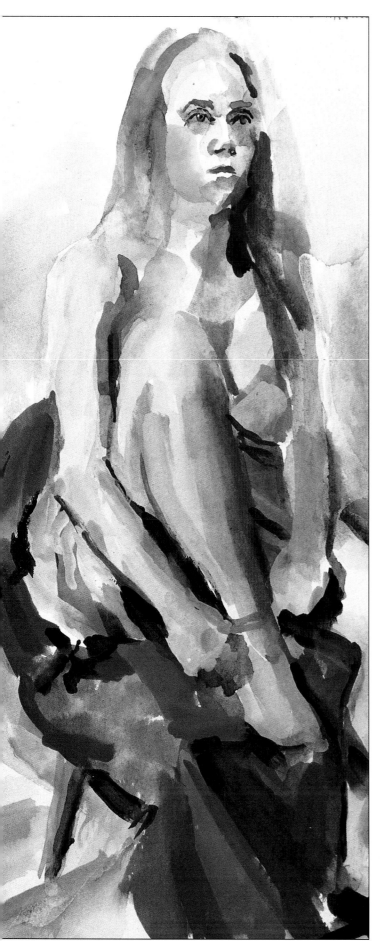

<div style="text-align:center">**YOU WILL
NEED**</div>

Piece of 400gsm (200lb)
Not watercolour paper
32 x 24cm (12½ x 9½in)

Stay-wet palette

12 gouache paints: Burnt
umber; Cerulean blue;
Titanium white; Cadmium
yellow; Cadmium red deep;

Cadmium red pale;
Ultramarine; Alizarin
crimson; Red-violet; Burnt
green earth; Neutral grey;
Ivory black

Brushes: Nos.12 and 4
rounds; No.16 filbert

FIRST STEPS

**1 ▶ Paint a loose
outline** Mix up
a watery blend of
burnt umber and
cerulean blue to
make a neutral
tone. Using a
No.12 round brush,
start to map out
the body, noting
the relative
positions of the
limbs and head.

**2 ◀ Start filling in the
form** Change to
a No.16 filbert brush
and mix combinations
of titanium white,
cadmium yellow and
the two cadmium
reds – deep and pale
– to make a range of
peachy flesh tones.
Start filling in the
body, applying the
paints loosely.

3 ▼ Add cool tones Mix a cool blue from cerulean blue and a little burnt umber to paint the shadow along the side of the raised leg. With a more concentrated mix plus a little ultramarine and alizarin crimson, paint the triangle of the underwear.

4 ▶ Balance the colours Add a warm gold to the girl's left arm with a dilute mix of cadmium yellow and a touch of cadmium red deep. Suggest the sweep of her hair with burnt umber. Then use the No.12 brush to fill in the silk slip in a watery purple mixed from red-violet with a little cerulean blue and ultramarine. Balance this colour with a russet red shadow to the left of the raised leg – this is mixed from cadmium red pale, cadmium red deep, red-violet and burnt umber.

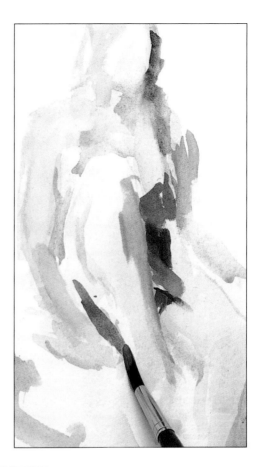

5 ▼ Fill in negative shapes Paint the russet triangles of fabric created by the position of the girl's legs. These negative shapes are important – get them right and the correct positive shapes will emerge. Now paint the varying tones on the girl's left arm, using the neutral mix from step 1 with cadmium red pale, cadmium yellow and white.

DEVELOPING THE PICTURE

Continue working up the flesh tones with pale pinks and peachy tints. As you are adding colour loosely, you'll need to define the edges of the limbs with darker lines of shadow in places.

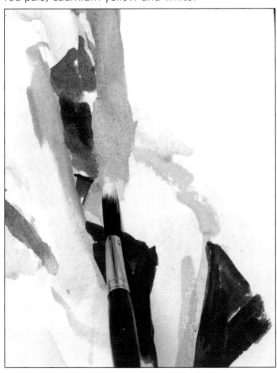

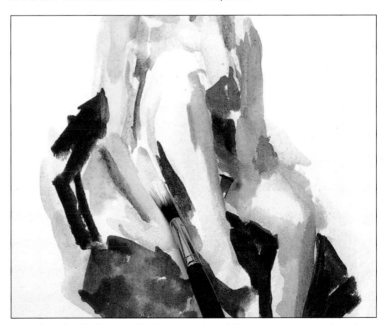

6 ▲ Develop flesh tones Having completed the russet areas, mix pale pink for the girl's right arm where it catches the light, using cadmium yellow, cadmium red pale and white. Add a little cadmium red deep, burnt green earth and more white to the mix to describe grey shadows on the arm and left leg. Don't worry about being exact at this stage. Gouache is forgiving, so you can adjust colours and tones as you go.

7 ▶ Develop the tones
For the shadows on the breasts, dilute the slip mix from step 4. Mix neutral grey, red-violet and burnt green earth to paint the stocking tops and a shadow beneath the foot. Wash a mix of cerulean blue, white and cadmium red deep over the wall. Now adjust limb tones, using the mixes from step 6 with more green earth for shadows and more white for lights. Put in the darkest shadows with neutral grey, cadmium red deep and ultramarine. Add a white highlight on the knee.

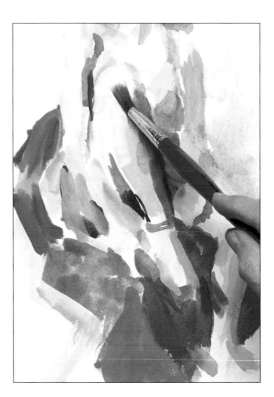

8 ▼ Model the face Paint the hair with a washy neutral grey mixed with burnt green earth. With the brush tip, pick up mixes from the palette to suggest facial features, using pale grey-browns for the eyes and a pinky-mauve for the mouth. Paint a slash of cadmium red pale mixed with white for the cheek, and cadmium red deep with white for the nose. Put a grey accent under the lower lip.

Master Strokes

Spencer Frederick Gore (1878-1914)
The Green Dress

In this oil painting by the British artist Spencer Gore, another pensive young woman is getting dressed. Gore's early work was strongly influenced by the Impressionists – which is evident here in the subtle play of light in the scene and in the sketchy application of the paint. The artist has used the device of a mirror to show the girl's face from two different angles – one as a three-quarter view, the other in profile. The palette is limited to a range of creams together with blue-greens and orange-browns – complementary colours that set up a strong contrast.

Dabs of thick, creamy paint are applied to the window panes to create an impasto surface that suggests sunlight filtering into the room.

The girl's face is modelled through the use of light and dark tones, with no attempt to capture the detail of her features.

9 ► Paint the fabric folds Extend the background shadows with a wash of red-violet, cerulean blue and white. For the chair leg, mix a light brown from burnt green earth and white; add the shadow in burnt green earth and neutral grey. Use the same browns on the girl's hair. Mix deep reds from red-violet and cadmium red deep to block in the folds in the draped fabric, defining the shape of the feet as you do this. Add more water and a little cadmium red light for the paler areas of the fabric.

REWORK PROPORTIONS

TROUBLE SHOOTER

Gouache paint is naturally opaque, which means it is ideal for overpainting areas and adjusting mistakes you might have made. Here, for example, one arm seems too broad, but it can be slimmed down by overpainting the edge in white.

Express yourself

Soft-focus figure

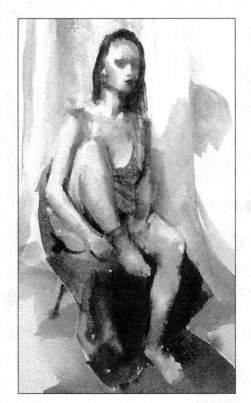

This smaller version of the figure study is worked in watercolour on a textured paper. Wet-on-wet washes produce soft passages of colour that run together where they meet, creating fuzzy, out-of-focus edges. Contrasts of light and dark tones give the face its form, and its features are just hinted at rather than clearly defined. Washy grey shadows form a hazy backdrop that enhances the rather ethereal feel of the composition.

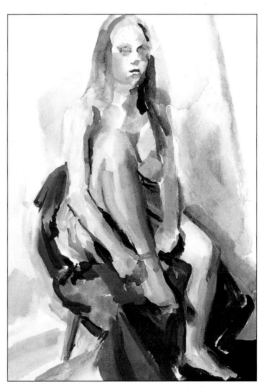

10 ▲ Define the arm Edge the right forearm with a neutral grey/burnt green earth mix. Using a deep red from step 9, define the upper edge of the forearm, the slip and the lips. Finish the bottom right corner of the painting with a mix of red-violet with a little ultramarine.

A FEW STEPS FURTHER

Although the artist wanted the girl to have a dreamy look, the expression remains a little undefined. So revisit the face and suggest the features in greater detail.

11 ▶ **Work on the eyes** Use a No.4 round brush for the details. Paint the irises in cerulean blue with a touch of neutral grey, putting in black pupils and a white highlight. Then, with the very tip of the brush, draw the eyelids in a brown mixed from red-violet and ivory black.

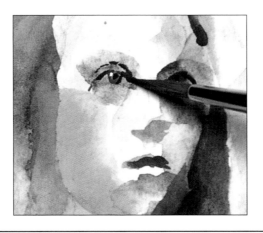

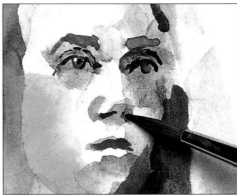

12 ▲ **Complete the features** Paint the right eyebrow in burnt umber, and the left one in neutral grey. Use a peachy flesh tone from the palette to define the nose. With the red used for the lips in step 10, mark the nostrils.

THE FINISHED PICTURE

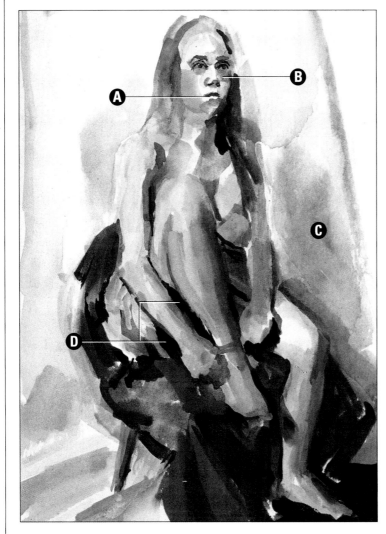

A Suggest the lip
The girl's bottom lip remains unpainted. It is suggested by the dark shadow beneath it.

B Distant expression
Subtle shadows around the girl's eyes, cheeks and jaw give a distant, rather melancholy feel to the picture.

C Anchoring the pose
The blue-grey shadows create a pleasing neutral background, as well as anchoring the pose.

D Dark outlines
Areas of deep russet red shadow surrounding the girl's forearms and legs were added to help define the forms of the limbs.

Flesh tones

Rendering flesh tones isn't as difficult as many people imagine – so long as you paint the colours you actually see rather than what you expect to be there.

One of the biggest worries for artists trying to paint the human figure is achieving accurate flesh colours. Art manufacturers offer a supposedly simple solution by selling a paint called flesh tint or flesh tone (basically Naples yellow with a touch of vermilion). You might want to use this in small dabs to suggest far-away people in an outdoor scene – but for serious figure painting it is hopelessly inadequate at describing the endless variations of human flesh.

The colour of flesh, like everything else in the world, is determined by two things – its inherent colour, often called local colour, and the colour of the light that illuminates it. Both of these vary enormously. So try to forget what you think you know about flesh colour and, instead, look intently at the colour you see in the given light.

Local colour

First consider local colour. As we all know, human skin varies enormously from person to person. It also varies greatly on the same person. In fair-skinned people, for instance, the colour of cheeks and ears, where the blood vessels are close to the skin, appears much redder than that of the forehead or chin.

On the body itself, the hands, feet, elbows and knees are usually warmer than the paler, pearly tints of the hips, breast and stomach. Similarly, the tops of the forearms contain more red than the undersides. For dark-skinned people, differences in local colour are less pronounced – but look closely and they can still be detected.

Changing with the light

Next, look at your subject in different lights. The local colour of all parts of the body changes according to the type and strength of light. A figure illuminated by candlelight or tungsten light, which both contain a lot of light at the red end of the spectrum, appears much warmer than

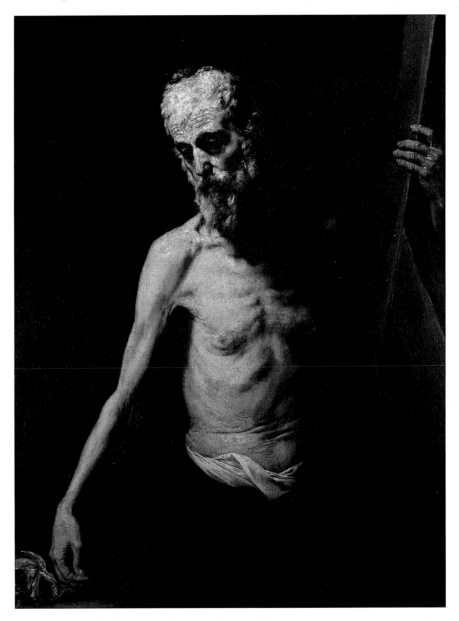

one lit by sunlight. In fact, sunlight itself changes through the day, being warmer in the evening than at midday.

Of course, it is not necessary to know the relative warmth or coolness of every type of light. But it is important to note that under different kinds of lighting your sitter will, in effect, change colour. So don't assume anything – respond to each new sitting with fresh eyes. Close observation, as ever, is the key.

▲ **Lighting plays a crucial part in rendering flesh tones. Here, in Jusepe de Ribera's *St. Andrew* (*c.* 1630), it throws a yellow cast. Note, however, how the cheeks and nose still retain a red-brown colour.**

Another important consideration is the model's surroundings. The shadow areas on your sitter are not directly lit but they will pick up light reflected from nearby objects. If you pose a nude on a

blue drape, for instance, you'll get cool shadows next to warmer lit areas of skin tones. This not only creates lively complementary contrasts but also helps you model form more convincingly – the warm colours advance while the cool shadows recede. If you are painting a head-and-shoulders portrait, look for light reflected from the clothes, particularly in the shadow areas of the neck.

Whether you are using oils, acrylics or watercolours, glazing is a great technique for rendering human flesh. It involves building up colour in thin, transparent layers, allowing each layer to dry before applying more paint. The process lets you subtly modify the colour in different parts of the body. To capture rosy cheeks, for example, you could lay a thin wash of red on top of a pearly white skin tone.

Furthermore, the technique of glazing can really capture the translucency of skin. Remember that flesh tones in fair-skinned people consist of the colour of bone, blood vessels and veins modified by the 'glaze' of a translucent skin.

Picking your palette

Pay attention to the palette as well. It's probably best to avoid using the manufacturer's flesh tint mentioned at the beginning of this article. Instead opt for the tried-and-tested colours shown in the box below.

Although there is no set formula, some combinations of colours work

USING DIFFERENT MEDIA

Here, the same sitter has been painted in watercolours (below) and oils (right), and the palette for each painting is shown beneath (minus white). White is used in the watercolour simply to add a little sparkle to the eyes. In oils, it is used extensively in the warm flesh-tone mixes. In watercolour, don't wash colour over the whole face – look closely at your model's face and decide where each colour should go, building up glazes of colour. In oils, it pays to use a toned ground – otherwise the skin tones tend to be paler than intended.

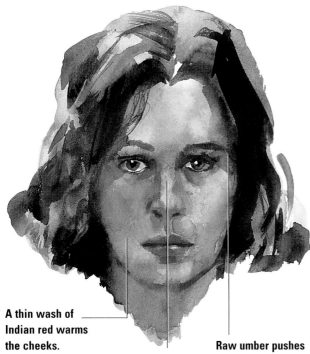

A thin wash of Indian red warms the cheeks.

Alizarin with a little cobalt blue makes a cool tone to model the nose.

Raw umber pushes the side of the face back and suggests reflected colour from the hair.

Cobalt blue, alizarin crimson and yellow ochre combine to make the shadows on the chin.

Yellow ochre, lightened with white, produces a warm yellow for the pale tone on the nose.

Terre verte, mixed with yellow ochre and raw umber, creates cool tones in the hair.

Watercolours

| Cobalt blue | Alizarin crimson | Terre verte | Yellow ochre | Raw umber | Indian red |

Oils

| Cobalt blue | Alizarin crimson | Terre verte | Yellow ochre | Raw umber | Indian red |

better than others. Burnt sienna or Indian red is a good starting point for many types of skin colour. For the pink tones on pale skins, mix it with yellow ochre – rather than, say, cadmium yellow, which can be too rich and overpowering. For more sun-tanned skin, use it with alizarin crimson or vermilion. For dark-skinned sitters, try beginning with burnt sienna and raw umber.

Rather than using paints, you may be happier using dry mediums, such as soft pastels or Conté pencils. You can create similar effects to glazing by laying hatched strokes of different colours over one another.

Toned ground

With these media, try using a mid-toned ground so you can work up to the lights with colours such as Naples yellow and light rose madder and down to the shadows with, perhaps, burnt sienna and burnt umber. For the ground, choose a colour

▲ Peter Paul Rubens was a master at rendering the pearly whites and rosy reds of Caucasian skin, as shown in *The Rape of the Daughters of Leucippus* (*c.* 1618). Note how the red and brown drapes are reflected in the shadow areas of nearby flesh tones.

sympathetic to your subject – maybe a brown, a yellow or a salmon pink. Alternatively, use a cream or beige support – let this stand for the lightest skin tones and simply work up to the darks.

119

Bold colour for portraits

When you are painting a portrait, take the opportunity to look for the more unusual and exotic colours in the sitter's face, rather than automatically reaching for 'flesh tone' or other conventionally used shades.

The primary objective of a portrait painter has traditionally been to show a recognisable likeness of the sitter – especially if the painting is of a public figure, or if it has been commissioned by a relative or a company wishing to honour one of its dignitaries for posterity. An artist who takes too many risks or becomes overly self-expressive in this situation can come seriously unstuck, as the British painter Graham Sutherland (1903-80) discovered following his controversial portrait of Sir Winston Churchill, painted in 1954. Churchill so hated the style of the picture, which he felt to be undignified, that his wife, Lady Clementine, had it destroyed.

If you take the portrait as just another subject to paint, it can be useful for experimenting with colour and developing your painting skills. You can concentrate more on the varied effects of light on flesh and devote less time to portraying the details of the individual features.

Colours in flesh

Surprisingly, even in the multi-ethnic societies in which most of us now live, it is still possible to buy a tube of paint labelled 'flesh tint', which is a soft yellowish pink. You should avoid the temptation to add this to your palette, because in reality the flesh colour of even a so-called 'white' person can range through the whole spectrum, from yellow at the centre to either of the extremes of red

▶ *Portrait of Camille Roulin* by Vincent van Gogh (1889), shows the artist's appetite for strong colour. Note the unexpected use of green, yellow and orange on the face.

▶ The French painter André Derain (1880-1954), one of the creators of Fauvism, has exaggerated both the colours and the form of the sitter's head in *Portrait of a Man with a Newspaper* (1914).

or blue. The exact shade depends on the colour and intensity of the light source falling on the face, and also on the ethnic origin of the sitter.

Because flesh has no easily discernible 'local' colour (unlike, for example, grass, which most people would acknowledge as being 'green'), the majority of the colours you can see in a face will have to be mixed by using the full range of your palette. The starting point for any given colour will be governed by the tone in that area of the face. In bright daylight, the cheekbone of a fair-skinned person might have a yellow, bluish or even greenish hue contrasted against the more shadowed adjacent ear, which will probably appear to be a deep red or brown. Even light-coloured hair will look dark where it meets and contrasts with the lighted cheek and is likely to require you to dabble in the umbers and viridian to achieve the right tone and colour.

Colour temperature also has an important part to play in how different areas of the face appear to the viewer. The same colours that look warm on the lighted side of the head appear cooler on the surfaces that are turned away from the light and vice-versa.

Seeking out colour

One of the reasons that the nude figure has been such a popular subject for painters throughout the history of art is because artists have been fascinated by observing and analysing the colours in human flesh. These colours don't immediately jump out at you in the same way as they might in, for example, a still life of apples.

Artists have to learn to see. There is an old saying, often heard quoted in art schools, that 'you can only see what you look for'. In a portrait, this task can seem easier if you build up your picture around the features and hair, but the subtle changes of colour around what is basically a six-sided form still demand some very careful observation. You may

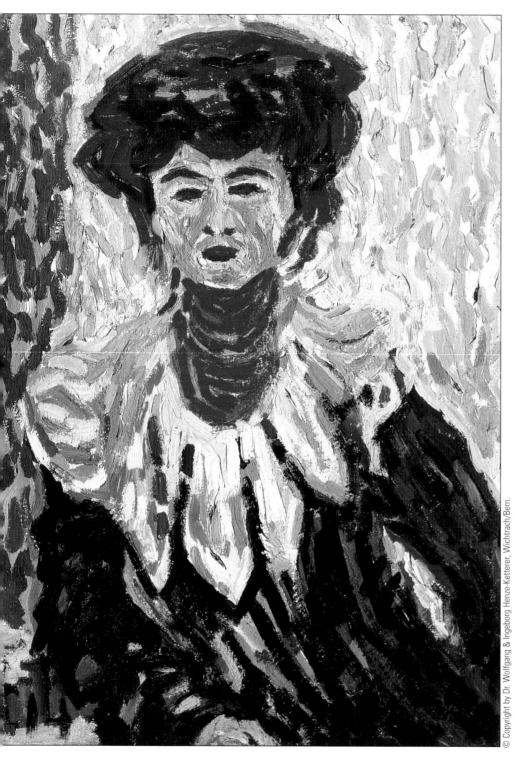

◀ The boldly contrasting pinks and greens on the woman's face echo those in the fragmented background in this vigorous portrait of *Doris with a Collar* by German Expressionist painter Ernst Ludwig Kirchner (1880-1938).

understand so-called Modern Art or what might be termed 'pure painting'. A picture can never actually reproduce nature. It has to be a visual equivalent or a statement which conveys the essence of the subject – in this case, a head or face. An artist doesn't copy what he sees: he interprets it in paint.

The Fauves' use of colour

Henri Matisse (1869-1954) was one of the first artists to realise the implications of this fundamental idea. He led the thinking of a group of painters who deliberately heightened their colouring and minimised their perspective to sacrifice depth in favour of the surface pattern of colour and decoration. Their use of flat, raw and often violent colour was displayed to a startled public at a Paris exhibition in 1905, where a critic described them as 'Fauves', which translates as 'wild beasts'.

Although the group was short-lived, its influence on painting in the twentieth century was considerable, particularly in terms of contrasts of pure colour. Matisse remained faithful to these ideas and although he was influenced by Paul Cezanne's (1839-1906) concerns with the modelling of form in his early years, his work continuously explores the behaviour of colour with reference to the world around him. His art is always joyful – he once said that he would like his paintings to be similar to a good armchair in which a man could rest and enjoy himself.

Fauve portraits are worth studying to encourage you to be bold in the use of unlikely colours. Remember, there is almost always direct and reflected light on a face, which will increase the range of colour possibilities. Once the Fauves spotted a hint of colour, they trebled its intensity and applied it with direct brush strokes to give vitality and power to the portrait. Try using colours such as green, orange, purple, mauve and yellow as flesh tones the next time you work on a portrait.

well see a patch of green or violet on a shadowed plane of the face once you start looking for less obvious colours.

Form or pattern?

The way in which you make use of colour in portraiture depends a lot on your approach to the subject. Are you primarily trying to describe the form and make the head and face look three-dimensional and solid? Or are you going to treat it as a flatter shape with much more emphasis on colour and pattern, focusing on the 'character' of the sitter rather than on the structure of the head?

In 1890, the painter Maurice Denis (1870-1943) wrote: 'Before being a war-horse, a nude or some story or other, a picture is essentially a flat surface covered with coloured pigments arranged in a certain order'. This is an important concept in beginning to

Pastels for portraits

Pastel sticks were first used in the sixteenth century – but they really came of age as a medium for portraiture two hundred years later.

Pastel is sometimes unfairly dismissed as a lightweight medium, inferior to oils and associated with over-sentimental portraits of children. Yet pastel has a long and distinguished history, particularly in the field of portraiture.

As a portrait medium, pastel has the advantage over paints of greater speed and directness. Applied with only crayons and fingers, there is nothing to get in the way of the artist's direct response to his subject, enabling him to capture the sort of fleeting gesture or expression that reveals more about the sitter than merely outward appearance.

A 'dry colouring method'

Pastel sticks – simply pure pigment bound with gum – first came into use in the sixteenth century. They were invented by Jean Perréal (*c*.1455-*c*.1530), a minor French artist, who used them to enhance his chalk drawings. Leonardo da Vinci said that he learned the 'dry colouring method' from Perréal, who travelled to Italy several times at the turn of the sixteenth century.

Initially, pastel was used merely to heighten charcoal and chalk drawings with touches of colour. But eventually artists began to paint portraits entirely in pastel, recognising the realism that was possible using pastel on tinted papers.

Carriera's society portraits

Pastels were taken up in eighteenth-century France by the Venetian artist Rosalba Carriera (1675-1757). A popular painter of snuff-boxes and miniatures,

◄ Pastels are often associated with a loose, impressionist style, but in *The Chocolate Girl* (*c.*1744-45) Jean-Etienne Liotard shows the remarkable precision and detail that can be attained with the medium. Look, in particular, at the glass.

CHARDIN'S REVOLUTIONARY TECHNIQUE

Jean-Baptiste-Siméon Chardin is primarily known for his oil painting of everyday middle-class life – but he was equally adept at portraits in pastels. He introduced methods of building form and suggesting light with parallel hatchings of pure colour. This is particularly evident in his *Self Portrait with*

Spectacles (1771) below. In using broken colour and visible strokes that emphasise the texture of the medium itself, Chardin anticipated the style of the French Impressionist master of pastels Edgar Degas (1834-1917). Chardin was an artist who was truly ahead of his time.

▲ In close-up, you can see the individual strokes of pure pigment which, from farther away, merge together and create new colours.

she took up pastels in her middle age and her portraits of society figures were in great demand throughout Italy.

In 1720 she travelled to Paris, where she enjoyed huge acclaim. Female portraits were very popular in the eighteenth century (often their purpose was to make young ladies known to prospective husbands), and during her one-year stay in France she painted countless portraits of nobility.

Harmonious palette

Carriera was gifted with a glowing sense of colour and a superb mastery of pastel technique. She used a softly harmonious palette of pinks, blues and whites and applied her colours in broad, flat strokes, often blending them with a stump to create velvety, vaporous textures. She also knew how to flatter her sitters, portraying them in low-necked dresses and with flowers in their hair.

Carriera's influence resulted in a lighter, more playful style of portrait than had gone before. Sitters were shown in bust-length (head and shoulders), often with one hand visible, with the shoulders in front view and the head turned. Portraits by François Boucher (1703-70) and Jean-Baptiste Perroneau (1715-83), who worked both

in oils and pastels, depicted the frivolous life of the court of Louis XV, a world of sumptuous silks and satins, powdered wigs, scented fans and powder-puffs.

Latour's speed and vivacity

The success of Carriera prompted Maurice Quentin de Latour (1704-88) to take up pastels and he became the most celebrated pastellist of the eighteenth century. Latour handled his 'coloured dust' with great speed and vivacity, aiming to convey the personalities of his sitters by recording their fleeting expressions and emotions. 'Unknown to

them,' he said, 'I descend into the depths of my sitters and bring back the whole man.'

'Miraculous work'

Latour painted two huge, ambitious portraits in order to prove that pastel could hold its own with oil painting. His consummate technical skill is evident in his portrait of Gabriel-Bernard de Rieux, in which he contrasts the weight of the sitter's linen robe, the delicacy of his lace ruffles and the lightness of his hair. One admirer declared, 'It is a miraculous work, it is like a piece of Dresden china, it cannot possibly be a mere pastel.'

Latour's other masterpiece is a full-length portrait of Madame de Pompadour, the king's adviser and mistress. She is depicted surrounded by objects symbolising literature, music, astronomy and engraving. As with all royal portraits, only the head was painted from life, using a round piece of paper which was later pasted in position on a larger sheet; the portrait was completed using a stand-in wearing the royal robes.

Chardin's close-up studies

During the latter half of the century, some artists began to move towards greater realism and naturalness in painting. The greatest of these was Jean-Baptiste-Siméon Chardin (1699-1779). He did not take up pastel until the age of 72, when failing eyesight forced him to abandon painting in oils.

At the same time he began to tackle a subject he had hitherto avoided – studies of the human face. His portraits and self-portraits focus on the face in close-up. The extreme simplicity of their composition and the lack of any background trappings allows the inner, private self of the sitter to become the focus.

While most of his contemporaries produced dazzling but somewhat superficial portraits, Chardin's portraits are intensely alive – he was able to get

▶ For the most part, Rosalba Carriera uses blended pastel strokes in her portrait, *Sister Maria Caterina* (1732). But notice how she captures the texture of the fabric around the neck, using individual strokes of a blunt white pastel.

'beneath the skin' of his sitter and reveal the inner person. Furthermore, he developed a new and distinctive way of applying the pastels – see Chardin's revolutionary technique, left.

The flamboyance of Liotard

One of the most accomplished pastellists was the Swiss painter Jean-Etienne Liotard (1702-89). He was capable of creating highly finished works and rendering detail with an astonishing accuracy. Having spent four years in Constantinople, he completed many

portraits of people in Turkish dress. These included self-portraits – he himself adopted Turkish dress and a beard. His exotic work and flamboyant personality brought him success in Paris, the Netherlands and Britain.

With the outbreak of the French Revolution in 1789, pastel fell out of favour for a time because it was associated with the frivolity and excesses of the *ancien régime*. It would be another 30 years before pastel enjoyed a revival, in the hands of the great Romanticist, Eugène Delacroix (1798-1863).

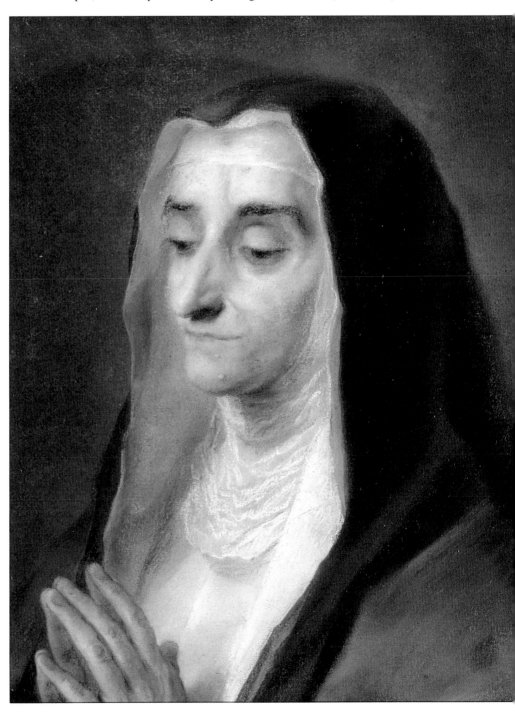

Portrait in oils

Exploit the slow-drying qualities of oil paints to build up a well-modelled portrait with layer upon layer of colour.

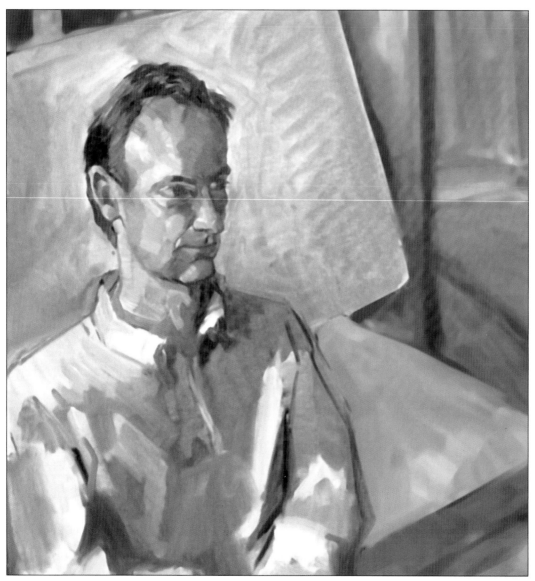

◀ Before you start, study your subject and note particularly how the facial features relate to one another.

YOU WILL NEED

Stretched white canvas 74 x 61cm (29 x 24in)

Cotton rag

Turpentine

11 oil colours: Raw sienna; Burnt sienna; Yellow ochre; Rose madder; Cobalt blue; Burnt umber; Titanium white; Sap green; Cadmium yellow; Ivory black; Crimson

Large palette or sheet of glass

Brushes: Nos.4 and 6 flat; 13mm (½in) flat; No.6 filbert

Linseed oil

White spirit and jar for cleaning brushes

Oil paints can seem a time-consuming medium – they take a long time to build up and a long time to dry. Yet these are the very qualities that make them ideal for a beginner. As the paint stays malleable, you can modify a brush stroke by overlaying further colour, or wipe it off altogether with a turps-soaked rag.

In this portrait, the artist constantly altered colours as he built up the layers of paint on the face. As a result, the final picture contains a striking array of flesh colours, including greens, browns, reds, pinks, yellows and oranges.

Before embarking on the painting, it is a good idea to lay in a toned ground on the canvas. This gets rid of the daunting expanse of white and gives a middle tone from which you can build up the darks and lights.

The face is built up by alternating between drawing and painting. After starting with a loose line sketch, use thin paint to begin blocking in tone. Then return to the drawing, refining the outlines of the facial features before working up the tone and colour further with thicker paint. In this way, the face slowly and surely emerges.

FIRST STROKES

1 ▲ **Create a coloured ground** Begin by wetting a cotton rag with turps and using it to smear raw sienna across your canvas. Add more turps if necessary to keep the colour pale and transparent.

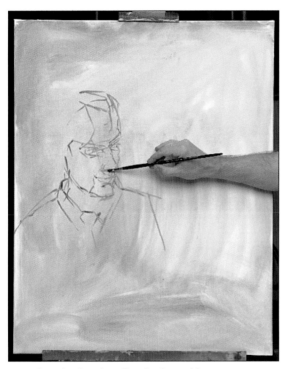

2 ▲ **Start by drawing** Continuing with turpsy raw sienna, begin to plot the main features of the face and shoulders with a No.4 flat brush. Pay close attention to how the different facial features relate to one another. Note how, for instance, the tip of the nose aligns with the far cheek.

3 ▶ **Block in tone** Use a mix of burnt sienna, raw sienna and yellow ochre on the shadowed side of the face. Increase the burnt sienna bias of the mix to render the hair and the deep shadow under the nose. Add some rose madder for the mid-tones on the forehead. Increase the rose madder content of the mix for the near cheek and the lips. With a 13mm (½in) flat brush, scrub in the background with cobalt blue, burnt umber and a little white.

A PORTRAITIST'S PALETTE

Before you paint, try premixing your colours on a large sheet of glass. You can then select each colour you see in the subject instantly without having to embark on the trial-and-error method of mixing paints every time. Here are the colours our artist premixed for his Caucasian sitter. The vertical rows show colours lightened with white. The horizontal rows show sap green and crimson lightened with cadmium yellow.

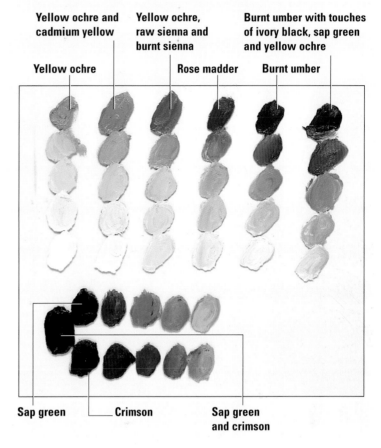

Yellow ochre and cadmium yellow

Yellow ochre, raw sienna and burnt sienna

Burnt umber with touches of ivory black, sap green and yellow ochre

Yellow ochre

Rose madder

Burnt umber

Sap green

Crimson

Sap green and crimson

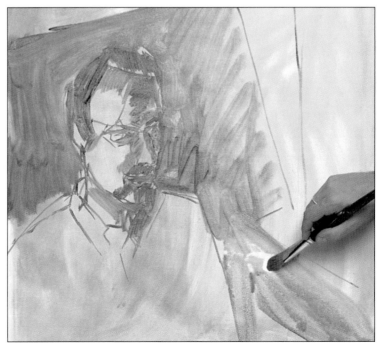

4 ▼ Build up the shadows Continue to scrub your blue mix roughly on the shirt. Then return to the face. Using a No.6 filbert brush, build up the shadow areas with your mix of yellow ochre, raw sienna and burnt sienna. Use rose madder and titanium white across the cheek and the bottom of the nose. Then apply thin sap green to the neck.

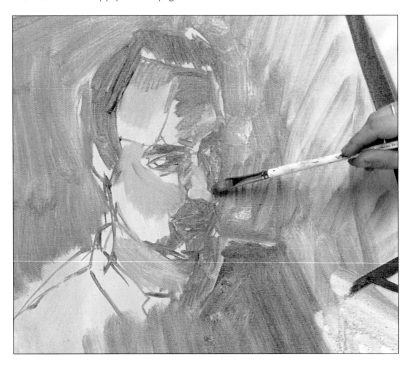

DEVELOPING THE PICTURE

Now you can concentrate on building up the light and dark tones to model the face. Don't worry about developing the background much further – because it is rendered very roughly, more attention is focused on the face.

5 ▼ Work up the lights Add cobalt blue to the sap green to define the jawbone. Then use yellow ochre, cadmium yellow and lots of white to put in the bright highlight above the near eye.

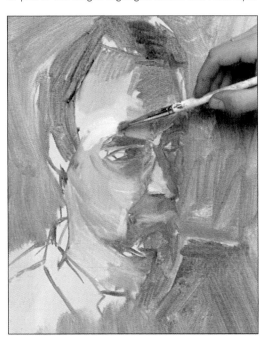

6 ▶ Put in the darks Look closely at your model to identify the darkest tones. Apply ivory black with a little burnt umber to the shadow under the chin, and to register the hair at the side of the head. Then add more burnt umber to your mix to consolidate the drawing, marking in the eyebrows and the outline of nose and mouth.

Express yourself
Sculptural drawing

Before you paint, try a preliminary sketch with, for example, a roller-ball pen. Attempt to draw around the form so that you get the idea of the sculptural quality of the head. In this drawing, for instance, look at the curved lines around the forehead – they don't indicate tone or detail, but simply describe the rounded form.

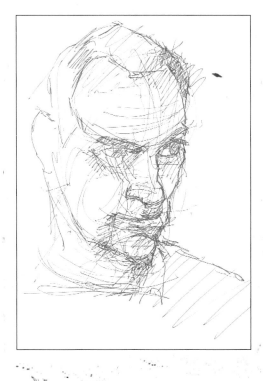

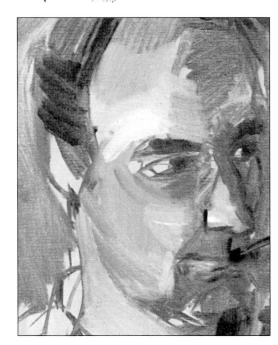

7 ▼ Refine tones With burnt umber and touches of ivory black, re-emphasise the outline of the chin. Then apply white to the rest of the shirt. Begin to differentiate the tones in the forehead, using crimson and cadmium yellow with a touch of raw sienna for the shadowed side of the face.

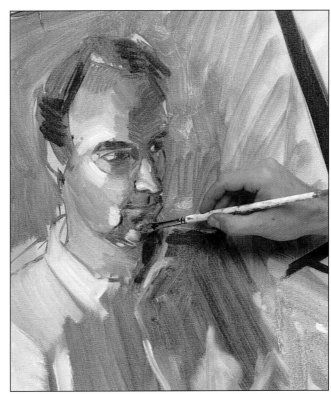

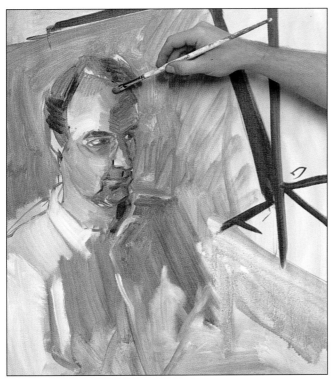

8 ▲ Return to the light areas With white and a touch of cadmium yellow, put in the highlights on the illuminated left side of the face – the lightest areas are above and below the eye, along the side of the nose and on the chin.

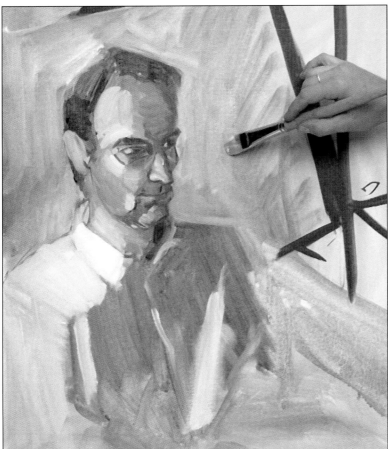

9 ◄ Emphasise the pale tones Put in titanium white and a little rose madder on the ear. Then paint the lit sides of the forehead and neck with white, some yellow ochre and cadmium yellow. Use neat white to rough in the light parts of the shirt. Return to the 13mm (½in) flat brush to develop the background with white and some cobalt.

TROUBLE SHOOTER

USING A MAHLSTICK

A mahlstick (a long, sturdy piece of wood) is invaluable if you're embarking on a large-scale oil painting. Simply hold it in your non-painting hand and lean it against one edge of the canvas. This helps keep your painting hand steady for detailed work and stops it from smearing the colours already on the canvas.

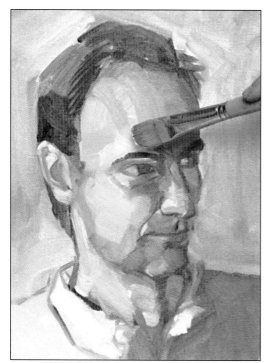

10 ▲ **Model the chin** Put in the shadowed parts of the shirt with cobalt blue and a touch of white. Changing to the No.6 flat brush, refine the drawing around the chin with sap green and white. Add some burnt umber to this mix to create a grey for the near eye socket.

11 ▲ **Draw details** With burnt umber, refine the mouth and the crease to the nose. Define the collar edge with cadmium yellow and crimson. Draw the ear recess with rose madder and white. Use the 13mm (½in) flat brush to work up the lights on the neck and above the eye.

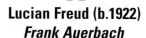

Master Strokes

Lucian Freud (b.1922)
Frank Auerbach

In this portrait, the renowned British painter Lucian Freud employs a similar technique to that used in the step-by-step painting, using bold brushwork to break the face into distinct planes. Note how from the unusual viewpoint used by Freud, the face area – from the eyebrows down to the bottom of the chin – occupies only about a third of the total head area.

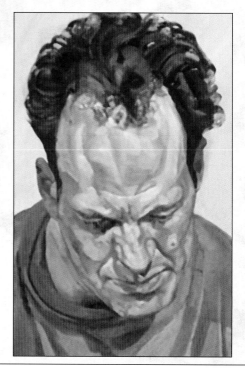

Strong, directional brush marks were used to convey the wiry nature of the hair. Dabs of pale grey give the impression of the background showing through the wispy ends of the curls.

Because of the unusual angle of the head and the lighting from above, shadows appear under the protruding parts of the face – the brow, cheek bones, nose, lower lip and chin.

12 ▶ **Emphasise the cast shadows** Add yellow ochre and white where the warm light catches the back of the neck. With crimson, yellow ochre and cadmium yellow, tighten up the shadow of the collar on the neck. Then use a mix of cobalt blue and ivory black to render the deep cast shadows on the shirt.

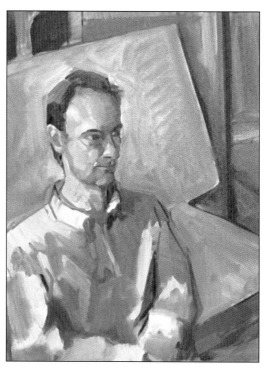

In the last half-hour or so of painting, you can make small but telling adjustments to the colours and tones. In particular, work up the bright highlights on the skin.

13 ▶ Add highlights on the hair The light skimming across the hair creates some wonderful yellows and light browns. Add these with mixes of yellow ochre, sap green and raw sienna.

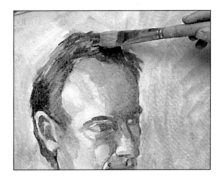

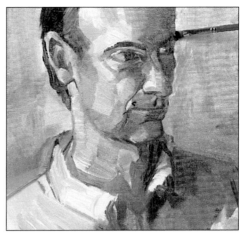

14 ▲ Adjust the tones With the No.6 flat brush, redden the shadowed side of the forehead and far cheek with raw sienna, crimson, cadmium yellow and rose madder, letting the brush strokes follow the form of the forehead. Then readjust the shadow of the collar on the neck. Finally, bring the pale yellow tones of the neck right up to the ear.

THE FINISHED PICTURE

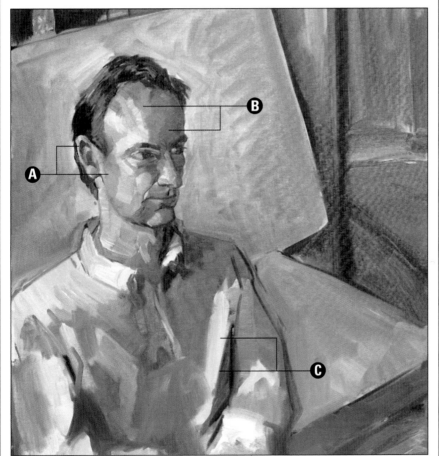

A Flesh colours
A frequent feature of Caucasian skin is a pinker colour halfway down the face – around the top of the cheeks, the nose and especially the ears.

B Modelling with tone
The rounded surfaces of the face, particularly the curved forehead, were modelled by breaking them up into small planes, each one with its own colour and tone.

C Roughed-in shirt
No attempt was made to register the pattern of the shirt, only the fall of light on it. The viewer's gaze is drawn to the most important part of the portrait – the face.

Portrait of an older man

The lived-in features of a mature person provide absorbing material for the portrait painter. Try capturing this distinguished gentleman in oils.

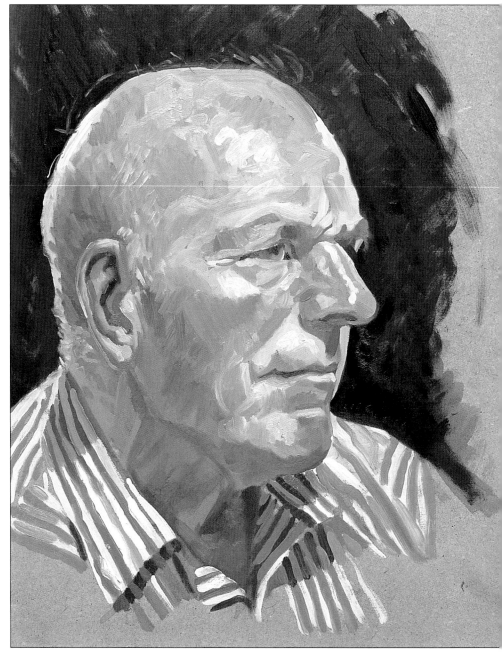

B efore you begin a portrait, take time to study your sitter's head. The basic form of the head is determined by the bony structure of the skull. This can be seen as an upside-down egg shape with the largest end representing the top of the head. The features are embedded into, and project from, the surface of this egg. In older people, such as the subject shown here, the flesh tends to droop in places and the skin over the bony areas is often stretched and shiny.

Getting the eyes right

The eyes are probably the most telling feature. To make them appear an integral part of the face, remember that the sockets are recesses, and the eyeballs sit within them, enclosed by lids. These can be expressed by a line of shadow under the top lid and a highlight on the lower lid. Creases around the eyes give character to the face, and are especially evident in an older person.

The mouth is a remarkably mobile feature. It does not have an outline, but is defined by a change in colour and texture. The only line is between the upper and lower lips. The bottom lip is usually lighter in tone than the upper lip,

because it faces upwards and therefore catches the light. From side on – as in this painting – you can see quite a prominent recess below the lower lip.

Made of bone, cartilage and fat, the nose varies significantly in size and form from person to person, and adds

▲ **The artist has given the head a sense of solidity by breaking it down into planes of different tone and colour.**

character to the face. The distinctive bridge is formed where the nasal bone stops at the top of the nose.

YOU WILL NEED

Piece of unprimed
MDF 37 x 31cm
(14½ x 12¼in)

1 acrylic paint:
Phthalo blue,
green shade

Jar of water and
palette

9 oil paints:
Cadmium yellow;
Alizarin crimson;
Titanium white;
Phthalo blue;
Cerulean;
Cadmium red;
Ultramarine;
Lemon yellow;
Viridian

Turpentine and
palette

Brushes: Nos.1
and 5 short
flats; No.0 round

LOOKING FOR THE ALIGNMENTS

Before you begin a portrait, take time to study your subject closely to establish the positions of the features on the basic egg shape of the head. Look at how the features sit in relation to each other.

When you work on the underdrawing, put in lines horizontally and vertically across the head, linking one feature to another as shown in the illustration below. Remember these are not set in stone – feel free to adjust them as you develop the picture. There are some generalisations you can make about proportions – for example, the mouth is midway between the bottom of the nose and the chin. However, each individual is different and it is the variations from the norm that give a face, such as the one in our portrait, its distinctive character.

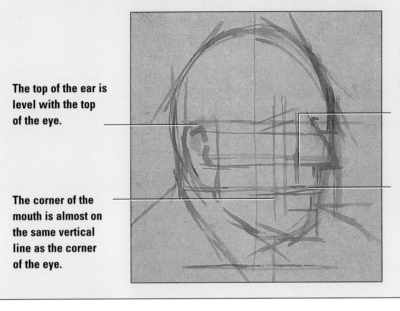

The top of the ear is level with the top of the eye.

The corner of the mouth is almost on the same vertical line as the corner of the eye.

The bottom of the nose lines up with the projecting lobe at the front of the ear.

The mouth aligns with the bottom of the ear lobe.

EXPERT ADVICE
Lighting the sitter

Spend some time arranging the lighting for your portrait. A strong, directional light gives contrasts of light and shadow that reveal the form of the head and create a mood. To achieve this effect, the artist has simply attached a clip spotlight to the easel, illuminating the sitter from the front and above. This creates a striking highlight on the forehead and distinct shadows in the eye sockets and under the chin.

FIRST STEPS

1 ▼ Lay in the underdrawing Using phthalo blue acrylic paint and a No.1 flat brush, draw the egg shape for the head. Start to plot the features on this basic shape (see above). Mark the horizontals of the eyes, nose and mouth, taking them back to the ear. Tick in three verticals – one for either side of the eye and one for the eyeball. Extend all three lines to check vertical alignments.

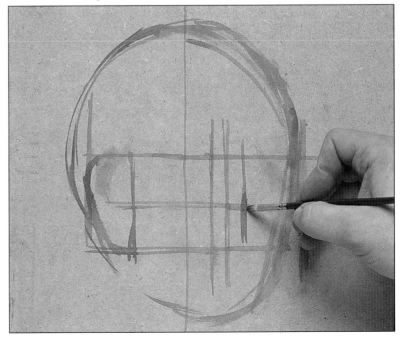

2 ▼ Refine the drawing Continue laying in the construction lines, making adjustments as necessary. Every face is different, so check each measurement carefully using your thumb and pencil or paintbrush. Indicate the slope of the shoulder and the neckline – it is important to sit the head comfortably on the body. Notice that the neck sits into the front of the shoulders, rather than directly on top of them.

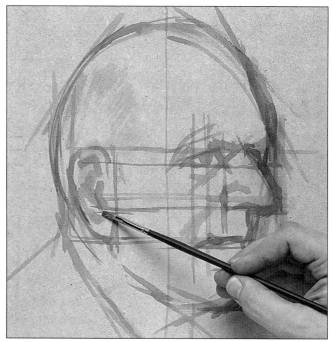

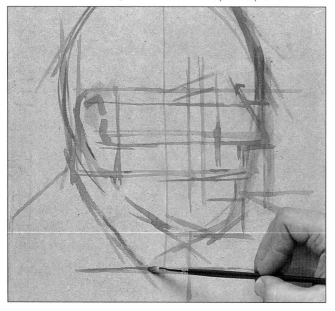

3 ▲ Start to lay in tones Using a very dilute wash of the same phthalo blue, start to indicate the areas of shadow in the creases around the eye, by the nose and within the ear. The washy paint soaks into the MDF and initially creates a dark tone – but remember it will dry lighter and bluer.

MIXING UP THE FLESH TONES

A limited palette based on two versions of each primary gives you a wide range of mixes ideal for capturing flesh tones. Each pair of primaries should include one that is relatively warm and one that is relatively cool.

In this project, the artist used lemon yellow (cool) and cadmium yellow (warm); alizarin crimson (cool) and cadmium red (warm); phthalo blue (cool) and cerulean (slightly warmer). He added viridian, a bright, transparent green which was mainly used for the shirt.

Here are some of the ways he used the colours to create neutral flesh tones – each mix has a fair amount of white included. Use this chart as a reference to complete the step-by-step. Don't be afraid to mix all three primary colours up together, as in the first, second and fourth rows.

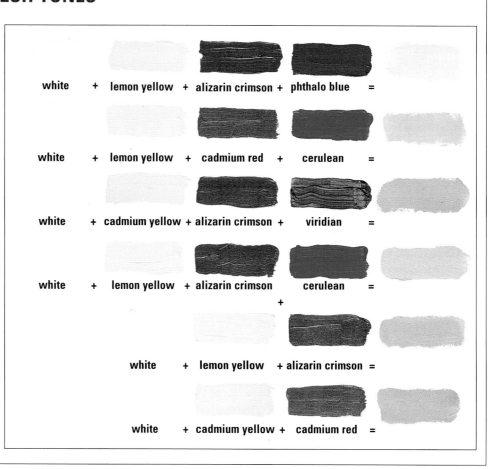

white + lemon yellow + alizarin crimson + phthalo blue =

white + lemon yellow + cadmium red + cerulean =

white + cadmium yellow + alizarin crimson + viridian =

white + lemon yellow + alizarin crimson cerulean =
+

white + lemon yellow + alizarin crimson =

white + cadmium yellow + cadmium red =

4 ▶ Block in some shadows Change to a No.5 flat brush and start to block in the background, using the tone to refine the silhouette. Using the same washy colour, indicate the stripes on the shirt. Then lay in the broad areas of mid tone on the side of the head and face, and on the neck. Put in the shadows within the eye socket, under the nose, on the top lip and under the bottom lip. As soon as you add these details, the face begins to take shape.

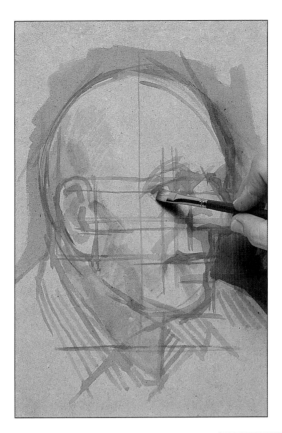

5 ▼ Dry the wash Use a hair-dryer to dry the painting – the paint assumes its true colour as it dries. Check the image against the subject and, still using the acrylic paint, make final adjustments. At this point the artist also checked the drawing in a mirror – because the reversed image is unfamiliar, it is easier to spot mistakes.

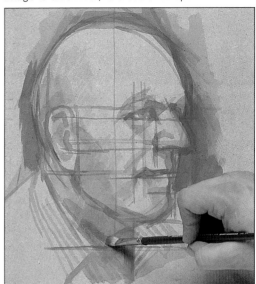

DEVELOPING THE PICTURE

Clear away all your acrylic equipment, including the water and the brushes, and lay out your oil paints and turpentine. Skin tones are complex and subtle, so prepare to work broadly at first, gradually refining the image and colour mixes as the painting progresses.

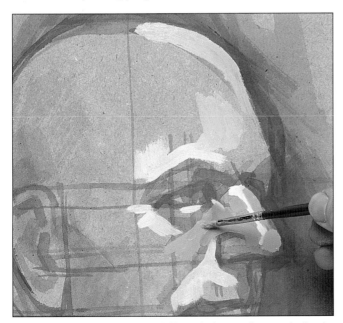

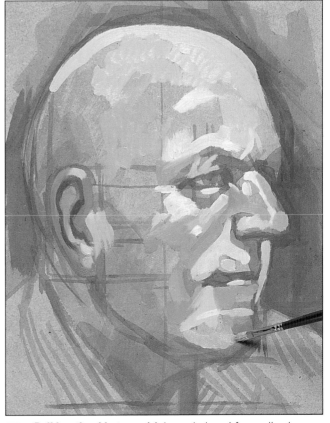

6 ▲ Start to apply skin tones Mix cadmium yellow and alizarin crimson and add varying amounts of white to create a range of tints. Start to apply warm tones to the nose and forehead, with cooler, paler tones where the head catches the light – along the top of the eyebrow, the cheek-bone and on the pad of muscle over the mouth.

7 ▲ Build up the skin tones Make a dark red from alizarin crimson with a touch of phthalo blue and paint the shadow inside the ear. Mix varying amounts of cadmium yellow, alizarin crimson, cerulean and titanium white to create a range of mid flesh tones. Build up patches of these colours, following the contours of the head.

Master Strokes

Frans Hals (1582/83-1666)
Portrait of a Preacher

One of the greatest portraitists of the seventeenth-century Netherlands, Frans Hals was gifted at capturing the fleeting expressions of his sitters. This portrait of a preacher was painted in the latter part of Hals' life, when his pictures became darker and more restrained. He shows this ageing face with all its imperfections – its florid flesh colour, its skin blemishes and its deep furrows – and the portrait is all the more interesting for this.

The eyes are an arresting part of the portrait, with a luminous, liquid appearance. Bright white highlights shine out from the black pupils.

A wide palette is used to convey the flesh tones, including green, yellow, orange and blue, as well as the more obvious pink and beige skin shades.

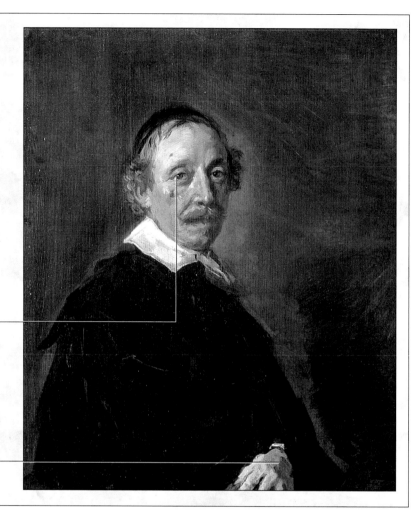

8 ▼ Darken the background Mix phthalo blue with a little cadmium red to create a dark tone for the background. Load the brush and start to block it in, using the colour to paint into the head, refining the silhouette. Adding this dark background focuses attention on the head and helps you to assess the tones.

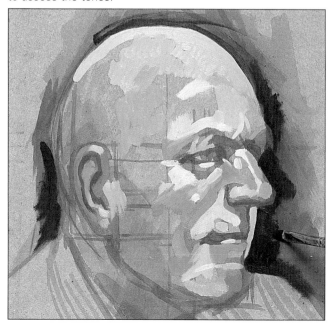

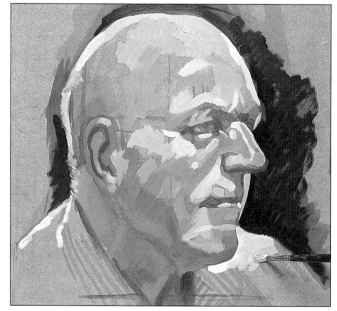

9 ▲ Add light tones Mix cadmium yellow, alizarin crimson, phthalo blue and white and use this dark flesh tone for the shadow areas on the side of the face and on the neck. Paint a narrow strip of white around the edge of the head to suggest the rim of reflected light. Apply a patch of a pale tone on the left shoulder where this area catches the light.

10 ▼ **Put in lights and darks** Apply a dark flesh tone in the eye socket and under the nose using ultramarine, alizarin crimson and touches of white and lemon yellow. This helps to suggest the recession. Add a highlight of very pale flesh tone on the brow by mixing white and touches of all your other colours.

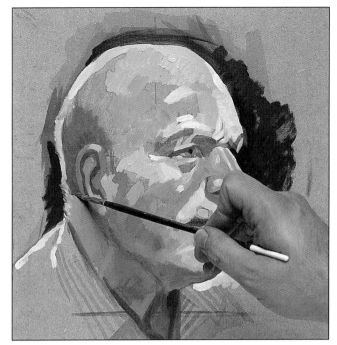

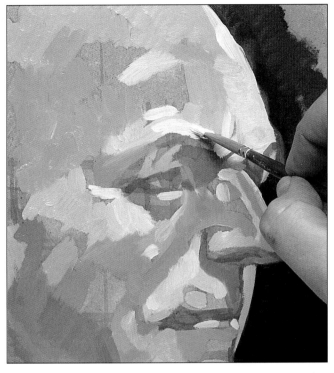

11 ▲ **Work on the eye** The eyes are a key part of a portrait – the trick is getting them right without overworking them. Define the top of the eyebrow with a warm brown made from alizarin crimson with touches of phthalo blue, lemon yellow and white. Then use the background mix from step 8 to define the top lid and touch in the pupil. Notice how this brings the portrait to life. Use a dark mix of phthalo blue with cadmium red and a touch of lemon yellow for the hair.

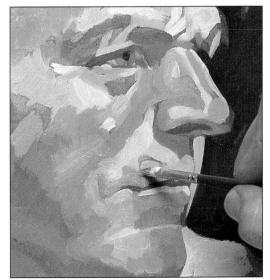

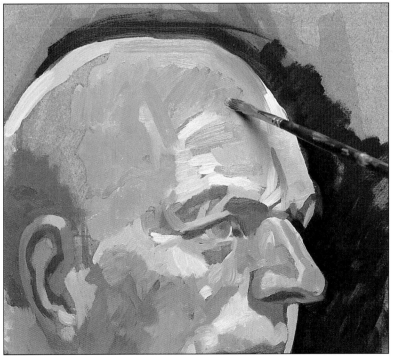

12 ▲ **Paint the mouth** As you work, constantly compare one area with another and make adjustments as necessary. To give the image harmony, allow touches of colour to travel from one part of the painting to another. Develop the darker tones around the mouth by adding some white to the hair mix used in the previous step. Use the off-white mix of step 10 to register the light on the lower lip. Avoid the temptation to 'draw' the mouth; simply put down the tones that you see and a convincing form will emerge.

13 ▲ **Add warm tones on the skull** The areas where the bone comes nearest to the surface tend to be warmest in tone – the dome of the head, the nose and the cheek-bones. Use mixes based on cadmium yellow, cadmium red and titanium white, and lemon yellow, alizarin crimson and white, for these areas. Paint the whites of the eye, but don't actually use white – use the pale flesh tone mix from step 10.

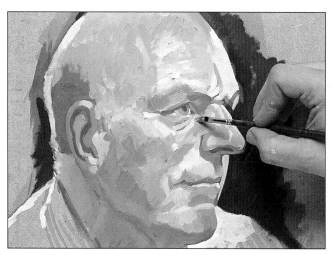

14 ▲ **Refine the flesh tones** Work over the entire head, applying warm and cool mid tones. Gradually blend the different tones so that the face begins to read as a continuous surface. Every now and then, stand well back to assess the image against the subject.

Express yourself

Soften the edges

Here the artist worked quickly and broadly, using the same limited palette to make a range of warm and cool colours. The unprimed support was left unpainted around the head, giving a less emphatic background.

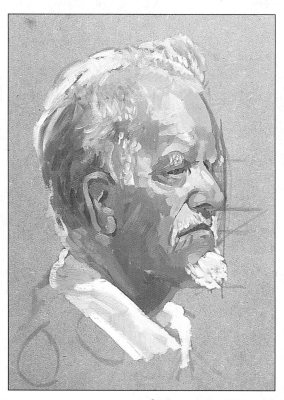

15 ▼ **Paint the shirt** Paint the stripes of the shirt with a range of off-whites, then put in the dark stripes with greens based on viridian neutralised with alizarin crimson. Notice the darker stripes in the shadows of the collar and chin – these are rendered with almost neat viridian.

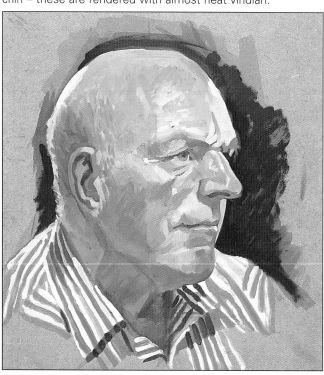

A FEW STEPS FURTHER

The portrait is resolved and is a remarkable likeness. Just a few refinements will bring the image into final focus.

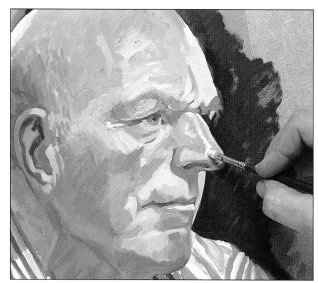

16 ▲ **Add highlights** Using the off-white, add a few bright impasto highlights where the top surfaces catch the light – on the nose, for example.

17 ▼ **Refine the eyes** Change to a No.0 brush to add a tiny but important shadow in the corner of the eye, using the red-brown mix from step 7.

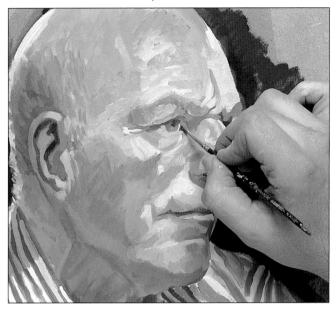

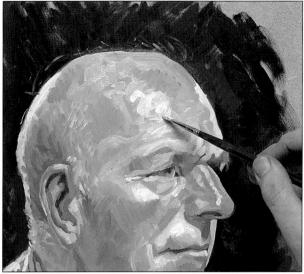

18 ▲ **Add background and highlights** Using the No.5 flat, extend the background, using the mix from step 8. With the tip of the No.0 brush, feather in pale strands of hair with the off-white mix. Return to the No.5 flat to highlight the forehead.

THE FINISHED PICTURE

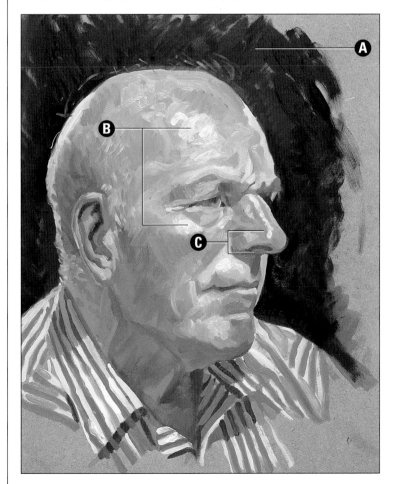

A Dark background
The emphatic dark background focuses attention on the head. It was also used to 'cut back' into the portrait, refining the silhouette.

B Telling highlights
Creamy, impasto highlights were used to show where the skin was stretched tightly over the cheek-bones and the forehead.

C Contrasting tones
The nose was modelled by using warm tones on the top surface, and cool tones for the receding plane under the nose and on the shadow cast by it.

Portrait in oil pastels

This moody portrait is the perfect way to explore the possibilities of working with oil pastels.

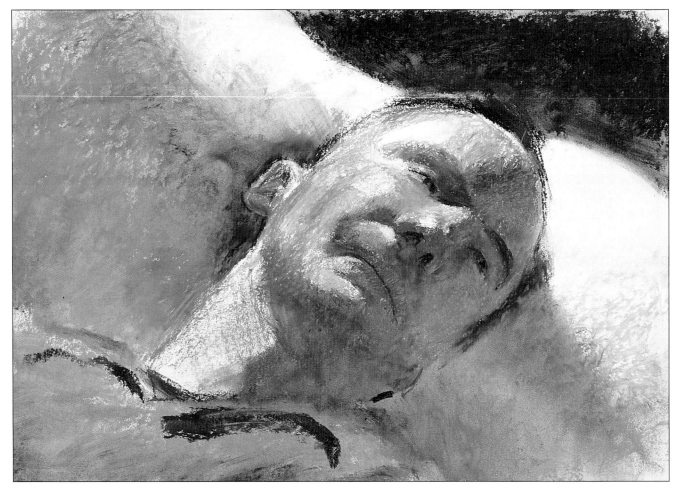

If you think of oil pastels as a rather unsubtle medium best suited to applying broad bands of pure colour, then perhaps they wouldn't be your first choice for a portrait. However, this project proves their versatility.

Oil pastel techniques

Oil pastels have a waxy, sticky texture. Using short, light strokes, you can build up layers of colour one on top of the other. These colours will appear mixed to the eye, creating interesting new colours. Alternatively, you can physically blend the colour with your fingers. The artist used this technique on the shadowed side of the face, smudging together deep green, burnt sienna, blue grey and sepia to create even areas of tone.

Another blending technique – especially suited to large areas – is to rub the colours together with a rag dampened with turpentine. This alters the texture of the oils, creating a wash effect. In this painting, the artist used a rag over the background shadow, which helps throw the head forward. At the end, you can also cut back into the pastels with a palette knife to create sharp highlights.

▲ **Various oil pastel techniques were used to build up a range of textures and colour effects in this portrait.**

FIRST STEPS

1 ▶ **Establish the outline and main shadows**
Roughly mark out the head with the edge of a deep green pastel, then block in the main shadow areas in the same colour. Work burnt sienna over the green to deepen the shadow on the forehead and to pick out warm patches on the ear and nose. Introduce blue-grey shading next to the ear.

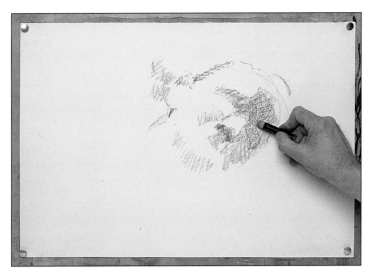

2 ▼ **Build up the tone** Using strokes of burnt sienna and deep green in layers, work around the nose and cheek, and over the eyes and bridge of the nose. Use your thumb to smudge the colours over the eye and in the crease of the cheek. Darken the shadow around the ear and add a spot of cadmium red to the inside of the ear.

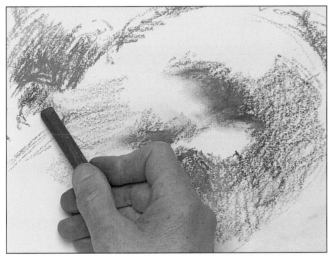

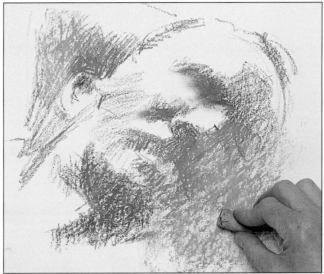

3 ▲ **Deepen the shadows** Using the deep green, work on the shadows under the nose and mouth. Layer deep green and burnt sienna to build up the shadow area under the chin. Block in the cushion around the face with strokes of deep green, then add blue-grey, using the side of the pastel.

DEVELOPING THE PICTURE

Now that the head shape and facial features of the model are roughly mapped out and the basic areas of dark tone are established, you can go on to develop the colours and textures in the portrait.

4 ▶ **Add some darker detail** Continue using the blue-grey to block in the shadow areas on the pillow. Lightly mark in the eyebrows and some hair with a black pastel. Also use the black to render the hair on the model's left side – note how this also defines the outline of the head. Blend this area slightly with your finger.

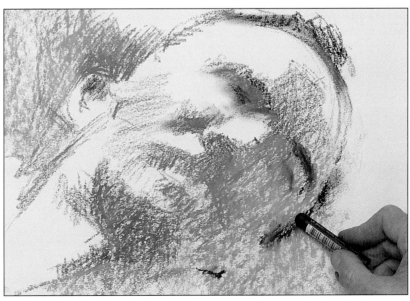

5 ▼ Build up the features Mark the mouth using burnt sienna, and blend slightly. Note how the light is shining through the ear, bringing out the colour of the blood vessels, so add more cadmium red here. Build up the tone on the shadowed side of the face by working burnt sienna and blue-grey together around the eye area. Darken the tone under the chin and on the cheek with burnt sienna and sepia, blending the colour with your fingers.

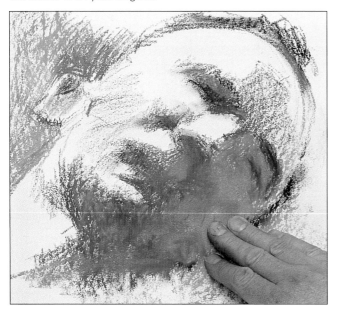

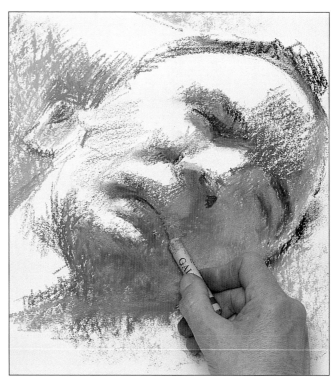

6 ▲ Work on the mouth Using sepia, loosely re-mark the position of the nostrils, then draw a line for the mouth. Darken and smudge the shadow at the corner of the mouth. Using flesh pink, lighten the top lip.

Express yourself

The drama of tone

In this version of the portrait, the artist has pulled further back from the model, bringing in a large expanse of dark background. This contrasts effectively with the strong highlights on the forehead and cushion, setting up dramatic interest. Further contrast is achieved by surrounding the warm skin tones with cool greys on the cushion.

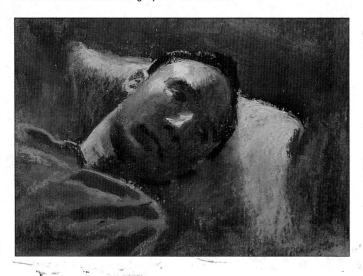

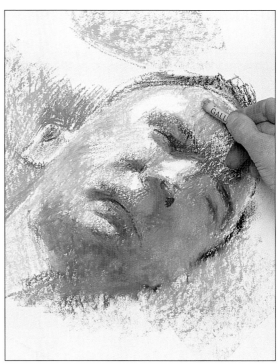

7 ▲ Work lighter areas Identify the lightest parts of the face – the patch on the forehead, the tip of the nose and around the ear – and leave these areas untouched. Work the other light parts of the face in strokes of flesh pink, cross-hatching in areas where you wish to build up tone, such as on the neck. Where the pink meets the darker tone on the face, blend the two areas together at the edges.

8 ▶ Add depth to the shadows On the cushion, build up the shadow around the model's right ear, using strokes of the sepia pastel overlaid with more of the blue-grey. Blend this area with your fingers. Use blue-grey on the other side of the cushion too, adding loose strokes of deep green on top. Emphasise the crease running from the nostril to the corner of the mouth, using the sepia and burnt sienna pastels.

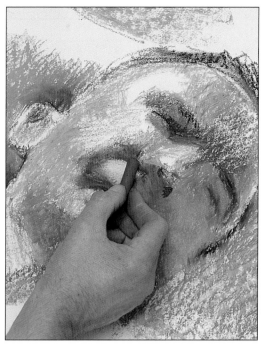

Master Strokes

Theodore Franken (1811-76)
Gentleman Reclining on a Sofa

The young man in this painting is reclining in his room, surrounded by his possessions. Through these, we are made aware of his interests – fencing, shooting, reading, music and pipe-smoking. The room has a comfortable, rather untidy look and is clearly where the young man feels at home.

The figure, with feet propped up and arm flung back, exudes an air of complete relaxation.

Details, such as the cap and book thrown on to the floor, add to the casual atmosphere.

9 ▼ Create a wash effect Dampen a corner of a rag with turpentine. Rub the rag over the dark shadows on the pillow both below and above the head to create a smooth, washy effect. Also rub over the darkest patch on the model's forehead.

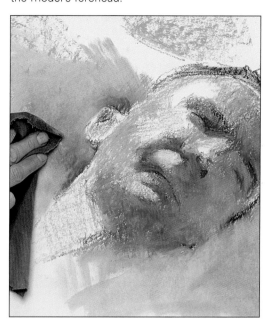

10 ▼ Continue building facial features Use sepia to block in the shadow area above the cushion, then rub the dampened rag over it. Add a sepia fold to the shirt, dragging the colour slightly with the rag. Now work burnt sienna and deep green around the top of the mouth and smudge them together. Add burnt sienna to warm the end of the nose, and sepia to build up the shadow under it. Using a palette knife, scrape away some of the pastel at the outer corner of the right eye, redefining highlights that might have been lost.

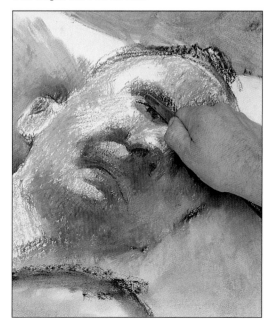

11 ▼ **Put light tone on the cushion** Darken the bridge of the nose with sepia, then smudge the sepia down the shadowed side of the nose and under the eye. Dot a touch of burnt sienna inside the ear. Use Naples yellow to block in the light areas of the cushion, working over the edge of the shadowed area to soften the join.

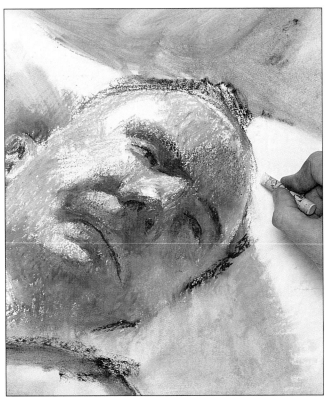

12 ▲ **Add depth to the cushion shadows** Use bold strokes of deep green over the shadowed wash areas on the cushion, then work these back slightly with the dampened rag. Build up further strokes of deep green as well as blue-grey and sepia. Add bold strokes of sepia to the shadowed background and blend with the dampened rag.

CORRECTING MISTAKES

TROUBLE SHOOTER

If you are unhappy with the position of one of the facial features, such as the nostrils, smudge out the detail using your thumb. Remove the excess pastel from the paper with the tip of a palette knife, then continue building up the facial features, repositioning the nostrils as you wish.

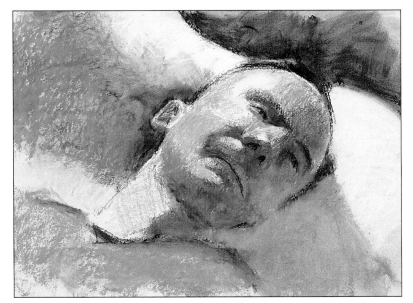

13 ▲ **Add light and dark details** Use Naples yellow to highlight the forehead and around the eye, and flesh pink to lighten the cheek, ear and under the lower lip. Dot cadmium red pastel on the nostril and upper ear. With the palette knife, scrape back some pastel from the top of the ear. Smudge sepia under the ear and chin with your finger. Add a touch of black to the nostrils, eyes and hair. Smudge the hair, then draw in some fine hairs on top of the head. Use yellow ochre to block in the clothes, pulling blue-grey over it and adding Prussian blue at the neckline.

At this stage the work could be considered complete. However, if you wish to continue a bit further, you can add a few more touches that will help to define the features of the face and add more depth overall to the finished piece.

14 ▶ Bring out the features Warm up the shadow under the chin with burnt sienna, working some deep green over the top. On the shaded side of the face, use sepia to define the side of the nose and the crease down to the mouth. Put fine strokes of cadmium red on the lips.

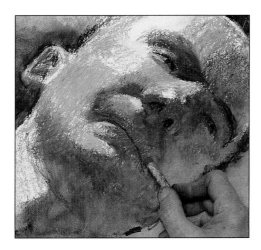

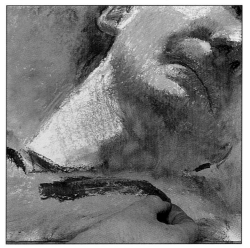

15 ▲ Complete the picture Block in the light area of the cushion next to the neck with blue-grey. Blend black into the clothing and make sepia marks at the neck. Finally, use sepia to add a shadow to the forehead.

THE FINISHED PICTURE

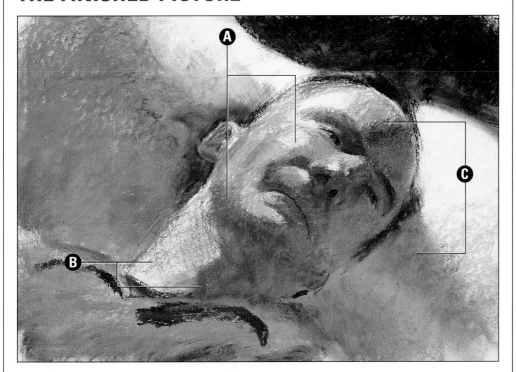

A Lighting effects
The bold, directional lighting used for this portrait has created distinct areas of highlight and shadow. This has given a sense of drama to the finished piece.

B Warm and cool flesh tones
Colour was built up in layers to create the flesh tones in the portrait. Cool greens and blue-greys predominate on the shaded side of the face, and warm pinks and yellow on the lighter side.

C Change of texture
There is an effective textural contrast between the smooth, washy effect on the background cushion and the layered strokes used to build up the forms of the face and neck.

Sepia pastel portrait

With a single oil pastel blended to a wash with turpentine, you can create a moody, tonal portrait with a subtle painterly quality.

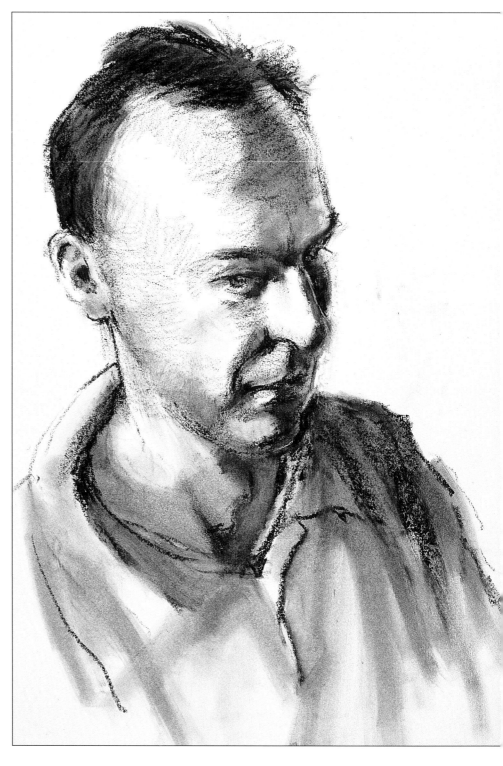

O il pastels are a versatile medium, as they can be used alone or manipulated with turpentine to create a rich, tonal painting. So even if you limit yourself to just one colour – sepia in this portrait – you can create a variety of effects.

Here, the outlines and details were drawn with the sharpened point of a sepia pastel, while areas of tone were blocked in with the side of the pastel. The pigment was dragged into a painterly wash in places by working over it with a cloth dampened with turpentine.

Modelling the head

Creating a good likeness is the key to successful portraiture. To do this successfully, start loosely, sketching in the outline of the head and positioning the features – do not be sidetracked into adding a great deal of detail to any one area at this stage. Make sure that the relative distances between the features are accurate. Measure the distances between them with your pencil and

constantly check between your model and your drawing.

Quickly move down from the head to the neck. This progression is very important, as the neck literally 'holds' the rest of the composition. The way the head is balanced will affect the muscles in the neck and it is essential that the two forms work as one unit.

The subject becomes recognisable quite quickly: by steps four and five an impression of the model's face begins to emerge. As you add depth of tone and detail to the features, the likeness is brought into sharper focus. The form is put down first and the expression is 'hung' on that.

Capturing the mood

Lighting has been used to enhance the moody quality of this painting. The strong lighting from the left casts the right-hand side of the face into shadow, creating a brooding atmosphere that seems to complement the deeply absorbed gaze of the sitter.

The clothes of the sitter can help you define character even in a head and shoulders portrait. The model here is wearing casual clothes and they are loosely depicted, primarily by using the dampened cloth to pull areas of tone into the folds of the shirt. A more formal outfit and character might be more precisely painted.

Finding a sitter

It is not always easy to persuade people to model for you, but remember, you always have a model on hand – yourself! If necessary, set up mirrors and work on a self-portrait in a similar three-quarter view.

◄ **Soft washes and sharp details add depth and variety to this portrait.**

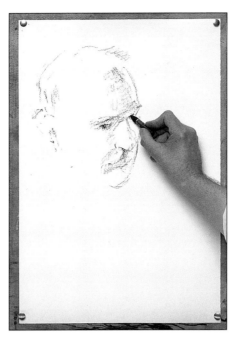

FIRST STROKES

1 ◄ **Sketch in the head** Using the well-sharpened tip of a sepia oil pastel, sketch the shape of the head. Indicate the position of the eye sockets, mouth and curve of the forehead by blocking in these areas with the side of the pastel. Keep your shading light, as the pigment will spread slightly when it is washed over with turpentine in later steps. Draw in the nostril and the pupils with the tip of the oil pastel.

2 ▼ **Add the neck** Draw the neck, comparing it carefully with the head. Make sure the head looks correctly balanced on top of it. Block in the shaded side of the face and neck. Loosely outline the shoulders and the top of the clothing.

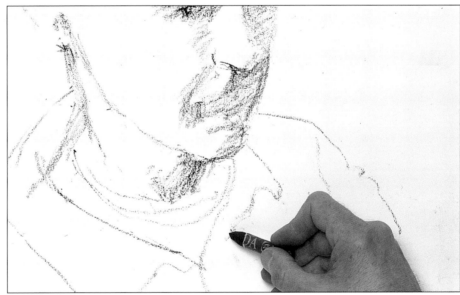

3 ► **Use a damp cloth** Sketch in the hair. Then dampen a soft cloth with turpentine and rub it over some of the shaded areas on the face to give a smooth, washy effect. Start with the shadow on the forehead, then work over the eye sockets, across the bridge of the nose and down the right side of the face. In some places, pull the pastel pigment out slightly at the edges to soften the transition between dark and light.

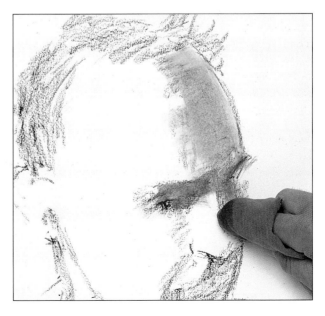

4 ▶ Build up the shading Continue rubbing the damp cloth over the face and hair, building up the shadows under the nose and mouth. Work down to the neck and shoulders. As you progress, use the damp cloth and pastel in combination, building up the darker areas by adding more pastel, then rubbing back with the cloth. When you add pastel to an area already dampened with turpentine, the pastel will soften and blend into the paper.

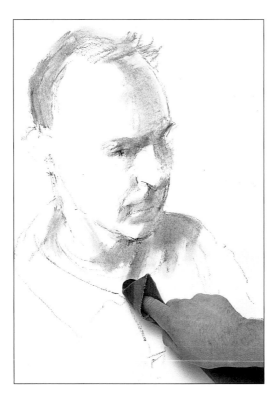

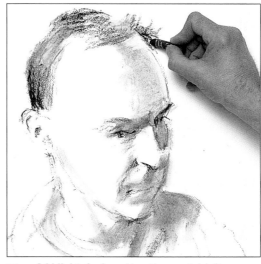

5 ▲ Add light shadow Use the pastel left on the cloth to add some light shadows, pulling the cloth over the jawline and around the shirt collar. With the sharpened edge of the pastel, add some detail around the left nostril and mouth, and emphasise the eyes and eyebrows. Work over the hair once more with the pastel.

Master Strokes

Lucian Freud (b.1922)
Man in a Blue Shirt

This powerful portrait by British artist Lucian Freud is painted in a loose and expressive style. The sitter has an interesting and characterful face and is holding a pose in which he is looking downwards rather than gazing out of the painting in a more conventional manner. The play of light on his face has produced distinctive tonal areas that convey the form of the head.

Brush strokes are clearly visible on the man's dark hair, capturing its thick, wavy texture.

The face has a real sense of solidity. This is partly due to the brushwork, which follows the form of the face, and also the result of the carefully rendered variations in tone and colour.

Subtle shades of blue on the shirt suggest the gentle folds and shadows in the softly draped fabric.

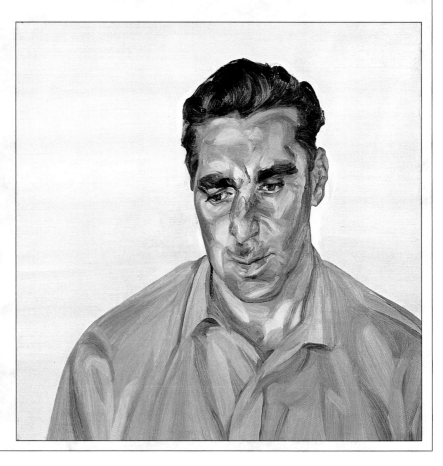

DEVELOPING THE PICTURE

The basic areas of tone are now laid down across the face. Build up more depth in the portrait by continuing with pastel shading in conjunction with washes of turpentine.

6 ▼ **Strengthen tone** Use the cloth to blend the pastel on the hair, then add texture to the eyebrows and the hair above the ear with the point of the pastel. Darken the shadow on the forehead, using the pastel and cloth. With the pastel, build up the tone on each side of the nose, around the mouth and under the chin, rubbing it back slightly with the cloth. Work more pastel around the nose and chin, then use your finger to soften and blend the applied pigment.

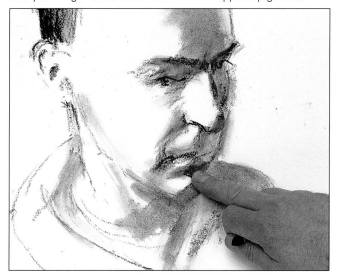

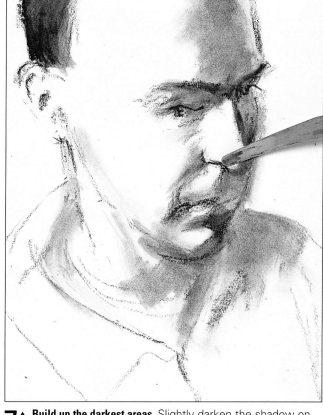

7 ▲ **Build up the darkest areas** Slightly darken the shadow on the forehead and rub back with the cloth. If you build up too much pastel or extend dark areas into light by mistake, you can scrape the pastel off using the edge of a palette knife.

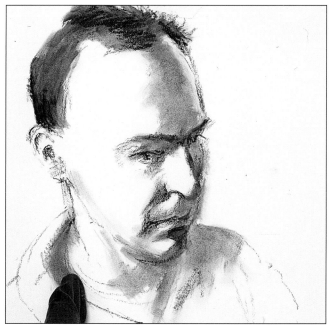

8 ▲ **Add definition** Use the cloth to rub back the pastel on the hair above the ear, then add more pastel at the top and right of the hair. Sharpen the pastel and use the point to define the facial features: the eyes and the shadow beneath them; the crease running from nose to mouth; the mouth itself; and around the ear. Add more pastel to the shadow cast by the shirt collar and rub back with the cloth.

EXPERT ADVICE
Painting with a cloth

You can use the turpentine-dampened cloth like a paint brush. First rub the cloth over an area of heavy pastel pigment, such as on the right shoulder, then lift it off and use it to loosely mark in the folds of the shirt.

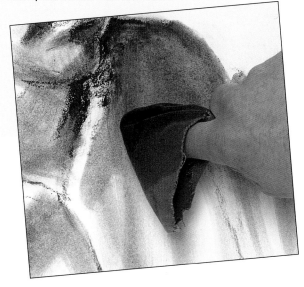

9 ▼ **Work on the lights and darks** Use the pastel left on the cloth to add light tone to the ear, cheekbone, chin and neck. Darken the shadow on the forehead and rub back with the cloth, then use the pastel to block in deep shadow on the right side of the neck and the shoulder.

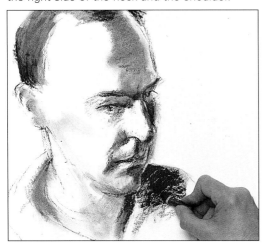

10 ▶ **Work on the features** Use the sharpened point of the pastel to outline the collar and the shoulder on the right. Add some tone under the chin and put in some detail around the nose and at the corner of the mouth. Also add definition to the ear. Use the palette knife to cut back into the mouth to bring out the highlights here. Bring out the texture of the hair with some bold pastel lines.

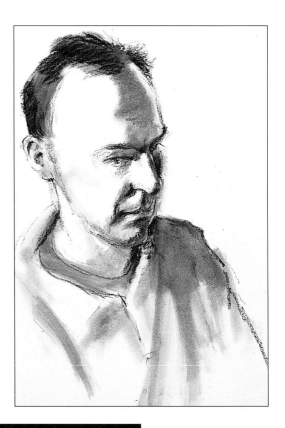

Express yourself
Black-and-white portrait

Try the same portrait using charcoal. Here, the artist achieved the smooth dark and medium tones by rubbing over these areas of charcoal with his finger. The highlights on the nose and forehead were lifted off with a putty rubber.

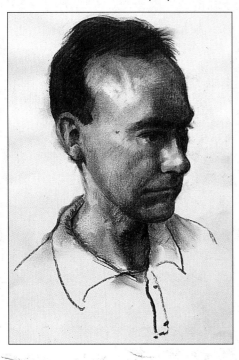

A FEW STEPS FURTHER

The portrait could now be considered finished. However, if you wish to work on it further, the picture could be made more dramatic and expressive by building up the mid tones and darkening the shadows.

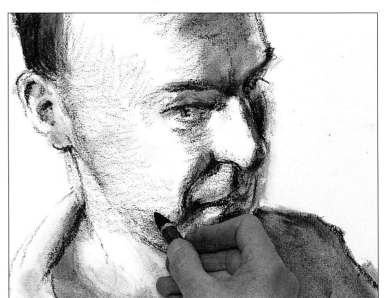

11 ▲ **Work on the mid tones** Darken the shadow on the forehead, then add some gentle pastel strokes on each side. Create some tone on the lit side of the face, using long, light strokes of the pastel. Continue these down the side of the neck. Build up the shadow under the eye on the left and extend it down the side of the nose and around the mouth and jawline.

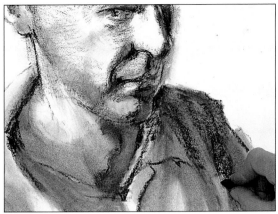

12 ▲ **Work up dark tones** Draw in the Adam's apple. Use the barely damp cloth to lift some of the shadow on the right of the neck. Add a little more pastel to the clothes, then use the cloth to drag more pastel into the folds. Use the point of the pastel to draw line detail on the clothes.

13 ► **Clean up the picture** Use the dampened rag to rub gently and carefully over some of the mid tones on the lower part of the face. With the edge of the palette knife, carefully clean around the right-hand edge of the face where the pastel and turpentine may have spread. This will help the dark side of the face to stand out cleanly against the pale paper.

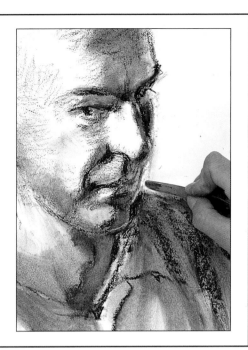

THE FINISHED PICTURE

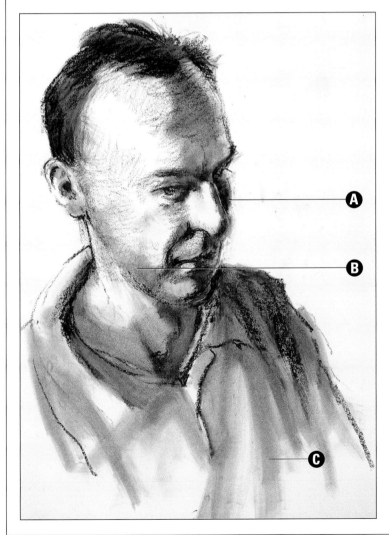

A Strong contrast
The oil pastel was scraped back around the shadowed side of the cheek to create a sharp division between the dark tone and the light background.

B Added depth
The soft, vertical strokes used to add mid tones to the face and neck in the final steps add depth to the overall portrait.

C Fabric folds
The loose folds of the casual shirt were depicted by using a cloth dampened with turpentine to 'pull' the sepia pigment over the paper.

Portrait of a girl

Black and grey drawing sticks– together with the traditional colours of sepia and sanguine – help give this portrait a timeless charm.

S anguine, sepia, black, grey and white – these traditional colours and shades have been favoured through the centuries by artists such as Leonardo da Vinci (1452-1519) and Peter Paul Rubens (1577-1640) for drawings and preparatory cartoons for paintings. They have been used to good effect in this portrait of a girl, although a more modern note has been introduced with a little blue pastel on the model's jeans.

The initial drawing and the darkest tones were rendered with the black drawing stick, and a grey drawing stick provided a strong tone for the background. A warm, flesh colour was introduced with sanguine, while sepia and white created contrasting lights and darks in the model's hair.

White was also used for the striped T-shirt, which plays an important part in helping to define the contours of the figure. The grey Ingres paper stands for the darker stripes on the T-shirt, and is a useful, mid-toned support that suits the neutral and earth shades.

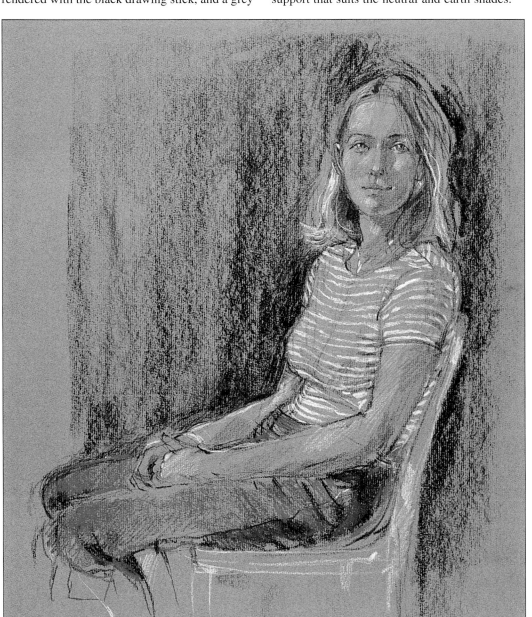

◀ **By omitting the model's lower legs, the artist creates a compact composition with a strong diagonal running from bottom left to top right.**

YOU WILL NEED

Piece of grey Ingres paper

2 artist's drawing sticks: Black; Grey

2B charcoal pencil

3 Conté pencils: White; Sanguine; Sepia

2 soft pastels: Prussian blue; Pale flesh

Putty rubber (for erasing mistakes)

Craft knife (for sharpening pencils)

FIRST STEPS

1 ▼ **Make a sketch** Using a black drawing stick, sketch the head at the top right of the paper, putting in guidelines to help position the facial features. Mark the central axis of the body, then draw the torso and legs. With the side of the stick, lightly shade the background.

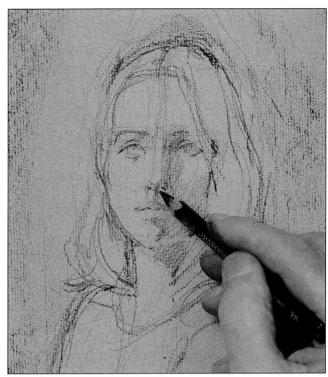

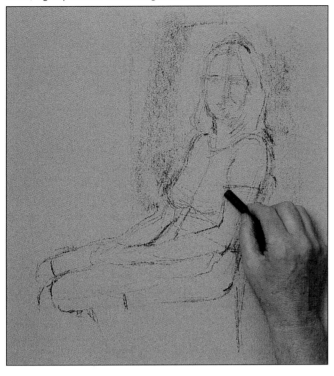

2 ▲ **Draw the features** Change to a sharp 2B charcoal pencil and put in the shaded area on the right of the face down to the neck, leaving the prominent cheekbone and the forehead unshaded. Now bring out some of the detail in the eyes and nose. Lightly shade the shape of the mouth, defining the line where the lips meet.

INTRODUCE WARM COLOUR

At this stage, you can start to warm up the flesh colour by using a sanguine Conté pencil on the face and arms. The addition of further neutral colours helps to extend the range of tones in the portrait.

3 ▶ **Add sanguine Conté** Dot in highlights on the eyes with a white Conté pencil and darken the pupils with the charcoal pencil. Then, with a sanguine Conté pencil, add colour to the brow, cheeks, lips and just below the nose. Work some sanguine over the shaded parts of the arms and hands.

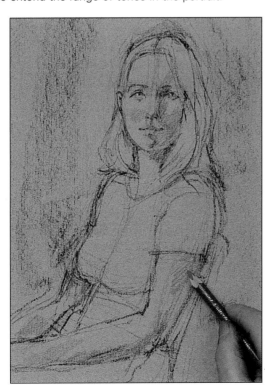

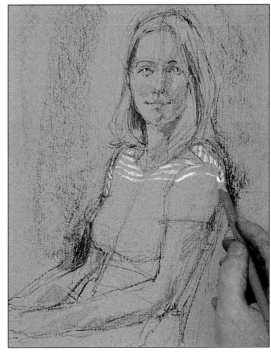

4 ▲ **Draw white stripes** Extend sanguine shading down the neck. Change to a sepia Conté pencil to render the dark tones in the hair. With the white Conté pencil, begin drawing stripes on the T-shirt. Notice how they curve on the sleeve, indicating the shape of the shoulder underneath.

5 ▶ Continue the stripes Work stripes across the rest of the upper body, using them to define the shape of the breasts, stomach and back. Take up the sepia pencil and add more shading to the hair, so that it frames the face on the right. Using the white Conté pencil, brighten the hair with a few highlights and lighten the chair with a pale outline.

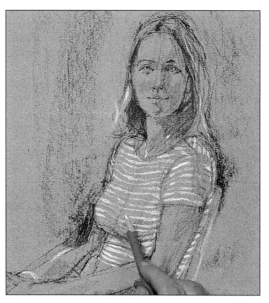

EXPERT ADVICE
Creating a smile

Facial expressions can be changed with tiny adjustments to the drawn features. Whether your model is smiling or not, you can create a subtle closed-mouth smile by adding little upturned marks at each corner of the mouth. This is preferable to an open-mouthed smile with teeth showing, which can easily look like a grimace.

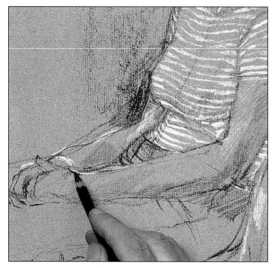

6 ◀ Work on the hands Continuing with the white Conté pencil, render light tone on the upper arms and outline the forearms down to the hands. Changing to the charcoal pencil, add definition to the hands and shade the top part of the jeans.

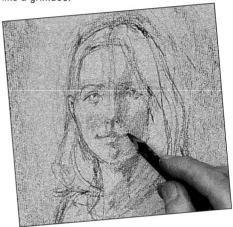

7 ▶ Introduce grey shading Put in white highlights on the brow, the tip of the nose, the cheekbones, above the mouth and on the hands. Now use a grey drawing stick on its side to extend the dark background. Shade the jeans in grey, too, working the creases with darker lines made by pressing harder on the pastel tip.

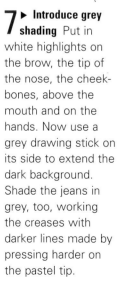

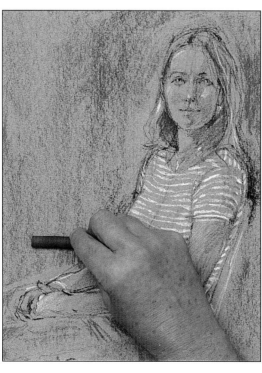

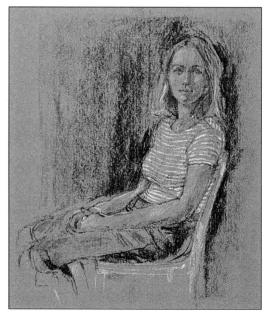

8 ▲ Add details Using the black drawing stick, darken the shading around the body. Rub on some dark tone on the shaded part of the jeans, indicating the seamline. With the white pencil, add a few streaks to the hair and build up the shape of the chair. Warm up the face with more sanguine Conté, brightening it with additional highlights in white.

Although the portrait owes its character to the use of neutral and earthy colours, it is fun to inject a splash of colour by using a blue soft pastel on the jeans and in the eyes.

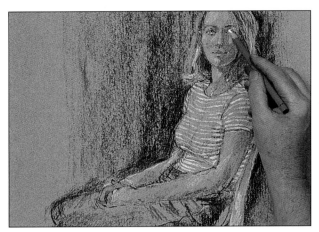

9 ▲ **Strengthen darks and lights** With the charcoal pencil, deepen the shadow on the underside of the hair and strengthen the background tone above the legs. With the white Conté pencil, draw highlights on the eyelids, under the eyes, on the left of the chin and on the ear.

10 ▼ **Put in a splash of colour** Sharpen the facial features with the charcoal pencil. Then, with a Prussian blue soft pastel, rub some colour over the jeans, darkening the deepest shadows with a little black Conté blended over the top. Touch in a little blue on the irises. Finally, add a few warm highlights on the hair with a pale flesh soft pastel (see Finished Picture below).

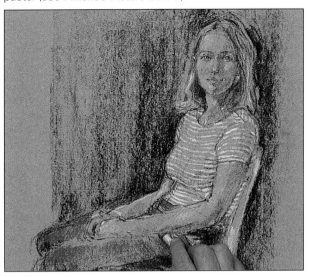

THE FINISHED PICTURE

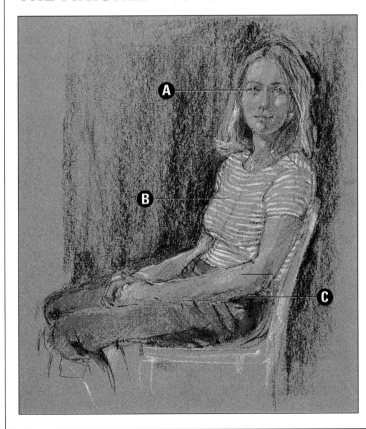

A In the eyes
The artist draws the viewer's attention to the eyes by sharply defining the lids, eyeballs and pupils. He also adds highlights on the tops of the lids and tiny catchlights in the eyes themselves.

B Revealing form
The stripes on the T-shirt are helpful to the artist as they follow the form of the figure underneath.

C Flesh tones
To describe the flesh tones, sanguine is used for the shadow areas while the paper is left untouched on the lit areas. The white Conté is used only for the palest highlights.

Portrait of a seated woman

The combination of line drawing and soft washes in this portrait is created with water-soluble coloured pencils.

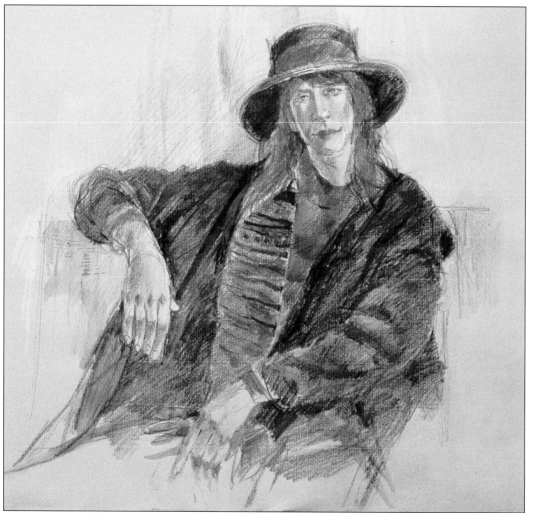

YOU WILL NEED

Piece of pale yellow ochre Ingres paper 51 x 39cm (20 x 15½in)

14 water-soluble coloured pencils: Deep black; Light carmine; Pale geranium lake; Indian red; Burnt ochre; Vandyke brown; Yellow ochre; Light grey; Moss green; Cadmium yellow; Light blue; White; Medium black; Medium grey

No.5 soft round brush

Jar of water

Putty rubber

This study of a seated woman combines portraiture and figure-drawing skills. When working on this type of pose, you can make use of some of the techniques described in previous pages.

Start with a mid tone

Choose a pale yellow ochre tinted paper for the portrait. This will give you a useful mid tone that can stand for the basic flesh colour. You can then move towards the light and dark tones – a traditional and effective method of working. With the paper providing a unifying colour, the image comes together more quickly than if you have to build up all the tones on white paper.

Before you begin, decide how to position the subject within the paper. Check the composition by framing the scene with your thumbs and index fingers or by holding up a card viewfinder. As you develop the drawing, use a pencil held at arm's length to check the proportions and angles of the parts of the body in relation to one another.

FIRST STROKES

1 ▼ **Sketch the pose** Start to draw with the deep black water-soluble pencil, working lightly and freely. Use the pencil to check proportions and angles, especially the angle of the shoulders and head (see page 355). Indicate the centre line of the head and the line of the eyes to establish the symmetry of the face.

2 ▼ **Begin to add some shading** Still using the deep black pencil, add some light tone and more emphatic lines to suggest areas of shade. On the face, these are evident under the chin and nose, and on the upper lip. There are also shaded areas within the folds of the fabric and on the model's right shoulder.

3 ▲ **Draw the right arm and hand** Firm up the lines of the arm, checking the slope of the upper arm and the angle it makes with the forearm. Note, too, the severe foreshortening of the forearm. Find the location of the right hand by using the pencil to measure the distances from the head, the other hand and the edge of the coat. Sketch the hand with a few lightly applied lines, suggesting the location of the knuckles and the individual fingers.

TROUBLE SHOOTER

AVOIDING COCKLING

Don't use too much water on the brush when blending the coloured pencil, as it will lead to cockling (or buckling). It is best to use water only for small areas of wash or for softening lines. If you do want to create wetter washes, use a heavyweight paper – at least 300gsm (140lb) – or stretch the paper first.

4 ▼ **Develop the shading** Indicate the finger joints and the shadows between the fingers. On the sitter's left hand, add dark tone to show how the fingers turn under. Hatch some shading under the brim of the hat, under the chin, down the right side of the face and between the lips.

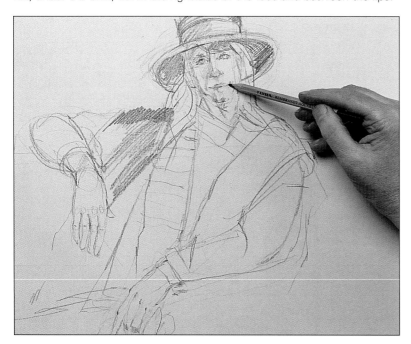

DEVELOPING THE PICTURE

Now it is time to give the drawing a painterly quality by adding some pencilled colour and blending it with a moistened brush. The water softens the pigment, creating pleasing washes.

5 ▼ **Blend the hatching with water** Dip a No.5 soft round brush into water to moisten it and start to blend some of the hatched areas. Don't overdo it – you are aiming to achieve an attractive combination of line and wash.

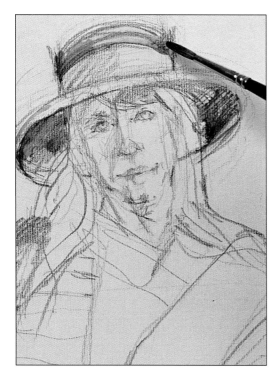

Express yourself

Watercolour portrait

In this portrait, the artist has captured a good likeness of the model with the minimum of pencil lines and a few light washes of watercolour. The features and form of the face are built up in the most detail, while the hands and clothing are merely suggested.

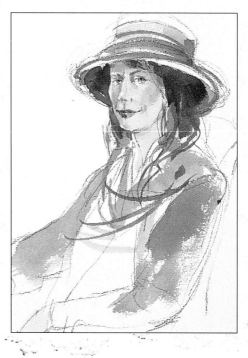

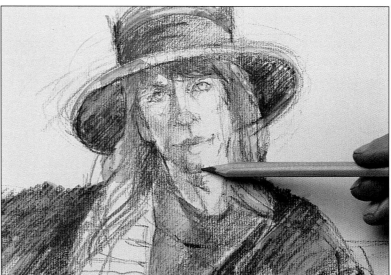

6 ▲ **Introduce some colour** Use light carmine and pale geranium lake as a base for the jumper, blending the colours with the moistened brush. Hatch Indian red on to the hat band. Apply light carmine to the upper lip, then use burnt ochre to warm the shadows on the side of the face, along the nose and in the eye sockets. Add **Vandyke brown** to the hair.

7 ▼ **Put colour on the hands** Hatch burnt ochre on the shaded side of the hand. Add touches of burnt ochre and Vandyke brown on the knuckles, where the bones are close to the surface. Add an indication of these flesh tones to the left hand in the same way.

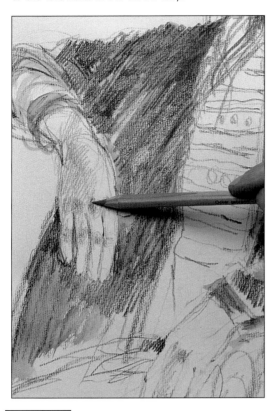

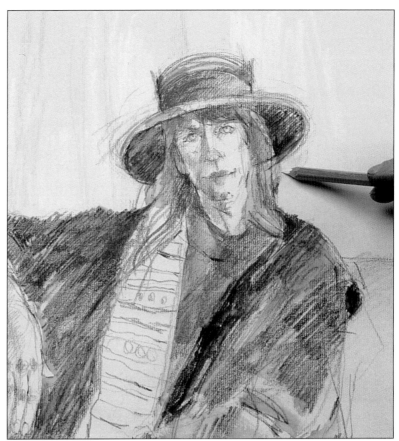

8 ▲ **Fill in the light background** Sketch in the folds of the muslin behind the model with a yellow ochre pencil. Use light grey for the rest of the muslin, hatching it in with vertical strokes that follow the fall of the fabric. Apply the colour lightly to suggest the fabric's transparent nature.

EXPERT ADVICE
Adding highlights

Dashes of a pale colour or white will add a few lively highlights to the face, where prominent features such as the nose or chin catch the light. A dot of white on each eye will make them sparkle.

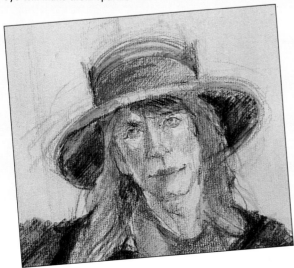

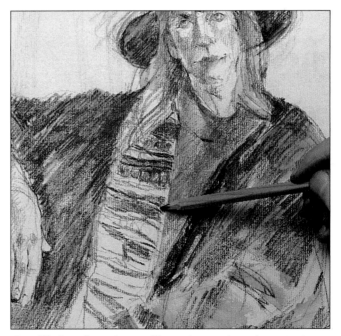

9 ▲ **Work on the waistcoat** The waistcoat is an important splash of colour and pattern. Loosely apply moss green, light carmine, pale geranium lake, burnt ochre and cadmium yellow to suggest the stripes. Add deep black pencil for the black elements of the pattern. Don't make this area too detailed – it should blend with the rest of the drawing.

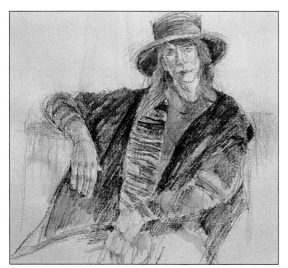

10 ▲ **Blend the waistcoat colours** Soften some of the stripes on the waistcoat with a moist brush to give the textile a blended appearance. Stand back and compare the image with the subject. Half-close your eyes to check that the tones are correct and make any necessary adjustments. Add highlights to the nose and eyes, as described in Expert Advice opposite.

A FEW STEPS FURTHER

If you feel that you need to make a few adjustments to your portrait to achieve a better likeness, you can easily rub out parts of your drawing and rework them.

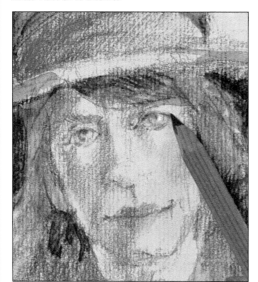

11 ▲ **Redefine the eyes** To soften the eyes, rub out the existing lines with a putty rubber and redraw them with a very sharp medium black pencil. Use a light blue for the irises, picking out highlights with white. Emphasise the lids with Vandyke brown.

Master Strokes
~∞~
Augustus John (1878-1961)
Dorelia Wearing a Hat

British artist Augustus John was a renowned portraitist. This drawing of a young woman, worked in red chalk, is full of lively, flowing lines and bold hatching, especially on the hair and hat. By contrast, there are also subtle smudged areas to add softness to the face and clothes.

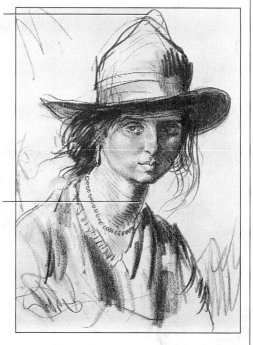

The initial exploratory lines that the artist made when sketching the hat have been left showing to give the drawing a spontaneous feeling.

The model is lit from her right-hand side, throwing the left side of her face and neck into deep shadow. Highlights and mid tones appear on the illuminated side of her face.

12 ▼ **Work on the face and mouth** Continuing with the Vandyke brown, add definition to the nose and right cheek, then soften the shaded areas of the face and neck with burnt ochre. Define the mouth in light carmine, placing a tiny touch of Indian red at the left side.

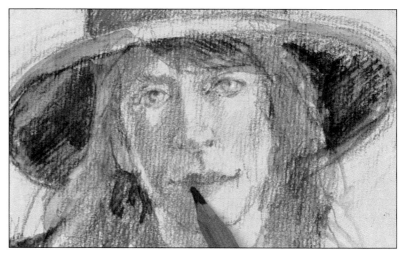

13 ▼ **Work on the clothes** Indicate some highlights on the cheek with white. Add richness to the hair with burnt ochre. Pressing hard, hatch diagonal strokes of Indian red to darken the hatband and sweater. Now use medium black to emphasise the darker areas around the hair and hat, adding a line of detail on the hat brim. Darken the coat, using the same black pencil.

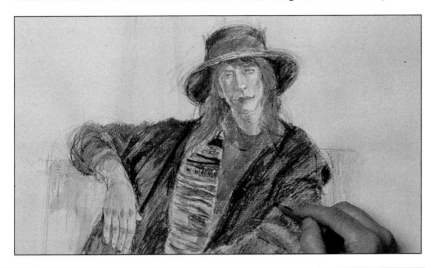

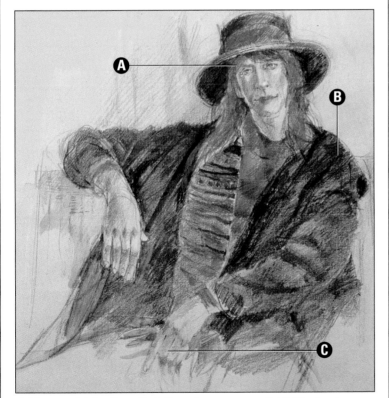

THE FINISHED PICTURE

14 ▲ **Adjust the tones** Use Vandyke brown all over the waistcoat to knock back the colour, so that it tones with the rest of drawing. Shade the hands with a little burnt ochre. Finally, use medium grey to shade the bottom of the coat and emphasise its folds.

A Characterful details
Sensitive line drawing has defined the detail of the model's features and brought out the character of her face.

B Soft washes
The addition of a little water has softened the water-soluble coloured pencil, creating smooth blends of colour.

C Lifelike hands
The hands have been modelled with different tones to make them look realistic without being overworked.

Creating highlights

To give a realistic impression of the sheen and tints of a sitter's hair in watercolours, try 'masking out' areas with an ordinary household candle.

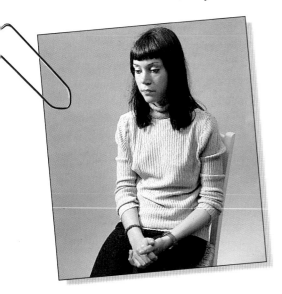

One thing you learn pretty quickly when painting portraits is that a mass of hair is never one single colour. The light will always bring out unexpected tints and highlights. The model in this painting has dark brown hair, but the sun shining through the window also brought out strong glints of gold and copper in it.

Masking highlights

In watercolour, you can capture this effect by painting the hair in two or more washes of colour and masking parts of each layer with the wax of an ordinary household candle – a technique known as wax resist.

In this portrait, our artist started on the hair by masking out streaks of white paper with a wax candle to create white highlights. The waxy candle marks were then overpainted with yellow ochre, causing the masked white highlights to show through the paint. The same technique was used again to mask out a few streaks of yellow ochre before applying a wash of burnt umber. The result is pale and golden highlights in a mass of deep brown hair.

As well as the colour of the hair, pay attention to its overall shape. Try to ignore the thousands of individual hairs that spring from the skull – instead, treat the hair as a solid mass. Paint it in broad strokes exactly as you would render the face and body. In short, simplify what you see.

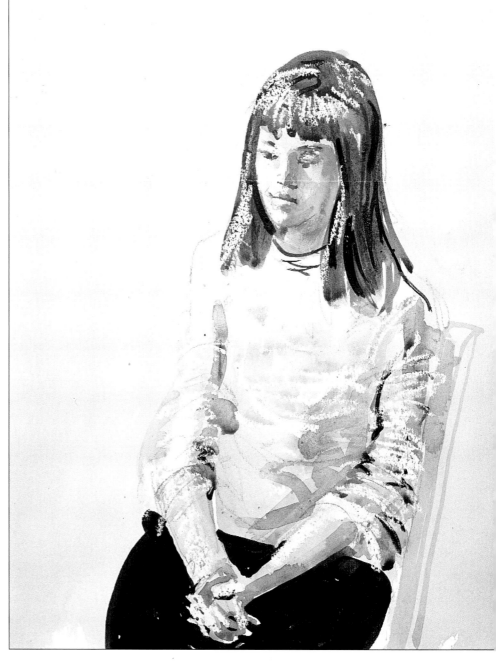

▲ Notice how the candle has been applied not only to create highlights in the hair – but also across the body and around the arms. This helps give the whole picture a lively, textural surface.

FIRST STEPS

1 ▼ **Start with a basic drawing** Make a simple outline drawing of your subject. Keep pencil lines to a minimum as they are only a guide to the subsequent watercolour painting. Establish the main shapes – the head, body and arms – and indicate the position of the facial features. A carpenter's pencil, available from hardware stores, has a wide, flat lead and will encourage you to concentrate on the essentials and ignore superficial details.

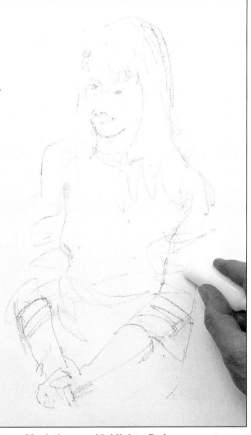

2 ▲ **Mask the wax highlights** Before you start painting, take a white household candle and block in any areas that you want to be white in the finished picture. These include all the light areas on the illuminated side of the face and the highlights on the face and hair.

YOU WILL NEED

Piece of 300gsm (140lb) Not watercolour paper 40 x 46cm (16in x 18in)

Carpenter's pencil

White household candle

6 watercolours:
Yellow ochre;
Indian red;
Raw sienna;
Ultramarine;
Ivory black;
Burnt umber

Brushes: Nos.6 and 5 round brushes; 38mm (1½in) flat brush

Cotton buds

3 ▲ **Block in the flesh colour** Using a No.6 round brush, paint the arms and face in a mixture of yellow ochre and Indian red. The waxy candle marks will show through the watercolour, emerging as bright white highlights.

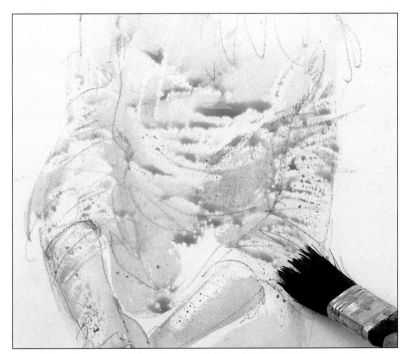

4 ▲ **Paint the sweater** Changing to a 38mm (1½in) flat brush, paint the sweater in raw sienna. The candle wax will again show through the paint and help to indicate the rounded, solid form of the body.

DEVELOPING THE PICTURE

It is now time to work on the hair with layers of paint and more wax. Also, block in the background around the figure with a large brush, taking the opportunity to improve and redefine the outline of the figure where necessary.

5 ▼ **Paint highlights in the hair** Using a No.5 round brush, loosely block in the lightest hair tones in a wash of yellow ochre. There is no need to be too precise about this, because much of the yellow will eventually be covered with brown.

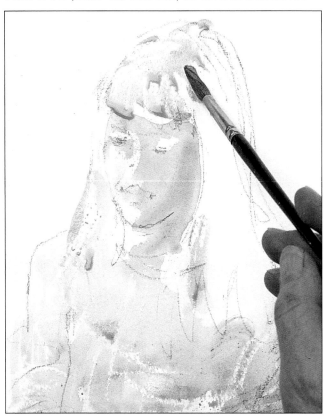

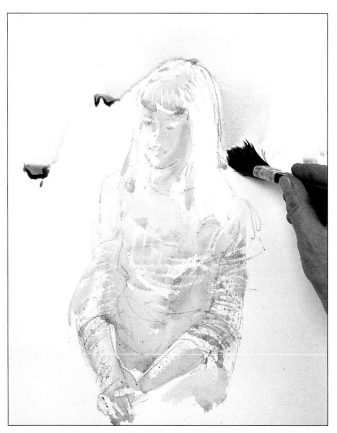

6 ▲ **Add the background** Change to the 38mm (1½in) flat brush and block in the background loosely in a mixture of ultramarine and ivory black.

EXPERT ADVICE
Removing dried paint

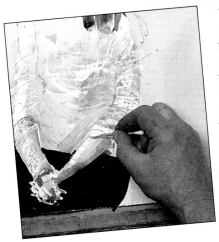

Tiny blobs of paint may collect and dry on top of the candle wax. You can remove these by lifting them carefully with a cotton bud. If the blobs have dried, try dampening the cotton bud first. Go carefully – if you press too hard you might actually rub the colour in more.

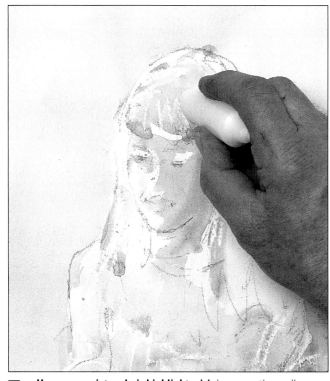

7 ▲ **Use wax resist on hair highlights** Make sure the yellow ochre on the hair is completely dry, then add a few strokes of candle wax to protect some yellow areas before applying the final wash of paint over the hair. Make the candle marks in the same direction as the fall of the hair.

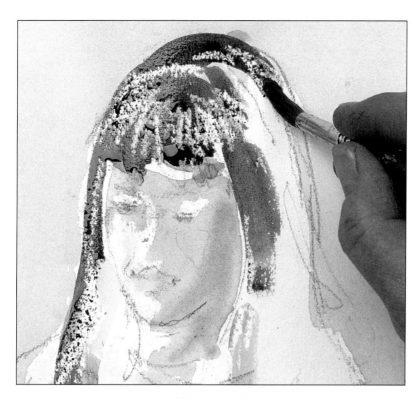

8 ◄ **Block in the brown hair** Using the No.6 round brush, paint burnt umber over the entire hair area. Again, let the brush strokes follow the direction of the hair. The protected areas of yellow ochre will emerge as golden glints through the dark brown wash.

9 ▲ **Paint the trousers** Still using the No.6 round brush, start to block in the trousers as a flat area of ivory black with only the occasional highlight left showing.

Express yourself

A portrait sketch

This portrait sketch in black and white shows how highlights in the hair can be achieved quickly and effectively by leaving patches of the paper untouched. Shadows are blocked in as broad areas of hatched pencil tone.

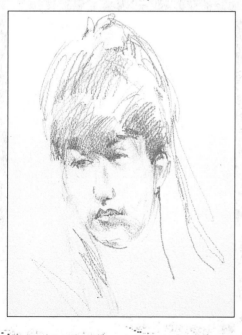

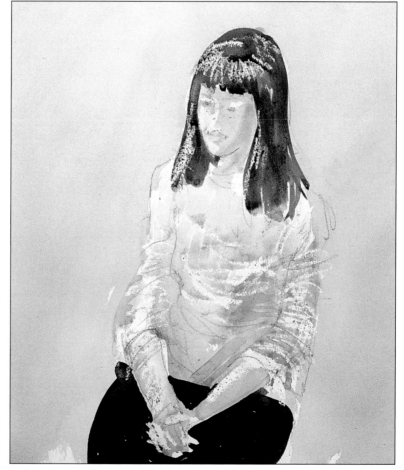

10 ▲ **Define the figure** Complete the trousers, taking the black up to the bottom edge of the sweater. Note that the trousers, which are painted as a flat area, do not really convey the form of the figure. It is the changes of tone in the sweater that give the impression of the three-dimensional figure beneath the clothing.

You have now painted all the main areas of the composition, but the figure still needs a few finishing touches. Some darker shadows, particularly on the face and hair, will help bring your portrait to life without sacrificing the freshness of the paint. However, it is important not to overdo the detail or to overwork the painting at this stage.

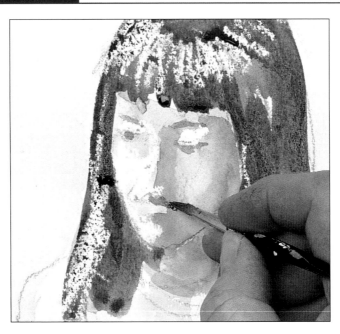

11 ◄ Develop the face
Still using the No.6 brush, add darker tones to the face in a mixture of Indian red and yellow ochre. The mixture must be stronger than the initial wash colour so that these darker areas show up. Leave the light patch on the far cheek unpainted. Using the No.5 round brush, define the facial features by painting grey shadows under the eyes, on the upper lip and along the eyebrows with a mixture of ultramarine and burnt umber.

Master Strokes

Valentin Serov (1865-1911)
Girl with Peaches

A renowned Russian artist, Serov is best known as a portraitist and, as his reputation grew, he painted many celebrities, particularly from the world of the arts in Russia. This beautiful, informal portrait is one of Serov's early works, painted when he was only 22 years old. It has a fresh, luminous quality that perfectly captures the dappled effect of gentle sunshine filtering into the room, highlighting the girl's hair, face and clothing.

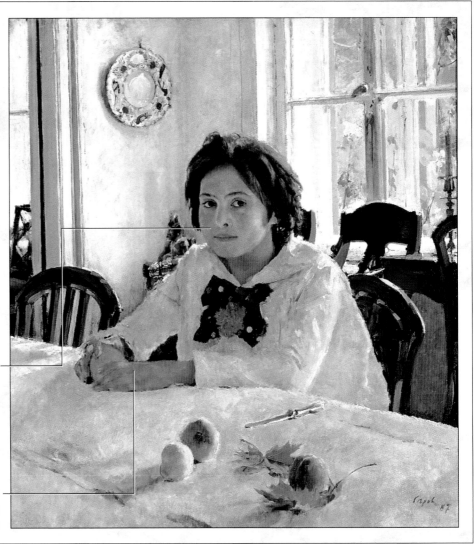

The girl has a radiant, peachy complexion, the colours on her rosy cheeks echoing those of the fruit on the table.

The casual pose, with the arms propped up on the table, lends the portrait an air of informality.

12 ▶ **Paint in the shadows** With the same fleshy shadow mixture of ultramarine and burnt umber, paint broad strokes along the shaded side of the body and arms. Then paint the back of the chair in long smooth strokes of pale grey, achieved by mixing a little ivory black with plenty of water.

13 ▲ **Add hair shadows** Still using the No.5 brush, add a few dark streaks of shadow to the hair in ivory black. Start each streak at the crown of the head. Lift the brush to achieve a tapering effect at the end of each stroke.

THE FINISHED PICTURE

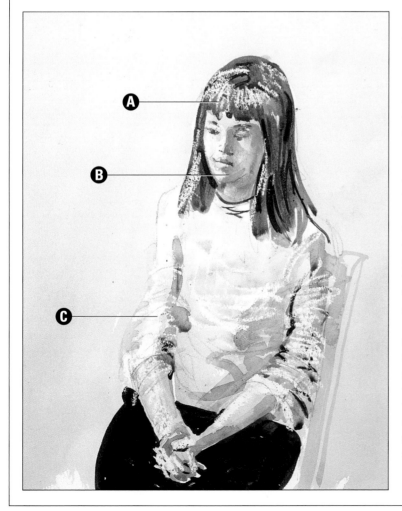

A Adding highlights to the hair
Reflections and highlights in the hair were built up gradually, using a candle wax resist. Reflected light was represented by the whiteness of the paper.

B Simplifying the flesh tones
The face was painted in a mixture of Indian red and yellow ochre. This was first applied as an overall pale wash. Shadows were then painted on top of the wash using a stronger mix of the same colours.

C Following the form
On the body, the direction of the wax highlights follows the form of the subject – helping describe the rounded arms and the torso underneath the clothing.

Nude figure study

Draw with confidence and even your mistakes will contribute to a sense of movement and suppleness in this striking figure study.

A rather unconventional combination of drawing media was used to capture this male model – oil sticks and chunky graphite. And the artist used the two media in a rather unusual way: he established the tone first, then he tackled the line drawing.

The main angles of the torso, limbs and head were first blocked in boldly with raw sienna oil stick. Darker tones were then overlaid in heavy strokes of graphite. As work progressed, a turpentine-soaked rag was used to blend the oil colour and graphite to a smooth, satin-like finish. This broadly established tone and colour became the framework for a more precise graphite line drawing, which defined the outline and features of the model.

Selecting the pose

The artist began by making a few quick sketches of a variety of poses. As well as helping him select the most interesting position, the preliminary sketches were useful aids in making decisions about the final composition. They showed where to place the figure on the paper without leaving too much empty space around the subject.

In figure work, it is vital to show the centre of gravity and how the weight of the figure is distributed. In this study, the arms and shoulders are bearing the weight of the head and torso. To check the pose, the artist sketched the floor area occupied by the figure – a triangle between the two hands and the feet.

Working with a live model

The chosen pose was not an easy one to keep. The model took a number of rests during the session and after each one resumed a slightly different pose. These slight shifts are inevitable when working

from a live model. The solution is to carry on working from the new pose, even if this means making corrections by drawing over lines already made. In this study the artist has sometimes made two or three lines

to accommodate changes of position – an approach that adds to the feeling of life in the finished work. For the same reason, no attempt was made to erase mistakes – new lines were simply drawn next to the incorrect ones.

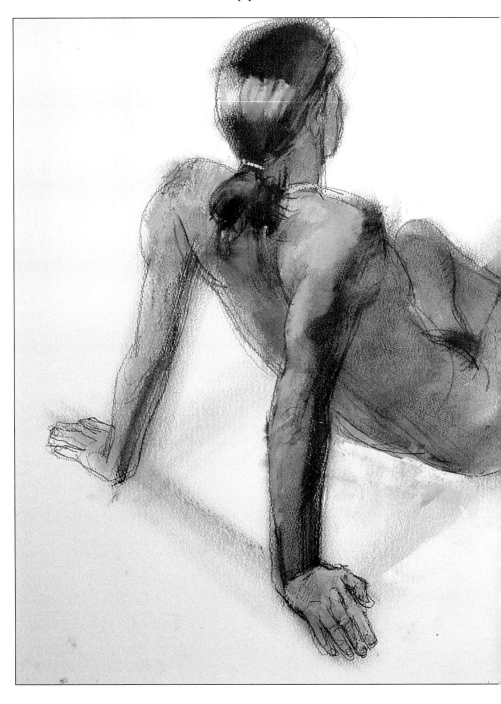

▶ **By sharply defining and subtly modelling the muscles in the arms and shoulders, the artist shows the tension in the pose and how the weight of the figure is distributed.**

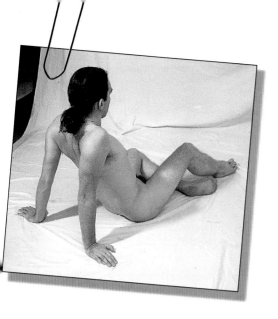

PRELIMINARY SKETCHES

Before starting on the main drawing, make a few quick sketches of the model in a variety of poses and study the different shapes the body makes on the paper. This will help you find a composition that you want to develop. And it will also help the model choose a comfortable enough pose to maintain.

FIRST STEPS

1 ▲ Block in the colour Start to block in the figure using a raw sienna oil stick. Treat the limbs and torso as simple slabs of colour, looking for the main directions rather than detail. Be bold with the composition and try to place the figure centrally on the paper so that the subject takes up most of the picture surface.

2 ▶ Soften the colour Dip a clean rag in turpentine and soften the oil-stick colour, wiping in the same direction as the drawn strokes. Work in strong, bold shapes to retain a sense of movement in the drawing. Don't worry if the colour appears to go outside the figure area – this will be defined accurately at a later stage.

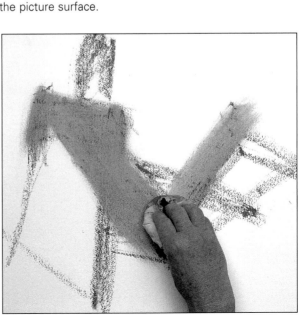

3 ▼ Strengthen the shadows Continue establishing the shape of the body with the rag and oil-stick colour. Then begin with the graphite stick. The arms are taking the weight of the body, so emphasise the tension on them by establishing the taut line down the outer arm and adding dark shadows.

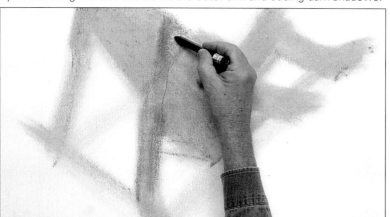

4 ▼ Blend the graphite Use the turpentine-soaked rag to blend and spread the graphite. Work in bold, directional strokes to establish areas of broad, dark shadow.

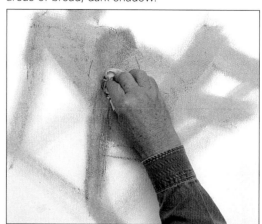

5 ▼ Develop the form Build up the colour and tone on the arm, using the raw sienna oil stick and graphite. Alternate between the two, blending them together with turpentine to build up a sense of solid form.

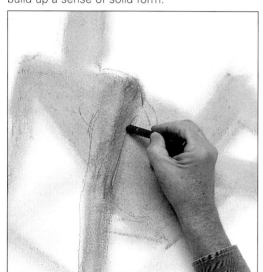

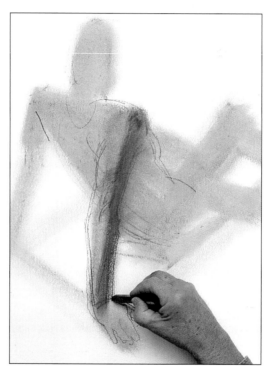

6 ◄ Develop the figure Indicate the angle and position of the neck and shoulder muscles with the tip of the graphite stick. Establish the curve of the back, lining this up accurately in relation to the shoulders and hands. Complete the dark tone on the arm, building up and blending the graphite to achieve a dense black shadow.

Express yourself
Capturing the pose

Figure studies do not have to be highly finished – quick, sketchy drawings can be very effective in conveying a pose with the minimum of detail. Here, the main angles of the figure were put down rapidly with oil stick, then rubbed with a turpentine-soaked rag. The outlines and features were added with spontaneous line work and only a little tonal shading. The oil colour that falls outside the outlines contributes to the lively feel of the study.

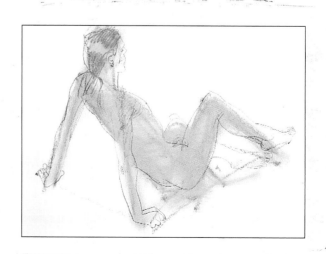

DEVELOPING THE PICTURE

As the weight of the shoulders and torso is borne by both arms, it is important to develop them equally. While continuing to work up the tone and colour of the foreground arm, it is now time to start work on the second arm.

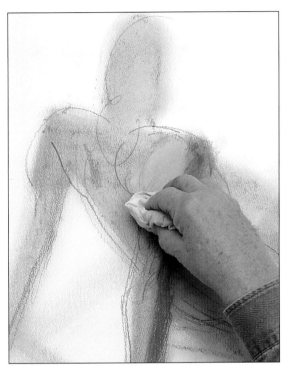

7 ▲ Add highlights Start to develop the shoulder blades and second arm in graphite. Show the highlights on the foreground shoulder in Naples yellow oil stick. Using a clean rag, soften and blend the light tone with a little turpentine.

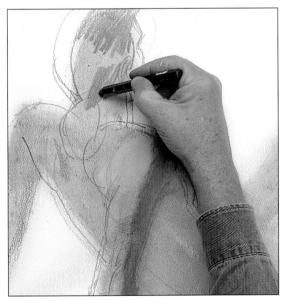

8 ▲ Work on the head Use the graphite stick to establish the position of the head and face. Draw the hair, blocking in the dark local colour. Use bold, closely hatched strokes to describe the direction of the hair and to indicate the shape of the head.

Master Strokes
Albrecht Dürer (1471-1528)
Adam

This painting by German artist Albrecht Dürer, the greatest figure of Renaissance art in northern Europe, illustrates his mastery of portraying the human figure. It shows Adam holding the apple from the Tree of the Knowledge of Good and Evil, with which he was tempted by Eve.

Dürer became fascinated by the concepts of ideal beauty, proportion and harmony, and has created in Adam a superb figure that fulfils these criteria. The muscular form of the body is conveyed through subtle use of shadow and highlight. The hands and feet are beautifully depicted in sensitive detail, as are the facial features.

The dark background and the stony ground make a harsh setting for the figure, suggesting that Adam has been cast out of the Garden of Eden into the wilderness beyond.

The warm flesh tones used for the face are enhanced by the red lips and the glowing, golden hair.

Painted in great detail, the apple, leaves and twig have the meticulous quality of a botanical drawing.

The curves of the muscles and bones under the skin are brought out by using dark tone that blends almost imperceptibly into the flesh colour.

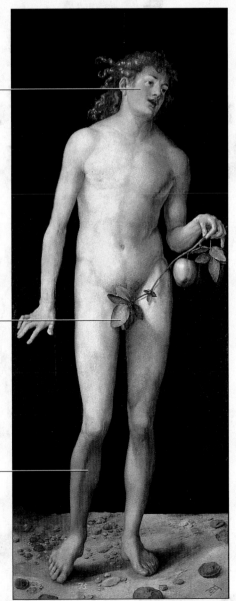

9 ▼ **Continue drawing** Work over the head with graphite, allowing the white paper to stand for the highlight on the hair. Then strengthen the shadow tone of the far arm. Soften and intensify these dark tones with turps. Then draw the thighs and knees, checking the space between the knees against the length and width of the thighs. Accentuate the compressed muscles between the shoulders by adding sharp shadows to the folds of flesh.

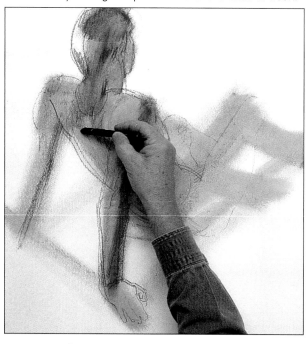

TROUBLE SHOOTER

DEFINING THE BODY

A little white oil paint can be applied with a palette knife to tidy up the outline of the figure where it extends beyond the graphite lines. A word of warning – too much tidying up can detract from the sense of movement, so don't overdo the white paint.

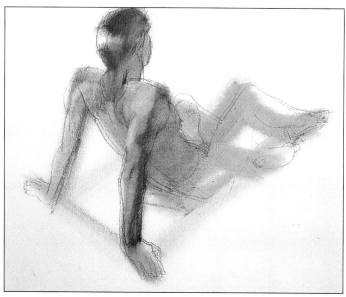

10 ▲ **Develop the torso** Using a little turps on a clean rag, soften the hair and the edge of the highlight. Alternating between graphite and turpentine, build up shadow on the torso and right arm, rubbing back into the graphite to describe the rounded form. Finish the line drawing by positioning the feet and legs correctly in relation to the rest of the figure.

A FEW STEPS FURTHER

The study is almost complete, but the model might have moved slightly since the first broad colour was established. In addition, many light and dark tones will have become lost during the continuous blending. Work across the figure, re-establishing the lights and darks and redefining the drawing to accommodate any slight changes in the pose.

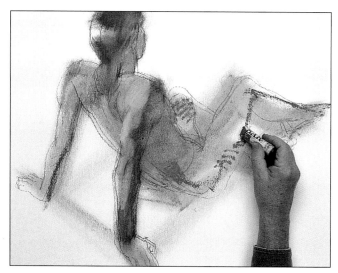

11 ▲ **Add some shadows** Working from the model, add streaks of raw sienna to indicate the shaded areas on the legs, lower back and right wrist.

12▼ **Develop tone and highlight** Blend and soften the shadows with turpentine and a rag, smudging the lines so that they become part of the form. Take a clean rag and remove some of the colour from the back of the right hand to create a pale highlight.

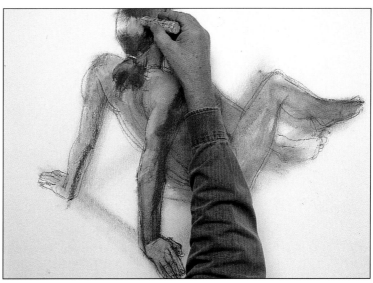

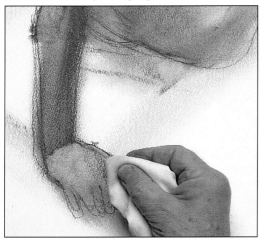

13▲ **Add finishing touches** Working carefully from the model, use the graphite stick to strengthen the profile of the face and the curve of the back. Complete the linear drawing by establishing the hands. Accentuate the highlight in the hair with Naples yellow.

THE FINISHED PICTURE

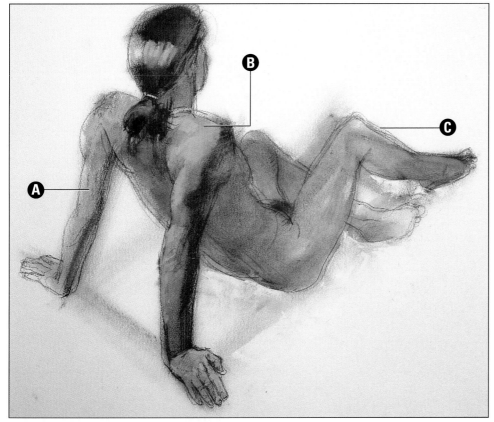

A Coloured underpainting
The initial application of raw sienna establishes the local colour and the main directions of the pose.

B Pale highlights
Naples yellow was used to describe the pale highlights, particularly on the arms and shoulders.

C Linear drawing
Overdrawn lines in graphite give an impression of movement to the outstretched legs.

Female nude in charcoal

Charcoal is generally regarded as a broad medium, suitable for sketching and for bold, expressive work. However, as this drawing shows, it is also capable of producing an extremely subtle and delicate effect.

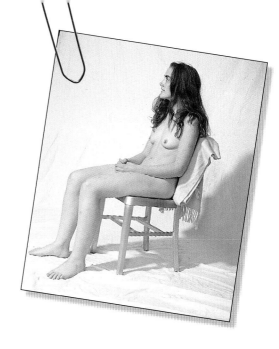

In this nude study, the artist has developed the subtle contours of the figure with fine lines and subtle modelling, but using only a minimum of blending. He worked methodically from dark to light, developing the mid tones and shadows with a series of finely hatched strokes. The result is a rich diversity of tone that brings out the soft textural qualities of hair and skin, and captures the play of light on the face and figure.

Although the drawing is carefully worked, there is nothing static about it. While solid and stable, the impression given is that the girl could get up or change position at any moment.

This effect is due in part to the way charcoal marks break up slightly on the rough surface of the paper, giving them a feeling of energy, but it is due mainly to the artist's skilful draughtsmanship. Nothing is overstated, and there are no hard lines or contours to freeze the pose. There is a 'lost-and-found' quality to the drawing – the hands and feet, for instance, are barely stated – and this gives an impression of air, light and space surrounding the sitter.

Composing the drawing

The artist has positioned the head and torso of the figure to the right of centre, to give her more space in front than behind. This provides the sitter with space to 'move into' and emphasises her gaze. It also opens up the image, helping to produce a relaxed and natural feel. However, if a figure is placed too close to the edge of the support, it can create a feeling of tension and imbalance.

▶ **Sensitivity is the keynote to the success of this nude figure study. It is achieved by the use of simple, delicate charcoal lines.**

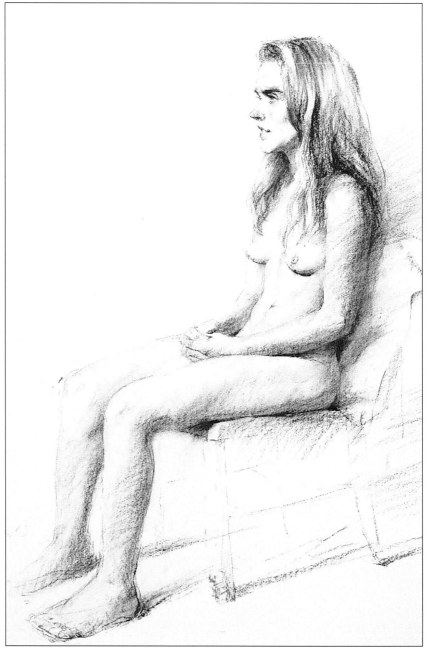

YOU WILL NEED

Piece of good-quality, rough cartridge paper 84 x 59cm (33 x 23½in)

Thin sticks of willow or vine charcoal

2 hard chalks or pastels:
Dark brown; White

Putty rubber

Spray fixative

PRELIMINARY SKETCHES

Just as you might move from place to place to find the best viewpoint when drawing a landscape, so you should also sketch a figure in different poses and from different angles before deciding which one to use for the finished drawing. Simple sketches like these will free up your drawing hand and help you to get to know the personality of your sitter.

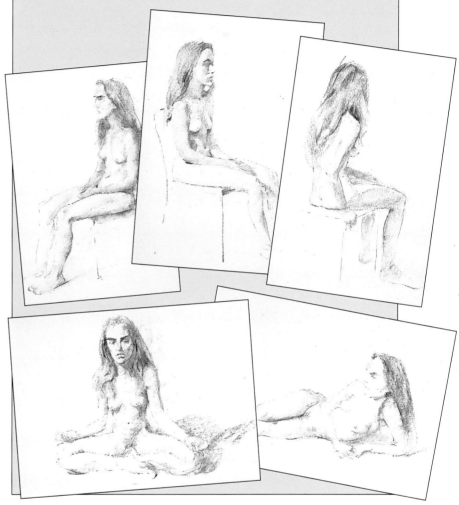

FIRST STEPS

1 ▲ **Position the figure on the paper** With the tip of a charcoal stick, start to plot the main outlines of the figure. Use very light strokes so that you can easily erase mistakes with your fingertips. Observe your subject carefully, looking for the major lines and angles and how they relate to each other. Establish the position of the head and remember that it fits into the rest of the body roughly 7½ times.

2 ▶ **Develop the body and head** Draw the outline of the legs and arms and then suggest the shadows under the breasts. Change to a short piece of charcoal and use it on its side to put in the first tentative shadows that define the facial features and also to model the form of the head.

3 ▼ **Draw the chair** Continue working on all parts of the figure, always double-checking the angles and proportions. If a leg is too short, for instance, it can easily be adjusted at this stage, when the lines are light enough to be rubbed out. Sketch the outlines of the chair; if drawn accurately, it will give you something to measure the various parts of the figure against. Sketch the foot and put in the cast shadow on the floor.

DEVELOPING THE PICTURE

Once the proportions of the figure are correct, you can start to develop the outlines and to model the form and volume with shading.

4 ▶ **Begin to add shading** With a little more pressure on the stick, flick in the model's dark eyebrows, the shadow between the lips and the shadow that defines the hair curving back off the brow. Use both the tip and the side of the stick to establish the shadows on the limbs. Look for details, such as the bone of the knee and the shadow where the thigh muscle is pushed up by the chair seat.

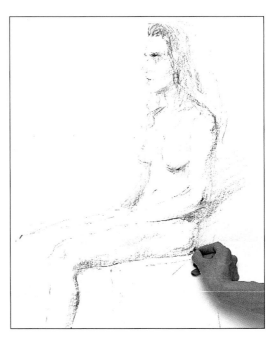

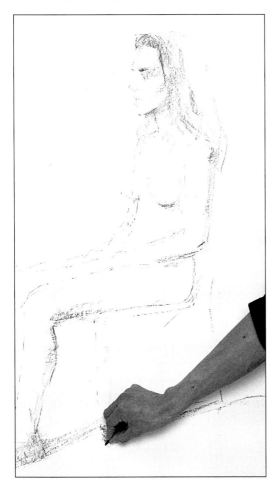

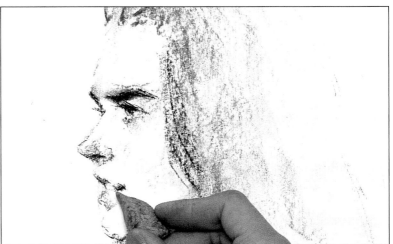

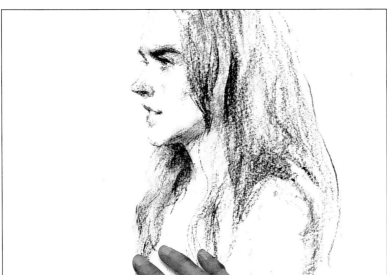

5 ▲ **Add detail to the face** Snap off a short piece of dark brown hard chalk or pastel and use a corner of it to draw the facial features. This requires a delicate touch – the eyes, mouth and nose must be drawn accurately, but should not be overstated. Mould the corner of a putty rubber to a point and use it to soften and lighten the lower lip, which catches more light than the upper lip.

6 ◀ **Work on the hair** Look for the highlights and shadows on the hair. Put in the mid tones with soft side strokes of charcoal and increase the pressure where the hair is darker – for example, behind the model's neck and where it is pushed up by her left shoulder. Use your fingertip to soften some of the strokes, but leave some crisp lines for definition.

7 ▶ Add the chair fabric Begin to suggest volume with some light hatching on the arms. Use a featherlight touch and smudge the lines in places. Model the breasts and put in the nipples. Use the side of the charcoal stick to suggest the fabric folded over the chair, behind the figure. Model the torso with the faintest smudges of charcoal.

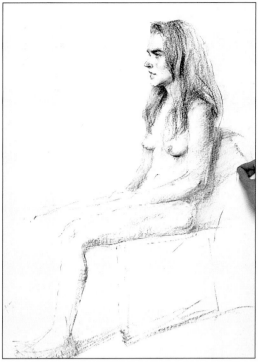

EXPERT ADVICE
Check proportions

Look at vertical, horizontal and diagonal alignments to check that the proportions and relationships between different parts of the figure are correct. Note where these line up with other parts and lightly draw lines to check your accuracy.

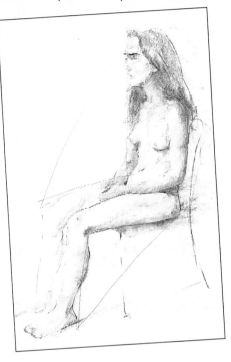

8 ▼ Add more shadows Strengthen the shadow that runs down the back of the arm, making it lighter where reflected light bounces into the shadow (just beneath the elbow). Define the folds and shadows on the fabric a little more. Put in the shadow cast by the arm on to the upper thigh, and strengthen the shadow under the thigh, so that the leg 'sits' convincingly on the chair. Start to model the lower leg, laying on some chalk or pastel and blending it into the charcoal marks with your fingertips.

9 ▼ Draw the hands When drawing hands, suggestion is the key; if you draw them in outline, they look clumsy. Look carefully for the main shapes of light and shadow and put them in very lightly and sketchily, barely suggesting the individual fingers. It's amazing how mobile and lifelike the hands will look!

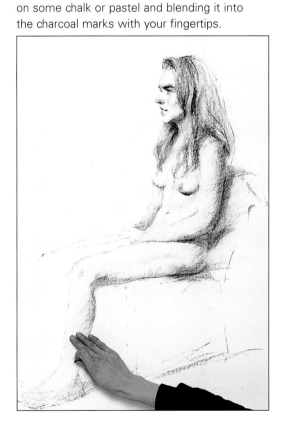

10 ▶ Sketch the right foot

Redefine the model's right leg, using soft strokes with the charcoal. Keep measuring the right leg against the left to ensure that it sits in the correct position and is in perspective. Sketch in the foot, avoiding the temptation to outline it too carefully.

▲ **Thin sticks of charcoal are ideal for the delicately hatched and feathered strokes in this drawing.**

Master Strokes

William Edward Frost (1810-1877)
Life Study of the Female Figure

The reclining female nude is a classic pose in Western art, but the figure in this oil-on-canvas study is unusual because she is shown from the back. The painting is sensual, yet enigmatic – is she in repose, or is there a sadness implied in the tilt of her head and the black ribbon in her hair? The painting is also full of contrasts: between the curves of the figure and the strong diagonals of the composition, between the textures of the brush strokes and between the use of light and shade.

Paint is applied very precisely to define the woman's hair and to show its detail and high sheen.

In contrast, the brush strokes used to paint in the shadows and contours of the shoulder blades are bold and textured.

The strong, curving hollow of the woman's spine is marked with a deep shadow tone.

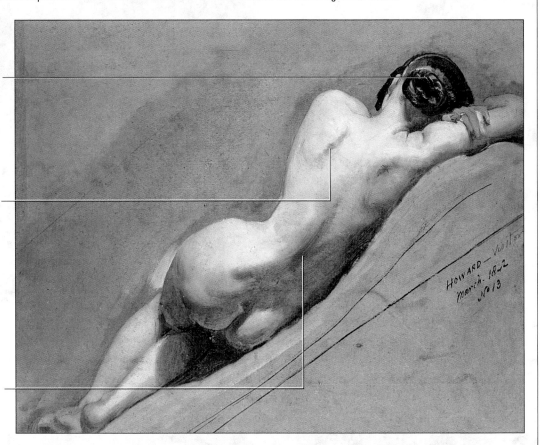

11 ► **Strengthen shadows** Build up the forms of the model's legs and feet by using lightly hatched strokes for the shadows and half-tones. Suggest the toes of the left foot, but leave the right foot relatively undefined so that it gives the impression of receding into space. Strengthen the shadows underneath the left foot (to anchor it to the ground plane) and the left knee.

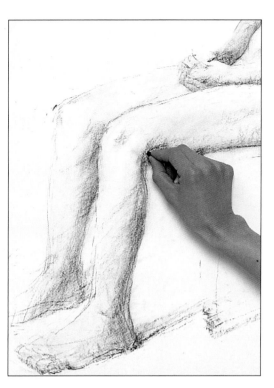

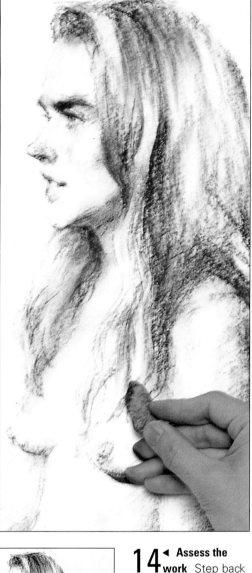

12 ▼ **Suggest volume and weight** Refine the highlights and shadows overall, but don't overwork the darks. Add highlights with white chalk or pastel to reinforce the volume of the figure. Draw the chair seat and hatch in some shadow to suggest the weight of the figure.

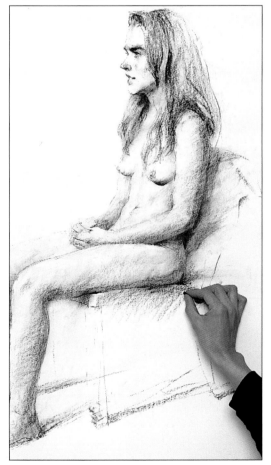

13 ► **Refine the hair** Introduce the more subtle tones in the hair and define its soft texture and sheen. Deepen the darkest shadows by smoothing the marks, and then use the putty rubber with firm pressure to pull out the lightest highlights.

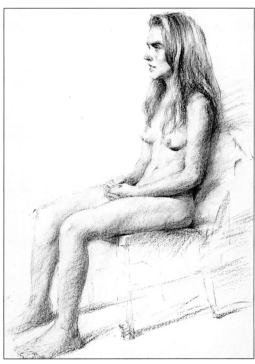

14 ◄ **Assess the work** Step back from the drawing and assess it tonally; consider whether any of the shadows need to be darkened or if any of the highlights need sharpening.

Express yourself

The bare essentials

This version of the subject demonstrates the versatility of charcoal. In contrast to the delicacy of the step-by-step drawing, here the effect is bold and direct. The artist has used a thick charcoal stick and applied it with heavy pressure to pick out the major dark shapes of the figure and create a dramatic, semi-abstract image. This is a useful technique to use for preliminary drawing as it forces you to concentrate on the essentials.

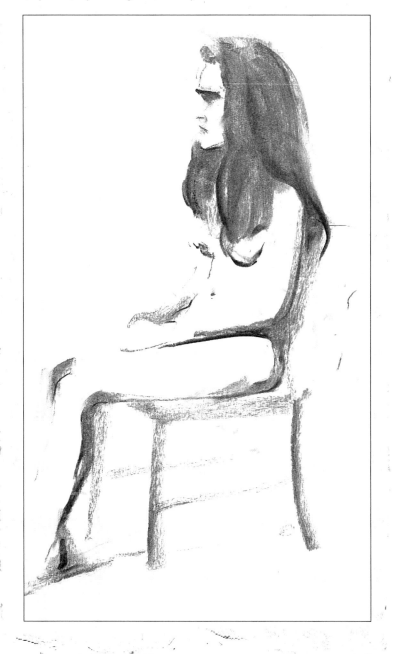

The seated figure is now looking very realistic and requires only a few subtle touches to finish the drawing.

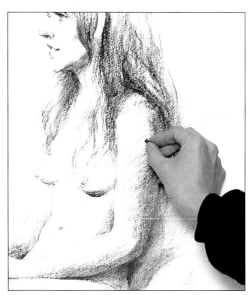

15 ▲ **Add more darks** Work over the upper arm with hatched strokes to darken the tone of the shadow. Also, deepen the tone of the hair where it drapes over the shoulder. This brings the nearer part of the body forward in the composition and adds depth and richness to the drawing.

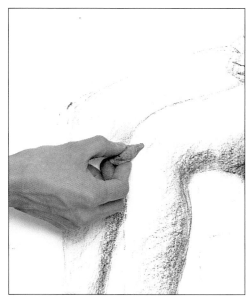

16 ▲ **Create some highlights** Mould the putty rubber into a point and use it to pull out the highlights on the prominent bones of the tops of the knees.

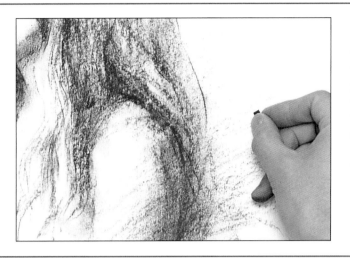

17 ◀ **Add a final shadow** Use charcoal and light hatching to create some shadow behind the model, blending it with the back of the hair. This *sfumato* technique lends atmosphere to the drawing and helps to unite subject and background. Finish by spraying the drawing lightly with fixative to prevent smudging.

THE FINISHED PICTURE

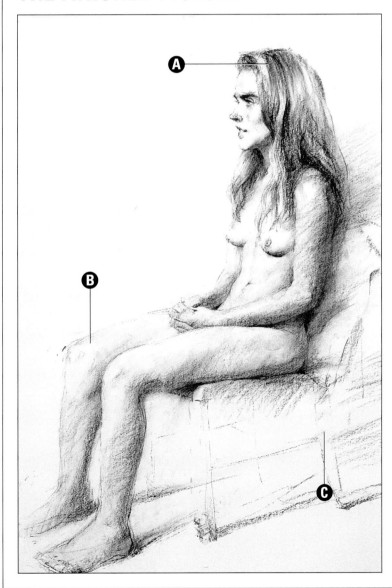

A Textured hair
Soft, smudged strokes combined with crisp lines and erased areas help to build up an impression of the sheen and texture of real hair.

B Subtle modelling
The softly rounded contours of the figure are modelled with featherlight hatchings that are built up layer by layer.

C Simple background
The chair is merely suggested in the drawing. It gives the figure a context without competing with it for attention.

Casual figure study in oils

The oil paints used to create this study of a young woman give the picture a distinctive, loose style, and a relaxed feel.

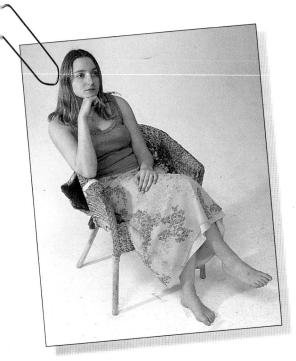

To do justice to a figure study in oils usually takes several hours – the painting here, for instance, took the best part of a day. During this time, sitters inevitably shift their weight slightly as they settle into a pose. Instead of ignoring these small changes, it pays to keep redrawing the figure as the painting progresses. This was the technique used in this portrait.

Keeping the painting alive

Frequent reassessments – boldly made in red and blue – kept the picture alive and lent a feeling of movement to the work. They also resulted in a more faithful rendition of the sitter – it is, after all, easier to paint the pose in front of you rather than the pose you remember.

A broad approach should start with the initial drawing. This need be no more than a few well-placed paint strokes to show the main directions of the subject. The positioning of the legs on the floor is particularly crucial. To get this correct, draw an imaginary square on the floor, linking the legs (see Step 1).

Flesh colours

Skin colours are kept simple. The subject is lit from the left, creating a strong bluish shadow down the right side of the figure. You will therefore need to introduce cool colours on this side while reserving warmer pink and brown mixes for the flesh tones that catch the light.

By using the traditional oil painting technique of working 'fat over lean', you will be able to build up the flesh tones in a loose yet controlled manner. The term 'fat' is normally used to describe paint that has been mixed with oil to give it a rich, thick texture. 'Lean' paint has been diluted with turpentine or other spirit to speed up the drying time. Hence the expression 'fat over lean'.

Start by blocking in washes of dilute, or lean, colour. As you develop the figure, introduce oil to your colours to create planes of bright colour in thicker, more opaque strokes. Then, by using less turpentine and more oil, gradually build up the image in progressively thicker layers until the work is complete.

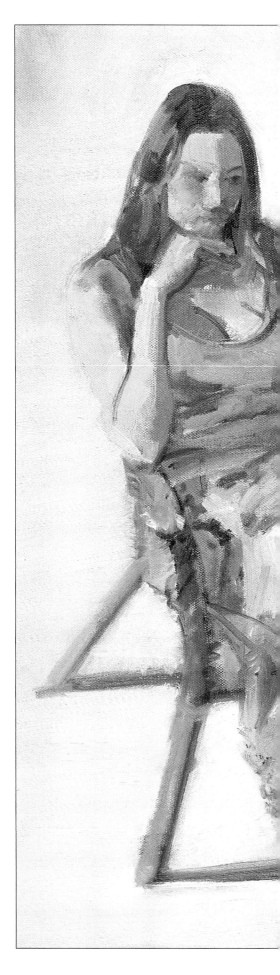

▶ **Dynamic, broad brush strokes are a key feature of this study. Even the fingers and facial features are painted in this way.**

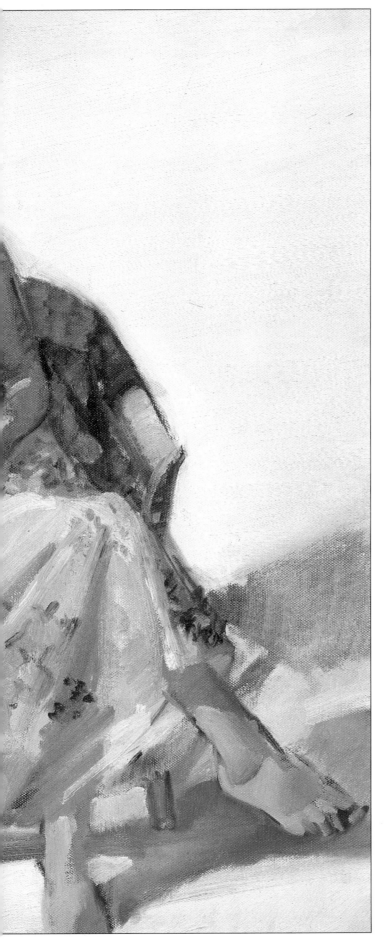

YOU WILL NEED

Acrylic-primed, stretched canvas 61 x 46cm (24 x 18in)

Brushes: No.12 filbert; Nos.2, 4 and 25mm (1in) flats

Mixing palette

Turpentine and linseed oil

Tissues or rags

10 oil colours: Raw umber; Cobalt blue; Permanent mauve; Crimson lake; Yellow ochre; Titanium white; Ivory black; Cadmium red pale; Lemon yellow; Burnt sienna

FIRST STEPS

1 ▲ Make a brush drawing Dilute raw umber and a little cobalt blue with plenty of turpentine and use this with a No.12 filbert brush to map out the position of the figure on the canvas. Paint with broad strokes, concentrating on the main lines and directions of the figure and chair. You may find it helpful to join the base of the legs into a square shape.

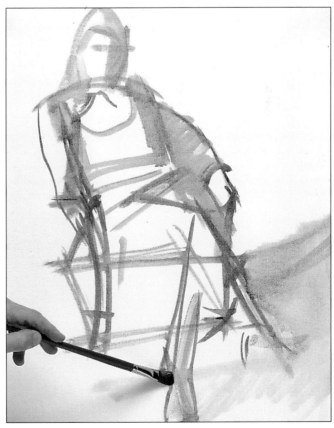

2 ▲ Block in the shadows Using the same dilute colour, loosely block in the shadow areas on the figure and indicate the shape of the thrown shadow on the floor.

3 ▶ Redefine the pose Add permanent mauve to the existing mixture and indicate the shadow on the clothing. Take the same colour into the shadow on the floor, paying attention to the cool, dark area between the feet. Change to a No.2 flat brush and redraw the figure. Make any necessary corrections and accommodate any changes that might have taken place in the pose by drawing over the existing lines using crimson lake.

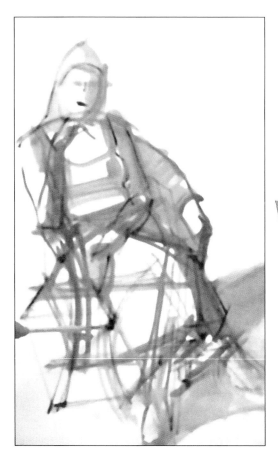

A LARGE PALETTE

When working in oils, some artists prefer to mix their paints on an offcut of board, such as hardboard or marine ply. Unlike a conventional palette, the mixes can then be spread out and kept apart. This can encourage a looser, livelier painting style. A board measuring about 75 x 50cm (30 x 20in) is an appropriate size and can be rested on a table beside the easel.

4 ▼ Strengthen the shadow Returning to the No.12 brush, mix a dilute cool shadow colour from raw umber, permanent mauve and a little cobalt blue and use this to strengthen the shadow on the floor. Add a little yellow ochre to the mixture and block in the inside of the chair and the cool, dark shadows on the figure.

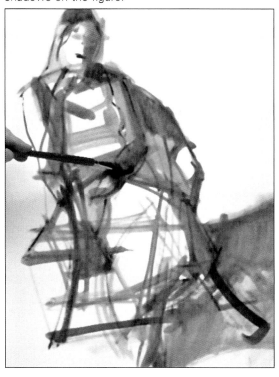

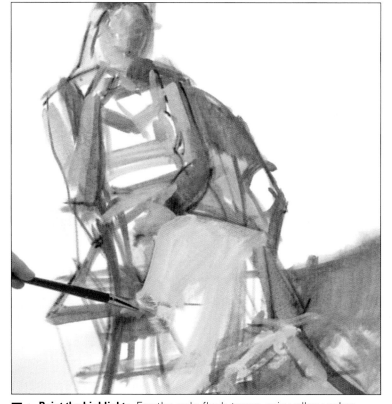

5 ▲ Paint the highlights For the pale flesh tones, mix yellow ochre, titanium white and a touch of crimson lake. Paint each highlight on the limbs as a single stroke. Add a little more white and crimson lake to the mix and block in the lit side of the face. Make a pale pink for the skirt with white, crimson lake and a touch of yellow ochre.

6 ▼ Block in the background Mix off-white for the background by adding a little of the palette mixtures to undiluted white. Working in bold, diagonal strokes, use a 25mm (1in) flat brush to block in the area around the figure. Vary the tone by adjusting the colours in the mixture – on the shaded side of the figure, the background should be slightly paler.

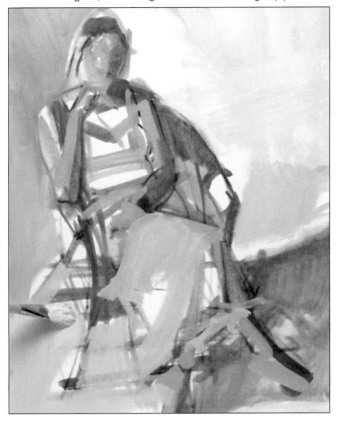

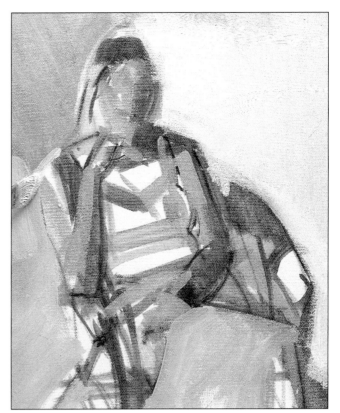

7 ▲ Define the figure Continue blocking in the background, cutting closely into the outline of the figure and using the thick off-white colour to redefine the form.

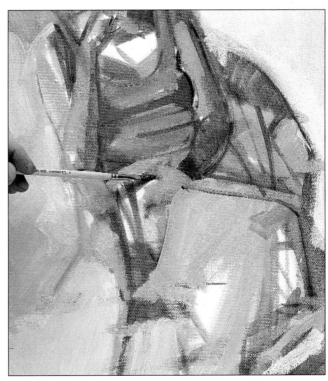

8 ▲ Redraw in blue Complete the background. Then change to the No.2 flat brush and finish blocking in the chair in yellow ochre and titanium white. Make sure the chair legs are accurately spaced. Paint the pink top in mixtures of crimson lake, permanent mauve and white. Finally, take in any adjustments to the model's position, using the cobalt blue.

DEVELOP THE PICTURE

The main areas of the chair and figure are now established. It is time to develop the features and add a little detail, carefully maintaining the broad, lively brushwork of the initial stages.

9 ▾ Define the face and hair With a No.4 flat brush, strengthen the cool shadows on the arms and neck in cobalt, white and a little raw umber. Mix raw umber, crimson lake, cobalt and white to paint the shadows on the face and define the features. Moving to the hair, paint the pale highlights in yellow ochre and white, and the dark shadows in raw umber.

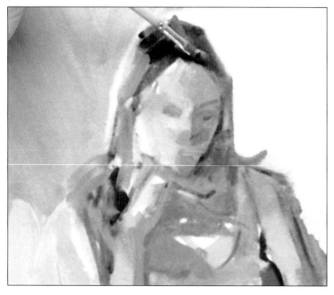

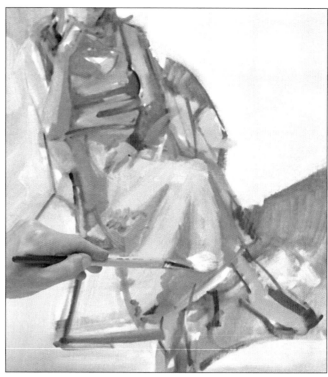

10 ▴ Paint the skirt tones Using crimson lake and the No.2 brush, redefine the figure and reposition the legs and feet to accommodate any changes in the model's position. Mix light and dark versions of mauve, crimson, white and ivory black. Change to the No.12 flat and use the two mixes to strengthen the shadows and highlights on the skirt.

11 ▾ Add pale flesh tones Build up the flesh tones in opaque colour. Mix white, cadmium red pale, yellow ochre and a touch of lemon yellow and apply this thickly in short strokes to the illuminated side of the arms and face with the No.4 flat.

12 ▸ Develop the chair Add dark tones on the chair to match those on the figure, using the No.2 flat. The cushion is painted in ivory black and titanium white with a touch of cobalt blue. The structure of the chair and the dark interior of the seat are strengthened in a mixture of raw umber, burnt sienna and ivory black.

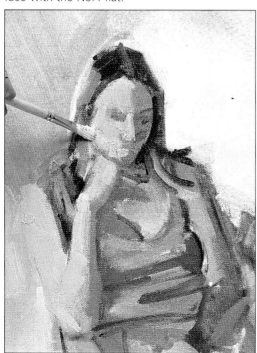

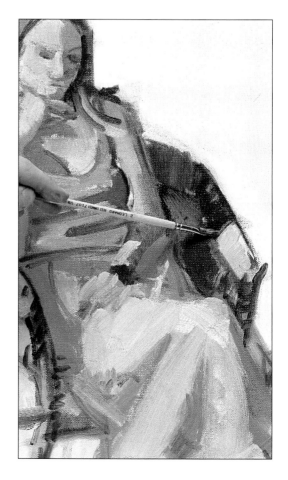

13 ▼ Strengthen shadows Suggest the skirt pattern with dabs of crimson lake. Change to the No.12 filbert and paint around the shape of the figure with the off-white background mix. Work into the shadow under the chair, using the background colour with added mauve.

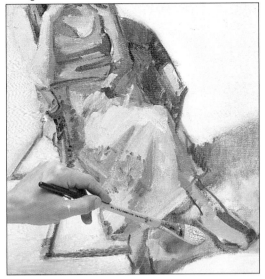

14 ▶ Describe the foot Using the No.2 flat brush, describe the shape of the raised foot. Look carefully for the planes of light and shade and paint the pale areas in white, yellow ochre and cadmium red pale. For the shadow areas, darken this mixture with a little raw umber and cobalt blue.

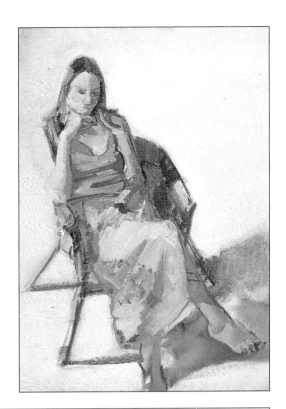

Master Strokes

—◦◦—

Thomas Wyck (*c.* 1616-77)
Young Girl Seated Before a Window

In this painting by the Dutch artist Wyck, natural light coming through the window illuminates the face of the young girl, leaving the room behind her in shadow. There is a lot of detail to be explored in the scene, but the girl's lit face and bright clothes serve as the focal points. Draped fabric plays an important part in the composition. The cloth on the cushion follows the shape of the girl's arm, while the curtain on the right echoes the curve of the body.

The rounded forms of the arms and the planes of the face are built up with creamy flesh colours blending into light grey shadows.

The precise rendition of light and shade on the red skirt and green apron describes how the fabric falls into folds and creases.

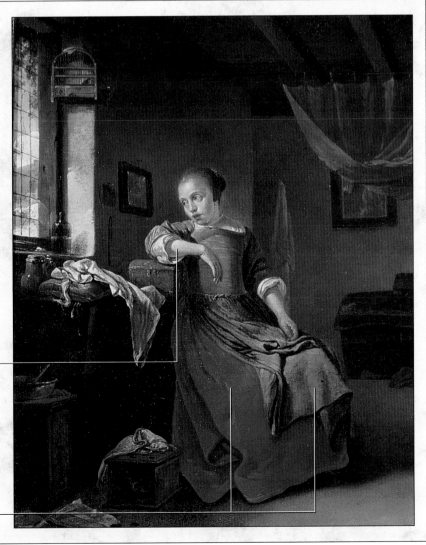

Express yourself
Sketching in paint

In this portrait, the artist is less interested in detail than in capturing the most important elements of the face. Like the main figure study, this approach is extremely valuable as a painting exercise – it discourages spending too much time on superficial pattern and detail, which can reduce the impact of the main structures and general composition.

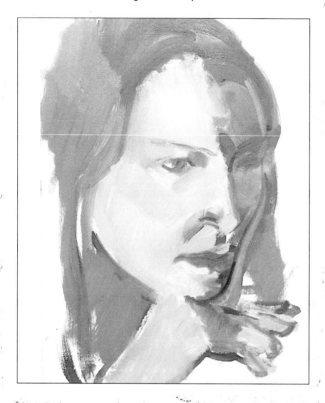

 EXPERT ADVICE
Improvised mahl stick

When wet colour makes it difficult to reach a particular area of the painting, you can use a large brush with a long handle as an emergency mahl stick. Hold the brush handle well clear of the wet surface and rest your painting hand on the handle to avoid smudging the wet oil colour.

The composition is bold and strong, but the face and body would benefit from a little more definition. Take care not to overwork the painting and bring in too much detail, as this would detract from the deliberately loose style.

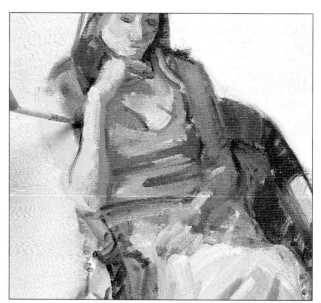

15 ▲ **Complete the arms** Develop the skirt pattern in crimson lake and white, defining folds in mauve, white and raw umber. On the arms, pick out the highlights in yellow ochre, white and crimson lake. Suggest the shadows in yellow ochre, mauve and lemon. Take the light and dark tones into the face and hands, sculpting the wrists and fingers.

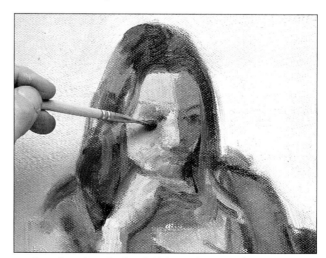

16 ▲ **Complete the head** Using mixtures of raw umber, yellow ochre and white, develop the highlights and shadows on the hair. Strengthen the shadows around the eyes, nose and mouth in mixes of raw umber, cobalt blue and yellow ochre. Paint the cheeks with yellow ochre and cadmium red pale, and the eyes with black and cobalt blue.

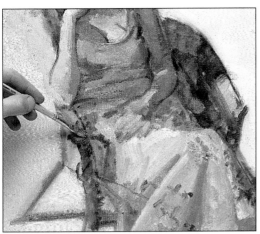

17▲ **Add chair texture** Work into the torso, using mixes of permanent mauve, crimson lake and white to define the stomach and chest. Darken the chair with raw umber, using directional strokes to indicate the wickerwork.

18► **Add final lights and darks** A few final details and the painting is complete. Define the chair legs in raw umber and yellow ochre. Sharpen the shadow under the chair, using a mixture of permanent mauve, cobalt blue and raw umber. Add highlights to the arms of the chair and on the patch of floor underneath it, using yellow ochre and white.

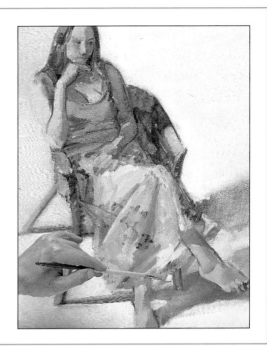

THE FINISHED PICTURE

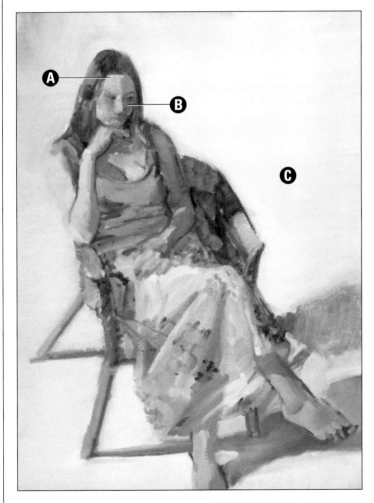

A Warm highlights
The pale, opaque flesh colours on the face catch the eye – they are mixed mainly from white with touches of red and yellow.

B Broad approach
The facial features were indicated as areas of light and shade with the minimum of detail, which complements the loose paintwork used for the rest of the figure.

C Integrated background
To create a colour harmony, the pale background was painted in white with small amounts of other mixes used elsewhere in the painting.

Relaxed study in watercolour

Cool blues, mauves, pinks and greys, enlivened with touches of brighter colour, create the right mood for this tranquil study.

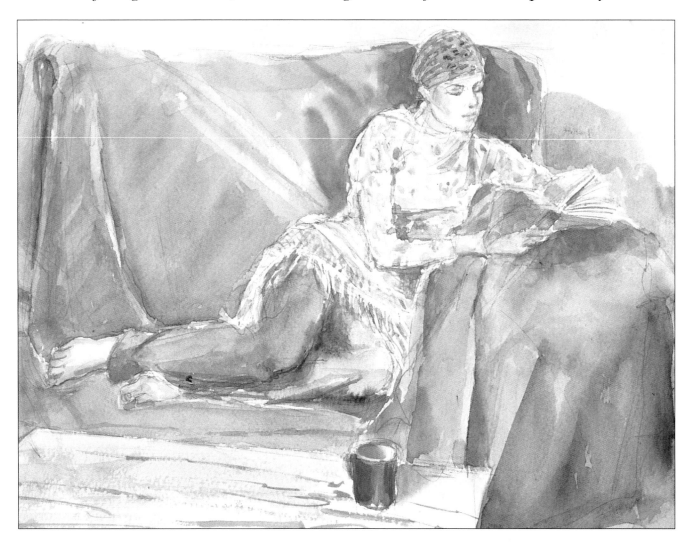

This relaxed study shows off the versatility of the watercolour medium. Working with wet-in-wet washes, colours have drifted into each other to suggest the luxurious texture and the fall of the velvet throws on the sofa.

And these large expanses of colour contrast effectively with the more detailed study of the sitter. Moreover, the warmish pinks and purples of the sofa covers – together with the browns of the table and floor – also play off against the cool colours of the subject's clothes. This contrast helps to focus attention on the sitter. In terms of colour, the picture is further lifted by the lively pattern of blues and yellows on her blouse.

Looking at shape

Understanding how shapes work together is a major part of painting. The woman's pose – half lying, half sitting – creates an interesting, fluid shape. This is set off against the angularly shaped expanses of the velvet throws. The coffee table in the foreground helps lead the eye into the picture.

▲ **Note how most of the detailed work in the painting has been reserved for the sitter and her clothes. The rest of the painting has been completed in relatively loose washes.**

FIRST STROKES

1 ▼ **Sketch in the scene** Using a 2B pencil and light but legible strokes, sketch the
model and the draped sofa, checking the angles and proportions of the figure.
Don't be afraid to erase parts of the drawing with a putty rubber and start again.

YOU WILL NEED

Piece of 300gsm
(140lb) Not watercolour
paper 28 x 38cm
(11 x 15in)

2B pencil

Putty rubber

Brushes: Nos.10, 6 and
2 rounds

15 watercolours: Winsor
violet; Naples yellow;
Burnt sienna; Purple
madder alizarin;
Permanent rose;
Payne's grey; French
ultramarine; Raw
sienna; Burnt umber;
Sepia; Cerulean blue;
Black; Emerald; Raw
umber; Cadmium red

2 ▼ **Establish the back-drop** With a No.10 round
brush, block in the background throw with
light washes of Winsor violet. Now take up a
No.6 round and work on some smaller areas.
Begin on the face and hands with a very watery
Naples yellow and the broad headband with burnt
sienna. Throw the model's head forward by
adding strong shadows in Winsor violet behind it.

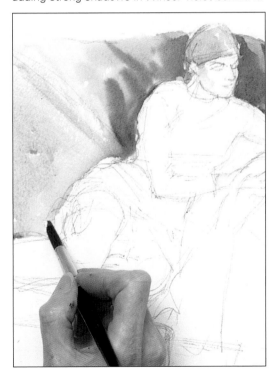

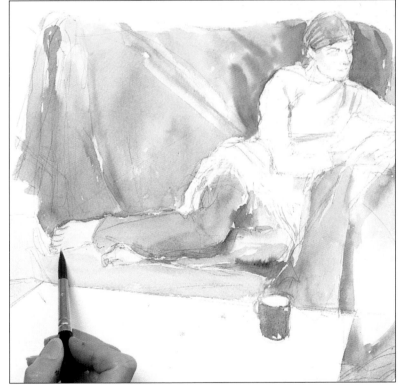

3 ▲ **Fill in the scene** With the No.10 brush, paint the foreground fabric in
purple madder alizarin, and deepen the background fabric with mixes of
purple madder alizarin and Winsor violet, adding permanent rose highlights.
With a wash of Payne's grey and a touch of French ultramarine, paint the
trousers, the fringed shawl, and the shadows on the blouse and wall. Use
raw sienna over burnt sienna for the sofa, raw sienna on the sitter's
headband, Naples yellow for the feet and French ultramarine for the mug.

DEVELOPING THE PICTURE

The main areas of your composition are now blocked in, and the pale and brighter colour registers are established. Progress by working with a range of other colours, right across the picture, using various paint thicknesses and techniques.

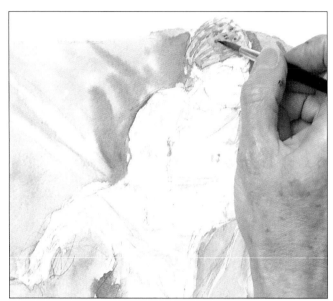

4 ▲ **Add upper-body detail** Changing to a No.6 round brush, use the tip to pattern the blouse with watery raw sienna. Add a little more Payne's grey on the fringed shawl. Dot in the design on the headband in burnt umber and sepia.

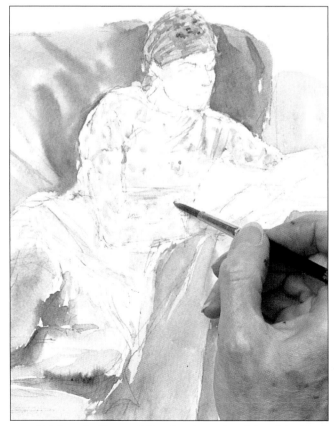

5 ▲ **Brighten the blouse** Still using the pointed tip of the No.6 brush, lift the whole scene by painting in the blue parts of the blouse pattern with cerulean blue.

◄ Sepia (top), Winsor violet (bottom right) and purple madder alizarin (left) have been used extensively in the picture and help to set its overall colour key. They harmonise well with each other, creating an air of calm.

EXPERT ADVICE
Be complementary

By making use of complementary colours – opposites on the colour wheel – in a prominent part of the scene, you can really lift the whole. Here, placing brown-yellow and blue together in the blouse's pattern enhances the colours and brings a bright but balanced element to the picture.

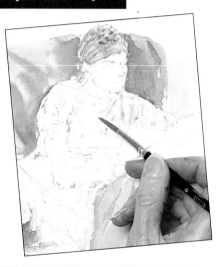

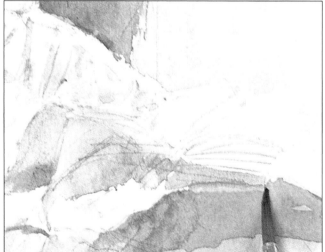

6 ▲ **Paint in the book** Now bring the model's book into the picture, balancing the right-hand side of the painting. Use the fine tip of the No.6 brush to sketch in an outline of the book cover in watery sepia. Put in the faintest suggestion of the pages in the same colour. Working wet-in-wet, use sepia and Payne's grey to block in the book cover. With a mix of purple madder alizarin and Payne's grey, paint the shadow of the book on the throw.

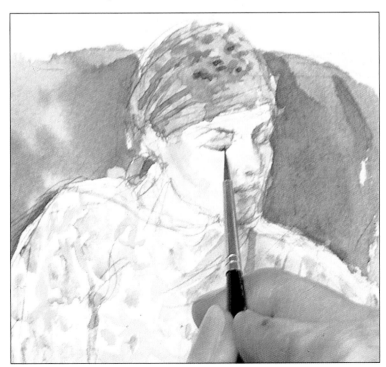

7 ▲ Work on the large areas Taking up the No.10 brush, start working up more depth and richness on the two throws. Use purple madder alizarin on both of them, laying thin washes over the dried colour to suggest the texture and sheen of velvet.

8 ▼ Define the facial features Now turn your attention to the face. With a No.2 round, start to add some fine detailing with intense sepia paint. Wash a little watery burnt sienna over the lips.

Express yourself
A different viewpoint

This painting, also in watercolours, creates a different mood to the step-by-step one. The high viewpoint – combined with the curled, sleeping body position – provides a highly original figure study. Note how the model's nightgown is beautifully described by controlled wet-on-wet washes. The contrast in tone here – from the white of the paper to the deep blue shadow in the middle of her curl – really brings out the form of the body. The teapot and cup and saucer in the corner pick up on blue of the nightgown and help balance the composition.

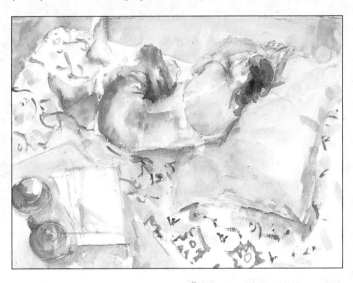

9 ▼ Intensify the darks With the No.10 and No.6 brushes, use a mix of cerulean blue and black to define the feet and legs by adding shadows on and between them. Intensify the shadows across the blouse, too. Using the No.10 brush, wash strong Naples yellow across the table as a base colour.

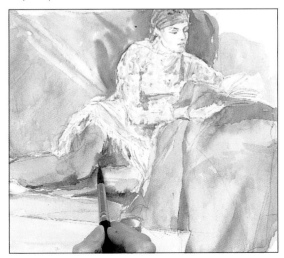

10 ▼ **Work on some detail** Use the same blue-black mix and the tip of the No.6 brush to define the shawl's fringe, then dot ultramarine along its border. Mix up cerulean and emerald paints and wash this across the wall behind the sofa. Notice how leaving the pencil underdrawing in has created some surface interest and definition.

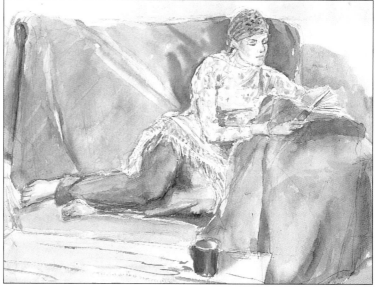

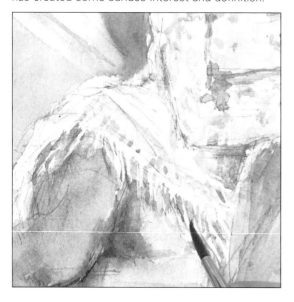

11 ▲ **Adding definition** With the No.6 round, sweep lines of dry sepia, burnt umber and raw umber across the table to suggest wood grain. Using a 'palette mud' mix of black, burnt umber and ultramarine, strengthen the shadows on the legs and next to the mug. Add sepia to this mix to build up the tone of the book. Paint a little sepia and burnt sienna on the feet and hands, and a touch more detailing on the fringed border of the scarf.

Master Strokes

Paul Gauguin (1848-1903)
Fair-haired Woman on a Sofa

This painting was made in 1884, a year after Gauguin gave up paid employment to become a full-time artist. The viewpoint creates a harmonious composition of horizontals – the outstretched pose of the reclining woman is echoed by the straight lines of the *chaise longue* and the bold, wide band of brown running along the bottom of the wall.

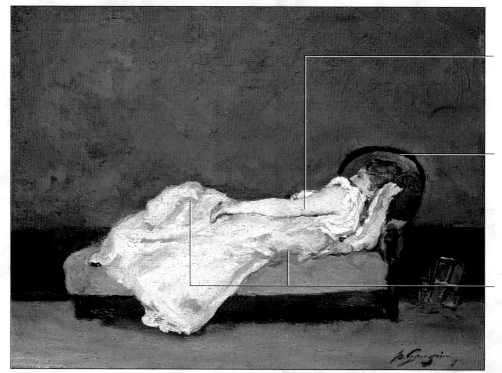

Surrounded by the dark tones of the wall, floors and *chaise longue*, the white dress and pale flesh tones really leap out.

The curved line of the *chaise longue*'s back helps frame and draw attention to the woman's head.

The greyish-browns of the walls and *chaise longue* are picked up in some of the shadow areas of the dress.

A FEW STEPS FURTHER

Now that you have worked hard on bringing up the detail on the reclining figure, even up the balance of the picture by giving a little more attention to the larger expanses of plain colour on the throws and sofa seat.

12 ▶ Finish the drapes Wash some plain water across the throws to give them more drama and depth. Using Winsor violet and the No.6 brush, strengthen the shadows on the background throw. Wash a little cadmium red lightly over the foreground throw.

13 ▲ Bring up the sofa Using the No.10 round, add the final touch by washing watery sepia across the front of the sofa seat. Now the drapes, table and model are all well-balanced, and the central figure retains its solidity, strength and interesting visual detail.

THE FINISHED PICTURE

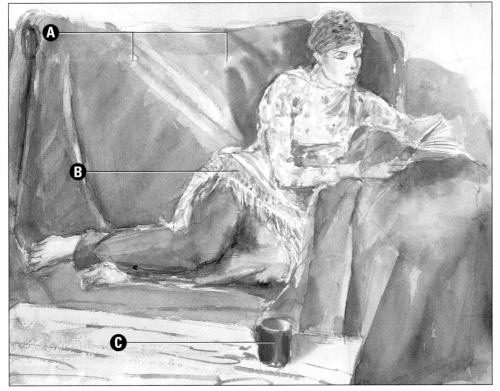

A White highlights
The tiniest flecks of unpainted white paper are sufficient to represent white highlights on the luxurious fabric.

B Central interest
Attention to detail by painting the pattern on the fringed shawl brings a point of interest to the centre of the picture.

C Drawing the viewer in
The artist has placed a strongly coloured object – the mug – in the foreground to help draw the viewer into the picture.

Drawing in coloured ink

Spontaneous lines drawn in pen and ink give this figure study a sense of vitality, while colour washes add solidity.

Coloured ink is often used as a substitute for watercolour to create paintings with beautiful, intense washes. But, of course, it is equally appropriate for line drawings.

Remember, ink cannot be rubbed out, so once you have made a mark you have to live with it. It is, therefore, a good idea to start a pen-and-ink drawing with caution. Use dilute ink and tentative marks to plot the position of the subject on the paper. When you feel confident about the composition, gradually introduce bolder lines and stronger colour. And once you have established the main lines of the composition, you can be much more free in making minor corrections later.

Pen and wash

For this figure study, our artist started with a line drawing using a limited range of waterproof coloured inks. The drawn lines were approximately the same colours as those on the figure – warm earths and orange for the flesh, sepia for the hair. Washes were added to the completed drawing with a Chinese brush.

Pale lines and marks used in the early stages of this drawing were achieved by first dipping the pen in coloured ink, then dipping the loaded nib in water. The deeper you dip into the water, the paler the mark will be. This technique, sometimes known as 'double dipping', takes a little practice, so try it a few times before embarking on a drawing.

Making corrections

No matter how careful you are, corrections are inevitable and you will almost certainly need to make a few adjustments as work progresses. In addition, the model will need frequent rests and will never return to exactly the same position after each break.

In this drawing, the artist made several changes to the position and shape of the model's right hand. Far from detracting from the final result, the corrections lend a sense of movement to the drawn figure.

If the model moves, or you discover a mistake, simply make another line to replace the incorrect one. And don't worry if you need several attempts and end up with a number of overdrawn lines. Always take a positive approach and treat corrections as a valuable part of the drawing process.

▶ **The relaxed pose of the model together with the folding chair create a composition full of exciting diagonals.**

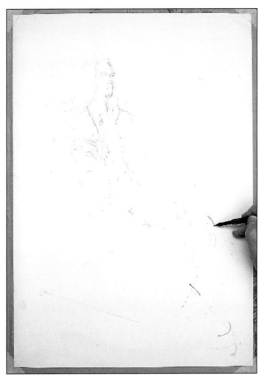

YOU WILL NEED

Piece of cartridge paper 60 x 40cm (24 x 16in)

Dip pen with medium nib

6 waterproof inks: Orange; Burnt sienna; Raw sienna; Sepia; Blue; Black

Chinese brush

Jar of water

Dishes for mixing washes

FIRST STEPS

1 ▲ **Plot the figure** Using a dip pen, plot the position of the figure with dots of faint colour to mark key points. Working with dilute inks, start to draw the head and shoulders. Use orange, burnt sienna and raw sienna for the flesh, and sepia for the eyes. Continue with the rest of the figure. Establish the lines of the waistcoat in dilute sepia. Use sepia, too, to mark the position of the crotch, knees and feet.

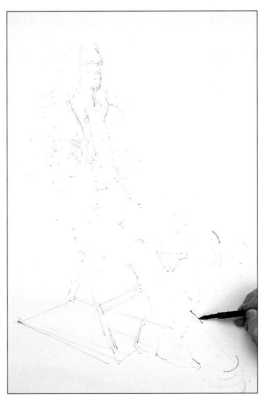

2 ◄ **Work on the legs and feet** Still working in dilute sepia, move to the lower half of the figure and establish the legs, feet and chair. Make sure the spaces between the figure and the chair are accurate, and also that the triangular space between the knees is correct.

3 ◄ Define shirt and waistcoat Working in dilute blue and sepia, establish the shirt sleeve and waistcoat. Pay attention to the creases and folds in the fabric as well as to the outlines. These will help to indicate the position of the arm and shoulder underneath the fabric. Strengthen the hand and the chair back to match the newly established dark tones on the clothing.

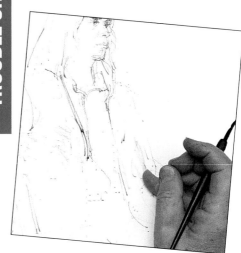

TROUBLE SHOOTER

SMUDGING LINES

If a drawn line is obviously too dark compared with the rest of the drawing, smudge it with your finger or a paper tissue before the ink dries. The resulting pale smudge will soon become integrated into the picture.

4 ► Begin to add detail to the face Shade the nostril with burnt sienna and the upper lip with hatched lines of raw sienna. Emphasise the hair around the forehead by hatching the shadows with strokes of pure sepia. Use overlaid strokes of sepia to describe the eyebrows, eyes and eye sockets.

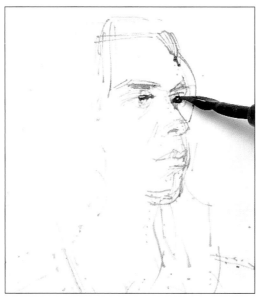

DEVELOPING THE PICTURE

Now that you have established the basic shape and position of the figure, you can concentrate on the texture of the clothing, making adjustments where necessary. Begin to describe the torso and legs with finer details.

5 ► Develop the clothing Work on the top part of the figure in blue and sepia inks, suggesting the fabric of the waistcoat and shirt in bold, flowing strokes. If you need to make any adjustments, simply draw over the existing lines.

6 ▲ Make corrections to the torso Working closely from the model, continue to build up the torso. Make any necessary corrections as you go. For example, the position and shape of the hand has been changed to accommodate a slight shift in position by the model. Also, the torso is a fraction too long and this is corrected by repositioning the belt.

7 ▼ Outline the trousers Moving down the figure, draw the left hand and outline the legs in burnt sienna and blue. Follow the contours of the trousers, paying attention to the stretched fabric at the knees to establish the position of the legs.

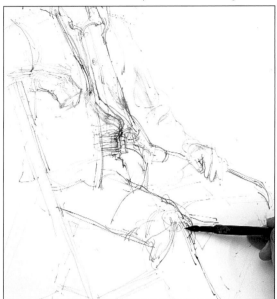

Finding the right tone for different areas of the figure drawing is a matter of trial and error. To avoid making mistakes that you can't easily correct, test the diluted ink on a separate piece of white paper before committing it to your actual drawing.

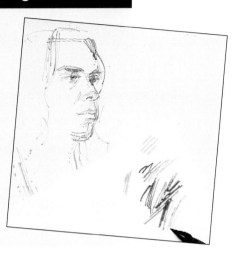

8 ▲ Complete the legs Smudge the dark lines on the trousers in places to create deep shadows. Keep checking the model's pose and make any necessary alterations, as before. Here, the back leg is being repositioned slightly in relation to the chair.

Express yourself
A pastel portrait

When you have completed the ink drawing, try a portrait or figure study in pastel, then compare the two mediums. This portrait of the same model is drawn in sanguine pastel, and the artist has taken advantage of this powdery colour to blend some of the lines, such as those shading the cheek, by rubbing them with a paper tissue. On the hair, however, the fine pastel lines describe texture and movement in the same way as pen and ink.

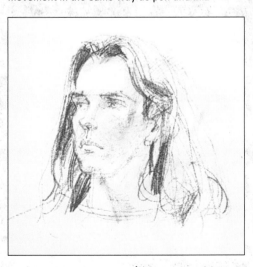

9 ◄ Work colour and texture into the hair Establish the local colour and shadows in the hair in pure sepia, cross-hatching the darkest areas. Build up the texture using bold strokes that follow the direction of the hair.

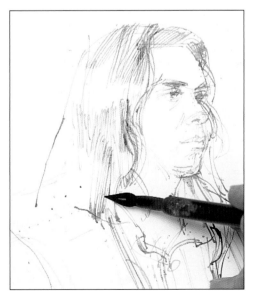

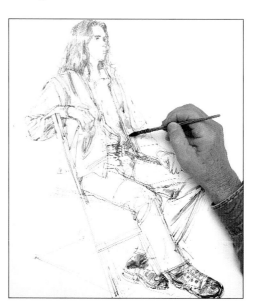

10 ▲ **Firm up the lines** Working in pure black, go back over the figure, strengthening the earlier, tentative drawing. Make any last-minute adjustments by drawing over earlier marks with strong, decisive lines.

The structure of the drawing is now complete. However, you might want to develop the tone by adding washes of local colour and introducing some darker shadows.

11 ▶ **Add tone and colour** Work back into the drawing in black to indicate dark shadows, such as the one on the inner collar. Block in the boots with heavy black shading, leaving the highlights as white paper. With a Chinese brush, paint the waistcoat in a wash of blue and raw sienna, and allow this to dry. Use the same colour to cross-hatch tone on the forehead.

Master Strokes

Walter Richard Sickert (1860-1942)
Yvonne

Unpretentious domestic interiors were among Sickert's favourite subjects – this intimate study of a young woman captures her in a simply furnished bedroom, absorbed in her task. The paint is applied vigorously, yet quite sparsely in places so that the canvas is left showing through the pigment, giving a slightly broken surface. The walls and floor are painted in drab shades, but the picture is lifted by the play of light across the figure and bed. The light is reflected particularly brightly on the woman's slip, attracting the eye towards the centre of the composition.

Light falling on the scene from the front right of the picture creates a strong vertical pattern of shadows on the wall behind the bed.

By positioning the bedpost right in the foreground, Sickert draws the viewer straight into the picture, heightening the sense of intimacy.

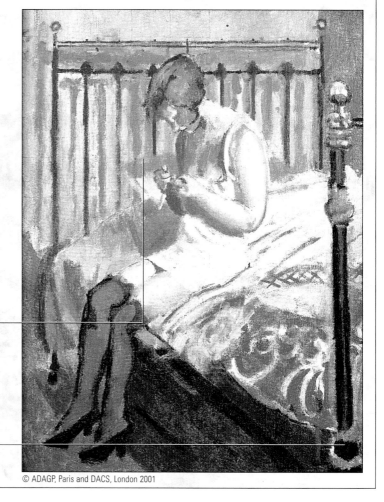

12 ▶ **Brush on more colour** Paint the dark shadow areas of the hair with dilute sepia ink. Then make a dilute mixture of blue and black, and use this to paint the grey shirt.

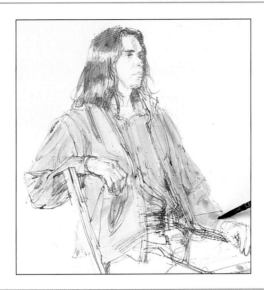

13 ▲ **Darken the shoes** Finally, use the dip pen and pure black ink to define the shadows on the boots, using the direction of the lines to describe the rounded forms.

THE FINISHED PICTURE

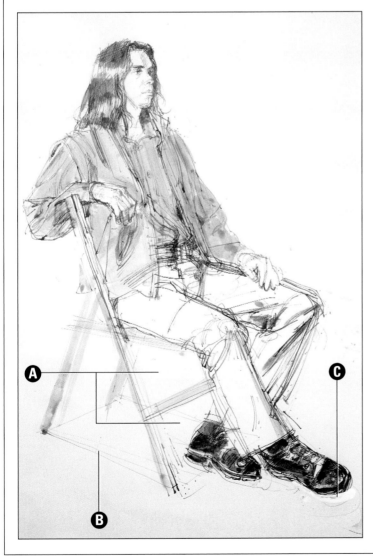

A Negative space
The chair was treated as an integral part of the subject, the negative spaces between the chair and figure playing an important role in the overall composition.

B Positive shape
The space on the floor occupied by the chair and model was established in the drawing as a positive shape. The legs and feet of the figure were then positioned correctly in relation to this shape.

C Black and white
The boots were darkened with a final wash and a little white liquid paper was used to correct the shape of one of them.

Self portrait

If you can't find a willing model to sit for you, the obvious answer is to draw a portrait of someone who is always available – yourself.

▲ **By using water-soluble coloured pencils, the artist was able to combine lively shading with soft washes of colour.**

If you are new to portrait drawing, you might feel uncomfortable about asking someone to sit for you until you have had more practice. Instead, an excellent way to find out more about the human face in your own time is by studying your reflection in a mirror and drawing from this.

For a full-face portrait, set up a mirror in front of you, about 30cm (12in) beyond your drawing board, so that you can see your head and shoulders comfortably and clearly. Alternatively, to view yourself from different angles, place two mirrors so that one reflects the image from the other.

It is natural to frown slightly as you look hard at your features and concentrate on capturing them on paper. Try to avoid doing this by consciously adopting a relaxed expression.

Light and colour
For this self portrait of the artist, the lighting was set up on the left, illuminating this side of the head and throwing the right side into shadow. This helped to emphasise the three-dimensional form of the features, as well as giving an interesting contrast of tones.

The lively colour on the face was achieved by gradually building up the flesh tones with layers of coloured pencil. Two useful shades for flesh tones – warm brown and rose pink – are given away free with this issue. They can be blended with a little water where required.

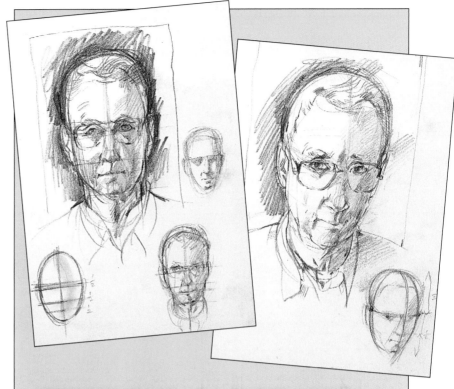

YOU WILL NEED

Piece of cartridge paper, 50 x 40cm (20 x 16in)

6 water-soluble coloured pencils: Warm brown; Rose pink; Light blue; Dark grey; Cobalt blue; Indian red

Putty rubber (for erasing mistakes)

No.1 brush and jar of water

FIRST STEPS

1 ▼ **Sketch the head** Use a warm brown water-soluble coloured pencil to sketch the head and shoulders. Measuring the proportions with the pencil, mark guidelines to position the eyes, nose tip and mouth (see right). Sketch the features and indicate the main shadows.

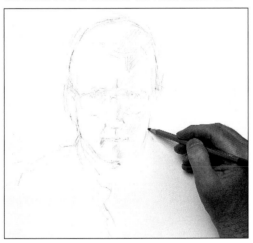

2 ▼ **Strengthen the shadow** Still using the warm brown pencil, shade the upper lip. Darken the shading on the right side of the face, taking it down to the shirt.

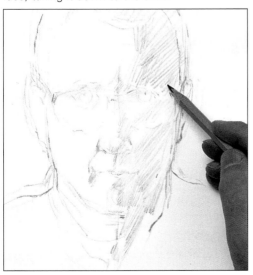

STRAIGHT ON OR AT A SLIGHT ANGLE?

A front view of your face (left) is easier to observe in a mirror and your features are positioned symmetrically. Notice how the eyes come about halfway down the head. The tip of the nose is about halfway between the eyes and chin, and the mouth halfway between the tip of the nose and the chin.

You can also try drawing yourself with your head slightly turned (right). This may be more pleasing in terms of composition, but is a more awkward position to achieve with a single mirror. You need to sit at an angle to the mirror or to turn your head frequently. The same guidelines for positioning the features apply, although the lines need to be curved to follow the form of the head.

BRING IN MORE COLOURS

Now that the structure of the face and the main tonal areas are mapped out, introduce more colours to build up a realistic flesh shade and define the features. Some of the colours can be blended into a wash with water.

3 ▶ **Introduce a warm pink** Extend the warm brown shading to the left side of the neck and very lightly shade the left side of the face, including the glass of the spectacles' lens. Then change to a rose pink pencil to warm up the flesh colour on the face and neck.

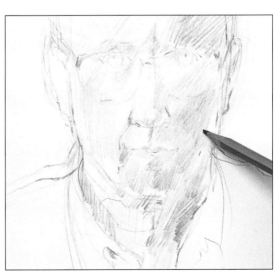

203

4 ▼ Define the eyes Darken the shadow above the nose, under the chin and on the right of the face with the warm brown pencil. Define the spectacles, shading lightly over the right lens. Develop the eyes, colouring the irises with a light blue pencil, then use the same colour to shade loosely over the shirt and add cool shadow to the white hair.

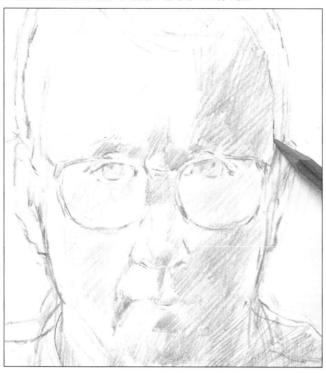

5 ▼ Shade a dark background Using a dark grey pencil, work lively shading across the background. Minor adjustments to the head outline can be made at this stage. The dark colour throws the head into relief and forms a strong contrast to the artist's white hair. Hatch a few textural lines over the right side of the hair.

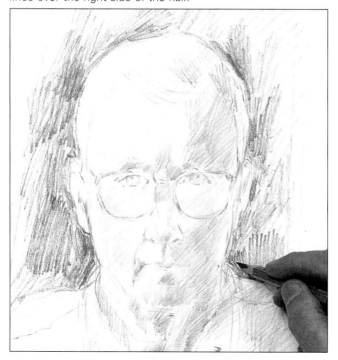

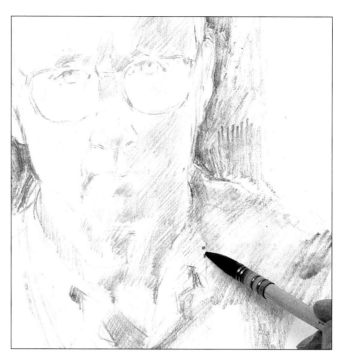

6 ▲ Brush on some water Emphasise the pupils with the dark grey pencil, then change to a cobalt blue pencil to liven up the colour of the shirt. Now dip a No.1 brush into water and wash over the background to soften the dark grey pencil lines. Clean the brush, then use it to blend the two shades of blue in the shirt.

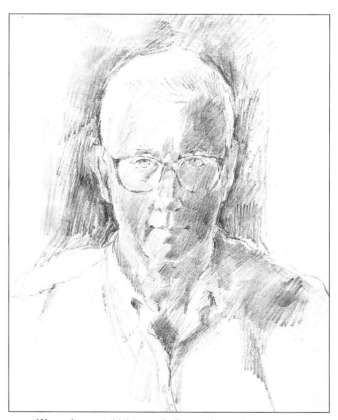

7 ▲ Warm the tone Using an Indian red pencil, warm up the tone on the right of the face. A little tone at the corners of the mouth lifts it into a smile. Shade lightly across the face with warm brown and rose pink, leaving highlights of white paper. Redefine the features with the warm brown pencil.

The lively rendering of the artist's face is now complete. There is always room to add a few more details to the features, but don't overwork them and risk losing the spontaneity of the drawing.

8 ▶ Shade a darker background With the dark grey pencil, deepen the tone around the head, fading the colour out towards the edges. Add texture to the eyebrows with a few jotted marks in warm brown and dark grey. Extend the shirt with light blue hatching.

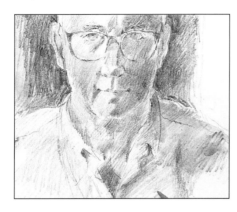

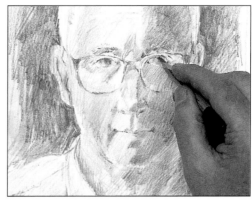

9 ▲ Add final definition Use light blue again to add depth to the irises. With Indian red, put in the final definition on the eyes, including the inner corner of the eye on the right. Darken the pupils with dark grey.

THE FINISHED PICTURE

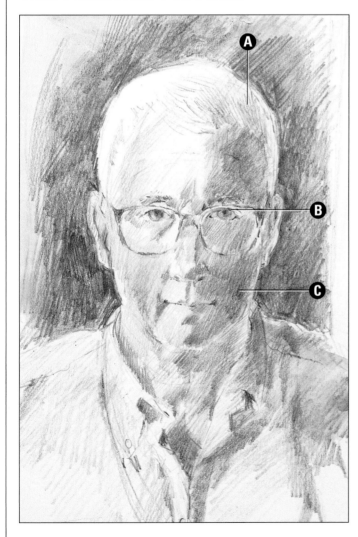

A Hair texture
Just a few loose lines in light blue and dark grey were drawn on the shaded side of the white hair to suggest its texture.

B Sensitive detail
The facial features, especially the eyes, were sensitively drawn with a sharp coloured pencil. They show the artist's character without becoming too dominant.

C Blended flesh tones
Layers of brown and a warm pink were worked lightly over one another, visually blending to give a warm and lively flesh colour to the face.

Creative portrait

Use a combination of conventional and unusual materials and techniques to produce a colourful, decorative portrait.

The idea behind this painting is simple – the artist wanted to be creative and free in his approach, while at the same time retaining a likeness of his sitter. To get the best from an exercise such as this, choose a subject you know really well – a relative or a friend. By all means, work from a reference photo rather than from life – but don't copy the photo slavishly.

The idea is to let your imagination have free reign, using the subject as a jumping-off point. Allow yourself to take pleasure in the colour and consistency of the paint, the way it moves on the surface or drips from a brush or stick. Try to retrieve the pleasure you gained as a child from paint and mark-making. On the other hand, keep in mind that the image you produce should resemble the subject and capture something of his or her personality. So stand back and review the progress frequently and, if the image has moved too far away from accuracy, drag it back with a few judicious touches. It is a tricky balance but this painting proves it can be done.

Immerse yourself in the subject
Before you begin, make a close study of the reference photo or the subject. Familiarise yourself with the proportions, colouring and expressiveness of the face and the way in which these reflect mood. The more you immerse yourself in your subject, the more you see and understand.

Make preparatory notes and sketches, observing, for example, the undertone of the skin – some people have a warm, pinkish tone to their skin, like the model on the left, while others may have a coolish tinge, which is exaggerated under some lighting conditions. This will give you a clue to the palette you might use. Make this study some time before you put brush to canvas. When you tackle the project, these visual memories will come into play.

A useful way of freeing yourself from working too literally is to make a digitised print from the colour photo (see above, right). If you don't have computer equipment, go to a print bureau. Ask for the photo to be scanned at a low resolution (72 dots per inch or less) and blown up to twice the size. This will break up the photo into a mosaic of shapes and colours, and provide a good starting point for a colourful interpretation of the subject.

A layered approach
The step-by-step project is painted in three distinct stages, using three very different media and techniques. Working in layers and introducing unusual materials will help you to approach the subject with fewer preconceptions.

Use washy acrylic for blocking in the underpainting. It dries fast, allowing you to get the main elements of the composition in place quickly. Then place the painting on the floor and drip household gloss paint over it to create a tracery of lines. In the final stages, apply oil paint in dabs to pull the image into focus. This complexity creates a sense of depth and encourages the eye to linger and enjoy the painting. Finally, add glitter to the background – this will make the head really stand out.

▶ **A combination of traditional artist's acrylic and oil paints, together with less conventional materials – household gloss paint and glitter – results in a painting that is both entertaining and descriptive.**

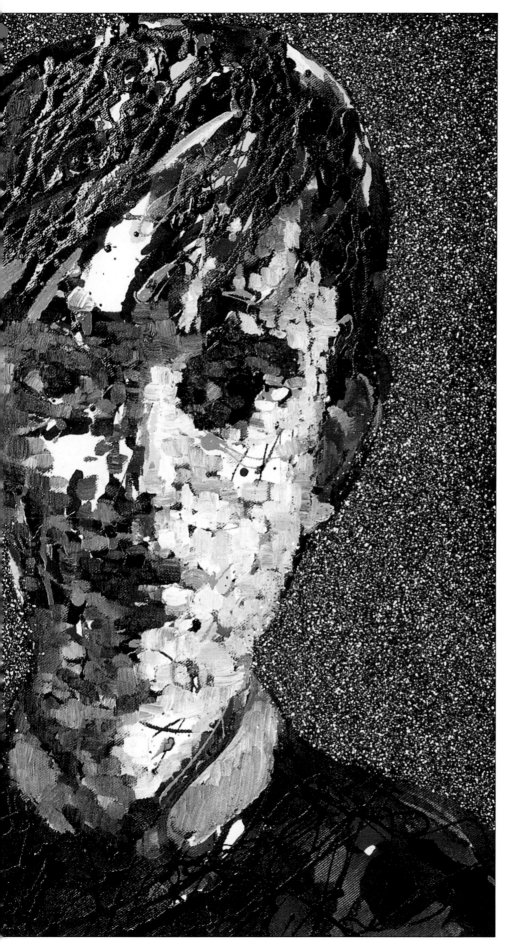

FIRST STEPS

1 ▲ **Establish the underdrawing** Using a 2B pencil, draw a rough egg shape for the head and start to plot the main features. Don't worry too much about achieving complete accuracy – a few minor distortions might say something about your response to the sitter.

2 ► **Block in yellow acrylic** Load a 50mm (2in) hake brush with dilute cadmium yellow acrylic paint. Using the digitised image as a guide, start to apply patches of bright colour on the blond hair and the light areas of the face and neck.

▲ **A wash of alizarin crimson (left) overlaid with ultramarine (centre) creates a deep purple shade (right) for the shadow tones.**

3 ► **Apply magenta acrylic** Still using the hake brush, apply magenta acrylic to stand for the cool reds and pinks in the digitised image. Work magenta over the pullover, too. The broad shape of the hake brush gives a range of thick and thin marks, while the pliant bristles give the marks a fluent, calligraphic quality.

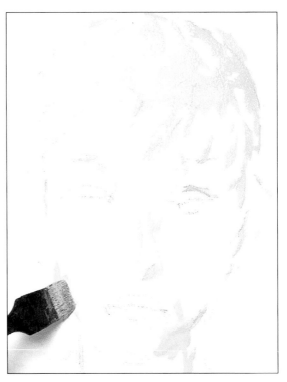

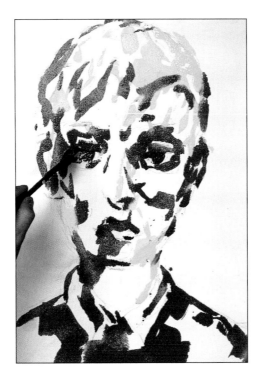

4 ▼ **Add a warm red** Still working with dilute acrylics and taking your lead from the digitised print, apply alizarin crimson over the crown of the head and on to 'hot' areas, such as the ears and around the eyes, defining their forms.

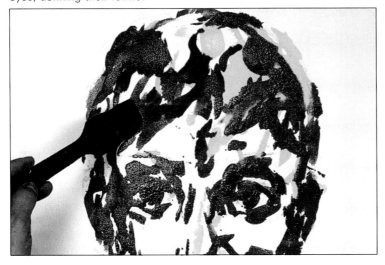

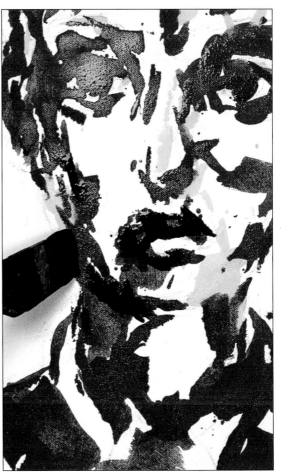

5 ▲ **Introduce a dark tone** Load the hake brush with fluid ultramarine acrylic and tap the end of the bristles on to the support to make lines charged with colour. Use these to refine the drawing, defining key features such as the mouth and jawline.

6 ▶ Develop the dark tones Continue applying the fluid ultramarine paint to the face and pullover, allowing it to bleed into the still-wet reds and yellow. This method of working gives rise to random blending and pooling of colour, and these 'happy accidents' should be welcomed. Notice how the blue blends with the two reds to produce mauves and purples.

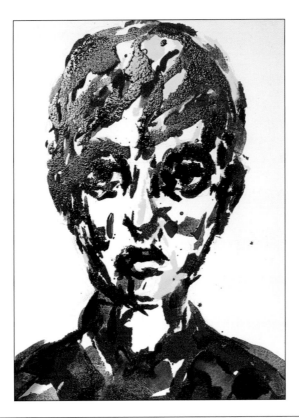

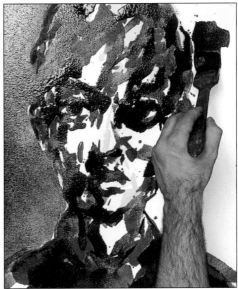

7 ▲ Paint the background Load the brush with violet and introduce this colour into the shadow areas – around the eyes, across the head and down the right cheek. Apply a thin wash of violet over the background. Leave the painting to dry thoroughly.

Master Strokes

Frank Auerbach (b. 1931)
Head of Gerda Boehm

This highly individual interpretation of a woman's head is painted in the Expressionist style by London-based artist Auerbach. Worked in oils, it demonstrates the artist's characteristic use of impasto, in which the paint is applied very thickly and retains the marks of the brush or painting knife.

Many aspects of the picture – the colours, the shape of the head, the thick, black outline – appear distorted. The aim of the artist, however, was not to produce a natural-looking likeness, but rather to convey the character of his sitter as he personally saw it. And, of course, in the thick, luscious brush strokes there is – as in the step-by-step project – an enjoyment of paint for its own sake.

On the face, greens and yellows have been loosely combined on each brush stroke to give a marbled effect.

Small peaks and narrow trails of oil paint were created where the brush was dragged across the support and lifted at the end of some of the strokes.

© Frank Auerbach

8 ▼ Drip gloss paint Using an old paint brush or a stick, mix magenta, cadmium red and phthalo blue household gloss paints in a jar to make a warm brown. Thin the mix to the consistency of single cream by adding a few drops of turpentine or white spirit. Place the canvas on the floor, load the brush or stick with colour and drip on lines of paint to 'draw' features such as the eyes, the curve of the jaw and the strands of hair.

EXPERT ADVICE
Dripping paint

Dripping thinned oil paint from an old brush or stick is ideal for breaking up areas of flat colour, such as on the boy's pullover, as it introduces a linear element. Move your brush around just above the surface, making expressive, swirling marks.

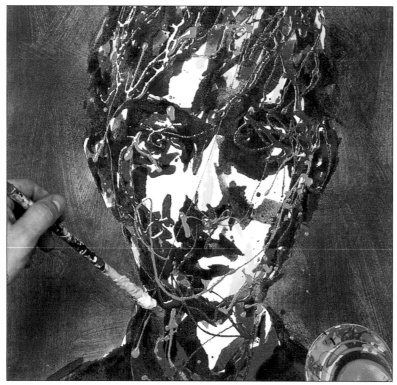

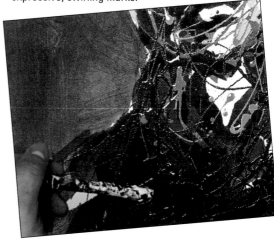

9 ▼ Drip more paint Working as before, drip more gloss paint over the image, spattering it in places. First use a tangerine mixed from cadmium yellow and magenta, then a violet mixed from magenta and phthalo blue. Follow this with white, then phthalo blue. Allow the paint to dry overnight.

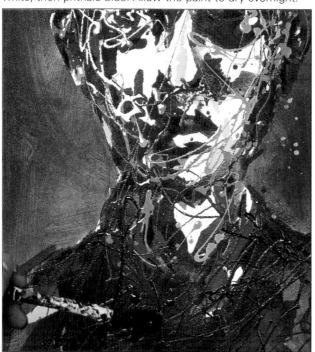

DEVELOPING THE PICTURE
The process of applying dripped paint required broad gestures and played up the abstract and decorative aspects of the composition. Now it's time to pull the image into focus by applying a mosaic of flesh tints in oils.

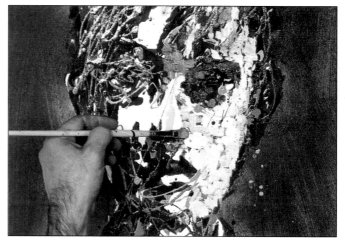

10 ▲ Apply oil paints Mix alizarin crimson, lemon yellow and ultramarine oil paints to create a dark tone; using a No.6 flat bristle brush, apply dabs to the right eye socket. Mix light flesh tones from titanium white, vermilion and alizarin crimson; white and vermilion; alizarin crimson and lemon yellow; white, alizarin crimson and ultramarine. Start to build up the right cheek, dab by dab.

11 ▼ Apply warm tones Mix a warm pink flesh tint from alizarin crimson, white and lemon yellow, then apply touches down the nose and on the lips. Add more white and take this colour on to the cheeks.

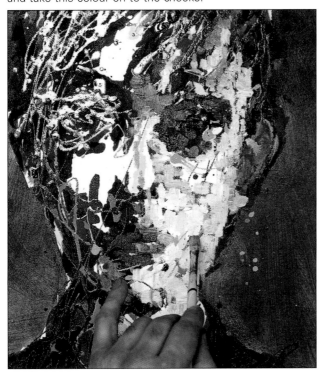

12 ▼ Develop shadows Build up the shadowed side of the face with various mixes of yellow ochre, burnt umber and burnt sienna, wiping the brush on a rag between mixes. Mix more dark skin tones from a mix of burnt umber, vermilion, ultramarine and a touch of white, and a mix of ultramarine and alizarin crimson.

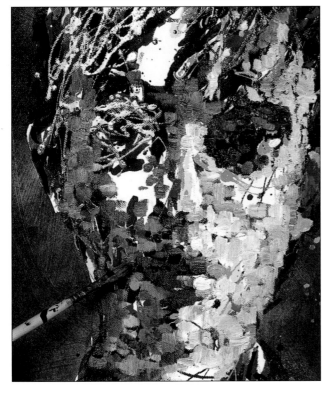

▲ The flesh tones were created with a wide variety of colours and tones, including white with a hint of ultramarine (A); white with a touch of vermilion (B); burnt sienna (C); white, ultramarine and alizarin crimson (D); ultramarine and alizarin crimson (E).

Express yourself
Coloured-pencil study

This coloured-pencil study of the boy has the same lively quality as the step-by-step painting. The artist held the pencils at an angle, allowing him to make thick, grainy lines with the side of the lead. Holding the pencil in this way also encourages a free and uninhibited drawing style – long flowing lines and scribbled areas of tone are easy to render.

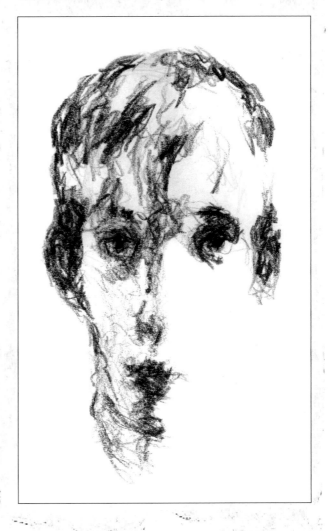

13 ▼ **Paint the eye sockets** Continue to sculpt the right side of the head with controlled, blocky brush marks, using the same dark tones as in step 12. Develop the right eye socket.

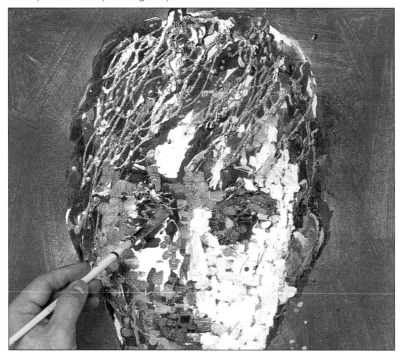

14 ▲ **Paint the right eye** Using touches of burnt umber, burnt sienna and the flesh tint from step 11, block in the eye. Simply put down the patches of light and dark, and warm and cool, as in the digitised print, and an eye will emerge.

A FEW STEPS FURTHER

The image now works as a good description of the subject. When you stand back, the separate dabs of colour resolve in the eye to create pearly skin tones. The background, though colourful, lacks texture by contrast with the rest of the image, so consider adding interest here.

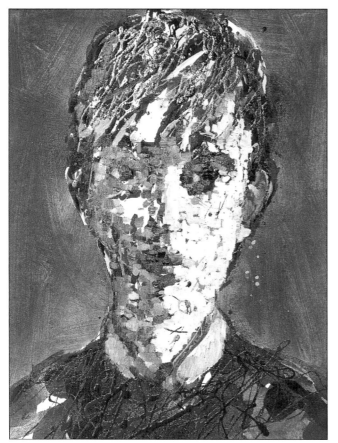

15 ▲ **Complete the flesh tones** Continue building up the flesh tones, keeping the brush marks loose and avoiding the temptation to 'fill in' all the gaps. The technique is most effective when the mosaic of oil paint forms a broken film that allows the underlayers to show through.

16 ▲ **Apply gloss to the background** Using a No.10 flat bristle brush, apply magenta gloss paint all over the background, working carefully around the head.

17 ◄ **Apply glitter**
While the magenta gloss paint is still wet, sprinkle a layer of silver glitter over the surface. Tip the support to shed any loose glitter. Work very carefully to avoid getting glitter on the face, or this will spoil the effect.

THE FINISHED PICTURE

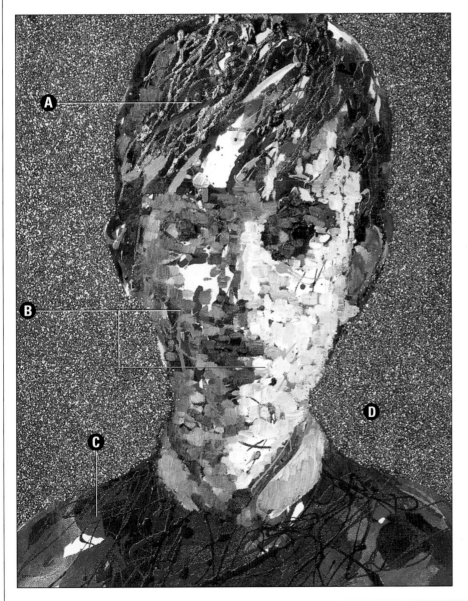

A Strands of hair
Dribbled gloss paint suggests the springy texture of hair. Washes of bright acrylic can be glimpsed through the shiny strands.

B Mosaic of paint
Dabs of oil paint in a wide range of flesh tones form a mosaic of small squares that, when seen from far enough away, really capture the advancing and receding planes of the face.

C Complex layers
Washes of semi-transparent acrylic paint have the luminosity of watercolour. Seen through dribbles of gloss paint, they create a sense of depth.

D Sparkling finish
Glitter adds a surprising but highly decorative touch, and ensures that the painting catches the light and sparkles.

A stylised portrait

*By combining tracing and collage, you can produce
an effective portrait of anyone you choose.*

People have always been fascinated by portraits. They give both painter and viewer the opportunity to study a face in detail and consider the character of the subject. Artists throughout history have used portraits to try various techniques and to explore different approaches to textures and colours to draw out the essence of their chosen model.

This stylised portrait uses the simple method of tracing the features of a photograph or painting. Even if you aren't very experienced at drawing faces, this ensures an element of accuracy and a surprisingly professional and satisfying result. Mounted over a collage of fabric or torn paper, this portrait will be sure to become an object of fascination and comment.

YOU WILL NEED

Photocopy of photo or portrait (choose a subject with strong shadows)

Light box, or window with light source behind it

Masking tape

Sheet of acetate (transparent film suitable for photocopying)

Piece of white paper

Black felt-tip pen

Coloured fabric or paper in five or six shades of the same colour

Scissors

PVA glue

Coloured mounting paper or card

Frame

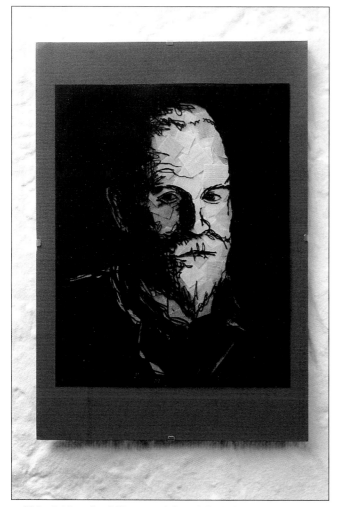

▲ This vivid, stylised likeness of the original photograph was
created using a fascinating technique that is fun to try out
and simple to follow.

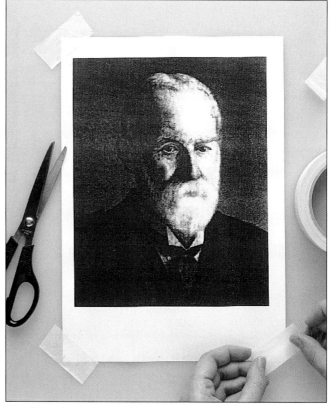

1 ▲ **Tape the photocopy to a light box** Take the photocopied portrait and tape it to a light box. If you don't have a light box, you can tape it to a window with a strong light source, such as bright daylight, behind it.

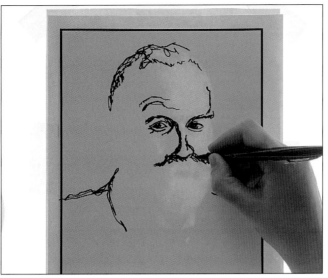

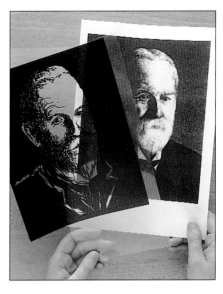

5 ▶ **Transfer the drawn portrait**
Ensure that your acetate is the type that can be passed through a photocopier. Photocopy the finished tracing on to the acetate.

2 ▲ **Trace the image** Tape a piece of white paper over the photocopy. Using a black felt-tip pen, begin to trace the features of the portrait, drawing dark marks over the shadows of the original. Start with the eyes, nose and mouth. Trace just the outlines of larger, shadowy areas.

3 ▶ **Strengthen the shadows**
When the main features are blocked in, colour in the darker areas of the portrait to create the deeper shadows of the face. A free scribbling action all over the shadow areas can look particularly effective.

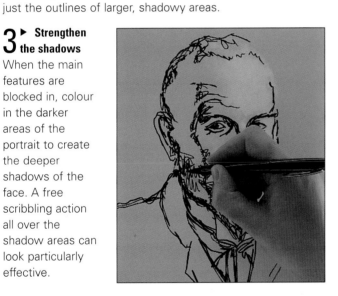

6 ◀ **Prepare the background**
Cut fabric or paper into 10mm (⅜in) squares. If you are using paper, you could tear it to give softer edges. Cut about 20 or 30 squares of each colour and keep them in separate piles.

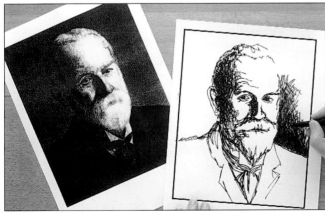

4 ▲ **Block in the background** Remove the photocopied portrait and tracing from the light box. Using the portrait as a guide, block in the background areas on the tracing with solid black. Fill in the clothing with black, too, but leave some gaps for the edges of features such as ties, collars and lapels.

7 ▲ **Glue on the background material** Arrange the background pieces on to the original photocopy of the portrait. Glue the lightest pieces on the lightest areas of the face. Then, working outwards towards the shadowy areas, glue on the darker pieces, grading the colour across the face.

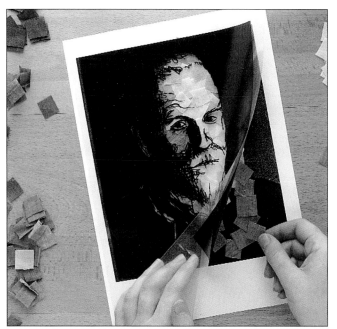

8 ▲ **Complete the background** Continue gluing on the squares of fabric or paper until all the light areas of the face and clothes have been covered.

9 ▲ **Finish the details** Position the acetate portrait over the fabric or paper squares. Wherever the features are not as light or dark as they should be, lift up the acetate and glue more squares in place. Leave to dry thoroughly, then trim off any excess border on the photocopy. Put dabs of glue on the back of the acetate in the blackest areas and stick it down. Mount on coloured card, then add a frame.

THE FINISHED PORTRAIT

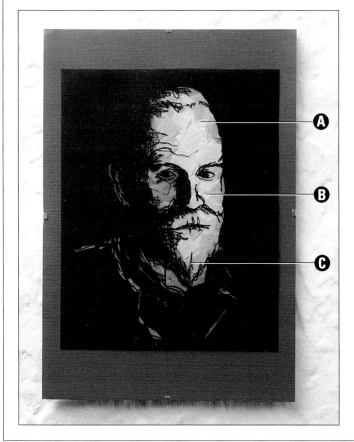

A Fabric collage
Little squares of flesh-coloured fabric were glued to the tracing of the face to provide the skin tone.

B Acetate layer
When the portrait was photocopied on to acetate, the light areas were left transparent, so that the fabric pieces underneath could be seen.

C Lively sketch
The lines used to trace the original portrait were kept loose and dynamic, avoiding any unnecessary detail.

Drawing a child

Find out how to draw successful portraits of your own and your friends' children that will provide lasting memories of their early years.

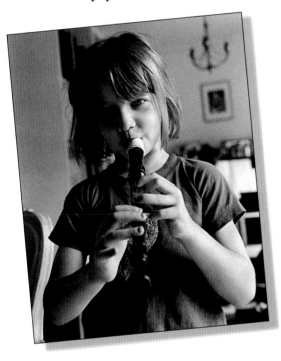

Pencil drawings are a wonderful way to capture those precious moments of childhood that are over all too soon. But drawing a child needs a different approach from drawing an adult friend or model. Very young children find it difficult to sustain a pose for long, so you will have to work fast and loose if you intend to draw from life.

To make a more considered study, with accurately rendered detail and shading, it is probably better to work from a photo – as the artist did here. However, there is a danger that pictures worked from photos can be rather static so, ideally, spend some time sketching your subject in life – looking in particular for subtle changes in the child's expression.

Holding a pose

Slightly older children can often be encouraged to hold a pose for longer periods if they are engaged in a favourite activity. One of the best times to draw a child is when they are 'glued' to the television, or lost in a book.

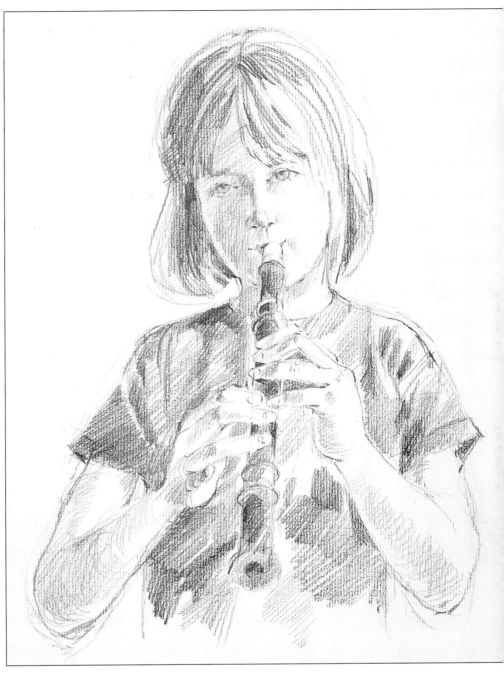

▲ **A light, sensitive touch with a graphite pencil conveys the soft, rounded limbs and delicate features of this young girl.**

The pencil drawing here is of a six-year-old girl. By posing her playing the recorder, the hands become an important focal point and they help balance the face. The slight tilt of her head prevents the portrait from being too symmetrical.

CHANGING PROPORTIONS

Children's faces and bodies alter with each passing year as their limbs become less chubby and their faces lengthen and gain definition. Be aware of these changing proportions when you are drawing – babies and toddlers have surprisingly large heads compared to their bodies, whereas adolescents gradually approach adult proportions.

In this diagram, the figures of three children of different ages are compared to an adult in terms of how many times the head fits into the body. A baby's head takes up a quarter of its total height, while the adult head fits into total body length on average between seven and seven-and-a-half times. The proportions of a six-year-old and a ten-year-old fall in between these extremes.

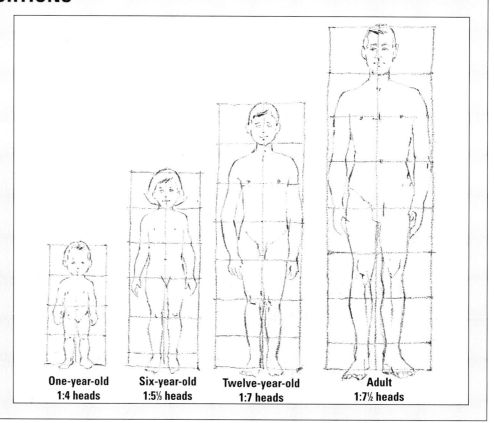

One-year-old	Six-year-old	Twelve-year-old	Adult
1:4 heads	1:5⅓ heads	1:7 heads	1:7½ heads

YOU WILL NEED

Piece of white Ingres paper

7B pencil

Putty rubber (for correcting mistakes)

Craft knife (for sharpening pencil)

FIRST STEPS

1 ▼ **Make a sketch** Draw the girl's head as a slightly tilted oval – to help you place her facial features, mark crossing guidelines that follow the angle of the head. Outline the shoulders and arms and rough in the position of the hands on the recorder. Lightly mark in the eyes, nose and mouth.

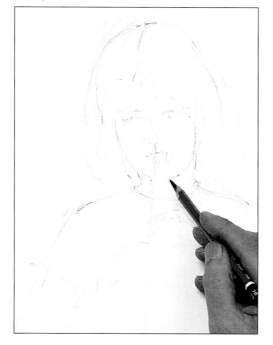

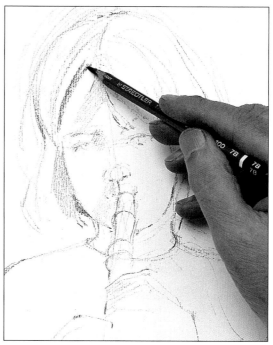

2 ▲ **Add definition** Define the eyebrows and the nose, marking nostrils on each side of the ball shape that forms the nose tip. Draw curved lines to show the segments of the recorder. Work a little light shading on the face to the left of the recorder, then hatch darker tone on the underside of the hair. Begin to add texture to the hair with curved strokes.

3 ▼ **Develop the fingers** Shade lightly over the left side of the face, which is in shadow. Now work on the lower part of the picture, strengthening the shoulders and arms. Draw the fingers carefully – look at how they are placed at intervals on the recorder holes and notice how the little finger of the right hand curls up.

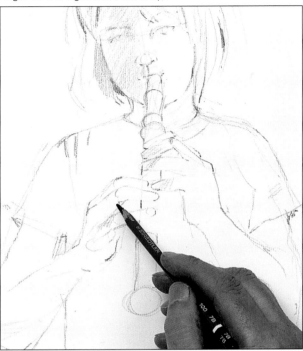

4 ▼ **Work up some shadows** Hatch shading around the fingers, curving the lines to indicate their rounded forms. Add more shading on the left side of the neck and on the arms. These shaded areas begin to give a three-dimensional feel to the limbs.

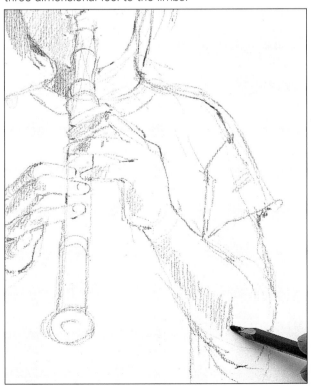

Looking at head size

In this photo of a boy aged three-and-a-half, the comparatively large size of the head is obvious – the domed skull dwarfs the shoulders. The features are close together, so that the facial area forms only a small part of the whole head. Make sure you show these proportions in your drawings.

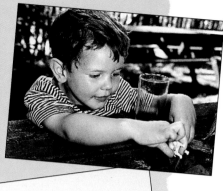

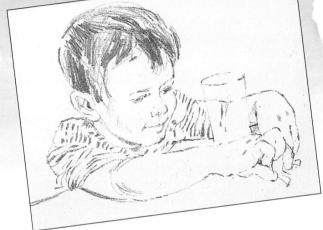

BRING IN DARKER TONES

At this point, it is a good idea to extend the tonal range by establishing some darker tones in the drawing. Work shading on the recorder and on the left side of the hair.

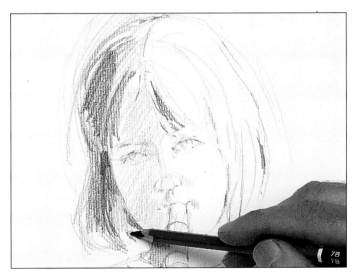

5 ▲ **Put dark tone on the hair** Sharpen your pencil with a craft knife and redefine the eyes around the iris and lids, taking care to keep the drawing subtle. Put in light shading at the corners of the nose and mouth. Now use more vigorous strokes to work dark tone over the left side of the hair.

6 ▼ Develop the features Lift the corners of the mouth into a smile. Shade the irises and emphasise the pupils, then put a small shadow under the inner corner of the right eye. Work up the dark colour of the recorder showing between the fingers. Loosely indicate strands of hair on the right, then add more shading under the chin on this side.

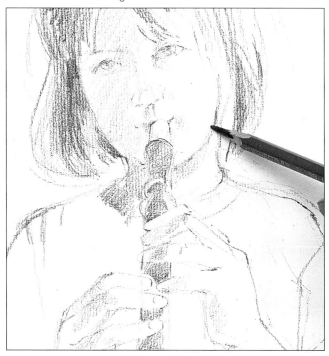

7 ▼ Work on the T-shirt Bring out the contrast between the light and dark sides of the face by shading once more across the darker left side, strengthening the nostrils and the shadow on the nose. Begin hatching areas of tone across the T-shirt to give the impression of folds in the fabric. The band of dark tone on the right shows the shadow cast on to the T-shirt by the girl's arm.

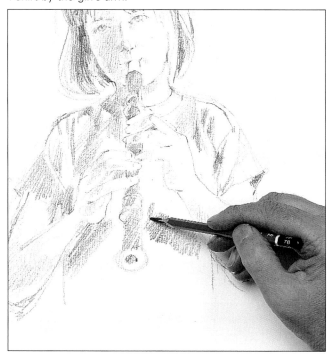

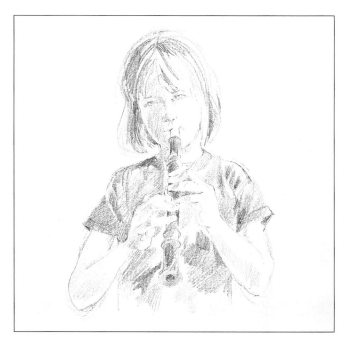

8 ▲ Complete the T-shirt Continue working medium and dark tones across the T-shirt to complete the shadows created by the folds. Moving back to the girl's face, very slightly darken the shading on the left of the face, leaving a pale edge to define the face against the dark hair.

A FEW STEPS FURTHER

It is important to avoid being heavy-handed when drawing a portrait – so to add any more definition to the features, keep a light touch.

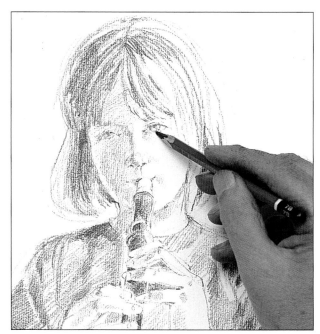

9 ▲ Refine the features Add shadow to the left side of the nose – the dark edge helps isolate this plane of the face from the gentler contour of the cheek. Fill out the fringe, then put in some subtle final touches on the eyes.

10 ▶ **Deepen tones**
Darken the shading on the arm, using curved lines to describe its rounded form. Strengthen the deep shadow on the T-shirt just below the arm. Put more definition into the fingers, darkening them at the joints.

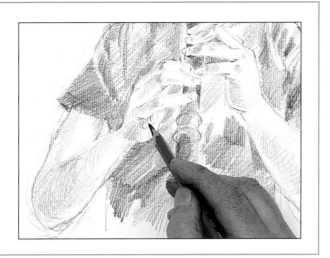

THE FINISHED PICTURE

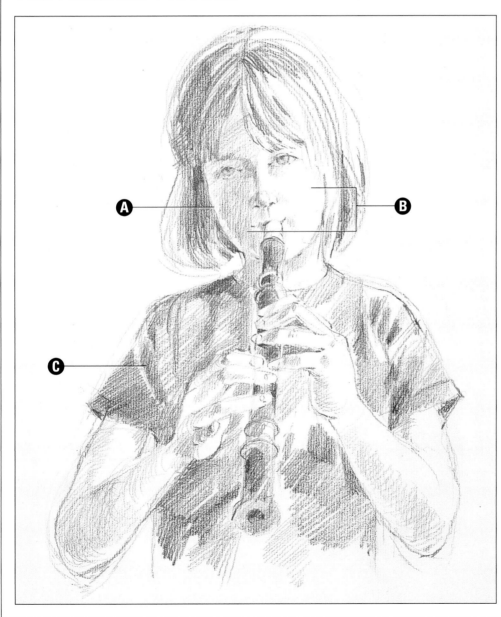

A Oval face
The face of the young girl retains its babyish chubbiness, so the outline around the jaw and cheeks was kept very soft and smooth.

B Light and dark
The portrait was lit from the right. The resulting contrast between light and dark on the face gives the drawing added interest and avoids the flattening effect that a front-lit, full-face portrait can give.

C Fabric folds
The folds and creases in the T-shirt were simply described with different blocks of tonal shading.

Pastel portrait of a child

The pure, vibrant hues of soft pastels and their powdery bloom make them ideal for describing the rounded features and dewy skin of a young child.

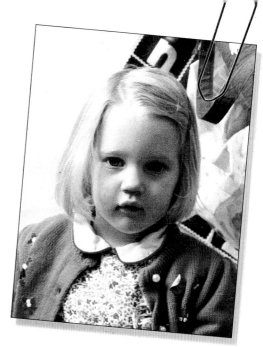

For your first exercise in portraiture, we'll be looking at how you can achieve a fresh, lively frontal depiction by using the principle of optical mixing – creating colour blends by gradually building up layers of broken colour that interact on the paper. From a distance, the separate strokes seem to merge, but because they are fragmented, the colours flicker on the eye and appear luminous.

Always start a portrait by blocking in the main lights and shadows that model the face. Once the structure is in place, you can progress to looking for the shapes within shapes, and then further breaking down the subtle planes and patches of colour that make up the overall flesh colour.

Using the paper colour

By choosing the paper colour wisely, you will find that you can leave areas of it untouched, thus saving yourself some work. For this portrait, the artist chose a buff-coloured paper, whose warm tone emphasises the fresh colours of the child's face. The mid-toned paper makes it easy to judge the relative lightness or darkness of the colours applied over it; this is more difficult to do when working on a white paper.

Proportions of a child's head

In general, the forehead of babies and young children is proportionately larger than that of an adult, and the eyes appear bigger in relation to the rest of the face. The nose, mouth and chin are small and soft, and appear to be set much closer together than in the adult face.

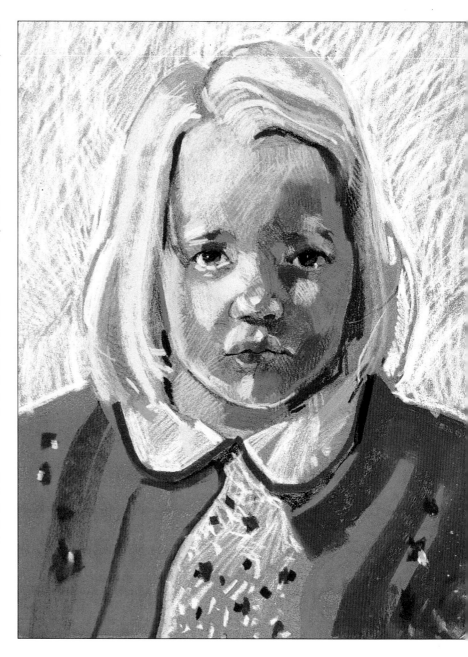

▶ In this pastel portrait, a complex network of overlaid strokes in varying tones of colour conveys an impression of light and shade on the child's face.

FIRST STROKES

1 ▶ **Make the initial sketch** Using a burnt umber Conté crayon, draw the outline of the child's face and hair, then plot the features with light, sketchy strokes. Look for highlights on the hairline, eyebrow and between the nose and mouth, and touch them in with a Naples yellow Conté crayon.

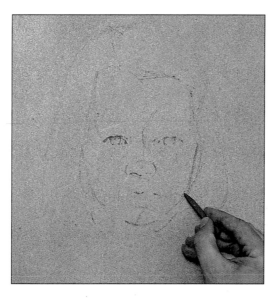

2 ▼ **Establish the shadow tones** Use the burnt umber crayon to block in the shadows in the hair, the eye sockets and under the nose and lower lip. Fill in the dark irises of the eyes.

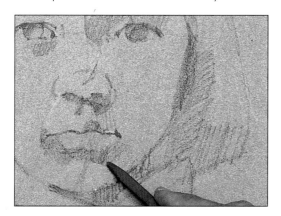

3 ▼ **Hatch in some highlights** With the Naples yellow crayon, block in the highlights on the skin and hair, mainly on the left, as this is where the light is coming from. Touch in the whites of the eyes. Use light strokes and avoid the temptation to start blending and rubbing, as you will lose the sense of form.

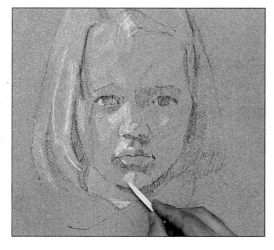

DEVELOPING THE PICTURE

Before starting to develop the flesh tones, step back and check the accuracy of your drawing. If you've worked lightly and loosely at the initial drawing stage, you will find it easy to make any necessary alterations.

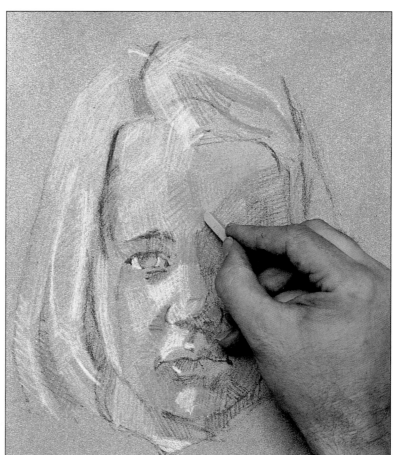

4 ▲ **Start to add colour** Using a burnt sienna Conté crayon, block in the warm mid-tones, mostly on the shaded right side. Use light, open hatching and cross-hatching, working in different directions to define the forms of the face. Then use a pale orange soft pastel for the warm highlights on the face and hair, again following the forms. The warm undertone of the paper should show through the overlaid strokes.

5 ▶ **Work on the eyes**
Use a black pastel, sharpened to a point to draw the pupil of the left eye. The brows cast a shadow over the eyes, so lightly shade over the top half of the iris. Fill in the whole of the right iris, as it is in complete shadow. Suggest the upper eyelashes with a broken line – never try to draw individual lashes because your model will look like a child's doll. Add the shadow between the upper and lower lips.

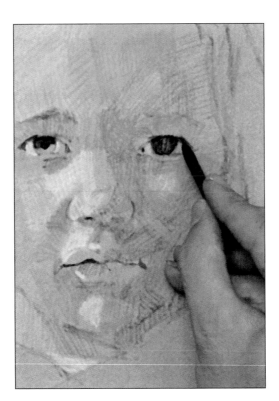

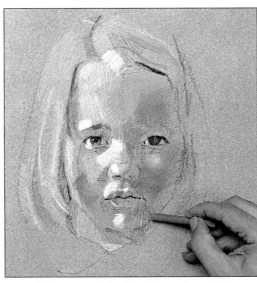

6 ▲ **Add tones and details** Use a piece of burnt orange pastel on its side to make broad marks on the brow, cheeks and lips. Define the eyes with cobalt blue and white. Touch in the highlights on the left with white, and the cool tones on the left with cobalt blue.

Express yourself

An informal portrait

In a very different treatment of the subject, the artist took the opportunity to sketch the little girl while she was absorbed in watching a cartoon on TV. He used Conté pencils in yellow ochre, raw umber, cadmium red, cobalt green and bright green on buff-coloured paper.

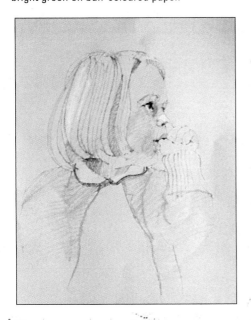

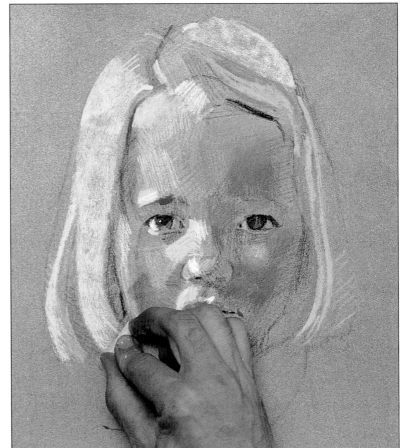

7 ▲ **Work on the hair** Use the point of a yellow ochre soft pastel to define the warmer tones in the girl's blonde hair. Then use a small piece of Naples yellow pale soft pastel on its side for the lighter, cooler tones. You don't have to fill in the hair completely; leaving the paper untouched in places provides another colour and also gives a more natural effect, preventing the hair from looking like a solid mass.

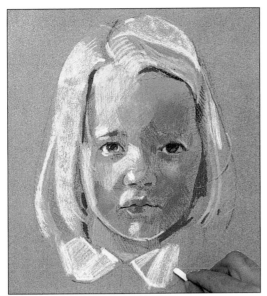

8 ▲ **Develop the skin tones** Strengthen the highlights on the left with Naples yellow and white. Add touches of burnt orange, burnt sienna and purple brown to the lips, then darken the nostrils and the shadow between the lips with black. Deepen the shadows on the right with purple brown. Use burnt umber to define the dark shadows around the face – these accentuate the form of the head. Add some wisps of hair with white, then fill in the collar of the dress.

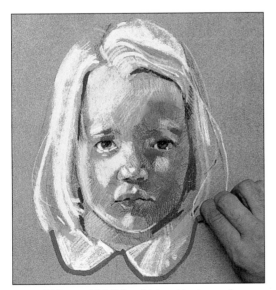

9 ▲ **Add more highlights** Using Naples yellow very pale, strengthen the highlights on the hair, adding more wisps with the tip of the pastel. With the same colour, lighten the cheek on the left, the forehead and chin, the tip of the nose and above the top lip. Stroke in soft highlights around the eye on the right and on the cheek. Complete this eye with dots of cobalt blue and white. Use burnt umber dark for the shadows beneath the nose and lips. Draw the red braid on the collar with vermilion.

Master Strokes

Pierre-Auguste Renoir (1841-1919)
Jacques Bergeret as a Child

Renoir achieved great success with his portraits from the late 1870s onwards. He was drawn to beauty in all his work and particularly enjoyed portraying attractive women and children. In this half-length portrait of a young boy, the child looks out of the painting with an innocent gaze. Renoir's characteristic feathery brush marks perfectly convey the soft, rounded face and wisps of curly hair.

A pale skin hue is often found in children with bright ginger hair like this young boy's. The white and pink tones of the face have a porcelain-like delicacy.

The viewer is drawn towards the boy's luminous, deep brown eyes – dominant facial features that contrast with the rest of his colouring.

With pastel painting, you can omit the background altogether so that attention focuses solely on the main subject. At this stage, the picture works well as a detailed portrait study of a child's face, the warm tone of the paper providing a harmonious background. However, you could make a more finished picture by completing the clothing and filling in the background with colour.

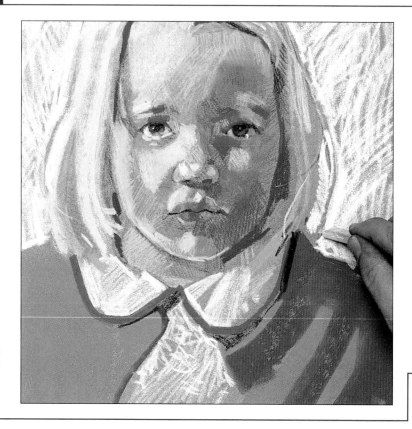

10 ▶ **Paint the background and cardigan**
Snap off a short piece of bright green pastel and use the side to fill in the cardigan. Then paint the shadows and folds in the cardigan, using dark green. Give a suggestion of the dress, using roughly worked strokes of white. Fill in the background area by loosely hatching and working in different directions.

CREATING DARKER SKIN TONES

To create the skin tones of a dark-skinned child, you will need basically the same range of pastel colours as for a light-skinned child. It is just a question of varying the proportions of the colours and adjusting their warmth or coolness, depending on the ethnic origin of your subject. The three portraits below will give you an idea of the tones and proportions that you will need.

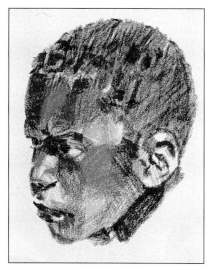

For this sketch of an African boy, the artist used dark burnt umber, dark and medium burnt sienna, medium orange, dark crimson, purple, black, white and touches of Prussian blue and cobalt.

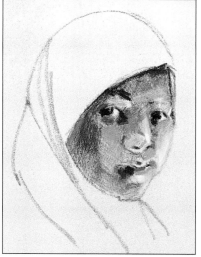

The skin tones and features of this Middle Eastern girl were built up with dark burnt umber, dark pink, burnt sienna, yellow ochre, Naples yellow, dark cool grey and black.

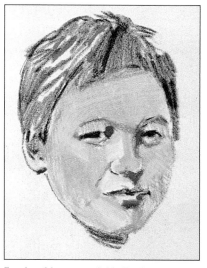

For the skin tones of this Far Eastern boy, the artist combined yellow ochre, burnt sienna, Naples yellow and orange. A touch of cobalt blue adds vivid highlights to the boy's black hair.

11 ▲ Add a touch of pattern Suggest the floral patterns on the dress and cardigan with dots and stipples, using vermilion, bright pink and white pastels sharpened to a point. Don't draw the pattern in detail, as you don't want to distract attention from the face.

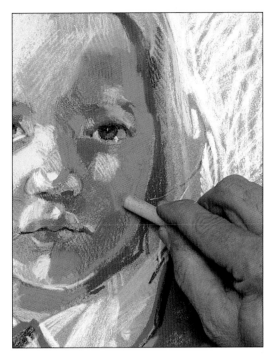

12 ◄ Complete the face Add more dark green shadows to the cardigan. Define the outer right edge, from the temple to the jawline, with burnt umber pale and work it across to the cheek. Add patches of the same colour to the chin, the nose and beneath the eyebrows. Finally, spray the picture with fixative to prevent smudging.

THE FINISHED PICTURE

A Tinted paper
The warm tone of the buff paper breaks through the overlaid pastel strokes, unifying the picture. It provided the artist with a useful mid-tone from which to work towards the darks and lights.

B Simple background
The artist omitted the background shown in the original photograph, which was too cluttered. The simple white background focuses attention on the child's face and echoes the white of the dress.

C Luminous flesh tones
The flesh tones are made up of separate patches of warm and cool colour. These blend in the viewer's eye and appear more luminous than if they were blended on the paper.

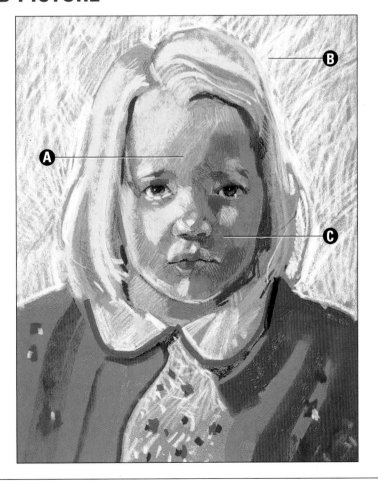

Portrait of a baby

In this tender portrait, acrylic paints are thinly diluted with water and used in the manner of traditional watercolour.

Painting a portrait of a baby presents a different set of challenges to depicting an adult. Babies' faces are smooth and relatively formless and they have fewer characteristic traits such as lines, wrinkles and folds to fix the likeness.

As a result, it's vital to make a good underdrawing. The best approach is to draw the facial features first, although you might find it helpful to jot in a faint outline of the head, too, just to get a rough idea of shape and proportion. As you progress, look and look again at your model and use

▼ **Building up veils of translucent acrylic colour captures the smooth, soft forms and fresh, dewy skin of this sleeping baby.**

the scale finder to check the proportions of the features in relation to the head. For instance, where does the corner of the eye sit in relation to the corner of the mouth? How does the width of the head compare to the length?

Holding the pencil

When drawing, hold your pencil on its side for greater freedom of movement, and use gentle, searching lines as you feel out the forms. These lines can be left in to help keep your drawing mobile.

Thinly diluted acrylics are an excellent medium for painting portraits of young children and babies. The traditional watercolour technique of building up

flesh tones in a series of thin, translucent glazes can be done with greater speed with thinned acrylic paint, as it dries more quickly. Warm and cool tones can be applied on top of each other to create the fresh bloom of young skin without the colour going dead. Slightly more opaque washes can be reserved for defining the facial features and the hands.

YOU WILL NEED

Piece of smooth watercolour board 36 x 56cm (14 x 22in)

HB pencil

8 acrylic paints: Crimson; Cadmium yellow pale; Winsor blue; Phthalo green; Permanent magenta; Cadmium yellow medium; Lemon yellow; Cadmium red

Brushes: Nos.14 and 3 rounds

Mixing palette

FIRST STEPS

1 ▼ Begin with the features Using an HB pencil, draw a very faint outline of the head to get a rough idea of shape. Sketch the features. Define the soft contours of the face and the chubby chin.

2 ▼ Draw the head Work over the domed head, using the scale finder to gauge proportions. Lightly shade the shadowed parts of the face. Sketch in the ear, using pencil guidelines to help you position it.

3 ▶ Complete the outlines Draw the baby's hand, once again carefully gauging its size in relation to the head (compared with adults, babies' hands are much smaller in proportion to the size of the face). Then lightly define the outlines and main folds of the clothing.

EXPERT ADVICE
Get it in proportion

With babies, the skull, forehead and cheeks are proportionately larger than those of an adult, and the facial mask of eyes, nose and mouth is more condensed. From this angle, the baby's head forms an almost perfect circle while the facial features fall within a triangle.

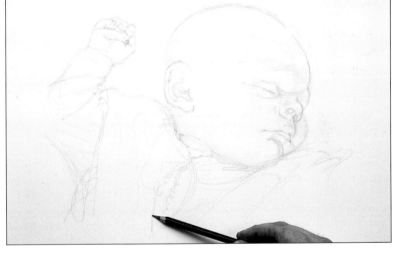

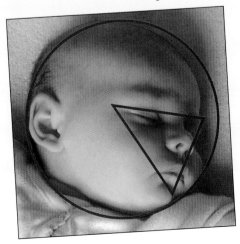

4 ▶ Model the hand The tiny, chubby forms of the hand are quite complex, and it is a good idea to model them with light and shade as a guide for the painting. Use light hatching to define the way the fingers curl over, creating a shadow across the palm.

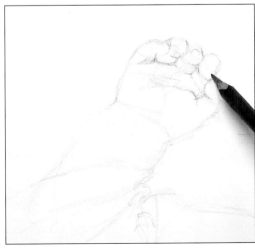

DEVELOPING THE PICTURE

When you are satisfied that those all-important proportions are correct, you are ready to begin painting. Start by laying in broad shapes of tone and colour and develop the form in more detail as the painting progresses.

5 ▶ Start painting the flesh tones Mix a pinkish flesh tone from crimson, cadmium yellow pale and a touch of Winsor blue, diluted with plenty of water to a transparent tint. Block in the broad areas of pale shadow on the face, head and hand using a No.14 round brush. Allow the paint to dry (use a hair-dryer to speed up the drying process if you wish).

▼ Crimson, cadmium yellow pale and Winsor blue are among the colours used for the flesh tints. Mixed in varying proportions, they give a full range of warm and cool hues.

Master Strokes

Tiberio de Tito (1573-1627)
Portrait of Prince Leopold de' Medici as a Baby

One of the most striking aspects of this portrait is the contrast between the smooth flesh tones of Leopold and the intricate detail of his ornate bedclothes. The bedclothes help proclaim the wealth of the Medicis – this is not just any baby, but a member of the powerful and cultured Florentine family. Leopold himself went on to found a great collection of artists' self-portraits at the Uffizi gallery in Florence.

The ears, cheeks and nose of the baby have a pronounced rosy colour in comparison with the forehead and body.

The tone gradually darkens towards the outline of the arm and shoulder. This helps convey the rounded, chubby form of the limb, with the pearly whites at the centre of the arm appearing to advance and the darker edges receding.

The small feet peeping out of the end of the coverlet imply the movement of a restless baby and give the portrait a delightfully informal feel.

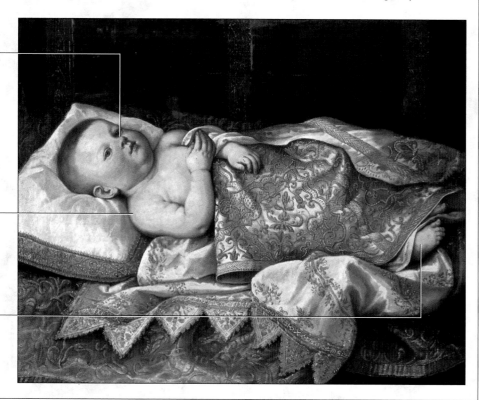

6 ▼ Add deeper tones Darken the pinkish wash with a hint of phthalo green and put in the slightly darker shadows – behind the ear, around the eyes and nose, and inside the nostrils. Use a No.3 round brush for the smaller shapes, such as the upper lip.

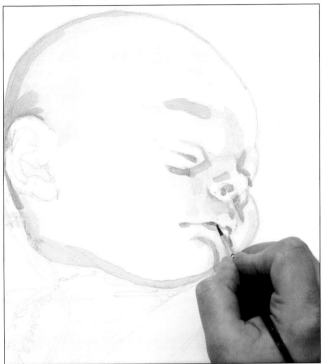

7 ▼ Paint facial shadows Intensify the mix with Winsor blue and a little permanent magenta; apply this warm, dark colour on the ear, eyelid, nose and lips. Dilute the mix and paint shadow across the top of the head with the No.14 brush, bringing it above the eyebrow, over the forehead and cheeks and under the chin. Mix a transparent tint of Winsor blue with a little pinkish flesh tone; paint cool shadows around the eyes and mouth.

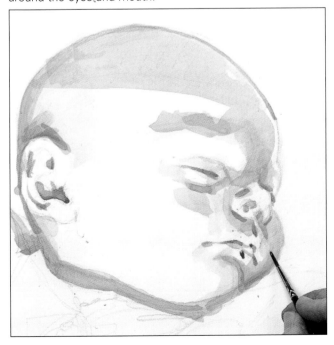

Express yourself
A drawing on tinted paper

This sketch of the same baby was drawn on tinted paper with a sanguine Conté crayon, highlighted with white chalk. With tinted papers, as opposed to white, there is less contrast between the drawn marks and the surface, so the effect is softer. The paper colour is an integral part of the image, allowing the modelling of the face to be done with minimal marks. Here, the smooth planes of the head and face are modelled with gentle hatched strokes.

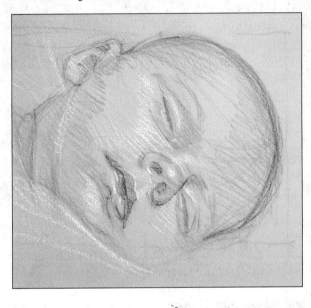

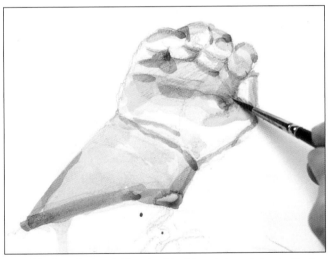

8 ▲ Work on the hand Use the No.3 brush to paint pale flesh tints on the hand and arm with cadmium yellow medium and a touch of the blue shadow mix. Model the chubby forms of the arm and hand with the warm, reddish shadow tones used for the face. Allow one wash to dry before applying the next and leave patches of white paper for highlights.

9 ▼ Build up the flesh tones Change to the No.14 round brush. Lay in the lighter flesh tones with overlaid washes of cadmium yellow medium for the cooler tones and a mix of cadmium yellow pale and a little crimson for the warmer ones on the upper cheeks. Leave patches of untouched paper to stand for the highlights on the brow bone, nose and mouth.

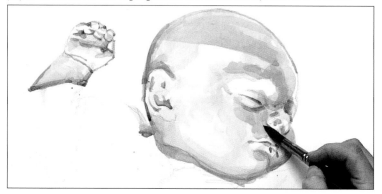

10 ▼ Paint the cast shadow Mix cadmium yellow medium, phthalo green and a touch of magenta to make a medium-toned greyish-green. Use the No.14 brush to sweep this in behind the shoulders and front part of the head, which casts a shadow on to the pillow. This helps to suggest the weight of the baby's head pressing on the pillow.

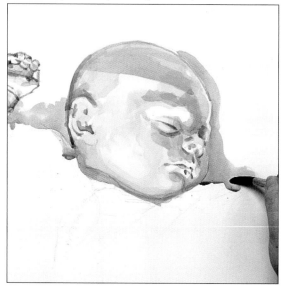

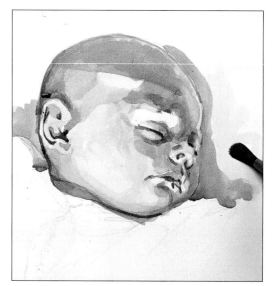

11 ◄ Add some reflected light Dilute the shadow colour and use it to paint shadow on the right side of the head and around and inside the ear and in the eye sockets. Mix up a little lemon yellow, greyed down with some dirty water from your water jar, and wash this in behind the head.

A FEW STEPS FURTHER

To finish the portrait, tighten up just one or two details. Don't be tempted to carry on tweaking, as you risk losing the luminosity of the image.

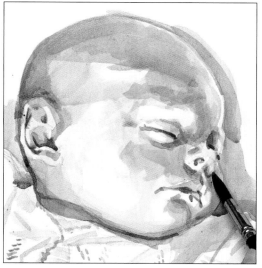

13 ▲ Complete the face Mix up a warm flesh tone from crimson and cadmium yellow medium and apply broad washes over the dome of the head to strengthen the modelling. Also add some to the ear lobe and over the cheeks, to emphasise their rosy warmth and softness.

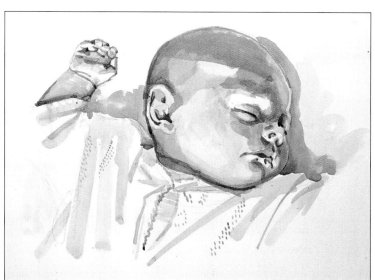

12 ▲ Paint the clothing Mix Winsor blue, phthalo green and magenta and dilute to a very pale tint with lots of water. Apply single strokes with the No.14 brush to suggest soft folds in the baby's jacket. When dry, use the brush tip to add a pattern of dots in a darker tone. Paint the pink edging with tiny strokes of magenta and cadmium red.

14 ▼ **Enrich the shadows** Mix a warm dark from phthalo green, magenta and Winsor blue and use the No.3 brush to tighten up the darkest shadows – on the fingers, the crease of the palm, the back of the neck and under the chin. Dilute the colour to a paler tint and use this and the No.14 brush to paint the shadow cast by the baby's hand and to enlarge the shadow cast by the head.

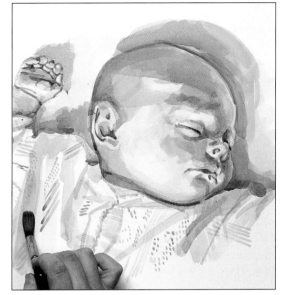

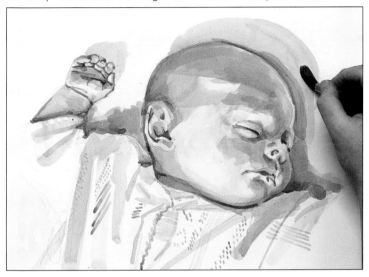

15 ▲ **Make some final adjustments** Strengthen the yellow tones behind the head with a mix of lemon yellow, phthalo green and a hint of magenta. Finish off by strengthening the detailing on the jacket.

THE FINISHED PICTURE

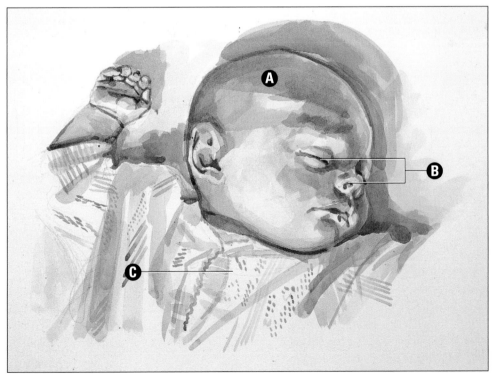

A Fresh colours
Layered, transparent glazes – warm over cool and cool over warm – effectively convey the softness and luminosity of the baby's skin.

B Warm darks
The darks of the eyelashes and nostrils are not painted with black but with warm neutrals, in keeping with the delicacy of the features.

C Reflective surface
Areas of white paper help convey the luminosity of the image. Light also reflects from the paper to make the translucent washes glow.

Mother and child

A sensitive pencil drawing with delicate watercolour washes is the perfect way to capture the affection of a mother for her baby son.

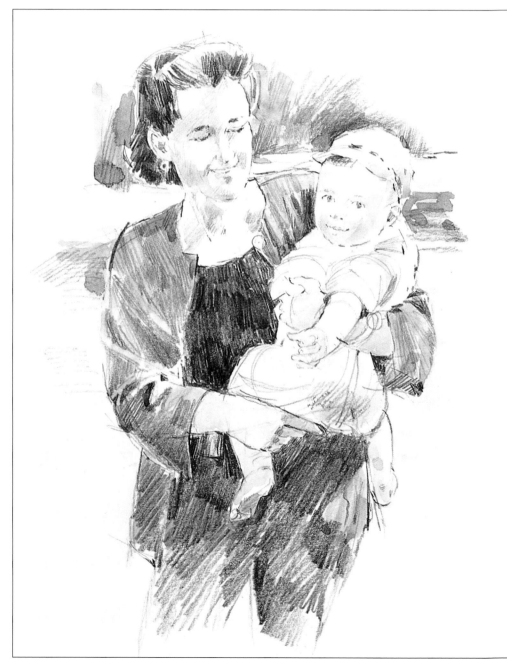

This portrait of a mother carrying her baby is a pleasing, natural composition. The woman holds the child in her arms and gazes down on him lovingly, while the baby looks out of the picture, full of curiosity. His outstretched arm seems to invite the viewer into the scene.

Check your proportions

When you are establishing the pose, first work out how the mother's weight is distributed and look at the main angles and proportions of the figures (see Expert Advice, opposite). As you make your initial sketch, check that your proportions are accurate by measuring from one part of the body to another and comparing distances.

Adult and baby

Also, be aware of the differences between an adult's body and that of a baby. Notice how the baby's head is large in proportion to its body. The height of a one-year-old child is roughly four times the length of its head, whereas for an adult the ratio is about 7:1.

A baby's face is rounded and smooth compared to an adult's, and its limbs are chubby with creases at the ankles and wrists. In this picture, the difference between adult and baby is further underlined by the contrast between the dark, heavy clothing of the mother and the light, delicate baby clothes.

▶ **The artist chose an oval format, which seems to emphasise the closeness between mother and baby.**

Piece of 190gsm (90lb) cartridge paper 35 x 25cm (14 x 10in)

7B pencil

Putty rubber (for erasing mistakes)

Scalpel or craft knife (to sharpen pencil)

10 watercolours: Light red; Burnt umber;

Payne's grey; Vandyke brown; Ultramarine violet; Cobalt blue; Cerulean blue; Sap green; Chrome yellow; Yellow ochre

No.5 round brush

Mixing palette or dish

Jar of water

FIRST STEPS

1 ▶ Sketch the figures
Using a 7B pencil, start by putting in guide lines to show the stance of the mother's body (see Expert Advice). Draw her head and the shape of her hair, then lightly mark in her facial features. Moving downwards, position the mother's shoulders and draw the baby within her encircling arms. Complete the mother's figure, working down to the tops of the legs.

2 ▼ Strengthen the mother's features Darken the hair with decisive, directional pencil marks. Put a little shadow on the ear. Develop the eyes – because they are looking down at the baby, they appear almost closed. Mark in the eyebrows, then refine the nose and mouth, adding a small shadow under the lower lip.

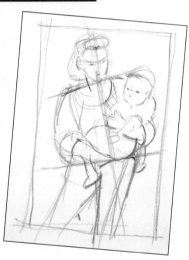

EXPERT ADVICE
Analysing the pose

Before you start any figure drawing, it's a good idea to make a quick sketch showing how the weight is distributed and how the body is angled. Here, the mother is supporting the weight of the baby on her left hip, which is thrust out to one side. Her shoulders follow a similar angle, while her head and spine are on a tilted axis that crosses at right angles. Her body weight is mainly on her left foot.

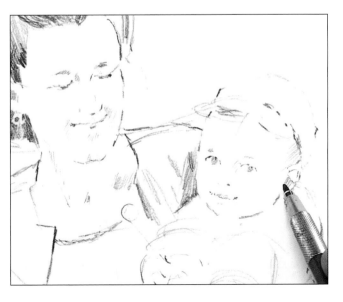

3 ▶ Work on the baby's face Add shadows on either side of the mother's mouth and neck. Work up creases on the left shoulder of her jacket. Outline the tops of the baby's eyes and darken the irises and pupils, then put tone in the eye socket. Dot in the nostrils and draw the mouth with sensitive lines. Develop the ear, showing the baby's soft hair above it.

DEVELOPING THE TONES

Start to add depth to the drawing with a range of tones, from the lightest shadows on the faces and limbs to mid tones and darks on the mother's clothing.

4 ▼ **Develop the limbs** Work up a dark tone on the mother's T-shirt, then put in shadows and creases on her jacket and the baby's rompers. Redefine the mother's and baby's arms and draw their hands. Shade lightly under the baby's foot and draw his toes, showing the crease where foot joins ankle.

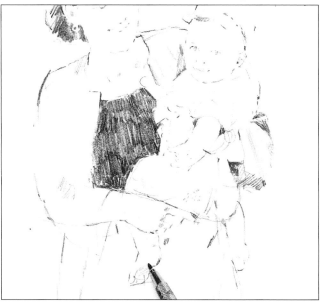

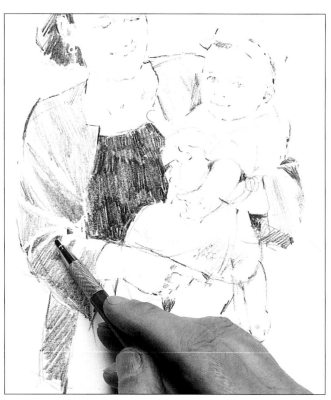

5 ▲ **Suggest fabric creases** The tone of the mother's jacket is lighter than that of her T-shirt, so use less emphatic pencil shading here. On the right sleeve, follow the direction in which the fabric is being pulled, but leave the paper untouched where the folds catch the light.

6 ▼ **Develop the tonal shading** Hatch dark and medium tones over the mother's jeans and left shoulder. Work very lightly over her face and neck, then refine her facial features and darken her hair. Hatch in some tone to suggest the background.

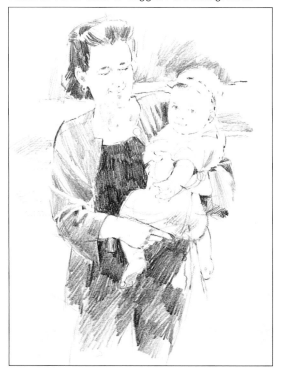

A FEW STEPS FURTHER

The pencil drawing is now complete, but you could take it further by adding light washes of watercolour. Don't flood it with too much water, as the paper will cockle.

7 ▶ **Paint the flesh tones** Make a dilute wash of light red watercolour. Using a No.5 round brush, apply it over the shaded part of the mother's face and neck. Paint the same wash over the baby's face, with slightly stronger colour on the eye sockets, cheeks and hair. Work this flesh tone over the limbs, too, keeping the baby's left arm pale.

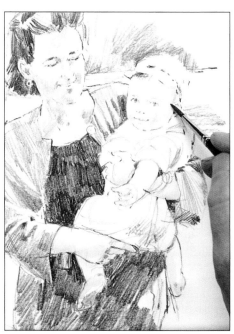

8 ▼ Mix more washes Mix burnt umber, Payne's grey and Vandyke brown, and wash over the dark areas of the mother's hair. Paint her jacket with a wash of ultramarine violet.

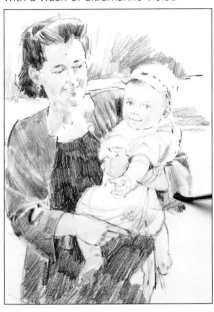

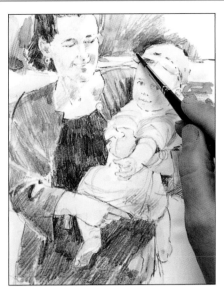

9 ▲ Warm the background Darken the T-shirt and jeans with a mix of burnt umber and Payne's grey. Paint the baby's clothing with a light wash of cobalt blue and cerulean blue. Mix sap green and chrome yellow for the background, adding Payne's grey for the shadows.

10 ▼ Model the faces Mix a slightly stronger flesh tone from light red with a little yellow ochre. Use this to bring out the contours of the faces, taking it down on to the shaded part of the mother's neck.

THE FINISHED PICTURE

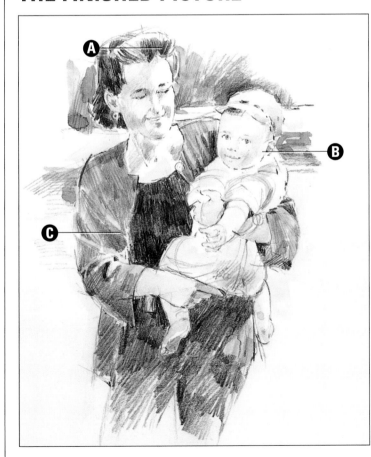

A Pencil texture
The pencil marks are still visible under the light washes of watercolour, adding texture and detail to the image.

B Baby face
The baby's face has been painted with a relatively even tone to convey his smooth skin and softly rounded features.

C Fabric folds
The pull of the fabric on the jacket sleeves is shown with directional pencil hatching. Light-coloured negative shapes stand for the folds.

Painting children

An informal portrait of children playing together is a wonderful way to capture glimpses of their childhood, using sketches and snapshots to help you.

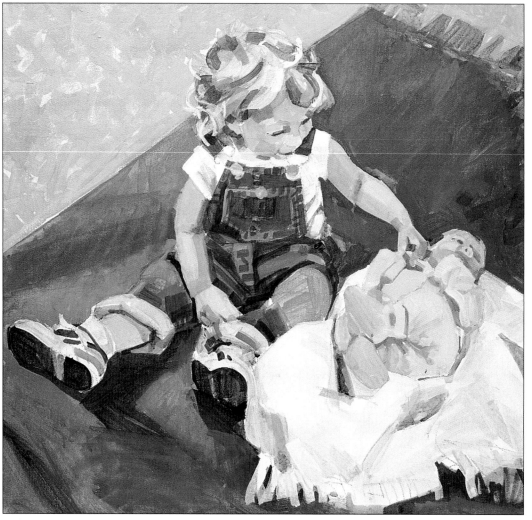

◄ When painting children, snapshots can be a help – but don't copy them slavishly. For this painting, the artist eliminated the pattern on the rug and altered the background colours for a fresh, harmonious composition.

Small children have a limited ability to sustain a pose, so you need to paint them quickly or use a snapshot. This is where acrylic paints come into their own. Acrylic dries rapidly, so you can build up the image without waiting for long periods between stages. You can apply flesh colours in thin, transparent layers to re-create the living quality of skin. Equally, you can use solid blocks of opaque colour for the planes of light and shade that model the face and figure.

Rather than trying to persuade a group of children to adopt a formal pose, you will get more lively results if you show them absorbed in an activity such as playing together. In the portrait shown here, the implied relationship between the little girl and the baby adds an extra intimate dimension to the image.

Obviously, when playing, the children will be moving about, so you might need to base your portrait on a photograph. Although photos tend to flatten forms and distort tones, they allow you to capture poses that are natural and characteristic of the children. As long as you back up a photo with sketches drawn from direct observation, you will end up with a portrait that expresses the children's personalities as well as a good likeness.

FIRST STROKES

1 ▲ Draw the composition Make a careful outline drawing of the subject with the brown pastel pencil. Draw the facial features and indicate areas of light and shade. If you are working from a photograph, use the squaring-up method to enlarge the picture. If you are working from life, use your pencil to measure angles and distances .

2 ▲ Search out dark tones Mix raw umber and a little deep brilliant red to make a brown shade. Using a No.8 flat brush, paint the dark tones in the hair. Then dilute the colour and paint the shadows on her face and limbs, and on the baby's head. Mix Payne's grey and cobalt blue for the folds in her dungarees and the baby's blanket, and for the soles of her shoes.

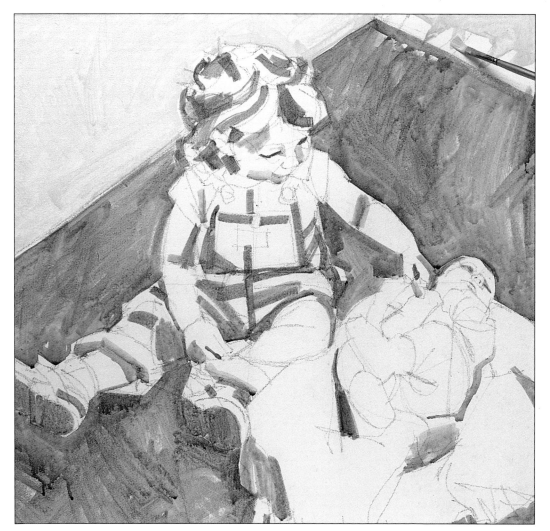

3 ◄ Block in the background To underpaint the rug, mix scarlet red, cadmium red light and deep brilliant red, softening the colour slightly by adding a touch of the brown mixture left on your palette. Dilute the colour thinly with water and scrub it on to the canvas with rough strokes worked in different directions. Mix a pale yellow from yellow ochre and titanium white, again thinly diluted with water. Fill in the area at the top of the picture, cutting into the fringe along the edge of the rug.

DEVELOPING THE PICTURE

Now that the main elements of the composition have been blocked in, step back and review your progress so far. The next stage is to develop and refine the colours and details, moving from one area to another and using slightly thicker paint in a series of built-up patches of acrylic colour.

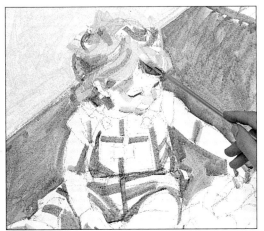

5 ▶ Paint flesh tones Mix a light flesh colour from yellow ochre, white and a touch of scarlet red, diluting it thinly. Fill in the girl's face, arms and legs, washing the mix over the shadow tones. Add white for lighter tones. Paint the mid-tones on the baby's face, adding red for a warmer shade.

4 ▲ Add more colour to the hair Returning to the figure of the toddler, block in the mid-tones in her blonde hair and her face, using a pale mix of yellow ochre and white toned down with a hint of Payne's grey. Leave a few flecks of bare canvas to stand for the highlights in the hair.

6 ▲ Paint the stretch suit To simplify the baby's shape, break down the subject into three basic tones: light, middle and dark. First, paint the dark, cool pinks in the folds, using colour left over from step 3. Then use the flesh colour from step 5, with some deep brilliant red, for the warm mid-tones. Add more white and a hint of yellow ochre to the mix for the lightest tones.

Master Strokes
─◦◦─
Sir Anthony van Dyck (1599-1641)
The Children of Charles I –
Princess Elizabeth and Princess Anne

In this charming unfinished oil painting, van Dyck has concentrated on the heads of the two children; this may have been a preliminary sketch for a larger work. The relationship between the children is emphasised, as in our step-by-step, by their physical closeness and the direction of their gaze.

Pale areas on the forehead and clothing show the direction of the light as well as the smooth texture of the child's skin and the fine fabric of her clothing.

The softly rounded contours of the baby's face, and the translucent qualities of the skin, are built up using many layers of subtly differentiated flesh tones.

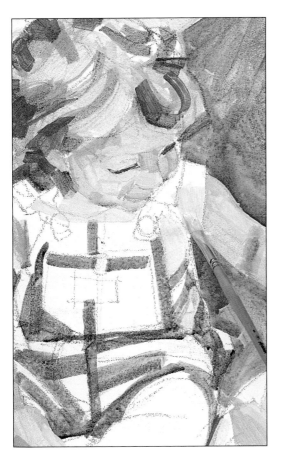

7 ◄ Develop tones and colours Add more dark tones to the toddler's hair, using a mix of raw umber and Payne's grey, remembering to leave a few flecks of bare canvas to represent the highlights. Now make a mixture of cobalt blue, white and a touch of Payne's grey to paint the pale shadows on the girl's white T-shirt.

8 ◄ Paint the baby's blanket Use the grey mix featured in the previous step to paint the shadows and creases on the baby's blanket. Add more cobalt blue for the darker shadows and more white for the lighter ones. Your brush strokes should follow the forms of the creases. Add hints of pink to the mix to show how the white blanket picks up and reflects colour from the rug below it.

Express yourself
Pastel sketch

In this version of the portrait, the artist has used soft pastels instead of acrylic paints. It can be interesting and instructive to tackle the same subject in a range of different painting and drawing media, and to work on different coloured supports. You will quickly discover how these can alter the mood or expressiveness of the subject.

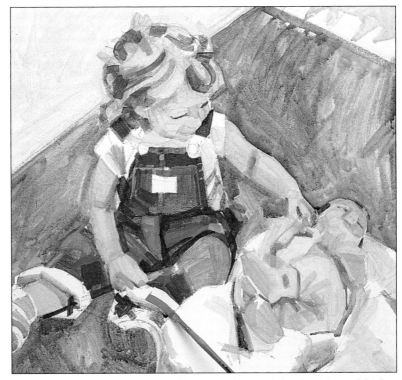

9 ▲ Paint the dungarees Now add more colour and detail to the toddler's denim dungarees. The basic colour here is cobalt blue, darkened with Payne's grey in the warm shadows and with Prussian blue in the cool shadows. Add some white, warmed with a hint of flesh colour from the palette, for the light areas. Keep the paint quite thin and let the brush marks show, so as to suggest the texture of the denim fabric.

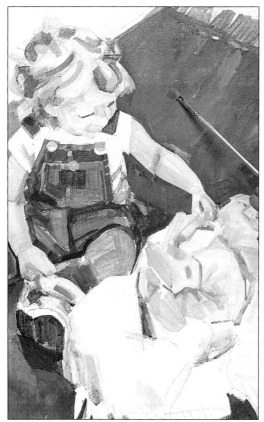

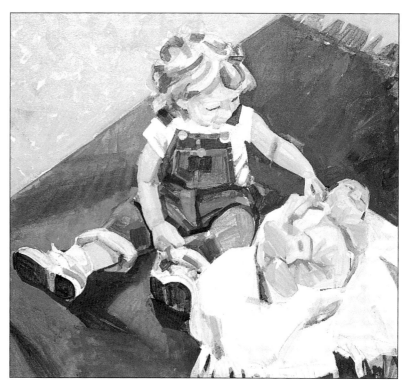

11 ▲ **Complete the background** Use white with a hint of the red paint left on your brush to fill in the white areas on the T-shirt, boots and baby's blanket. Mix a dark tan from yellow ochre, raw umber and a little white, warmed with a hint of red from the palette. Stipple colour on to the background, allowing the pale undertone to show through.

10 ▲ **Complete the dungarees and the rug** Use a strong Payne's grey for the remaining dark tones on the toddler's dungarees and the soles of her shoes. Add white to the grey for the trouser turn-ups. Suggest the buttons with a mix of yellow ochre and white. For the rug, mix some of the pinks, flesh tints and light blues on your palette into a generous amount of deep brilliant red to create a dull, pinkish red. Block in the rug with rough strokes, letting the pale underwash break through. Scrub a paler tone over the red in places and darken it with a touch of Payne's grey in the shadow areas.

EXPERT ADVICE
Colour harmony

To achieve harmony in a painting, stick to a limited range of colours and weave them through the composition. In this photo of the artist's palette, you can see how he has incorporated one colour mixture into the next.

A FEW STEPS FURTHER

Take a short break at this point. When you return to the painting, you will see it with a fresh eye and know at once what needs to be done to complete it. It is important to consider the composition for its abstract qualities as well as for its more obvious representational function.

12 ▶ **Refine flesh tones and hair** Complete the light tones in the girl's hair using a mix of yellow ochre and white. For the wisps of hair, mix cadmium yellow medium and white. Use a thicker mix of the same basic flesh colours as mixed earlier in step 5 to add emphasis to the children's chubby forms.

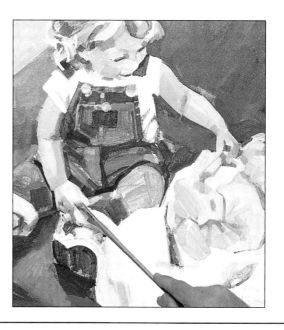

13 ► **Add textural details** Mix a dark, warm blue from Prussian blue and paint the stripes on the toddler's shoes. Then add the final folds and detailing on the dungarees.

14 ▲ **Finish painting the baby** Now all that remains is to strengthen the definition on the baby's clothing and bootees, using the same tones and colours as in step 6.

THE FINISHED PICTURE

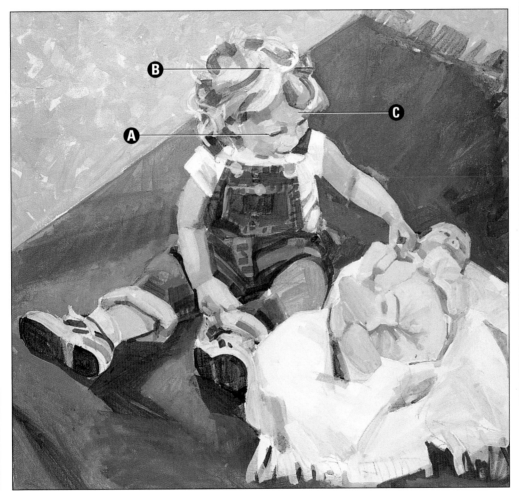

A Triangular composition
The toddler's gaze and out-stretched arm lead the eye to the baby. The two figures form a triangular composition which underlines the sense of warmth and intimacy in the portrait.

B Modelling
The children's skin and hair were painted quite simply. Each plane of light and shade was represented by one or two simple brush strokes, overlapping in carefully observed, natural shapes.

C Transparent colours
Children have fresh complexions, which have been captured here using transparent colour layers. These enable one colour to 'glow' up through another and allow light to reflect back from the white canvas.

Portrait of a retriever

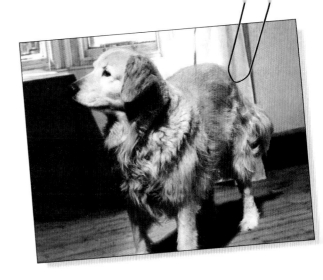

Pastel pencils are ideal for animal studies – they allow you to build up rich films of colour and also to pick out detail and texture.

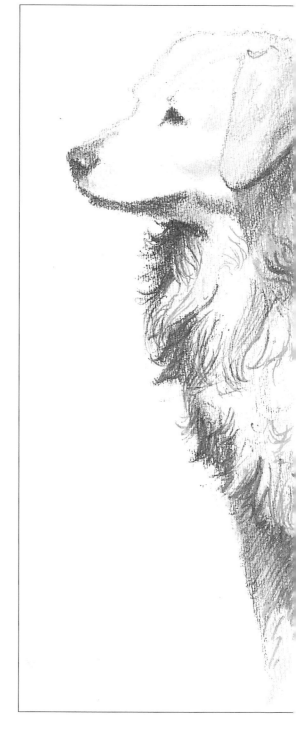

Pastel pencils have the same high pigmentation and intensity of colour as soft pastels. However, they are harder and can be easily sharpened with a blade, a pencil sharpener or on glass paper to give a fine, controllable point. For this reason, they are ideal for rendering animal features such as eyes, noses and ears, as well as the texture of fur. Colours can also be blended with a stump (torchon) or finger, and can even be softened and blended with water.

Beginning the painting

As with humans, the eyes are the key to the character and expression of an animal. Start your drawing by checking the size and position of the eyes in relation to the other features of the head. How big are the eyes, and how far apart? Check the curve of the upper and lower eyelids – are they the same or visibly different?

Looking at the eyes

Notice, in particular, the amount of shadow around the eye socket, and the shape of the tear ducts in the corners of the eyes. Remember that the appearance of the eyes will be affected by the turn of the head and the effects of perspective.

Much of the enjoyment gained from dog studies is derived from the colour, pattern and texture of the coat. Look at its length and thickness and the way it changes on different parts of the body.

Follow the form

Note that the coat can conceal the underlying form of the dog. In many ways, short-haired dogs are easier to draw than the hairier breeds because you can see indications of the underlying skeleton and musculature. With long-haired animals it is important to imagine the underlying structures.

The subject of this project has short hair over the face and skull. As a result, the forms of its strong jaw and elongated muzzle (inherited from its hunter-ancestors) are very apparent. However, the retriever's thick, rug-like fur swirls over its chest and shoulders – so take extra care here.

Texture of fur

Pastel pencils are ideal for rendering the texture of fur. They can be blended to give broad areas of background colour and tone, then directional strokes can be used to suggest the length and texture of the hair.

There is no substitute for working directly from the subject, so where possible make quick sketches of your dog. The slightest, speediest notes will help you to see and understand in a way that simply looking, or using photographs, can't – and they will also inform subsequent studies.

Using reference photos

However, a 'proper' portrait of your pet will take time – and this is where photography comes into its own. A photograph freezes the pose and provides plenty of detail. Take several photographs so that you can choose the best pose and keep the others to refer to for details.

Piece of
cartridge paper
45 x 55cm
(18 x 22in)

7 pastel
pencils:
Spectrum
orange;
Deep cadmium;

Burnt umber;
Spectrum blue;
Orange earth;
Burnt carmine;
Prussian blue

Stump

Brown felt-tip
pen

▼ **This delightful study captures the dog's alert, expectant stance, and revels in the golden colours and rug-like texture of its thick coat.**

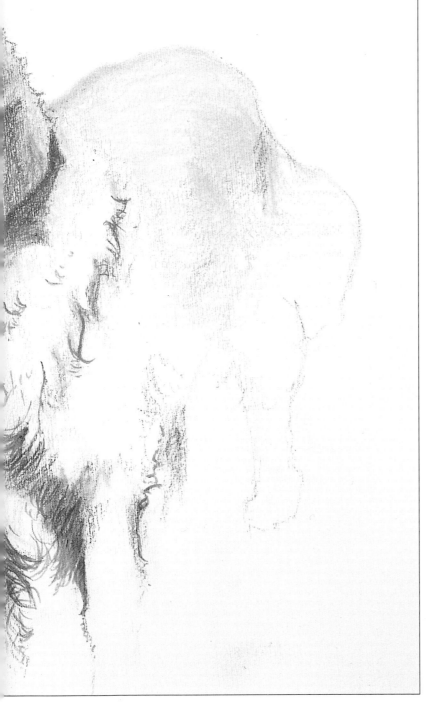

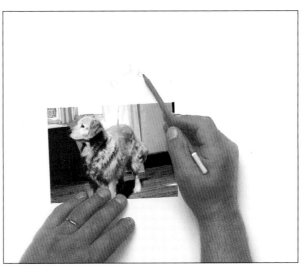

FIRST STROKES

1 ▲ **Plot the eye** Study the photograph carefully, then begin to construct the head, first drawing the eye and the brow above the eye. Start towards the top left corner of your paper leaving plenty of room at the bottom and to the right to develop the body. Work lightly, using a spectrum orange pastel pencil – an ideal base colour for the retriever's golden coat. Mark in the nose and the edge of the skull, checking proportions with your pencil.

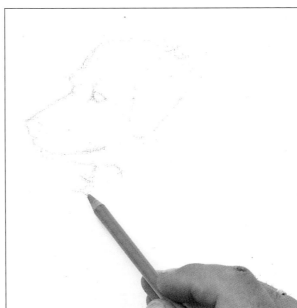

2 ▲ **Outline the head** Using the same pencil, continue to sketch the dog's head. Locate the mouth and lower jaw. Use the eye as the basic module for checking the distances between different parts of the head – for example, eye to ear. Make any necessary adjustments at this stage, before the drawing progresses too far.

3 ▼ **Start to draw the body** Use a tentative line as you begin to draw the body – you shouldn't commit yourself too soon as you might have to make alterations. Make flicking marks to indicate the fluffy fur on the dog's chest and then sketch in the animal's back. Use a deep cadmium pencil for the blonde coat – start by applying a layer of broken colour, hatching lightly over the head and muzzle.

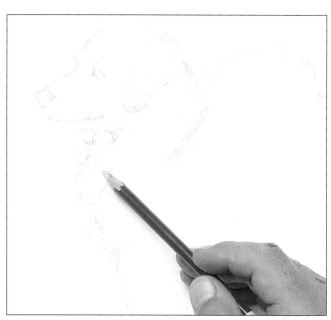

4 ▲ **Develop the coat colour** Work up the rich golden tones on the ears and back. Indicate the shadow where the thick fur opens up on the shoulders. The areas where the fur bunches or separates are important because they give clues about the texture of the coat. Use light hatching on the chest, following the direction of fur growth.

5 ▼ **Add darker tone** Develop dark tones on the chest, lower jaw, shoulder and beneath the ear with spectrum orange. As you work, the spectrum orange blends with the previously applied deep cadmium.

DEVELOPING THE PICTURE

The main features have now been established and the golden colour of the retriever's coat has been suggested. It is time to start developing the contrasts of tone that will make the dog look more solid and suggest the thickness of its coat.

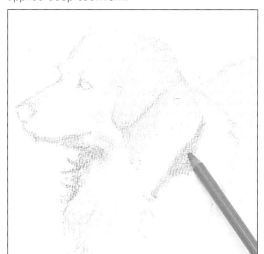

**EXPERT ADVICE
Using directional marks**

When rendering an animal's coat always make sure that your marks follow the direction in which the fur or hair lies or grows. This will look more convincing and will help you to 'feel' the texture and the underlying forms.

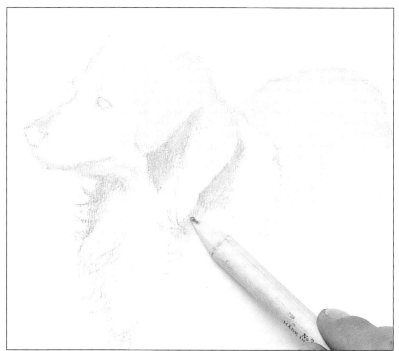

6 ▲ **Blend the pastel** Use a stump to blend the deep cadmium on the dog's back and skull to create a thin, smooth film of colour. Continue working over the rest of the dog's face – the yellow pigment picked up on the stump will deposit a subtle glaze of colour. Still using the stump, start to blend the shaded areas under the ear and where the fur has separated.

7 ▶ Add details Dot in the eye with a burnt umber pastel pencil. Use the same colour for the nose, then blend it with the stump. As soon as these key features are established, the image comes alive.

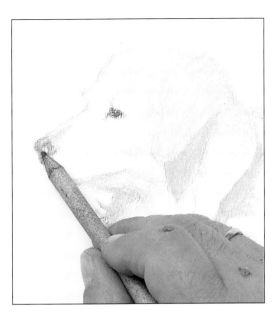

Express yourself

A friendly face

This full-face portrait, worked in soft graphite pencil, captures the retriever's loving and faithful nature. Its slightly drooping eyelids and prominent, moist nose are emphasised by using dense, dark tones, while the fur is described with a mixture of tonal shading and detailed textural lines.

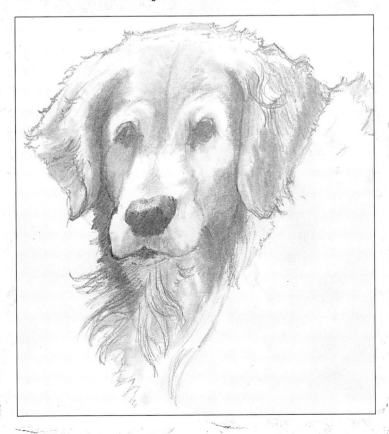

8 ▼ Develop the face Study the photograph carefully, then use the burnt umber pencil to add the lines of the mouth and chin. Work carefully as these are key features and critical to the eventual likeness.

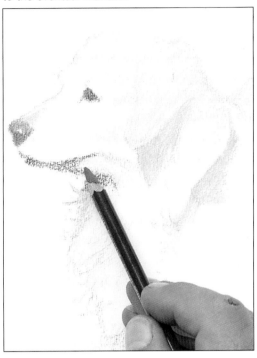

9 ▼ Add cool shadows Use a spectrum blue pencil to introduce cool tones to the shadow areas – they will resonate against the predominant warm tones. Use light strokes and follow the direction of the hair growth. Blend the colours with the stump.

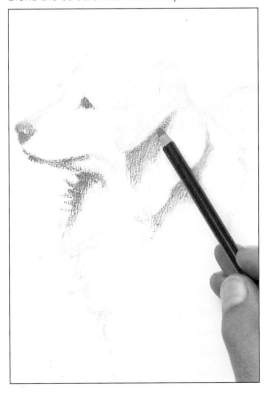

10 ▼ **Add warm tones** Work back into the fur with orange earth – a warm, muted shade. The shifts of colour in the fur create a subtle optical mix, making the area livelier, and suggest the texture of the short hair.

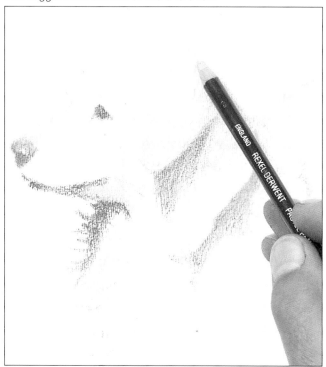

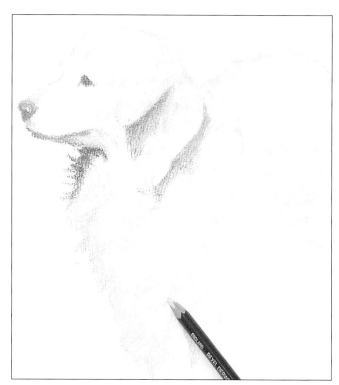

11 ▲ **Work on the body** Use the deep cadmium pencil to sketch in the dog's chest and shoulder, then work over these with orange earth. Use flowing lines and variations of tone to suggest the thick, tousled nature of the coat.

Master Strokes

Henry Rankin Poore (1859-1940)
Old English Stag Hounds

The artist has composed this group of hounds so that the animals can be studied from three different angles. The dog looking out of the picture is particularly striking, with its bold facial markings forming a mask shape. The stark contrasts between the black and white in the foreground play off against the heathery shades of the foliage in the background.

The steady gaze of the central dog provides the major focal point. Note how the angles of the other dogs help lead the eye to it.

Scuffed snow is suggested with textural marks in a variety of pale tints.

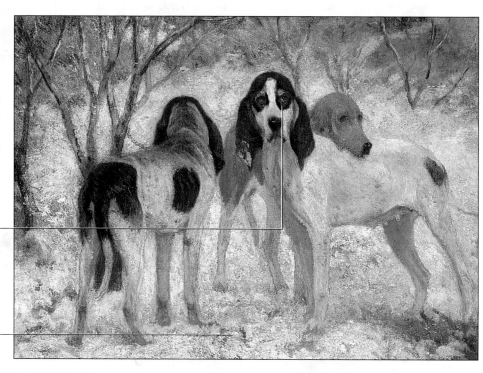

12 ▼ **Enrich the fur** Work into the fur on the dog's ear and neck with spectrum orange. Blend the colours lightly with the stump. Work into the chest with spectrum orange and burnt carmine, using flicking gestures to suggest the wispy texture of the fur. Add spectrum blue in the shadows over the dog's right leg and blend with the stump.

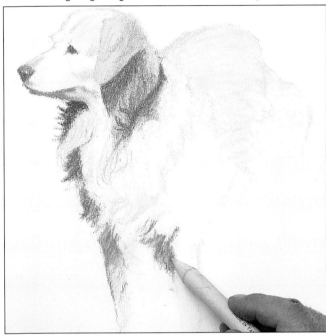

13 ▼ **Sketch in the legs** Use burnt carmine to indicate the animal's back legs. This area will be left largely unworked but by indicating the hindquarters the animal will appear more three dimensional. Develop the forelegs with spectrum blue, burnt umber and spectrum orange, using the stump to soften the marks and to 'pull out' wisps of fur (see Expert Advice, above).

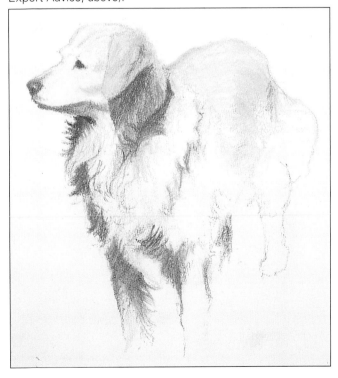

EXPERT ADVICE
Drawing with a stump

A stump is used mainly to blend and smooth out colours and tones on the paper, as here. However, once loaded with pigment it can also be used to apply a skim of colour. Alternatively, try pulling out strands from an area of colour to suggest tufts of hair or fur, for example – as on the left side of this patch of colour.

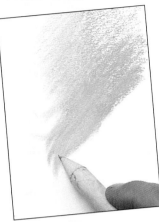

A FEW STEPS FURTHER

The drawing is almost finished – it is a good likeness and the alert pose and intelligent gaze are precisely depicted. The quality of the fur on the different parts of the animal has been suggested, but could be developed further to suggest its thick, attractive appearance.

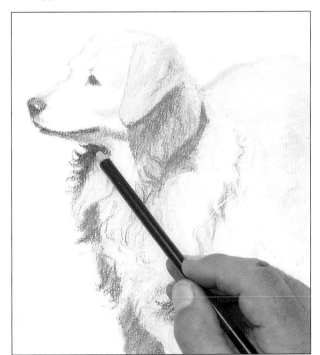

14 ▲ **Add detail to the head** Use Prussian blue to add touches of dark detail on and above the eye and to refine the shape of the nose. Put a dark line between the jaws and add shadow under the jaw to increase the three-dimensional qualities of the head.

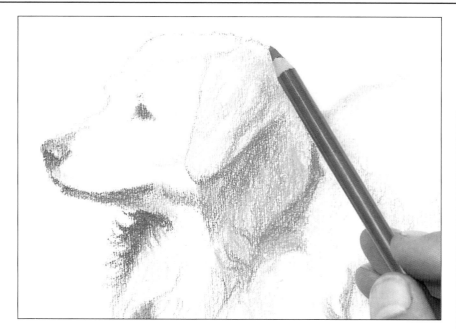

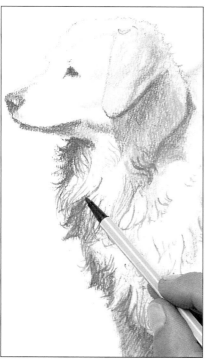

15 ◀ **Refine the dog's skull** Develop the rich tones on the ear with spectrum orange and burnt carmine. Use the same colours to refine the silhouette of the head.

16 ▲ **Develop the fur** Use a brown felt-tip pen to draw into the dog's curly pelt. The transparency and fluidity of this medium provides an interesting contrast with the grainy quality of the pastel pencil. Apply the colour with flicking strokes – a few marks will capture the bunching of the fur and its springy nature.

THE FINISHED PICTURE

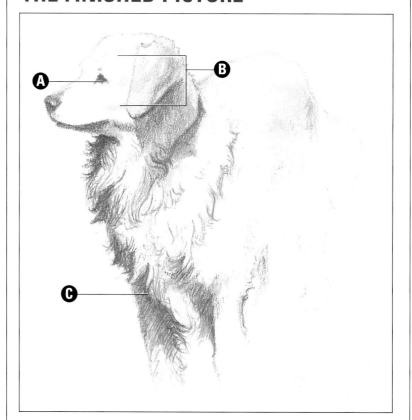

A A good likeness
Careful checking of proportions in the initial stages of the drawing ensured that the facial features were accurately placed.

B Pale colour
The delicate film of colour on the brow and muzzle was created with pigment picked up by the stump from darker areas of the animal's fur.

C Tousled fur
Lines in pastel pencil and felt-tip pen were applied over a background of blended pastel to create an impression of the thick fur on the dog's chest.

Birman temple cat

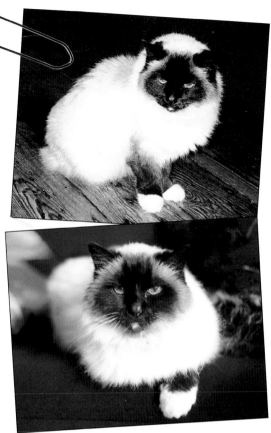

Photographs are an invaluable reference source for painting an animal. Choose the best background and pose, then combine them for a great composition.

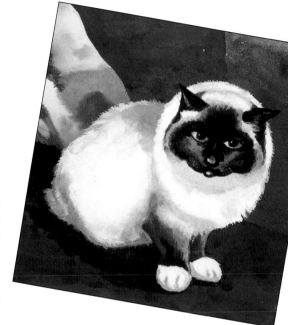

the temple was attacked and the head priest killed. At the moment of the priest's death, his favourite cat placed its feet on him and its markings changed forever. Its fur took on a golden cast, its eyes turned blue and its face, legs and tail became the colour of the earth. However, the cat's paws, having touched the priest, remained white as a symbol of purity.

The Birman temple cat used as a model here is true to this distinctive colouring. It has been painted from two different photos as well as from life. The photo of the cat sitting on the wooden floor shows the better pose, but the more interesting background in terms of colour is the one with the cat on the sofa, so the artist combined the two in her painting.

Blending with gouache

A small palette of gouache colours is used for the project. Gouache works equally well for delicate areas such as the cat's fur and for the strong, bold background. Used wet-on-wet, the paint creates areas of colour that blend softly together.

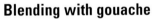

F amily pets are challenging but very rewarding subjects to paint. They do, however, have a habit of getting up and strolling away just as you're about to start painting. So, unless you have an unusually obliging specimen, your best option is to use photos to help you.

A danger with painting from photos is that you can end up with a picture that looks rather flat and two-dimensional. Purists often reject the practice and claim that they can tell when something has been painted from a photo because it lacks vitality. The secret is not to base your picture entirely on your photos but to use them more as a springboard for your work while also referring to your actual pet.

The Birman legend

An unusual breed of cat – the Birman temple cat – was chosen for this project. The story goes that this breed originally had yellow eyes and white fur and guarded the Temple of Lao-Tsun in Myanmar (formerly Burma). One day,

FIRST STEPS

1 ▼ **Make a pencil sketch** Using the photograph showing the cat in a sitting pose as a guide, make a sketch with a 2B pencil. This species is characteristically fluffy, so the front body, back body and head form roughly circular shapes.

Use your pencil to gauge the proportions of the cat. Align the tip with the top of the head and note where the bottom of the paws fall on the pencil. Use this measurement to check the breadth of the body. You'll find that, ignoring the tail, the two are roughly the same, so make sure your drawn cat is about as tall as it is broad.

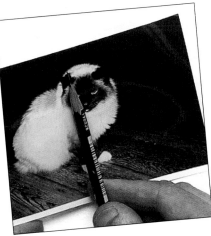

▼ **The strong colours and shapes in the background set off the fluffy texture and pale tones of the cat's fur.**

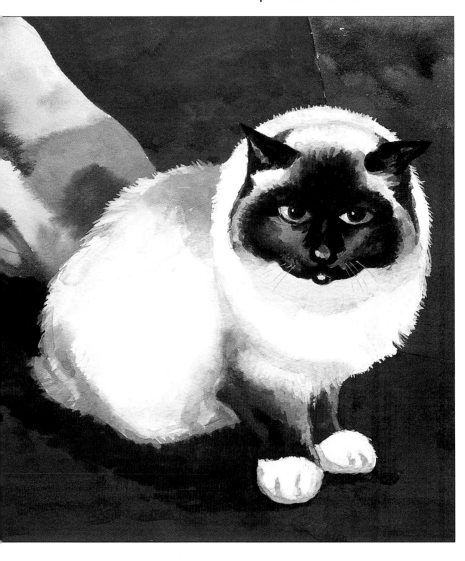

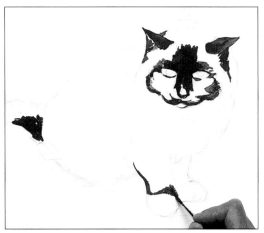

2 ▲ **Establish the darkest areas** Make a mix of ivory black with just a touch of Vandyke brown. Using a No.4 round brush, start painting the darkest tones – the face (apart from the cheeks) and the bottom of the legs and tail.

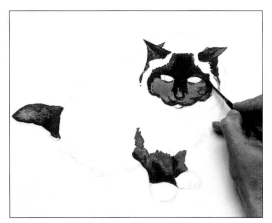

3 ▲ **Vary the tones** Add a little zinc white to your brown mix and finish off the tail and front legs. Use this lighter tone for the cheeks, too, taking special care around the eyes.

4 ▼ Work on the light tones Change to a No.10 round brush and make a thin, pale mix of zinc white with a hint of raw umber. Use this to paint the cat's body. For the darker tones, add a little more of the raw umber to the mix.

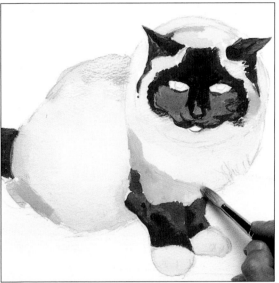

5 ▼ Paint wet-on-wet Referring to the photograph, build up tonal variations within the fur. Work wet-on-wet with various dilute mixes of white and raw umber, adding darker browns over lighter ones. The colours will bleed into each other, giving the fur a sense of softness so that the cat looks suitably fluffy.

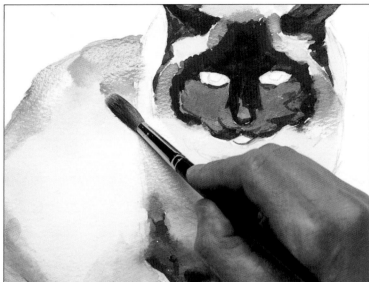

6 ▼ Change the background Allow about 15 minutes for the cat to dry. Now put your photo aside and look at the other one, where the cat is surrounded by colourful cushions. Use this as reference for the background. Still using the No.10 brush, add slashes of strong cobalt blue both above and below the cat.

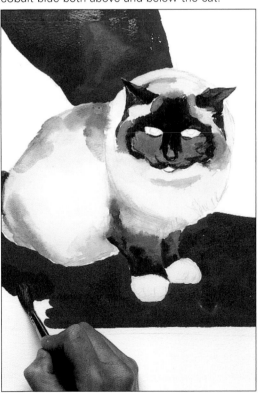

7 ▶ Add some red The blue changes the composition entirely, framing your subject and throwing it into relief. Add an equally strong red to the right of the blue, using scarlet lake with a touch of Vandyke brown. Paint carefully around the fur so as to not disturb any of the creamy body colour.

8 ◀ Paint the final cushion On the left is a cushion patterned with browns, gold and blue. Use yellow ochre mixed with a little white for the gold areas and, while this is still wet, add a thick band of cobalt blue. Paint the darker areas wet-on-wet with various mixes of raw umber, white and black.

DEVELOPING THE PICTURE

The completed background forms a striking contrast to the shape and colouring of the cat. Now turn your attention back to the cat itself and start to develop its features and the texture of its fluffy, silky fur.

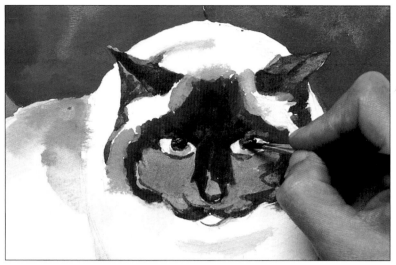

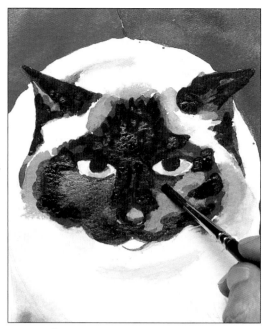

9 ▲ Paint the eyes Use the No.4 brush for finer details such as the eyes. Birman cats have pale blue eyes so mix up a dilute cobalt blue for these. Use pure black for the pupils to make them really stand out.

10 ▲ Strengthen the face Make a very dark mix of black and Vandyke brown. Using the No.4 brush, accentuate the darkness of the face, particularly around the eyes.

Master Strokes

Sir Edward Burne-Jones (1833-98)
Cat and Kitten

This delightful study of a mother cat and her kitten is worked in watercolour laid on plaster. The mother's rounded, bulky form dominates the composition and she gives a reassuringly placid and unflustered impression as her kitten plays with the tip of her tail. The kitten's body, by contrast, is made up of spiky shapes, such as its pointed tail, long legs and extended claws, and its pose suggests energy and mischief.

The irregular shape of the pale, neutral background seems to enclose the cat and kitten in their own small world.

The underlying forms of the mother cat's haunch and shoulder are defined with softly applied darker tones.

11 ▼ **Define the fur** With the No.4 brush, paint a pale gold ruff around the cat's face with a mix of yellow ochre and white. To give the fur a more downy appearance, apply the pale mix from step 4 with the very tip of the brush to paint individual hairs along the right-hand side of the body.

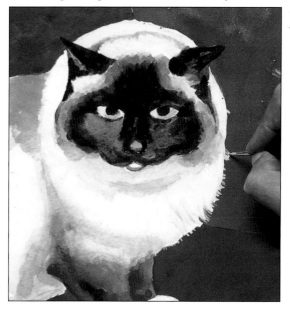

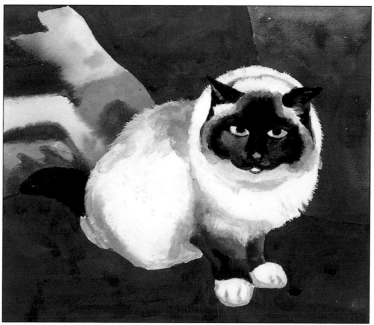

12 ▲ **Add tonal variation to the blue** Continue defining individual hairs above the cat's head and along the contour of its back, varying the tones by using some of the mixes from step 5. Finally, add shadows to the blue cushion with a mix of cobalt blue and black to make it appear softer and more luxurious.

Express yourself
Change of scenery

The original background of wooden floorboards was used for this interpretation of the Birman temple cat. The brown tones harmonise well with the neutral colours of the cat's fur, but the more colourful background of the step-by-step project complements the character of the cat.

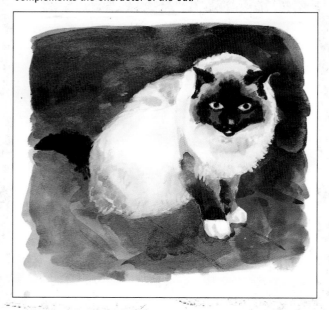

A FEW STEPS FURTHER

The picture is almost complete. As a finishing touch, add a few highlights to the cat's facial features to help liven it up and make it stand out more against the richly coloured background.

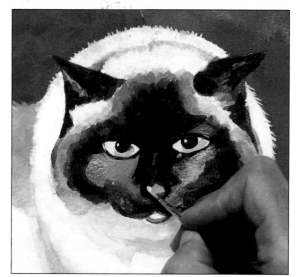

13 ▲ **Add highlights** Add a spot of white to each pupil to show reflected light. Make a pale grey mix from white plus touches of black and cobalt blue and paint the highlights on the fur under the eyes. For the tip of the nose, add more white to the mix.

14 ▼ **Create shadows** As the composition is built up from a combination of two photos, you'll need to use your imagination to create cast shadows on the cushions. Paint some dark shadows around the cat's paws and lower body, using a mix of cobalt blue and black.

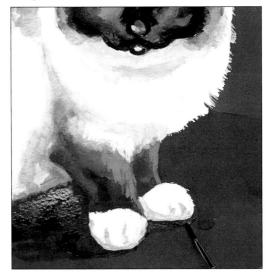

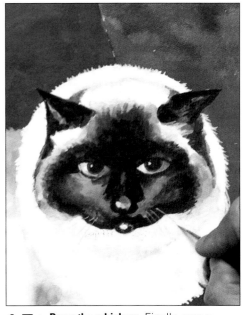

15 ▲ **Draw the whiskers** Finally, use a No.1 round brush and the pale grey mix from step 13 to draw in the delicate, sensitive hairs of the whiskers.

THE FINISHED PICTURE

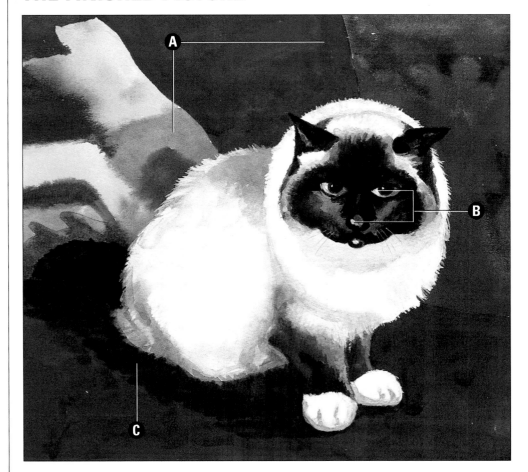

A Bold background
The bold swathes of colour in the background are left largely undefined, so as not to distract from the cat – the focus of the picture.

B White highlights
Dots of pure white on the eyes and pale grey on the tip of the nose suggest moistness and add an important touch of realism.

C Areas of shadow
The dark shadows around the cat's hindquarters prevent it from appearing to float above the surface of the cushion.